NO

Minimalism:Origins

Minimalism:Origins

Edward Strickland

Indiana University Press

Bloomington and Indianapolis

The paper used in this publication meets the minimum
requirements of American National Standard for Information
Sciences—Permanence of Paper for Printed Library Materials,
ANSI Z39.48-1984. ™

Manufactured in the United States of America

Library of Congress Cataloging-in-Publication Data

Strickland, Edward, date
 Minimalism:—origins / Edward Strickland.
 p. cm.
 Includes bibliographical references and index.
 ISBN 0-253-35499-4
 1. Minimal art—United States. 2. Arts, Modern—20th
century—United States. 3. Minimal music—History and
criticism. 4. Music—United States—20th century—History and
criticism. I. Title.
NX504.S77 1993
700—dc20 93-18396

1 2 3 4 5 97 96 95 94 93

Contents

to Ileana
poco por tanto

A

The death of Minimalism is announced periodically, which may be the surest testimonial to its staying power. The term itself, now common currency, appeared in the mid-sixties but was largely unheard outside of art and avant-garde music circles until the eighties, and no one seems certain how to define it even now. Yet Minimalism is not only recognizable but visible on all fronts, as the once-subversive style has been tamed by age and acceptance. It has, in fact, become part of the *lingua franca*, as mass culture has embraced what was once almost too easy a target for ridicule, from the repetition of "broken-record music" to the bald simplicity of monochrome canvases and monolith sculptures.

In popular music Minimalism was incorporated by numerous rockers in the seventies and stylized with artificial sweeteners into "New Age" music in the eighties. Over the past decade or so it has become a major influence on television commercials and Hollywood film scores (from the opening of *Cyborg* to the closing of *The Grifters*). Almost as an emblem of the displacement of Serialism from the mainstream by Minimalism, minor-mode repetition is now to cinematic suspense what tone clusters and fortissimo dissonance had been to horror and madness for decades, with the falling/rising minor thirds of Philip Glass in particular having proven a gold mine for Hollywood. His textures and timbres, in turn, were studied diligently by the house composer for a Special K commercial first aired in 1988: this time his major-triad arpeggiations were borrowed to suggest a happier, healthier life with Kellogg's than minor thirds were likely to evoke. Current IBM and Infiniti commercials borrow the repetitive keyboard figuration common to his work, Steve Reich's, and Meredith Monk's, and yet another emulates Monk's extended-vocalise in the service of NASDAQ. During a 1988 interview, several years after a miniprofile of the composer graced a magazine ad for Cutty Sark that was

hung sardonically around SoHo, Glass thought it important to note, "I don't do commercials" [*AC* 149]. In 1992 he rented out an excerpt from his avant-garde theater piece *The Photographer* as a jingle for Incognito perfume.

Minimalist painting and film-making have proven equally inspirational to Madison Avenue. One series of TV ads features little or no dialogue—in one commercial a couple confessing irresistible attraction amid giggles, in another a baby crying—both to a black screen, on which Aetna Life's name and number finally materialize with terse reminders about AIDS and college costs, respectively. *Barron's* offers a full-page ad with an empty rectangle in the center, beneath it two small-print sentences expressing the corporate "credo" and "JPMorgan" in bold print. A NYNEX spot has a silent fifteen-second still-shot—an eternity by TV standards, and an expensive one (thirty 1993 Super Bowl seconds sold for $850,000)—showing nothing but its Yellow Pages, until the words "It must be the weekend" appear below and the commercial ends. A half-minute commercial debuting shortly afterwards features silence and a black screen with white letters reading: "When should you talk to your kids about drugs?" (five seconds); "How about now?" (five seconds); "Go ahead, we'll wait" (fifteen seconds); "Partnership for a Drug-Free America" (five seconds).

The clever use of stasis and silence achieves its effect contextually— i.e., in juxtaposition to the otherwise unremittent sensory bombardment by the boob tube, just as spare newspaper/magazine ads catch one's eye amid page after page of crammed columns of once-in-a-lifetime prices and lush color spreads of gorgeous nicotine addicts contaminating the equally gorgeous Great Outdoors.

it's cool. understated. sophisticated.

It's hard to remember that Minimalist composers, now almost avuncular figures, were laughed offstage or assaulted onstage in their youth, or that now-revered artists were lampooned as opportunistic nihilists and simple frauds. And it's impossible now to hear/see the works as when they first appeared, even if one is hearing/seeing them for the first time, so cushioned is their impact by the mass-media knockoffs.

Beneath the *sic transit contemptus mundi* trope lies the historical reality of the contemporary art world, which has more to do with a futures market than a studio. Just as the network news lasts half an hour whether or not anything of note has occurred, so fresh product must be provided for consumers of the arts—be they juvenile rockers (Dick Clark: "I'm just the storekeeper. The shelves are empty, I put the stock on" [Bangs 139]) or well-heeled culturophages anxious to turn a prescient buck whether or not any artist in range has anything of other than monetary value to offer. Thus the standing of Minimalist art has benefited from the mass of stupefying triviality that has followed it. Though few would have suspected that planks and white canvases would ever become objects of nostalgia, their cold indifference has attained a largely retro-

active nobility after the proliferation of vacuously decorative, sloppily portentous, and fatuously eclectic art since the 1970s. The later history of Minimalism marks the transition of twentieth-century art from its waning as an autonomous and implicit critique of mass culture to its demystification and acceptance as but another commodity, albeit a highly inflated one, in a society geared progressively on all levels to the unremitting consumption of sensations.

The butt of jokes in *New Yorker* cartoons and *New York Times* art columns alike is now less likely to be derided as non-art than to be revered as the last "classic" period before the flood of artistic flotsam and jetsam termed "post-Modernist" (an appropriate coinage in that it has its vulgarity in common with much of the work it denotes). Meanwhile, elements of Minimalist style have been defused by time as well as by the media and marketing forces against which it stood, at least sometimes, in silent opposition, and by both the conservatism and commercialism of once-lunatic artists and musicians themselves.

The inexorable reductiveness of Minimalism may represent the final stage of the dehumanization of art analyzed by Ortega y Gasset in the 1920s—Kenneth Baker most effectively illuminates this aspect of the style, though Michael Fried had advanced the contrary argument twenty years earlier amid the fray—but it also represents the culmination of the whole modernist enterprise of purification of means—traceable, albeit perhaps too handily, from the humanist phenomenology of Impressionism to the objectivist phenomenology of Robbe-Grillet.

The reputation of Minimalism may also have benefited from its historical importance as an indigenous American style and its unparalleled transcendence of the barriers between media. Among earlier movements, the Regionalism or Populist Realism of the 1930s produced work in painting, music, and fiction that conveyed distinguishably American themes in analogous styles. The directness, expansiveness, and political sympathies of the panoramic structures of Thomas Hart Benton and John Steuart Curry, Roy Harris and Aaron Copland, John Dos Passos and John Steinbeck have more than "the American Scene" in common, but in the obvious debts to Mexican muralists and the international experimentalism of post-World War I Paris [see Tischler] the movement, at least in painting and music, is more distinctively American in content than in style.

After the next war, Abstract Expressionism established not only the independence of New York from Paris but its predominance. However, although analogies to the painting may be discovered in sculpture, the cut-ups of William Burroughs, and even the aleatorics of John Cage and his followers or the free-jazz harmolodics of Ornette Coleman, Abstract Expressionism remains primarily a one-idiom movement (if in fact the wildly diverse styles of Jackson Pollock and Franz Kline, Willem de Kooning and Clyfford Still can be said to constitute a movement). Minimalism not only was primarily an American phenomenon but also found

expression in painting, music, sculpture, dance, film, and literature to significant degrees.

Although the once-outrageous vocabulary of Minimalism in its diverse media has now been incorporated and its therapeutic power to shock co-opted by the culture at large, the term Minimalism itself remains both a stylistic and chronological abstraction, particularly in the area of painting. While the list of painters so categorized changes from critic to critic, the style remains most often associated with the 1960s, when according to conventional wisdom it arose in austere counterbalance to the flash of Pop and Op art, which was primarily though hardly exclusively two-dimensional. At the time Barbara Rose referred to Pop art as "the reflection of our environment" and Minimal art as "its antidote" ["ABC" 69]. Although the strongest and most often discussed Minimalist art of that period is three-dimensional, Minimalism is also commonly described, nonetheless, as a reaction against the continued hegemony of Abstract Expressionism. But since that movement was primarily concerned with painting, generic difficulties immediately arise on two fronts.

In its simplest definition, Minimalism is a style distinguished by severity of means, clarity of form, and simplicity of structure and texture. It is in one sense transhistorical, but to discuss it as an artistic movement rather than a stylistic tendency requires some chronological framework if it is to have any meaning at all as a cultural phenomenon. To call the builders of Stonehenge Minimalists is to evaporate the term; on the other hand, to date Minimal art from the 1960s is rather like dating British Romantic poetry from Tennyson. The restriction of the adjective Minimal to that and sometimes later periods remains a popular historical convenience, pigeonholing the style for smoother distribution in journalism and pedagogy.

In sculpture it is probably more accurate than most such classifications, for no sculpture accurately classifiable as Minimal existed earlier. However, the strongest and most daring Minimal painting was created before the 1960s even began, and long before the term reappeared in 1965—just as "action painting" was in its dotage by 1952 when Harold Rosenberg popularized the phrase, possibly borrowed from Pollock and in any case more snappy than precise [Naifeh/Smith 708, 711–12, 895].

In painting, then, where the multi-idiom reductive style later dubbed Minimalism first developed, the convenience of identifying the style with the decade debases the term by wedding it not to a style but to its stylization as surely as if Abstract Expressionism were restricted to the work of its second or "Tenth Street" generation or atonality to its later Serialist codification. In painting, the sixties witnessed not the birth, nor even the maturation, but rather the progressive academizing of severely reductive art in the proliferation of the work of numerous figures refining or domesticating the boldness of their predecessors or of themselves with often étude-like variations on their themes. The sculpture, which originated more than a decade after the painting, was both accepted and

stylized more quickly, its academizing a fait accompli by the seventies.

Within the specious chronological delimitation of Minimalism to the 1960s, Barnett Newman, Ad Reinhardt, Ellsworth Kelly, and/or Frank Stella are commonly said to "foreshadow" in the 1950s the Minimalism that *really* began only around the time the term hit the art magazines in 1965, but they are not "Minimalists" themselves—disqualified as much on chronological grounds as on the empirical evidence of their work. The term itself, rather than denoting what it is—a major movement within American abstraction throughout the third quarter of the century—adheres (or is glued) to the period of its public recognition and critical acceptance. If, however, Kelly painting monochrome panels in the early 1950s and Stella brushing bands of black house paint directly from can to canvas in the late 1950s are to be regarded merely as adumbrating developments of the mid-sixties, as if functioning within some teleological time warp, rather than practicing a Minimalism attributed restrictively and arbitrarily to their emulators, the term may be legitimately abandoned.

Alternatively, with a bow to the Arnoldian priority of criticism to creation, one may simply accept the term as primarily a temporal rather than a stylistic signifier and define Minimal art de facto as the art to which contemporary critics applied the term. In her thoughtful exploration of issues central to Minimalism, Frances Colpitt essentially adopts this approach, with a small chronological concession to Stella:

> Minimal Art describes abstract, geometric painting and sculpture executed in the United States in the 1960s. Its predominant organizing principles include the right angle, the square, and the cube, rendered with a minimum of incident or compositional maneuvering....
>
> Frank Stella's Black Paintings, which were shown as early as 1959 in the Museum of Modern Art's Sixteen Americans, inaugurate the period, while Robert Morris's process-oriented work and Michael Heizer's earthworks of the late sixties signal its demise. The bulk of contemporary critical literature appeared between 1963 and 1968, the period to which this survey is predominantly restricted.
>
> ...Minimalism is not used here with a lower case m. It is restricted to those artists who shared a philosophical commitment to the abstract, anti-compositional, material object in the 1960's. [1]

Kenneth Baker also treats Minimalism as a phenomenon born in the 1960s but extending well beyond the decade. While Colpitt notes that some of the figures of the sixties continue producing in the same vein, she excludes mention of artists who first followed in their tracks after her period of specialization. Baker, however, includes a discussion of the works that for Colpitt signal the demise of the movement, along with later process work of Richard Serra, the massive environmental projects of Robert Smithson and Walter De Maria in the 1970s, and even the sculpture introduced by Joel Shapiro in the seventies and eighties.

The word "minimal" is used loosely these days in reference to any stylistic austerity in the arts. The term "Minimalist" is only slightly more precise when applied to works of visual art. It carries two distinct implications, each with its own historical resonances. The term may refer to art, primarily sculpture or three-dimensional work made after 1960, that is abstract—or even more inert visually than "abstract" suggests—and barren of merely decorative detail, in which geometry is emphasized and expressive technique avoided. . . .

The other sense of "Minimalist" refers to the tendency of such people as Carl Andre, Dan Flavin, and Robert Morris to present as art things that are—or were when first exhibited—indistinguishable (or all but) from raw materials or found objects, that is, minimally differentiated from mere non-art stuff. [9]

Although "made after 1960" is another instance of stylistic genesis by critical fiat, Baker makes clear that his emphasis is on three-dimensional art rather than the painting, which "gets short shrift in this book" [19]. This admission justifies his exclusion of art produced before 1960, although it seriously deracinates the three-dimensional work of the decade he analyzes by ignoring the two-dimensional work from which it sprang. A considerable body of pre-sixties painting (e.g., the works by Newman, Kelly, and Stella he reproduces as illustrations in his text) is abstract, non-decorative, geometrical, and/or non-"expressive," thus amenable to the first of his two definitions, so the short shrift is evidently itself somewhat arbitrary. It is vindicated only by Baker's greater reliance on his second and more rigorously exclusive definition of Minimal art as aspiring to the condition of non-art: "most of the artists who might be called Minimalist painters . . . did not take abstraction to the point where it made their works unrecognizable as paintings" [19–20].

Robert Pincus-Witten seems somewhat more restrictive chronologically than either Colpitt or Baker, though his language is vague. Having coined the phrase "Postminimalism" for the period 1966–76 [1977 13], he delineates its origins thus: "The years 1966–70 mark a watershed in American art, ending the decade that derived its options, by and large, from a still earlier parent style, Minimalism" [15]. Minimalism is explicitly restricted to the period up to, and presumably including at least part of, 1966, when Minimal succeeded Pop and Op as the art craze of the year. The ambiguous "still earlier" (than Postminimalism? than the decade?) makes it hard to determine whether Pincus-Witten too dates the inception of Minimalism from the sixties, though that seems to be the implication.

Focusing on sculpture, Rosalind Krauss discusses Minimalism as a phenomenon of the 1960s with "immediate sources" in the work of Jasper Johns and Frank Stella in the mid- and late 1950s [1977 243–88]. In a survey of the avant-garde art scene in the 1960s, Barbara Haskell begins her analysis of Minimalism with Stella, "the first artist to accept geometric abstraction but abrogate its subjectivity and metaphysical

aspirations" [1984 91]—a status that might also be claimed for Ellsworth Kelly. Haskell refers in passing to Reinhardt and others, including "Chromatic Abstractionists" Newman and Rothko, segregating them from "their emulators" for their "essentially mystical tone . . . and their commitment to art as a form of moral statement." Stella is not so sharply separated from the Minimalist tradition, although Haskell notes that a quarter-century after their creation his blacks seem "rich and almost loosely painted, with manifold variations in surface handling and edge. In retrospect, the dark palette and iconic presence of these paintings radiate an almost religious aura, which William Rubin hinted at in 1960 when he wrote of being 'mesmerized by their eerie, magical presence'" [1984 91]. Apparently, then, the gulf between early and late 1950s is not quite so impassable, either in form or tone.

Without rejecting chronological considerations altogether, it might be advisable to let the characteristics of Minimal art determine its chronology, rather than vice versa. Before demarcating "the Minimalist era" by historical a priori, we might try to clarify the adjective itself.

Minimalism is here used to denote a movement, primarily in postwar America, towards an art—visual, musical, literary, or otherwise—that makes its statement with limited, if not the fewest possible, resources, an art that eschews abundance of compositional detail, opulence of texture, and complexity of structure. Minimalist art is prone to stasis (as expressed in musical drones and silence, immobile or virtually immobile dance, endless freeze-frame in the film, event-free narrative and expressionless lyrics, featureless sculpture, monochromatic canvases) and resistant to development (gridded or otherwise diagrammatic paintings and sculptures, repeated modules and held harmonies in music, simple and reiterated movements in the dance and film, the aborted or circular dialogues of the drama and fiction). It tends towards non-allusiveness and decontextualization from tradition, impersonality in tone, and flattening of perspective through emphasis on surfaces (neutralization of depth cues in painting or of the space/substance, image/reflection dichotomies in light environments, the restriction of dynamic and harmonic movement in the music, the human "still lifes" of the films, and the analogously univocal description of persons and objects in the poetry and fiction).

Many if not all of these qualities are shared by artists as apparently remote from one another as La Monte Young and Raymond Carver, though Young represents lower-Manhattan avant-garde experimentalism and perhaps the most rarefied attempt at musical transcendentalism in existence, while Carver's territory is the very different and grimmer repetition and stasis of everyday life in blue-collar and no-collar Middle America.

This study outlines the origins of Minimalism rather than its history, which continues, as many of the founding artists continue creating and

younger ones build upon, distort, or parody their discoveries. Although it was primarily the sculpture that provoked the initial attention given Minimalism as a movement, it was in painting that the rejectivist movement began and developed for fifteen years before the sculpture was exhibited, and it was out of the style and concerns of the painting that Minimal sculpture evolved. My own focus in the plastic arts is therefore on the painting, while the sculpture that grew out of it and brought the movement broader recognition circa 1966—when Minimal painting was already in its late, mannerist phase—is discussed comparatively briefly after a survey of Minimal music from 1958–74.

While the roll of Minimalist sculptors is widely recognized, despite the distaste of some for the term, there is, significantly, no accepted canon of Minimalist painters, in part because of the broader chronological boundaries of the painting, in part because virtually every painter associated with Minimalism, even those who arose in its heyday in the latter half of the sixties, has been explained as not really Minimalist on some grounds or other (Newman's rhetoric, Reinhardt's temporality, Kelly's chroma, Martin's personal touch, Ryman's painterliness, Marden's intuitive process, Tuttle's fundamentally post-Minimalist sensibility). The canon is itself thus reduced to minimal form, if not erased, by a rigor of categories that exceeds the technical rigor of the art. Yet the radically reductive tendency in American art beginning around mid-century is an undeniable fact, and the painting of artists as different as Newman and Marden clearly has more in common formally and stylistically than the work of, say, fellow "Impressionists" Manet and Monet or "Abstract Expressionists" Gorky and Kline.

Maurice Berger has noted correctly that much of the early writing on reductive art "was quick to notice formal, surface similarities, while it ignored the deeper philosophical or stylistic distinctions when these nuances threatened the unity of an argument" [4]. This study, fundamentally stylistic and formal in orientation, also tends to ignore the deeper philosophical distinctions and concentrates on the physical facticity of the artworks, an approach validated by their own muteness. The first and foremost criterion for my description of the work under discussion as Minimalist, that is to say, is its appearance as opposed to anyone's pronouncements about it, including the artist's, which may be as deluded or irrelevant as anyone's.

It is primarily because of his pronouncements that Newman seems a problematic choice as a founding father of Minimalism. Yet as early as 1962 formalist critic Michael Fried perceived a joint exhibition of Newman and de Kooning "as a kind of *agon*" between de Kooning's gestural style and Newman's "art conceived in terms of its absolute essentials, flat color and a rectilinearity derived from the edge of the canvas . . . a simplicity which is pretty near irreducible" [December 1962 54, 57].

Newman's "zip" paintings are thus considered here for the revolutionary clarity and simplicity of their composition: band(s) crossing a field.

On the other hand, Jules Olitski's spray paintings are mentioned only briefly—despite the dutiful flatness, nonpainterliness, and other theoretical concerns that impressed, among others, Fried—because the lush complexity of their colorism and soft, virtually non-existent, contours are alien to the classical simplicity I consider fundamental to Minimalism. Ad Reinhardt's black paintings are Minimalist for their virtual in(di)visibility; Rauschenberg's black paintings are not, for their textural complexity and aggregative structure; Frank Stella's black paintings are, for their unitary, holistic effect; Mel Ramsden's *Black Painting* is not, for its verbal "appendix," which transports the paint by force to the realm of conceptualism.

In environmental art, similarly, what Smithson's *Spiral Jetty* has to do with Minimalism escapes me, though De Maria's *Lightning Field*, in its expansive but unvaried repetition of simple and indivisible modules, might occupy the subset "epic Minimalism" comfortably with works in other media like La Monte Young's *The Tortoise, His Dreams and Journeys*, Newman's *Stations of the Cross*, Ronald Bladen's *The X*, Andy Warhol's *Empire*, perhaps the Rothko Chapel, and certainly the Yamasaki Cathedral—for what Chartres is to the Gothic and St. Peter's to the Baroque, the World Trade Center is to Minimalism.

Chronologically, the reductivist movement in the American visual and performing arts called Minimalist develops over roughly the third quarter of the century. In the fourth quarter the literary style called Minimalism quickly becomes a force in fiction, and the style is progressively adopted by popular culture, with manifestations not only in film music and TV commercials but in fashion (from the monochrome-polo-shirt-and-solid-shorts trend to the white-T-shirt-and-jeans trend), design (logos from *thirtysomething* to Absolut vodka, and album jackets from Talking Heads' *Fear of Music*, designed by Robert Rauschenberg, to Dire Straits' *making movies*), and even comestibles (Lite beer and frozen Light "cuisine," designer bottled water, the steady supplanting of traditional beer and bourbon by white wine and virtually tasteless vodka). The latter, along with Marlboro Lights and Lite-FM, may be manifestations of the sundry concerns of an aging population more than the dissemination of pop Minimalism, but the influence is there as it is in the more recent popularity of colorless cola and detergent.

John Rockwell, one of the most perceptive critics of Minimal music, has further mused, "What is nouvelle cuisine but a Minimalist reaction against the Victorian ornateness of French haute cuisine?" [1966 29]. In the same article he also speculated on the existence of a "Minimalist" politics of less government (somehow always more popular before than after the election). The adjective was frequently applied in the media to Jerry Brown's run for the presidency six years later [e.g., *New York Times*, March 6, 1992, A19], at the same time as Robin Finn was analyzing "power tennis" as "Minimalist" [March 8, 1992].

I date Minimal painting from Barnett Newman's *Onement I* in 1948,

Minimal music from Young's *Trio for Strings,* composed across the continent in 1958. Young's earlier long-tone works, begun the previous year with hints in his 1956 compositions, adumbrate but do not break through into the radicalism of the *Trio,* which very much echoes the relationship between Newman's field-*cum*-verticals of the roughly equivalent period preceding *Onement I.* Minimal sculpture was first exhibited in 1961, shortly after it began to be executed, with Robert Morris, Walter De Maria, Donald Judd, Carl Andre, Dan Flavin and others propelling sculpture into a radically new phase owing little to precursors in their own medium and much to the painters who preceded them—as much, in fact, as their painter colleagues dubbed Minimalists at one time or other.

Minimal film develops along with the sculpture and is undoubtedly equally influenced by the painting. Minimal dance somewhat predates the sculpture and film but has a largely simultaneous development, although it is foreshadowed by Merce Cunningham's work from the late 1940s onward to roughly the same degree as the work of Cunningham's comrade John Cage adumbrated developments in Minimal music.

In music popular misconception still dates the inception of Minimalism from Philip Glass and Robert Wilson's *Einstein on the Beach* in 1976 or the Columbia Records recording and release of Terry Riley's *In C* in 1968, four years after its composition and premiere. This is erroneous insofar as these came years after Young's long-tone compositions, which directly inspired Riley and in which Young began to establish a climate in post-Cageian experimentalism within which later Minimalist developments could be taken at all seriously. Nineteen sixty-four may still be considered, however, to mark the efflorescence of Minimal music—with the inception of Young's masterpiece, *The Well-Tuned Piano,* and the evolution of his ensemble work from progressively longer tones and held harmonies into the full-blown sustenance of the drone epic, *The Tortoise, His Dreams and Journeys;* Riley's evolution into modular notation with *In C;* and Steve Reich's systematization of Riley's freewheeling tape techniques into full-fledged process music at year's end.

In dance as in other media, Minimalism is now associated primarily with New York but like the music has California roots, specifically in the work of Ann (now Anna) Halprin. Halprin's work in the Bay area— she founded the Dancers Workshop Company in 1955—is sometimes dubbed Minimal merely because her musical accompaniment was provided in 1959–60 by co-musical directors Young and Riley, but the quality of the Cage-influenced "noise" they produced for her, and her aesthetic of multi-media sensory bombardment at that time, are probably equally resistant to the label. Riley's later tape-looped accompaniment was more strictly Minimal. So was Halprin's desegregation of the diurnal and artistic in dances composed of everyday tasks/objects and featuring motion closer to walking than to either ballet, modern dance, or Cunningham's mannerism, or based on functional movements like bathing and eating.

The reductive element in her work was developed in distinctive ways

by students of Halprin like Trisha Brown, Yvonne Rainer, and Simone Forti (Simone Morris during her marriage to Robert Morris from 1956–61), as well as by Steve Paxton, Lucinda Childs and others. As early as 1960 Simone Forti had pursued the demystification of dance within the framework of concept art (two of her *Dance Reports* were of an onion sprouting in a jar and boys playing with snow) and to developing dances out of movements not normally associated with the dance. One *Dance Construction* later named *Huddle* has the dancers huddling, climbing individually atop the huddle, and redescending into it. In 1960 she contributed these and other notations to *An Anthology,* edited by Young and Jackson Mac Low. In the *Dance Instruction* duet, one dancer (Robert Morris in its premiere) is told to remain lying on the floor while unbeknownst to him the second dancer is told to tie him to the wall. A more minimal and less histrionic piece called *Platforms* featured a male and female dancer entering boxes and whistling gently to one another for fifteen minutes before reappearing—a performance connected to the contemporary use by Robert Morris of one of the first Minimal sculptures, *Column,* as a stage prop in which he concealed himself.

Rainer, another theoretical writer as well as practical choreographer, shared a loft with the Morrises in 1960 and was "affected . . . deeply" by a Forti improvisation of sitting in various spots amid a roomful of rags [Rainer 5]. As early as *The Bells* in 1961, Rainer began exploring repetition, initially of whole sequences, and by 1964 of simple (combinations of) movements, thus building upon—or subtracting from—the work of Cunningham and Halprin in her own distinctive manner. The reductive element in her work is balanced by a good deal of athleticism. She contributed an essay written in 1966 to Gregory Battcock's *Minimal Art: A Critical Anthology,* an unfocused anthology but extraordinarily valuable as a primary as well as secondary source since its publication in 1968 marked the canonical status achieved by the art. In "A Quasi Survey of Some 'Minimalist' Tendencies in the Quantitatively Minimal Dance Activity Midst the Plethora, or an Analysis of *Trio A,*" Rainer outlined schematically the relationship between Minimal dance and art [Rainer 63; Battcock *Minimal* 263].

In film, Morris, Tony Conrad, and Jackson Mac Low were experimenting with shooting fire, smoke, trees, etc. in the early sixties, but it was Andy Warhol (whose Pop canvases and sculptures are frequently and mistakenly labeled Minimal) who had clearly by the mid-sixties blazed the trail of cinematic Minimalism for numerous later film-makers like George Manupelli, Michael Snow, and Richard Serra. *Sleep* (showing John Giorno asleep for six hours) was shot in July 1963 and first shown publicly at the Gramercy Arts Theater on January 17, 1964; *Empire* (starring the even more obdurately immobile State Building) was shot on June 25, 1964 and first shown publicly at the City Hall Cinema on March 6, 1965. Others less known and less Minimal because more inherently kinetic were *Kiss, Eat, Haircut,* (an occupied) *Couch,* and *Blow*

Job, all of which were shot after *Sleep* in 1963–64, although *Haircut* was presented a week earlier than *Sleep* at the Gramercy Arts.

Warhol soon compromised his economy of means by adding a second and third projector for the twenty-five-hour extravaganza he entitled ★★★★ in droll forestallment of the critics. In retrospect the Minimalist cinema may on the whole get about half a star, its negligible achievement founded on what seems a perversely reductive negation of its medium. While the same criticism might be made against the simplistic techniques of Minimalists in other media, their works have passed the principal test, survival, while the films are now largely period pieces and likely to remain so.

Literary Minimalism is a later development altogether, very much a child of the late sixties and seventies. The early works of Sam Shepard were influenced by the Minimalist aesthetic, as was the Minimal poetry that grew up in the wake of concrete poetry and in tandem with conceptual art. The fiction, which has had a more lasting impact, is most frequently associated with Ann Beattie and Raymond Carver, who published their first books in 1976, and the former conceptual artist Frederick Barthelme, whose stories began appearing toward the end of the decade. The prototype of the Minimalist novel, however, may be Joan Didion's *Play It as It Lays,* which appeared in 1970, almost as an emblem of the decade's cultural hangover after the traumatic excess of the sixties.

While the title of this book is meant to indicate its purpose as a study of the origins of Minimalism, it might suggest a further relationship between the common and proper nouns in that Minimalism itself remains an art of origins, an art exploring and exposing the building blocks of all its various media. That exposure accounts for much of the discomfort and outrage the art has provoked in its audience.

Painting from Lascaux to the latest show is similarly composed of pigment applied to a surface. Minimalist painting culminated the rejective purification of Modernism by reducing the medium to its components and displaying those components overtly. A single pigment might be applied uniformly across the entire surface. Alternatively, most or much of the surface itself might be exposed as an integral part of various geometrical configurations or simply to set off a line or lines of pigment more effectively.

Just as the Minimalist palette might be restricted to a single hue, so the element of line in Minimalist painting or drawing might consist literally of a single line, whether a few inches (Ellsworth Kelly) or several yards (Patricia Johanson) in length, drawn upon paper or bare canvas or upon a monochrome field. Form in Minimalism is characteristically reduced to undifferentiated holism or all-over pattern: the field and/or the grid or other regularized geometrical schemes. The works may feature

as corollary canvases of irregular shape but unitary design in isolation or conjoined to form the whole.

Those shaped and multipanel paintings, even when not of mural size, eschew the framing of the painting that is traditionally part of its public form, though fundamentally extraneous to the work itself. Later Minimalism played with the other crucial element in the conversion of artwork from creation to consumption: its being hung on the gallery or museum (or office or residence) wall. Works appeared on unstretched canvas simply pinned to the wall, or the wall itself might be co-opted as part (or whole) of the support, with paint dripped onto it from the hung canvas or applied to it directly within an otherwise empty frame.

Music is the organization of sound and silence, more specifically sounds of various frequencies and durations (notes) with silences of various durations (rests). In the earliest Minimal music, the long-tone works of Young, those rudiments are presented nakedly and emphatically: the first note in the *Trio for Strings* is held for five minutes, followed by the first rest, lasting half a minute.

The vertical arrangement of tones into harmony is dramatized in Minimal music in the sustenance of a single interval for several measures or even indefinitely, or of a single harmony for the duration of a full-length piece. The horizontal arrangement of tones into melody may in turn take the form of a simple cell or phrase repeated incessantly according to various structural principles (overlapping modules in Riley, phased unison in Reich, additive/subtractive cycles in Glass).

Repetition is a basic structural component of all forms of classical music, whether simple repetition as in binary dance-forms, ternary da capo, and unison canon, or varied repetition as in sonata, theme-and-variations, and various historical permutations of fugue and other contrapuntal forms. In much Minimal music, however, overt and immediately audible repetition of simple, even simplistic, material is the predominant structural principle.

In dance, film, sculpture, and literature, similarly, Minimalism exposes the components of its medium in skeletal form. Dance, the organization of motion and stasis, is often reduced to a modicum of elementary movements perhaps juxtaposed to episodes of immobility. Film, composed of twenty-four still-frames shown successively within a second to create the illusion of movement, may be reduced virtually to the status of the still-frame itself, while the "motion" side of "motion pictures" may be represented by the filming of a single element (fire) or human gesture (holding an object).

Minimalism has been charged frequently with being anti-art; it may be more accurate to call it anti-artifice. There is an almost Brechtian element in its forthright exposure of means, although in theater Samuel Beckett's work provides a closer analogue to Minimalism. His influence is felt directly on Minimalist drama in its use of snippets of non sequitur

as dialogue, again with the intent of defeating expectations by exposing the code of the medium. Much Minimalist fiction, in turn, consists of bare-bones narratives inhabited by intangible characters performing meaningless rituals and having pro forma conversations.

It was primarily in sculpture that Minimal art was identified as such to the public in the mid-sixties, although the 1965 articles of Richard Wollheim and Barbara Rose drew more examples from two- than from three-dimensional art. The sculpture, which arose in the early sixties in response to the painting that had been exhibited since 1950, is most emphatic of all the media in its rejectiveness. Sculpture is three-dimensional form, and Minimal artists presented work that met the bare minimum requirements of that definition: non-representational, geometrical fabrications—monochrome cubes, boxes, slabs, etc.—free of assemblage, gesture, or decoration, and aspiring to the status of autonomous objects. The disappearance of the pedestal served much the same end as the rejection of the traditional hanging of Minimalist paintings. The names given their work by Judd and Morris—"specific objects" and "unitary forms," respectively—further indicate the reduction of their art to, and identification with, its rudiments. That identification is what primarily identifies in turn the art here discussed under the rubric of Minimalism.

Paint

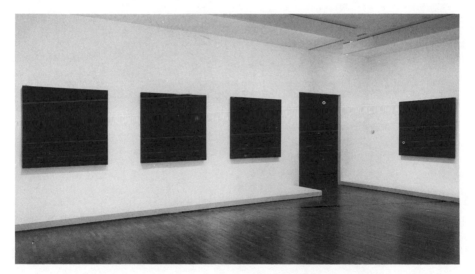

Installation view from the exhibition *Ad Reinhardt.*
June 1, 1991 through September 2, 1991. The
Museum of Modern Art, New York. Photograph
courtesy The Museum of Modern Art, New York.

B

In art, the question of whom to include under the Minimalist rubric was
from the beginning no more problematic than whether to use the rubric
at all. Just as in later music terminology, "hypnotic music," "pulse music,"
"trance music," "process music," "modular music," "systemic music," and
others had their moment in the sun before "Minimalism" won the field,
early attempts to characterize the painting and/or sculpture included
"ABC art" (Barbara Rose), "reductive art" (Rose, after Clement Greenberg
and Michael Fried), "literalist art" (Fried, after Robert Morris), "rejective
art" (Lucy Lippard), "neomechanist school" (Robert Coates), "structurist"
sculpture (Lippard), "Abstract Mannerism" (Peter Hutchinson),
"'rationalized' art" (James Mellow), "cool art" (Irving Sandler), "one-shot
art" (Sandler), "miniarts" (Douglas Davis), "object sculpture" (Rose),
"sculptecture" or "post-painterly relief" (Anne Hoene), "primary struc-
tures" (Kynaston McShine's title for the spring 1966 exhibition he curated
at the Jewish Museum), "systemic painting" (Lawrence Alloway's title for
the fall 1966 exhibition he curated at the Guggenheim Museum), "one-
image painting" (Alloway), "specific objects" (Donald Judd), "unitary
forms" (Robert Morris—used as the title of the 1970 San Francisco
Museum of Art show curated by Suzanne Foley), and "unitary objects"
(the Morris/Judd portmanteau phrase used by Sandler in the catalogue
essay for the 1967 exhibition American Sculpture of the Sixties at the Los
Angeles County Museum of Art).

Then-New York Times critic Brian O'Doherty displayed the gift of the
gab by coining at various times "new nihilism," "anti-art," "low-boredom
art," and "Democratic Nominalism," and entitling one column "Avant-
Garde Deadpans on the Move." Rose also notes the application of "idiot
art" and "know-nothing nihilism" to the avant-garde deadpans at the
time, while Mel Bochner told Frances Colpitt that "Dragnet art" (after TV

Sergeant Joe Friday's "Just the facts, Ma'am") was once current [Colpitt 5]. Steve Reich has credited English composer-critic Michael Nyman and Philip Glass American composer-critic Tom Johnson with the invention of the term Minimalism in the area of music criticism in the seventies, a question examined at the end of Part Two. However, in her fall 1965 article on "ABC Art" in *Art in America,* Rose had already applied the term implicitly to the music of Young (with a nod to Morton Feldman), as well as to the choreography of the Judson Dance Theater and the films of Warhol. (She cites Richard Wollheim's article "Minimal Art," published the preceding January, early in her essay and offers "ABC" as a synonym for, or a gloss on, Wollheim's "Minimal.")

Although Richard Wollheim is credited with the formal introduction of the term in a January 1965 *Arts Magazine* article which he told Frances Colpitt had been inspired by a lecture by Adrian Stokes [Colpitt 206 n.14], Rose herself had written in the February 1965 *Artforum* of an exhibition by Robert Morris, Donald Judd, Carl Andre, and Robert Murray that "the most obvious common denominator was how empty everything was, how much effort went just into rejecting all but the very barest, irreducible minimum" [35]. In the same month's *Arts Magazine,* Donald Judd, who was to voice the most vehement objections when the term caught on in 1965 and 1966, wrote that the sculpture of Robert Morris was "made on purpose, not found, to be minimal" [Judd 165]. Given normal lead time, one would assume both these pieces would have been written before Wollheim's article was published, although Rose's rejective-effort argument in fact echoes Wollheim's principal vindication of what he specifically terms "minimal art," and Judd notes that he "always put off until the deadline" submitting his reviews [Judd vii]. In any case, Judd had already suggested in the March 1964 issue that "Morris' work implies that everything exists in the same way through existing in the most minimal way" [Judd 118], and as early as the May 1960 issue he had described Paul Feeley's "confidence in the power of the minimal" [Judd 17].

The adjective was current if not specifically denominative in the art world in the mid-sixties, even among those less personally involved with reductive art. John Coplans observed in his January 1964 *Artforum* article on West Coast Hard Edge that John McLaughlin "minimizes the paint" in an art of "minimal components" and drew an analogy to Rothko and others noted for "minimization of brushwork" [30–31]. In the next month's *Arts Magazine,* Sidney Tillim described Stella's "pictorial parts" as "minimal" [21].

Furthermore, the term (like "Abstract Expressionism," which had been revived by Robert Coates of the *New Yorker* with reference to the New York School) had appeared in an earlier incarnation back in 1929. The same year Alfred Barr first used Abstract Expressionism to describe Kandinsky, David Burliuk described the painting of John Graham as "Minimalist" in his catalogue essay for Graham's exhibition at the Duden-

sing Gallery, noting that Graham's "latest period, Minimalism, is an important discovery that opens to painting unlimited possibilities" through its "minimum of operating means," and stating, "Minimalist painting is purely realistic—the subject being the painting itself." Despite Burliuk's debatable usage of "realistic" to mean reflexive, Graham himself adopted the term in his 1937 treatise *System and Dialectics of Art*, defining Minimalism as "the reducing of painting to the minimum ingredients for the idea of discovering the ultimate, logical destination of painting in the process of abstracting." He muses, "Painting starts with a virgin, uniform canvas and if one works *ad infinitum* it reverts again to a plain uniform surface (dark in color) but enriched by process and experiences lived through. Founder: Graham"—a description more prophetic, apart from the abused *ad infinitum*, than either self-descriptive or self-effacing [Sandler 1968 52–53; Osborne 376].

In the year preceding the publication of Wollheim's article, Rainer and Riley had broken through into phrasal repetition in their respective media; Young had completed his first realizations of *Tortoise* and *The Well-Tuned Piano* in New York; and Reich had begun his first phase piece, *It's Gonna Rain*, a work for tape based on the apocalyptic warnings of a preacher named Brother Walter in San Francisco's Union Square. It was premiered the same month *Arts Magazine* published the article by Wollheim, who mentions none of these underground developments in the performing arts and was unlikely to be aware of them. A more interesting omission is mention of the sculptors who had begun exhibiting early in 1963 work that was to popularize, often to their chagrin and ire, the "Minimal" tag.

The omission is not entirely surprising, however, since Wollheim formally (re)introduced the term in early 1965 in a theoretical rather than a topical context. Though not as negatively charged in intent as "Impressionism" or "Fauvism," "Minimal Art" was chosen with reference to the "minimal art-content" of the works in question. The rhetorical strategy of his article has led to frequent misinterpretation of the term as satirical; in fact, after Wollheim as devil's advocate at first dismisses the work on principles derived from the Protestant work-ethic (and more peripherally from the romantic cult of self-expression), he goes on to defend the reductive or rejective nature of the art on the principle that the "work" here is one of "dismantling" and simplification rather than traditional construction and complication.

Two years later, with clear reference to Wollheim, John Perreault observed, "The term 'Minimal' seems to imply that what is minimal in Minimal Art is the art. This is far from the case" [*Arts* 1967 30]. It was equally far from the view of Wollheim, so Perreault's ensuing argument with the term is with its misinterpretation—or later reinterpretation—by others. Perreault undertook to defend the "maximal . . . craftsmanship, inspiration, or aesthetic stimulation" of the best of the art by arguing, "What is minimal about Minimal Art is the means, not the end." This is

not so much the riposte to Wollheim ("minimal art-content") it appears to be as an adaptation of his argument.

As curious an element in Wollheim's "Minimal Art" as its shift of rhetorical stance is the canon the article establishes. In his first paragraph Wollheim tucks into a highly procrustean bed Ad Reinhardt's monochromatic canvases, Robert Rauschenberg's "combines," and the ready-mades of Marcel Duchamp (created/selected half a century earlier); photographs of Rauschenberg's *The Bed,* Reinhardt's *Abstract Painting—1961,* and Duchamp's cologne bottle and Underwood typewriter cover are used as illustrations. When Rose published her article in the fall, she was careful not only to cut the neo-Dadaist Rauschenberg and octogenarian Duchamp from the ABC team but also to differentiate between the contemporaries she was discussing/categorizing and Reinhardt. Largely on chronological grounds, she followed Lucy Lippard, who had observed a few months earlier that Reinhardt was "a precedent for, rather than an influence on, recent trends" [May 1965 52]. Rose treated Reinhardt as a predecessor rather than a practitioner of Minimal art, although when the article was published he had been painting black canvases for nine years and for five had been painting exclusively variations on the same trisected, quasi-cruciform, five-foot-square oil with a canvas divisible in turn into nine twenty-inch squares. In her *American Art Since 1900,* published in 1967, Rose more ambiguously reiterates Reinhardt's status as a precursor: "His insistence on an uncompromising, reductive, minimal art has made him an important source for younger artists" [203]. In the revised edition in 1975, however, she stated from a less chronologically and journalistically restricted perspective that the Reinhardt blacks "are generally considered the first contemporary minimal works" [222].

If Wollheim's largely ahistorical perspective (which might as easily and perhaps more accurately designate anonymous Shaker designers as American Minimalists) arose from his academic discipline, philosophy, Rose's segregation of decades in part reflected the periodical forum of her criticism. Journalistic topicality often determines the recognition given to artists on the basis not of their individual creativity but their participation in collective cultural phenomena (Eighteen Irascibles, Young Delaware Abstractionists) that may be only ancillary or quite extraneous to their art. Thus Rose notes, while excluding Reinhardt, Kelly, Noland and others from the ABC school, that "the artists I'm discussing, who are all roughly just under or just over thirty, are more related in terms of a common sensibility than in terms of a common style" [60]. Wollheim's "Minimal" was a philosophical (not to say moral) classification, whereas Rose's "ABC" was a chronological as much as stylistic category with parameters dictated primarily by reportage. (Donald Judd put it more trenchantly in the April 1969 *Studio International,* calling the article "just publicity" [Judd 198].) Her rubric encompassed both the Pop art that had been the rage two years earlier and the Minimal art that was the current

craze, placing Judd's unadorned boxes rather uneasily at the side of Warhol's reproductions of Brillo boxes.

Warhol's static films are landmarks in the desert of Minimalist cinema, but his Pop art, despite its exploitation of geometric and serial forms, has little to do with Minimalism—first and foremost because of its representational, even replicative nature. Lumping it together with Judd's sculpture is a little like conjoining the reductivism of Matisse and Brancusi fifty years earlier—although it must be noted that Judd himself downplayed the representational element in Warhol: "It is easy to imagine Warhol's paintings . . . simply as 'overall' paintings of repeated elements" [Judd 70]. More significant, however, was Rose's elimination of the strongest Minimalist painters from consideration on the basis of their age as much as their art. Partly as a result, even in the 1990s the term Minimalism remains deracinated historically by reduction to the conceptual generalization or journalistic contemporaneity of its introduction in 1965 by Wollheim and Rose.

If the Rauschenberg combines noted by Wollheim qualify as Minimalist at all, it is on the basis of the preexistent nature of the contents combined; on the primary grounds of composition they are far more maximalist than Minimalist. Duchamp's ready-mades provided the precedent for an art of noninvolvement by the artist that ultimately has more to do with Conceptual than Minimal art, though his influence was clear in works like Robert Morris's *Column*. Although the presentation of his bottle-rack anticipates the planks, lights, and felt strips of Minimalism, Duchamp has less if anything to do with arrangement. While his "creation" of the sculpture *Fountain* by signing and dating a urinal provides more than adequate philosophical underpinnings for the hiring-out to foundries of Minimalist sculptural designs by Judd and others, his own design, if any, is not Minimal but Conceptual. In terms of composition, once again, neither the bottle-rack nor the urinal are as objects formally simple enough to qualify as Minimalist; despite their symmetry and cold evenness of texture, both contain too many separable components and structurally complicated interrelationships. Furthermore, however anonymously constructed, their residue of functionalism—like that of the Brillo boxes—is too burdened with the anthropomorphism that was the *bête noire* of the Minimalist sculptors. Even the pseudonymous signature ("R. Mutt," borrowed from the plumbing-fixture manufacturer) and date preclude the kind of autonomy of the object sought in Minimalism, binding it to the artist who "created" it largely by the very action of signing it.

Rose mentions among the painters of "ABC Art" or what "may be described as Minimal Art" Larry Poons, Gene Davis, Billy Al Bengston, Richard Tuttle, Ralph Humphrey, and four unnamed painters who independently of Humphrey "arrived at the identical composition of a large white or light-colored rectangle in a colored border" [62]. While noting

similarities, she distinguishes the younger artists so categorized from Kenneth Noland and Ellsworth Kelly, whose paintings she describes, with her extraordinary knack for anticipating later terminology, as "conceptual" (quotation marks hers); from Noland (again) and Jules Olitski on the basis of the "more blatant, less lyrical and more resistant" work of the ABCers; and from their most important precursor, Reinhardt, on the basis of their wavering commitment to geometrical and symmetrical classicism and the "art-hood" which Reinhardt relentlessly defined in contradistinction from everything else within reach, be it psychology and religion or life itself. Rose segregated the ABCers from the classicism of Reinhardt with reference to their "quirky asymmetry and deliberately bizarre scale" (although symmetry is a predominant feature of most fifties and sixties Minimalism alike) and the ambiguous object-hood of their works: "paintings and sculptures look so much like plaques or boxes that there is always the possibility that they will be mistaken for something other than art" [65].

In fact there are several instances of just that mistake being made. Carl Andre's *Cedar Piece* was burnt by someone mistaking it for firewood [Baker 42], while Donald Judd refers to several misadventures with moving men who didn't know art but knew what they liked and trusted their instincts to the detriment of sculpture they took for "just metal . . . just fixtures . . . just junk" [Judd 209]. Not only is no man a hero to his valet, but, as Judd remarks glumly, "Nothing is ever art to any of the truckmen"; nonetheless, with few exceptions (e.g., some Richard Tuttle works) it is difficult to imagine the same mistake being made with many paintings, however Minimalist, if only because of their generally more readily identifiable parameters. As noted, Minimalism in sculpture is a much later phenomenon than in painting, and to group the two together for chronological convenience distorts the development of the painting long before "Minimal," "ABC," or any other adjective attempted to categorize them.

While Wollheim in "Minimal Art" takes Reinhardt as his first example of Minimalism, Rose in "ABC Art" takes pains to acknowledge his importance as a *precursor.* But if Reinhardt's (or Kelly's or Noland's) work does not qualify as Minimalist, the term has little meaning other than as a journalistic trendmarker. In painting, the "ABC Art" which is loosely equated with "Minimal Art" in fact represents the academy developed from the Minimalism originated by artists not thirtyish at the time but ranging from their early forties to sixty.

As we have seen, Colpitt distinguishes between "minimalism" and "Minimalism," restricting the latter "to those artists who shared a philosophical commitment to the abstract, anticompositional, material object in the 1960s" [11]. I considered in turn using "Minimalist" to refer to those artists and "Minimal" to their predecessors, but the distinction largely served to perpetuate the false dichotomy attacked herein, and so the adjectives are used interchangeably. I will, however, use the journalistic

"ABC" to refer to the later generation, "Minimal[ist]" to the whole movement, while noting that Rose herself, primarily concerned with elaborating upon and updating Wollheim, does not use the term "ABC" even once in her article after the title, though she refers several times to "Minimal" art.

Perhaps apologies are owed the artists for using either term, since neither has won many of their hearts. "ABC" permitted the then-nameless *Newsweek* art critic(s) to refer to Morris and Judd as "abecedarians" and, with all the condescension legitimized by godlike anonymity, as "the *philosophes*" of the group [May 16, 1966], while Mr./Ms. *Time* described "the new minimal-art movement" as "basic structure boys" who "require the maximum from the observer, offer the minimum in return" [June 3, 1966]. It is no wonder that, as noted by Corinne Robins in *Arts Magazine*, Judd and Morris both found the Minimalist tag "extremely objectionable" [1966 35], even apart from theoretical concerns.

In the American art criticism of 1965–66, the term "reductive," used early in Rose's article, appears almost as frequently as "Minimal." In the April 1966 *Art International*, Lucy Lippard referred to the "so-called reductive trend" while praising the "guts and assurance" of the "Structurist" Judd [73], and in the October issue expressed her dislike of the "still current" terms "reductive' and 'minimal,' rather insulting in their implication of a final result that is less in quality than some earlier original," and her consequent preference for "rejective" [33]. The table of contents of the issue gives the title of her article as "Rejectionist Art," which may have been an earlier (and more awkward) formulation. Rose herself had in part anticipated Lippard's term—and, as noted, possibly Wollheim's—in describing the efforts of Judd et al. in "rejecting all but the very barest, irreducible minimum" in her February 1965 *Artforum* piece on American sculpture.

In any case, Perreault prophesied in the March 7, 1968 *Village Voice* that "Minimal" was "a label that will stick," and six months later his paper did a photo spread on "The New Season: Mostly Minimal" [September 19, 1968 18–19], demonstrating that the phrase was launching its fourth season. It has, of course, stuck, despite the opposition of artists and critics. As composer Steve Reich, who prefers the term *musique répétitive* to Minimalism, remarked with a shrug, "Debussy resented 'Impressionism.' Schoenberg preferred 'pantonal' to 'atonal' or 'twelve-tone' or 'Expressionist.' Too bad for them" [*AC* 45].

Specifically in painting, recurrent Minimalist qualities are nonrepresentationalism and nonreferentiality; planarity; monochromaticism; regularity of contour; uniformity of dimensions; elimination (in monochrome color-field) or geometrical simplification (in grid or panel paintings) of line; eschewing of gesture and concomitant erasure of facture; anti-illusionistic flattening of surface; technical equalization of texture (beeswax mixes, spray paint, rolled enamel, acrylic matte, absorbent or

impermeable surfaces); avoidance or extreme simplification of relations; identification of image and surface; unvaried replication of pattern within the individual canvas and in series; and rectilinear symmetry, concentrism, and/or modularism as the dominant structural principles.

Unless we restrict the term "Minimalism" on journalistic grounds to the ABC generation, it is clear that Minimalist painting developed not only from Geometrical Abstraction and neo-Dadaist conceptualism but, despite its antithetical, even adversarial, aesthetic, from within Abstract Expressionism, on the heels of "action painting" itself—even an artist as young as Frank Stella saw himself as evolving from that tradition. Among his seniors, the very different near-monochromes of Barnett Newman and Ad Reinhardt were the stylistic enemy within the flamboyance of the New York School, representing not a preview but the birth of Minimalism.

In American painting, the Minimalist style is a revisionist and reductivist impulse that confronted the heritage of modern art to midcentury. Retaining an expressionist aesthetic, Newman simplified and regularized lines, obscured facture, and substituted broad fields for vortices of pigment and taped lines for biomorphic jellyfish. Reinhardt reduced geometrical art from irregular blocks of dancing color to uniform squares of all but immobile black, while Kelly fluctuated between Arp- and Mondrian-derived arrangements and the more prophetic and radical conception of smooth monochrome oblongs. Rauschenberg, like Morris in sculpture a decade later, revived the tired cause of anti-art by offering featureless canvases instead of Merz and manifestos. It was with reference to the work of Rauschenberg and Jasper Johns as well as his own that John Cage remarked, "Dada nowadays has in it a space, an emptiness, that it formerly lacked" [1961 xi].

The painters mentioned had little in common in terms of their aesthetic; what they shared was an impulse—short-lived in the case of Rauschenberg, abiding in Newman and Kelly, definitive in Reinhardt— to formal and stylistic purification of means in order to determine how much or how little was essential. The enterprise was academized in painting in the mid-sixties when Minimalism became codified as a "movement." Rather than a stylistic impulse informing a variety of distinct and even adversarial sensibilities, it became formalized as an aesthetic axiom. Rather than an individual discovery, Minimalism became an imposed theoretical precept as lifeless as the inert painting it generated: monochrome rags nailed to the wall, black canvases with appended explanations, single-line murals, panels to the left of us, panels to the right of us, un-stellar emulations of Stella, old Newman retreads.

Reinhardt saw his black paintings as the logical outcome of the monochromaticism to which even much of his early work tended, and which came to dominate his palette more and more in the first half of the 1950s. Even the geometrical red and blue monochromes of 1951– 54, in which Reinhardt worked with large rectilinear blocks of color as

opposed to the "bricks" of the late 1940s or the irregular polygons earlier, are more Minimalist than Expressionist despite the composition which finally allies them most closely with older geometrical abstraction. Ellsworth Kelly was similarly allied, but in the panel paintings he began on the French Riviera in the winter of 1951–52, the artist achieved a reductive art that went as far beyond Mondrian as Reinhardt's blacks were to go. Shortly before Kelly headed south from Paris, Robert Rausch-enberg painted his whites in North Carolina, and shortly before that Barnett Newman completed the final band on his masterpiece *Vir Heroicus Sublimis*. Not long after Kelly's return to Paris, Guy-Ernest Debord pre-miered (or tried to) the first imageless film in the same city, and within two months and four thousand miles John Cage's silent sonata was debuted. The period from April 1951 through August 1952 may be the watershed in early Minimalism, on both sides of the Atlantic, the year not only of less is more but of nothing is most of all.

C

At Black Mountain College in North Carolina around the time of his twenty-sixth birthday on October 22, 1951, Robert Rauschenberg produced the prototypical Minimalist paintings, a series of six works composed of from one to seven panels of rolled white enamel paint. In terms of material, he anticipated the use of housepaint on unprimed canvas in the black paintings the even younger Frank Stella would begin seven years later, although Rauschenberg's finished paintings might themselves have been taken from a distance for primed but unpainted canvases. In terms of concept, he pioneered multipanel construction contemporaneously with Ellsworth Kelly across the Atlantic, while providing the prototype for the plethora of largely monochromatic white and off-white paintings—with colored or unpainted borders, wedges, ledges, etc.—of the sixties (Jo Baer, Robert Barry, Al Held, David Lee, Robert Mangold, Agnes Martin) and later. Although Rauschenberg has not mentioned Vladyslav Strzeminski's self-styled "Unism," the Pole in part foreshadowed his effort by a quarter-century with a series of off-white monochromes. In Strzeminski's case, however, the paint was not rolled flat but thickly encrusted over various roughly geometrical patterns, in a style thereby closer to the monochromatic target and number paintings Jasper Johns began to produce within three years of the Rauschenberg panels.

White paint was to become the exclusive idiom of Robert Ryman in the mid-sixties. However, the white paintings, sometimes referred to as achromatic, he has now produced for three decades are almost lush in comparison with Rauschenberg's. It is difficult, in fact, to conceive of more reductive composition short of bare canvas; the closest approximation of that extreme may be the paintings composed of a single line that were executed in the sixties by artists like Patricia Johanson, yet even those are necessarily more complex in relations than Rauschenberg's

undifferentiated fields. Ryman's whites are striking by contrast with Rauschenberg's for their painterliness and concern with the inherent calligraphy of the brushstroke. Even in terms of color they remain relational: Ryman in fact disclaims producing white or monochromatic painting on the grounds that his surfaces (gray steel, brown corrugated paper, the different whites of cotton and linen) function as a second color in contrast to the white of the paint [Phyllis Tuchman 46].

The nearest thing to the pure reductivism of Rauschenberg's whites may be the very different monochromes produced by his then-studio assistant Brice Marden in the late sixties. Ironically, although he had in the strictest sense not painted his own wax-mixed monochromes to this point, Marden literally painted several of Rauschenberg's white panels, re-executing them with rollers according to his instructions. Rauschenberg had painted over all the original panels in the 1950s, but they had become legends and like singers of similar status found it hard to leave the stage. According to Calvin Tomkins, "In 1962, when Pontus Hukten wanted to show the white paintings in Stockholm, Rauschenberg had simply sent him the measurements and a sample of the intense-white pigment and canvas, and Hulken had had them recreated." In 1968 Ivan Karp wanted to show them, though they apparently had vanished again. Rauschenberg asked his studio assistant to oblige: "This time around, Brice Marden did the job" [Tomkins 1981 269]. By this time Judd and others had restricted their function to designing their sculpture and having more skilled craftsmen execute the designs. In the case of Rausch-enberg, design itself is reduced to an almost purely conceptual state.

At the same time, Marden was driving his own monochromes to the lower border of the canvas, completing the process of sealing the canvas with the impermeable surfaces of his beeswax-mixed oils. Despite equally holistic self-sufficiency, Marden's works, in locking in the painting and locking out the world, were the antithesis of Rauschenberg's whites, which as they developed literally invited the world in, at least as far as the enamel.

That invitation was somewhat belated, however. Initially, Rauschen-berg seems to have conceived the whites as being just as aloof as the works Marden produced later, though more in the sense of metaphysical purity than planar sealing. In a letter to Betty Parsons, Rauschenberg described his all-white paintings with greater floridity than he painted them: "They are large white (one white as God) canvases organized and selected with the experience of time and presented with the innocence of a virgin. Dealing with the suspense, excitement, and body of an organic silence, the restriction and freedom of absence, the plastic fulness of nothing, the point a circle begins and ends. They are a natural response to the current pressures and the faithless and a promoter of institutional optimism. It is completely irrelevant that I am making them. Today is their creator" [quoted in Ashton 1982 71].

The paintings were not, however, as God- or nothing-like in practice

as in theory. Anticipating Rauschenberg's later electronic *Soundings,* which lit up to reveal silkscreen images when the spectator made a noise, the all-whites were in fact viewer-interactive from their first exhibit. The transcendental purity and remoteness of the all-whites as described to Parsons seem severely qualified if not simply denied or forgotten in interviews years later—e.g., "I always thought of the white paintings as being, not passive, but very—well, hypersensitive . . . so that one could look at them and almost see how many people were in the room by the shadows cast, or what time of day it was" [Tomkins 1981 71]. In response to Barbara Rose's asking whether his monochromatic impulse was in any way related to Ad Reinhardt, Rauschenberg answered, "No. It was related to Albers's censorship. I had been totally intimidated because Albers thought that one color was supposed to make the next color look better, but my feeling was that each color was *itself*" [Rose 1987 37–38].

Many still agree with Robert Pincus-Witten's assertion in 1966 that the contribution of Josef Albers to Minimalism has been slighted. More precisely, Pincus-Witten, reviewing the Systemic Painting show curated by Lawrence Alloway at the Guggenheim in fall 1966, notes that Albers's "pertinence to the square format favored by Systemic Painters" is "more than obvious" [1966 43]. In Alloway's show, Agnes Martin, Paul Feeley, Will Insley, Ralph Humphrey, Robert Barry, Al Brunelle, Larry Zox, Robert Ryman, Al Held, and Jo Baer all used the (virtually) square format, with which Albers had been exclusively involved since 1950.

After Mondrian, who had come to New York in 1940 when his London studio was bombed away, Albers is the principal link between European geometrical abstraction and Minimalism. He had been born sixteen years after Mondrian, in 1888, and after training at Berlin's Royal School of Art and the Munich Academy, entered the Bauhaus in 1920 and was named Master five years later. He concentrated at first on making pictures in the style of stained glass windows with fragments of bottles, then designed metal utensils, furniture, and type-faces. When the Bauhaus closed in July 1933 after director Mies van der Rohe refused to accept Nazi administration, Albers left for New York and was hired through Philip Johnson as director of the Art Department at Black Mountain, which had just opened, and where he was to teach until 1949, the year after Rauschenberg's arrival. He was, often to their mutual dismay, Rauschenberg's principal teacher at Black Mountain from the fall of 1948 through the next spring, when he left Black Mountain. The next year he was appointed chairman of Yale's Architecture and Design Department and began his quarter-century *Homage to the Square,* publishing in 1963 the theoretical treatise *Interaction of Color.*

In his monumental series of squares nested within squares, the sides of the smaller always parallel to those of the larger, Albers explored the complexities of color relationships within the regularized simplicity of his

format. He examined the expansive and contractive tendency of contiguous colors and, among other optical effects which may ultimately link him to Op more closely than to Minimal art, a phenomenon directly analogous to the acoustical "beating" created in much early Minimal music when proximate frequencies are set in vibration simultaneously. In Albers's medium, the equivalent of the spontaneous, unsounded but audible "beat" was the suggestion of a third unpainted color created when closely related hues were painted adjacent to each other.

When asked by Lucy Lippard in 1967 (along with Claes Oldenburg, Marcel Breuer, Tony Smith, Agnes Martin, Dan Flavin, Donald Judd, and Ellsworth Kelly) for a capsule statement of his use of the square, Albers wrote, with jocular allusion to the tradition of Bauhaus functionalism, "The arrangement of squares in my *Homage to the Square* paintings and prints has become a convenient carrier of what I consider my color interaction (instead of color juxtaposition). It is a container for and a dish to serve my color cooking in." Like Reinhardt, he chose the square for its non-organic nature: "I consider the square a major man-made form because it is not obvious in nature, although it can be found under a microscope in salt crystals. Despite this fact . . . the square is not a discovery of natural science but an early abstraction of mathematics." He explained the function of the square as inviting by means of "a dominating frontal face . . . cultivation of color pulsation and vibration as a color motion from within—instead of a lateral movement presenting merely an arrested gesticulation." By the time of the statement, serial forms had proliferated widely in Minimalist painting and sculpture, but Albers took the technique back to his Bauhaus days: "As to the repetitive use of my square arrangement, one may refer the now popular concept of serial organization to a design fashion (or style) of about forty years ago called 'die Reihung,' meaning 'the row.' At that time the precision of machine production, made obvious through presenting lines of identical products, led to a new esthetic experience emphasizing a belief in human ability" [Lippard "Homage" 52].

Despite the structural simplicity and serialism of his forms, what most distinguishes Albers's work from Minimalism is his fundamental concern with composition founded upon color relations—precisely the emphasis that led Rauschenberg in a radically opposite direction. And despite the severe formal reductionism of the *Homage* series, he retained a hierarchy of forms and, albeit ambiguously, a figure/ground relationship between the shape of the canvas and the inner square(s) which replicated it. The unitary effect sought in Minimalism is exactly the opposite of what Albers was investigating: "interplay," contrast, the chromatic *tertium quid*, kinesis. He explored these with religious devotion and communicated that devotion, leavened with sardonic authoritarianism, to his students, including the "intimidated" Rauschenberg, who described him as "a beautiful teacher and an impossible person." Rauschenberg left Black Mountain in June 1949, just after Albers, though on subsequent stays in

1951 and 1952 he painted and first exhibited the whites, removing himself as far as possible from the interaction of color when Albers was in New Haven and no longer around to comment.

The relationship, as told to Calvin Tomkins by Rauschenberg, sounds like a Freudian's dream: "I represented everything he hated most. . . . Coming that way in mid-semester, and his knowing I'd been in Paris, I think he assumed I was going to be some kind of show-off. I was willing to submerge any desires I had into his discipline, but he never believed that. I don't think he ever realized it was his discipline I came for. I was Albers's dunce, the outstanding example of what he was *not* talking about. He'd pick up something of mine and say, 'This is the most stupid thing I have ever seen, I dun't even vant to know who did it.' If I hadn't had such great respect for him I could never have put up with the treatment." While Albers avoided comment on Rauschenberg after his student had become famous, Rauschenberg spoke gratefully of Albers's teaching in terms akin to Albers's own expressed goal on his arrival at Black Mountain: "I want to open eyes," praising Albers's "focus . . . on the development of your own sense of looking" and stating, "What he taught had to do with the whole visual world" [Tomkins 1981 31–32].

In the agonistic rhetoric of Abstract Expressionism, Robert Motherwell remarked, "The real game is between one's self and that virgin canvas—to end up with a canvas that is no less beautiful than the empty canvas is to begin with" [Tatge]. Calvin Tomkins, who has interviewed and written about Rauschenberg extensively, comments that the environmental reflections on the whites proved "to Rauschenberg's satisfaction at least, that there was no such thing as an empty canvas" [Tomkins 1981 71].

One may question, however, whether this revelation was part of Rauschenberg's initial conception, described so transcendentally to Parsons, or whether it was a later interpretation inspired by his friend and collaborator John Cage, who had been demonstrating in lectures as well as compositions the factitiousness of the distinctions between music, noise, and silence. First of all, Rauschenberg's "feeling that each color was *itself*" is as obviously in debt to Cage as in reaction to Albers since Cage had for years been preaching an anti-expressionist aesthetic of letting each sound be itself ("let sounds be just sounds" [1961 81]). Cage, who saw the white paintings for the first time the summer after their creation, called them "airports for the lights, shadows, and particles" [1961 102] and "a clock of the room" [quoted Tomkins 1981 71]. Rauschenberg glossed the latter quote to Barbara Rose by noting that the whites were not "a Dada gesture" but "had to do with shadow and the projection of things in a room onto the blank whiteness" [quoted Rose 1987 65].

It is a far cry from the metaphysical "silence" and "absence" described to Parsons to the functionalism of the airports and clocks in Cage's

metaphors, and from "the plastic fulness of nothing" to a projection screen. Just as the silence, lack of persona, and simple vacuousness of Jerzy Kozinski's Chance facilitates the psychological projection of endless contradictory feelings, motives, even identities upon him, so the physical emptiness of Rauschenberg's paintings attracted literal projection and was soon put to that mechanical use. The deployment of the canvas as a shadow-mirror, reflecting silhouettes of the viewer and the site mark the transformation of a series with the "innocence of a virgin" into a creature of this world. The violation was completed at what has been referred to as "The Event," the proto-Happening directed or provoked by Cage at Black Mountain in the summer of 1952, when slides and films were displayed on the all-whites during a multi-media gala that from the perspective of their metaphysical conception seems less like artistic groundbreaking than a gang-rape.

However he may have altered Rauschenberg's own view of the all-whites away from a transcendental and towards an environmental conception—one wonders what became of the "one white as God" canvas—Cage was inspired by the paintings to compose a musical analogue, 4'33". The work was named for its silent duration and has been proposed by various music critics as the quintessential Minimalist composition. Its relationship to Minimal music is much like that of the Rauschenberg whites to later Minimalism: it provided a conceptual *ne plus ultra* for radical reductivism.

The one-page score "for any instrument or combination of instruments" consists of three movements: "I Tacet," "II Tacet," "III Tacet." It was premiered in Woodstock, New York on August 29, 1952, by pianist David Tudor, who according to Cage's note when he published the score eight years later, "indicated the beginnings of parts by closing, the endings by opening [sic], the keyboard lid," thus democratizing high art, audience noise, environmental sound, and silence. The theatricality and interactiveness of the all-whites at Black Mountain reappeared at the debut of 4'33" "in an auditorium that was open to the woods at the back; during the first movement, attentive listeners could hear the sound of the wind in the trees; during the second, rain began to fall; during the third, the audience added its own perplexed mutterings to the other 'sounds not intended' by the composer" [Tomkins 1981 71].

The work desegregates not only the pianist and audience at any given performance, but musical professionals and laymen in general, since it was the first piano piece ever created that literally anyone, no matter how musically illiterate and/or physically handicapped, could play. Cage developed his radical form of participatory musical democracy further in what he called 4'33" *(No. 2)* in 1962: a "solo to be performed in any way by anyone" entitled 0'00" and dedicated to Yoko Ono and Toshi Ichiyanagi: "In a situation provided with maximum amplification (no feedback), perform a disciplined action." Cage authorizes any interruptions

that may occur but prohibits repeat performances, use of any "'musical' composition," and any "attention . . . given the situation." He notes that "The first performance was the writing of this manuscript."

While from the perspective of the concert hall it is even more anarchic than *4'33"*—which stipulates silence—and has been seldom performed, from another perspective it is and must remain the most frequently performed composition in history—the boys driving down my street now with rap music blasting are performing it, and so are you if you are "provided with maximum amplification." Were *0'00"* not so blithe it would be utterly Faustian.

On June 30 in Paris, meanwhile, Guy-Ernest (later Guy) Debord had caused even greater perplexity at the Musée de l'Homme while attempting to present his film *Hurlements en faveur de Sade*. The screening was stopped amid violence after twenty minutes of the imageless movie, which moved visually only from black screen to white screen from time to time, the first accompanied by silence and the second by a *mélange* of in-group dialogue, political proclamation, and citation of philosophers and American western movies [Marcus 331–39].

While the video portion of *Hurlements* goes beyond even the uneventfulness of the Minimal films that arose a decade later, its audio portion is inimical to their style, and more akin to the aesthetic of Pop Art, with its univocal treatment of Mao and Marilyn. As a conceptualist, Debord may be credited as a progenitor of the imageless *Film for the Blind* Les Levine produced eighteen years later and may well have influenced the metaphysical Minimalism of his compatriot Yves Klein, which was then in its latency.

A world-class provocateur and art-world celebrity for the last five years of his unfortunately brief life, Klein (1928–1962) elicited from his admirers testimonials to his supernatural powers and aura. This may tell us no more about Klein than about his admirers (one of whom described the "mystical" Klein as being "exactly like Christ," whom she had presumably not met). They tend to write with the gushing intensity of one trying to convince oneself of what one claims, and would like very much, to have experienced. At the same time, for all their extraordinary *sensibilité*, those admirers were in part the art-world equivalent of those sports and music fans whose desire will never be sated except by blood (symbolic in the more refined forms of sports and music—the "slaughter" of the opposing team, the flubbed note satisfying the "blood-lust" Glenn Gould sensed at the heart of the concert audience, the Dionysian star "torn apart" by the critics...). Finally, perhaps, Klein was no more a charlatan than a victim. As with his contemporarily deceased media celebrities in film and politics this side of the Atlantic, he was better loved dead.

The question of record-keeping is extremely problematic in Klein, since the chronology of his works for the years preceding his notoriety is

as vague as any. Its miraculously epiphanic content shares something of the otherworldly quality of the poses Klein was apparently able to strike for photographers on request. His manner of dating his works was both quirky and self-serving insofar as it attempted to establish him as a trend-setter and stylistic originator perhaps more than the facts warranted.

Though his earliest "presentation" of his monochromes was a private one to friends in London at the end of 1949 or beginning of 1950, he claims to have begun them in 1947, and his chief associate/hagiographer Pierre Restany elsewhere notes that "the monochrome adventure began very early, in 1946" [Restany 11], with Klein's vision of "universal impregnation by color" [quoted in *Yves Klein* 1982 15]. The efficient cause of this further preponement of the adventure by a year and the dubious dating of the first "exhibition" may have been the appearance of Lucio Fontana's proclamation of *Spazialismo* and *Concetti Spaziali* (cf. Klein's assorted *Idées*) in a series of manifestos beginning in 1947 on his return to Italy from Argentina, and the execution and exhibition of his first mono-chromes in 1949 and 1950, respectively. Without the advance of Klein's dates Fontana might have laid claim to the monochrome field, since by then Malevich and Rodchenko were art history.

Fontana has been the odd man out in discussions of (pre-)Minimalist monochrome, and not without reason, since those features of his work which negate its objectivity are as important as those which ally it to the Minimalist aesthetic. Though Fontana (1899-1968) did not attract the same degree of international interest as Klein—he did not exhibit across the Atlantic until a 1961 show at the Martha Jackson Gallery in New York—he anticipated several of his ventures. Both Klein's brush-women and his concept of the blue monochrome as incarnate infinity bears upon Fontana's Spatialist rejection of the limitations of the easel, although the brush-women could hardly be considered the ultra-modern technology prescribed by Fontana. Klein's "aerostatic" sculpture, similarly, takes Fontana's rejection of the pedestal and floor-space to new heights.

Fontana, born in Argentina but raised in Italy, spent World War II in Buenos Aires, where he issued the neo-Futurist *Manifesto Blanco* in 1946. In 1947 he created the first of his *Ambiente Spaziali* by painting a room black, a negative foreshadowing by a decade of Klein's more celebrated "Le Vide"; he exhibited another *ambiente* of space distorted by ultra-violet light in Galleria del Naviglio in 1949. In 1950 Fontana began exhibiting various monochrome series incarnating his *concetti spaziali* with *Buchi* ("Holes")—i.e., punctured canvases. The holes opened up the canvas to the third dimension and simultaneously dramatized the statements about the condition of traditional easel painting he had been making in his manifestos. The *Buchi* were quickly followed by cut and layered canvases fabricating a third dimension by innovative assemblage, and the slashed, fully monochromatic, and massive canvases called *Attese* ("Waits" or "Delays") exhibited in 1958. These were followed the next year by the

groups of smaller and nonrectilinear slashed canvases called *Quanta*, after which Fontana turned his deconstructive energy towards slashing huge ovoid sculptures and disassembling frames for the slashed canvases.

All these enterprises were alien to Klein's monochromes by their patent subjectivity and symbolism. Whereas Klein's placid blue monochromes may quietly evoke elemental or eternal forces, Fontana's pierced and lacerated canvases are obviously fraught with symbolic statement and with aggressively self-assertive ego—so much so that despite the poverty of their means, they are as allied to Abstract Expressionist gesturalism as Klein's are to Minimalism. The quasi-sexual assault on the canvas and on the tyranny of its two dimensions aims to destroy the autonomy of the painting by exposing or suggesting infinite space— perhaps subjective depth—behind it, and in so doing run counter to the impervious autonomy and objecthood of Minimalist art while anticipating the violence of some later conceptual art. During the ABC period, in fact, he appeared not with those artists but in the exhibit Destruction Art held at Finch College in spring 1968.

The only evidence of Klein's creation of monochromes in the forties— and it is pretty slim—is his explaining to a friend in 1948 that the small blue monochrome disc he had affixed to a notebook was a foretaste of the paintings of the future. The monochromes—orange predominant among other colors—were not presented until 1955, when they were rejected by the Salon des Réalités Nouvelles, nor exhibited until the next year at Galerie Colette Allendy. The next year he began his *époque pneumatique* with the "blue period" canvases for which he remains best known as a painter and most important for this study of Minimalism. In the strict sense, the monochromatic purity of the oranges was compromised, not insignificantly, by Klein's quite obtrusive signature—e.g., "K.mai.55" [*Yves Klein* 1983 103]. He first exhibited eleven of his canvases, saturated in what might be described as deep royal blue but which he preferred to view as International Klein Blue, at Milan's Galleria Apollinaire in 1957. He later developed a three-dimensional art of sponge paintings and sculptures using the same color, though he had already, arguably, explored the ultimate three-dimensional art in 1957 with an "aerostatic" sculpture of a thousand IKB balloons set adrift into the cosmos.

According to the artist, "It was in 1947 [not 1946] that I had the 'idea,' the conscious vision of 'monochrome.' I should stress that it came to me intellectually; it was the result of passionate research." The research culminated on the beach at Nice; as Ronald Hunt would have it, "the huge dome of blue sky arching above him became his greatest artwork [cf. Cage's *0'00"*]. But birds flying across it flawed its purity: 'Birds must be eliminated. Thus we humans will possess the right to levitate in an effective and total physical freedom" [33].

Klein does not mention whether his research was historical as well— i.e., whether he was aware of Malevich's 1919 *White on White*, an angled

off-white square within a lighter square; the lost monochromes in each of the three primaries that Alexander Rodchenko executed the following year (his *Black on Black* of 1919 is less purely monochromatic even than the Malevich); or Strzeminski's Unism.

The same year Klein "dreamed of having a great orchestra, of composing, with music of a single tone, a 'monotone' symphony . . . a single musical mass saturated with space, a melody melted into one note throughout." He adds in a parenthetical afterthought, "By the way, I composed this symphony two years later in 1949 . . . duration twenty minutes" [*Yves Klein* 1982 222].

The first hint of it in writing is the diary notation of February 1951 in which he mentions a monotonal piece to accompany an exhibit of monochrome paintings. The conception was notated by Pierre Henry in 1957 and used to accompany Klein's monochrome exhibitions in Paris at the Iris Clert Gallery and Gallery One in London. It was adapted again in 1960 to a setting for chamber orchestra and used on March 9 to accompany Klein's own version of action painting—not with brushes but with naked female models soaked in IKB and placed supine on empty canvases. The musical accompaniment to these *anthropométries* was not strictly monotonal but rather monochordal, as the symphony's lone triad was held by the musicians for twenty minutes, followed by twenty minutes of silence.

The score of a final setting, now entitled *Symphonie Monoton-Silence*, for twenty singers in all four ranges, ten each of violins and cellos, and three each of flutes, oboes, horns, and double-basses, was prepared in 1961, dated "1947—1961" with a large space after "1947—," which is off to the left and appears in darker ink than the rest of the date, indicating that the earlier date may have been added later. The "7" in "1947" has been scored heavily enough to suggest it may cover another figure. The setting in this version called for a D-major triad held for five to seven minutes and followed by forty-four seconds of silence. A reel-to-reel tape of the symphony is dated 1949 in the upper right hand corner of the box. The Rice University catalogue photo indicates erasure and substitution in the last two digits, which are glaringly larger than the first two.

In 1958, a year after the Galleria Apollinaire exhibition of blue monochromes, Klein opened the ultimately minimal exhibition at the Iris Clert Gallery in Paris, Le Vide. It was described by Restany in the invitation as "the lucid and positive advent of a certain realm of sensitivity . . . the pictorial expression of an ecstatic and immediately communicable emotion." More prosaically, it consisted of an empty gallery: ecstatic space framed by immediately communicable white walls, painted by Klein himself with rollers. (This was several years before it became fashionable among New York critics to complain of the compensation with theory for the practice of essentially contentless art.) Although Klein had experimented similarly at the Colette Allendy Gallery, setting aside part of the

exhibit space for no visible work, the Clert preview was the event of the season, with over two thousand people turning out for what proved an historic event. Those admitted to Le Vide never saw nothing like it, either before or after they were offered International Klein Blue cocktails composed of gin, cointreau, and methylated spirits.

Klein went on to market empty space still more directly, providing five "series" (receipt books numbered 0-4) of deeds to a "Zone de Sensibilité Picturale Immatérielle" payable in "fine gold"—quantity unspecified in Series 0, set at 20 grams in Series 1 and apparently (though accounts vary) doubling with each successive series to 160 grams a shot in Series 4—in what may have been rampant inflation but was also, metaphysically if not economically, the purest of Klein's many experiments attacking the border between art and life. According to one account [Hunt 33], Klein demonstrated his own semi-indifference to money by throwing half the gold in the Seine.

Parisian zoning laws were not the only boundaries evaded in Klein's work from the neo-Dadaist excursions to the art/life border and the even more tenuous frontier between Minimal and Conceptual art. The monochromes, visual and aural, are essentially Minimal, while the 1958 exhibit, the brush-women experiment, and the immaterial pictorial sensitivity areas are Conceptual, as is Klein's later attempt to fly. In this project, entitled *Saute dans le Vide,* he no longer contented himself with exhibiting "Le Vide" or selling it but jumped into it from a second-story window—evidently with a net, should any querulous literalists inquire. According to Klein, his "leap into the void" was successful, though the only documentation of his flight consists of doctored photographs.

For true skeptics the question is not whether Klein (or Carlos Castaneda) flew but whether there is a *difference* in asking (1) whether Klein flew because he believed he did and/or managed to convince a few devotees, and (2) whether he composed the *Symphonie Monoton-Silence* and the monochrome canvases by the end of 1947, though neither composition was seen or heard for years. Literalism again both clashes and meshes with conceptualism, but for historical and documentary purposes, the claim to 1947 composition has no more validity than the claim to flying.

For all his antics, Klein must be credited not only as a metaphysical hero/buffoon but as the originator of one important branch of Minimalist monochrome. The blue-period monochrome entails the saturation of the canvas by IKB. To K, blue was only mystically rather than naturalistically symbolic: "Blue has no dimensions, it is beyond dimensions, whereas other colors are not. They are prepsychological expanses, red, for example, presupposing a site radiating heat. All colors arouse specific associative ideas, psychologically material or tangible, while blue suggests at most the sea and the sky, and they, after all, are in actual, visible nature what is most abstract" [Osborne 295]. They are also the elements within nature most suggestive of the transcendence of nature in infinite expansiveness.

As important as the endlessness of symbolic space, however, is the absence of compositional space noted by Donald Judd in 1965 (in the laconic Hemingway voice also echoed later in Minimalist fiction): "Almost all paintings are spatial one way or another. Yves Klein's blue paintings are the only ones that are unspatial, and there is little that is nearly unspatial, namely Stella's work" [Judd 182]. In Klein's case, spatiality was erased through the fusion of the single hue and the saturated cotton.

As the inventor of this unspatial space, Klein ranks with Reinhardt and Rauschenberg among the pioneers of Minimalist monochromatic painting. The distinctions between them, however, are at least as important as their superficial resemblances. With Rauschenberg, as noted above, the traditional function of the canvas as a receptacle of representation and/or self-expression was overdeterminedly subverted. Initially, this American-made *vide* represented a supernatural purity of a symbolic order not remote from, and if anything more rarefied than Klein's mystical blues. Presented publicly, however, it was very problematically transformed from a metaphysical to a functional entity: a reflective tool as an environmental presence and a projective tool as a component in a multimedia extravaganza. In either case it was precisely the unsullied purity of its whiteness that permitted the contamination by images, be they silhouettes or film, to which Klein's deep saturation rendered his blues as impervious as the heavens, or more impervious insofar as planes, rockets, clouds, and asteroids had all been eliminated with the aforementioned birds.

While Klein moved away from monochromatic painting and sculpture to take Minimalism in the visual arts to invisibility, Rauschenberg's Minimalist impulses ended more or less completely with the one-shot experiment of the white paintings. Later in the 1950s various American painters worked in monochrome: Rollin Crampton, David Budd, Milton Resnick, and Ralph Humphrey. None of them, however, worked in a manner remotely similar to Rauschenberg's austerity but from within the gestural tradition, in which facture was evident, if not underscored, in their textures.

In terms of the lineage of the Minimal monochrome, Ellsworth Kelly had begun working in panels in Senary by the time Rauschenberg exhibited the all-whites. The next important painter in that tradition, Frank Stella, began his blacks seven years after the Rauschenberg whites. (Jasper Johns influenced but is finally peripheral to Minimalist abstraction with the uniquely ambiguous representationalism or mimicry of objects in his monochromes and their complicated and agglutinated surfaces.) At the very beginning of the 1960s Stella followed his black paintings with whites; in 1952 Rauschenberg went directly from the whites to blacks, like Stella aiming at a nonsubjective art. The difference in the black paintings of the two men illustrates the difference between true and superficially Minimalist art.

The results of both artists' experiments in black might be considered Minimal art in Wollheim's definition, since there is a minimum of both means and or self-generated content. However, Stella's nonrelational paintings are structurally unitary while Rauschenberg's blacks, composed of torn sheets of newspapers dipped in black paint, pasted to the canvas, and brushed over in more black paint, are fragmented and irregular in structure and texture and allusive in content, however obscured the references by the tearing and brushing. Despite the opacity of his blacks, Rauschenberg aimed in them for greater textural complexity after a transitional non-*collé* triptych of matte verticals. In his repetitive all-over patterns Stella strove for an artistic approximation of objecthood. Rauschenberg was interested in art where "there was much to see but not much showing" [Tomkins 1981 72]. Stella, of course, made the hallmark of his early art "What you see is what you see" [Battcock *Minimal* 158].

For Rauschenberg the black paintings were a step toward the incorporation of objects in the series of red paintings that came next and were the harbingers of the combines that would bring him fame and fortune. Stella too developed away from his initial paucity of means—a "dismantling," to use Wollheim's words, of techniques and of expectations of the artwork—to a multi-colored art in its more geometrical way was to become as grotesquely additive as Rauschenberg's *Bed* or *Monogram* goat.

Rauschenberg's whites were important in their momentary redirection of the Dadaist tradition from the stylistic excess which he proceeded to re-embrace. They provided a catharsis for the young artist and more a model than an impetus to later Minimalism. Minimalism was basically a day-trip for his fundamentally alien sensibility—like Klein's, at heart more flamboyantly theatrical and imbued with conceptualism. (It is a tribute to Rauschenberg's versatility that in 1968 Richard Kostelanetz noted that along with his work in mixed-means theater, he had also "sold paintings and sculpture" [47]). Rauschenberg was tuned to a lower pitch than Klein, merely walking on stilts, roller-skating, etc. instead of jumping out windows, but each had more than a touch of the ham and exhibitionist about him, which determined both the removal of IKB from the brush to the brush-women and the transformation of the Rauschenberg whites from images of the supernal to mirrors of the evanescent. Like Cage in music, Rauschenberg was an artistic chameleon with a strongly conceptual bent that embodied itself momentarily in Minimalist techniques.

If the whites are, in the context of Rauschenberg's multifaceted career, ultimately a stylistic anomaly, they remain, like Klein's blues, early Minimalist icons, forthright and irreducible. In terms not of artistic presence but of attendant verbiage, Rauschenberg's initial, transcendental apologia for the whites, which has much in common with Klein's elucidation of his blues on supravisual, quasimystical grounds, is remote from the later objectivist aesthetic. Their subsequent functionalism is more problematic in this regard: by employing the works as reflectors and

projection screens, Rauschenberg *de facto* confirmed their status as objects, yet endowed them with an interactive capacity that is alien to the cool autonomy of the Minimalist art-object. That autonomy is exemplified very differently but equally forcefully in both Stella and his great predecessor in black, Ad Reinhardt.

D

Nothing could be more inimical to the theatricality of both Klein and
Rauschenberg than the eremetic aesthetic and the near-obscurantist
technique adopted by Ad Reinhardt. While Klein's visionary antics repre-
sented a one-man Dadaist revival, and Rauschenberg fluctuated between
solo and collective anarchism, Reinhardt came to be known as "(Mr.)
Pure," "The Prince of Darkness," and "the black monk" not only for the
austerity of his palette but his unremitting personal aversion to the art
scene he lambasted brilliantly in cartoons, lectures, and interviews from
the mid 1940s to his death in 1967 at the age of fifty-three.

Reinhardt's aesthetic is summed up in the title of a 1962 essay
published in *Art International*, which Barbara Rose adopted for the anthol-
ogy of Reinhardt's writings she edited after his death: "Art-as-Art." The
essay begins, "The one thing to say about art is that it is one thing. Art is
art-as-art and everything else is everything else. Art-as-art is nothing
but art. Art is not what is not art" [Reinhardt 53].

The utterance is both Wittgensteinian and ostensibly tautological. In
historical context, however, it represents Reinhardt's demystification
of the artwork after the assorted mystery cults associated with Abstract
Expressionism, some deriving from its Surrealist roots. The technique of
automatism was adapted to the spontaneity of action painting (both
sharing a theoretical basis in Freudian free association), while several
Surrealist conceptions persisted: art as a landscape of the unconscious, the
artist as explorer, the painting as a mirror of the unique sensibility of the
artist...with each new canvas the latest episode in a personal epic.

Personal soap opera, in Reinhardt's view. Whereas the aesthetic of
Klein and (despite his disclaimers) Rauschenberg derives in good part
from the anti-art of Dada, Reinhardt banished that concept with the

others already mentioned. His "art-as-art" aesthetic has more to do philosophically with the art-for-art's-sake aesthetic of the late nineteenth century, but Reinhardt displays none of the personal or artistic flamboyance associated with Whistler, Wilde, and their English disciples. Though he was equally concerned with the autonomy of the artwork and equally given to a wit based on parodic inversion, there is nothing of either the preciosity or impressionism of the aesthetes in his pronouncements. The inconspicuous and often taciturn Reinhardt looked less like an aesthete than a trucker, though the syntactic spareness of his literary style varies from blunt Hemingway-influenced parataxis to litanies with a fragmented suggestiveness reminiscent of Mallarmé's "Toute chose sacrée et qui veut demeurer sacrée doit s'envelopper de mystère." Reinhardt had the dignity to reserve the latter for his notebooks, to avoid cheapening the mystery into the rhetorical mystification he found on all fronts.

Mystery had become debased currency even before the New York School reached the readers of *Life* magazine. Leonard Cohen once remarked that the function of the CBC's occasional television documentaries on active Canadian poets was to give the rest of the country a good laugh; south of the forty-ninth parallel, *Life* had presented Abstract Expressionism more or less as a terrific gag, harmless zaniness to perk up dullard McCarthyite culture. Though the devaluation had just begun, no one seems to have felt as sick about it and of it as Reinhardt, who viewed the portentous declamations of his colleagues as opportunism and obfuscation and was impelled to burlesque both (e.g.: "'Let no man undervalue the implications of this work, or its power for life, or for death, if it is misused.'—Clyfford Still, 1959 / 'Let no man undervalue the implications of this work, or its power for cash, or for bad credit, if it is misused.'—Ad Reinhardt, 1959" or "'Voyaging into the night, one knows not where, on an unknown vessel, an absolute struggle with the elements of the real.'—Robert Motherwell, 1959 / 'Voyaging into the nought, one knows exactly where, on a known vessel, an absolute harmony with the elements of the unreal.'—Ad Reinhardt, 1959"). These parodies, published in *Pax* in 1960 as "Documents of Modern Art," were republished fifteen years later, in *Art-as-Art: Selected Writings of Ad Reinhardt* [166]. Reinhardt would have appreciated the irony of their resurrection in a series entitled *The Documents of 20th-Century Art* . . . under the general editorship of Robert Motherwell.

The New York School was a colorful as well as brilliant group and still provide good copy with their alcoholism, egomania, paranoia, promiscuity, and premature death, as well as the *soi-disant* mysticism and sublimity of their work. Reinhardt responded to the self-indulgence of their style, their aesthetic, and possibly their lives by ironically adapting the perennial out-of-towner's critique of his hometown with "The New York School is a nice place to visit, but I wouldn't want to live there." In the same lecture notes he more civic-mindedly echoes the slogan of the

city's Department of Sanitation in what may be considered, both in style and content, the first Minimalist manifesto: "A cleaner New York School is up to you" [Lippard 1981 124].

Reinhardt brushed up the town by undertaking an artistic austerity campaign both in theory and in practice. He was proud to note that he had been born the same year as abstract art in 1913 and unlike the New York School had *always* painted abstractions. Except for the montage of his cartoons and the fragmented imagery of his early paper collages and oils deriving from sources as disparate as Kurt Schwitters and Synthetic Cubism, throughout his career he rejected figuration and representation along with narrative of any sort, confessional or traditional. By increasing the abstraction and decreasing the expressionism exponentially, Reinhardt differentiates himself from his Abstract Expressionist contemporaries.

A less terse reaction to the highbrow showboating of action painting and later—to Reinhardt, equally vulgar—developments appeared in 1964 in "The Next Revolution in Art," which "will overthrow natural, brute, expressionist, folk, monster, neo-primitive, junk, collage, assemblage, combine, mongrel, 'merz,' 'pop,' happening, unconscious, spontaneous, accidental, poetic, dramatic, 'song-and-dance' art and send it back to the everyday theater and environment, to the entertainment field and junkyard, to the folk places and lower depths where it all came from in the first place" [Reinhardt 61–62]. It is ironic that in this prophecy Reinhardt abandons the terseness of both Wittgenstein and the Department of Sanitation for the catalogues of Rabelais, the patron saint of stylistic excess here invoked in a rejectivist cause.

It is further ironic that *New Yorker* critic Harold Rosenberg, who as early as 1963 had identified Reinhardt as "the intellectual pivot of the new art" [1964 52], managed as late as 1970 to find in Reinhardt's almost antisocial canvases themselves a perverse form of grandstanding, suggesting that "by contrast with a Newman, Reinhardt's black squares and crosses reek of an asceticism that is almost theatrical" [1972 97]. This echoes, significantly, Michael Fried's more wide-ranging objection to Minimalist literalism in "Art and Objecthood," published in *Artforum* three years earlier.

Donald Judd, who in 1969 characterized that article as "stupid" [Judd 198], was impressed by Reinhardt: "I wanted to write on Reinhardt's work and had been to his studio for the purpose but Mellow didn't want an article on him" [Judd vii]. James Mellow was Judd's editor at *Arts Magazine* from January 1962 to March 1965, so the visit would have taken place during the formative stage of Judd's style. Sol LeWitt, in turn, has said that in the early sixties he and his circle regarded Reinhardt as "*the* important artist of the time" and producer of "the most radical art" [Zelevansky 19].

Nonetheless, Lynn Zelevansky finds Reinhardt's "poetry of . . . delicately nuanced surfaces and the contemplative character of his work . . .

antithetical to the spirit of Minimalism" [18]; Kenneth Baker, on the other hand, has pointed to its contemplative nature as a defining trait of Minimal art [22]. Yve-Alain Bois, twenty years after Rosenberg, disqualifies Reinhardt as a Minimalist because "nothing is more foreign to Reinhardt than what Michael Fried defined as the theatrical conditions of Minimal art" [*Ad Reinhardt* 1991 13]; I find the purported theatricality largely a critical invention, absent from both Reinhardt and most of the later work (Morris provides notable exceptions), which shares his quietude if not his nuance.

Reinhardt opposed with equal conviction the mythological and psychological allusiveness of the New York School, as embodied both in the pronouncements of Newman and the gestural painting of Pollock, who had undergone Jungian and other therapy, and Willem de Kooning (whose wife Elaine parodied Reinhardt in "Pure Paints a Picture"). The expressive and reflexive theory of the work as a testament of the creative unconscious and a chronicle of its own creation inevitably led to the *de-abstraction* of the canvas as surely as choosing to undertake a still-life or landscape. Whether it suggested external reality or the artist's soul or mood, the artwork was equally reduced, if not to mimesis in the strictest sense, at least to an allusive and representational function within the saga of the personality, while the artist was reduced, in effect, to selling his soul. Though even peaceful death remains a good strategy to increase one's sales, it did not escape Reinhardt that the market for Abstract Expressionism did not take off until Pollock smashed his car into a tree, after which prices for his art tripled overnight, while those of his surviving brethren leapt in tandem.

The case of Pollock was one of daemonic creativity, but also one of life, and death, imitating art. The confessional nature of "action painting" or what Irving Sandler preferred to term more precisely "gestural painting" was frankly repulsive to Reinhardt as an artist and as an individual. The title of one of his more brilliant cartoon-collages, "A Portend of the Artist as a Yhung Mandala" [*Ad Reinhardt* 1991 120], took on both autobiographical fiction (parodying the early-Joyce title in late-Joyce style) and analytical psychology as pestilent analogues to confessional painting. When interviewer Bruce Glaser casually mentioned his art in the context of action painting, Reinhardt replied, with a choice of words that points to the future as well as the past, "I suppose there is always an act or an action of some kind. But the attempt is to minimize it. There are no gymnastics or dancings over painting or spilling or flipping paint around" [Reinhardt 13].

The abstract style of the New York School was often compromised by their rhetoric and sometimes by their choice of titles. Barnett Newman is the best example of both, with the Biblical and mythological freight his titles imposed upon often starkly abstract canvases (*Abraham, The Wild*) adding to the burden his critical prose forced them to bear. On the other

hand, his comrades in color-field painting, Mark Rothko and Clyfford Still, normally identified their mature abstractions only by their colors (*Black and Tan on Red*) and chronology (*1951-N*), respectively, with occasional mention of date/number by Rothko and color by Still. The year after Pollock's 1947 breakthrough into drip-painting, his titles began to rely more on numerical series (*Number 12A, 1948*) than the poetic evocations (*Autumn Rhythm, Lavender Mist*) sometimes suggested by Clement Greenberg and others. Adolph Gottlieb and de Kooning remained as dubiously abstract in their allusive titles as in their crypto-figuration.

Virtually throughout his career Reinhardt tried to expunge all external references from his titles as from his canvases, although two notable exceptions were paintings entitled *Cosmic Sign* and *Dark Symbol* at— perhaps *for*—the exhibition entitled "The Ideographic Picture" Newman organized at the Betty Parsons Gallery in 1947 [Sandler 1966 41]. Apart from this uncharacteristic lapse, Reinhardt identified his works by number or as "Untitled" or "Abstract" and/or "Blue/Red/Black Painting," the only acknowledgment of the outside world being its temporality in the occasional identifying date (*Red Painting, 1952*). Even this, however, was a minor distraction. The nature of Reinhardt's mature work precluded his "branding" the painting with signature and date and he was notoriously cavalier even about signing and dating the canvas verso, often appending the date when the canvas was exhibited, not painted, and sometimes painting over canvases which remained with their original (and at least by traditional criteria now erroneous) date.

Reinhardt's unremitting distaste for narrative is summed up in another of the "Documents of Modern Art," dated 1947, in which he tersely riposted Rothko's and Gottlieb's "There is no such thing as a good painting about nothing" by changing the last word to "something." One is tempted to make more of the statement than its rejection of narrative, since the paintings are not only about nothing external to itself, nothing "out there," nothing in particular, etc. but about nothingness itself— although Reinhardt would probably eschew even the latter interpretation as excessively referential. His aesthetic represents the most austere reductivism imaginable, a merciless assault on incrustations of paint and cant alike in search of degree-zero art, or, as he put it, "the last paintings which anyone can make" [Lippard 1981 158]. In Brian O'Doherty's words, Reinhardt "achieved a sort of painting that functions like antimatter to other painting, a mirror image (not the opposite) of what other artists would consider painting to be" [1967 105].

In "Twelve Rules for a New Academy" Reinhardt listed the "Six General Canons or the Six Noes" as "No realism or existentialism. . . . No impressionism. . . . No expressionism or surrealism. . . . No fauvism, primitivism, or brute art. . . . No constructivism, sculpture, plasticism, or graphic arts. No collage, paste, paper, sand, or string . . . no '*trompe-l'oeil*,' interior decoration, or architecture." His "Twelve Technical Rules" were "No texture. . . . No brushwork or calligraphy. . . . No sketching or drawing. . . .

No forms. . . . No design. . . . No colors. . . . No light. . . . No space. . . . No time. . . . No size or scale. . . . No movement. . . . No object, no subject, no matter. No symbols, images, or signs. Neither pleasure nor paint. No mindless working or mindless non-working. No chess-playing" [Reinhardt 205–06].

The rigor of this theory takes Minimalist reductivism as far as, or farther than, it can go—arguably even beyond the realm of Reinhardt's own "last paintings that anyone can make," which include, however problematically, the recurrent "form" of a Greek cross, three constituent "colors" and resultant tones, a standard "size" of five feet square, etc. Reinhardt's merciless rejectivism, in addition, proves ultimately a form of transcendentalism, as each "not" further rarefies the hypothetical painting, abstracting it from any form of either outer or inner reality, nature or psyche. In this he is the spiritual heir of the craftsman-visionary Mondrian just as Pollock, for example, is of the gestural colorist Kandinsky, Mondrian's contemporary.

Writers on Minimalism have noted its connection to the whole tradition of geometrical abstraction going back to the second decade of the century. Kasimir Malevich's Suprematism was born in 1913 (in his sketches and in his stage designs for *Victory over the Sun*), Mondrian's neo-Plasticism the following year, their manifestos dating from 1915 and 1917, respectively. The influence of Malevich's squares-within-squares extends to Ellsworth Kelly and develops into the 1960s framing pattern found in Jo Baer (*Primary Light Group*), Robert Ryman (untitled 1961 oils on linen), Robert Mangold (*Frames* series), and others. The enclosed square motif was developed most extensively in Albers's *Homage to the Square*, the influence of which is felt in the concentrism of the paintings of the late 1950s and early 1960s by another of his students, Kenneth Noland.

Another and more important line of influence extends to Reinhardt and Kelly from Mondrian's neo-Plasticism through American abstraction-ists like Burgoyne Diller and Stuart Davis. Davis's loose and rhythmic geometricism was imitated by Reinhardt in the late 1930s in paper collages and oils like *Number 30* in 1938. In the next decade his circles and semicircles disappeared, as organic shapes were rejected for rectili-nearity and his polygons were gradually simplified into what he called "bricks" (cf. Mondrian's "my little blocks" in 1917—itself perhaps an ironic echo of Matisse's snide invention of the term "Cubism" in referring to "the little cubes" of the paintings). Reinhardt had a last fling with freer form in what he called his "Persian Rugs" from 1946 to 1948, which recall at moments Mark Tobey's white writing and in their loosest con-tours even biomorphism. Afterwards he remained meticulously faithful to geometrical abstraction, simplifying and standardizing his dimensions even further, finally abandoning bricks for squares as he embraced more strict geometrical regularity along with monochromaticism.

Reinhardt's achievement was to reduce his composition and relations

to that strict geometry and spartan palette before proceeding to dissolve geometry itself in monochromatic darkness.

His uncompromising rejection of narrative and external reference led some, paradoxically, to interpret his work as tendentious, ultimately rhetorical and polemical in intent. *Times* critic Stuart Preston seemed to have come to this conclusion after vacillating comments over the years. Reviewing various one-man shows by Reinhardt at the Betty Parsons Gallery, Preston remarked that Reinhardt's canvases "In their chill detachment and spirit of scientific precision . . . recall the work of Albers" [November 22, 1953], while little over a year later he said of the "scrupulously painted" works, "their spacious emptiness is soothing. Unlike Albers's, they are not a demonstration but a reverie" [February 5, 1955]. By November 1956, when Reinhardt had gone black, Preston described the work as "aesthetic manifestos rather than works of art, demonstrations that the art of painting can be reduced to complete anonymity. In their own way they are perfect—that is, if the impoverishment of the potentialities of painting is considered so" [November 11, 1956]. A related but anomalous view of the blacks was offered by Hilton Kramer in his punningly entitled "Ad Reinhardt's Black Humor," in which he made a connection between Reinhardt's earlier "sardonic cartoons" and the late paintings, which "are a form of pamphleteering—at once comic and despairing—against what he perceived to be the vulgarity and venality that have overtaken art in our time. . . . The apparent solemnity of these black paintings harbors a deadpan wit, but a wit that is not, finally, very affecting" [November 27, 1966].

It would be misleading to ignore, amid the negative quotes, the acclaim Reinhardt had provoked by the time of the last article, and not merely in radical circles. *Newsweek*'s "Black Monk" [March 15, 1965] was not, as one might suspect, a sarcastic putdown but a positive review of Reinhardt's three simultaneous shows (blacks at Parsons, reds at Graham, blues at the Stable). Two months after Kramer's article appeared, David Bourdon published another in *Life*—that bastion of the lunatic fringe of the avant-garde—the highly favorable if primitively written "Master of the Minimal" ("Reinhardt arrived at the minimal after a long and slow development. At many stages along the way, it seemed as if he had gone as far as he could go, but each year he reduced the elements in his art a little more" [February 3, 1967 47]).

Reinhardt experienced a banner year in 1957 to judge by the wittily unorthodox "Chronology" he prepared for his last one-man exhibition, at the Jewish Museum in 1966. Three of the year's highlights merited separate listings: "Willem de Kooning says in the Chuckwagon, 'The rich are all right'"; "Buys Pearl Bailey's record, 'They're good enough for me'"; and "Forms SPOAF (Society for the Protection of Our Artist Friends) (from themselves)." A less successful year was 1943: "Tried to talk Thomas Merton out of becoming a Trappist." Although he was raised Lutheran, Reinhardt himself was dubbed "the black monk" with reference not

to any religious affiliation but to his later palette and withdrawal from the art "scene"—a theatrical metaphor he found all too appropriate. Both were clearly moral questions to the artist, and Barbara Rose goes to the heart of the issue in noting, in a nice paradox, "The ethical content of the black paintings is manifest in their patent inaccessibility" [*Ad Reinhardt: The Black Paintings* 20].

Reinhardt was far from the first to explore black canvases, since Rodchenko had executed a black-on-black in 1919, nor was he entirely alone among his contemporaries: Barnett Newman's 1949 *Abraham* juxtaposed black and brown-black verticals and Mark Rothko's later palette darkened considerably, most radically in the 1964 *Black on Black* and the chapel murals at Rice University. Still also approached black monochrome, as did Rauschenberg and Rollin Crampton around the time Reinhardt began his first all-black some time in 1952. Reinhardt's blackness may have been more unremitting but it was, in the strictest sense, no more purely black than any of theirs. His color or lack thereof was no simpler an issue than his format, the so-called cruciform canvas he reproduced endlessly for the last seven years of his life (and with which he had experimented as early as 1954 in a seventy-eight rather than sixty-inch-square format).

Reinhardt's blacks are not black at all in a sense—certainly not in the sense of Frank Stella's 1958–60 black enamel paintings—since they were composed of deep blue, red, and green pigments in various mixtures. His diagrams clearly divided the constituent squares of even his late paintings into three tones as "B," "R," and "G" [see Zelevansky 21]. In terms of the vestigial images in his abstraction, within the nine-squares-within-a-square structure of the canvas a cruciform shape, strictly speaking, would call for the same hue in the five squares of the upright and transverse, whereas of Reinhardt's three tones the first occupies the four corner squares, the second the three squares of the horizontal transverse, and the third the middle squares of the upper and lower horizontal rows.

The shape is made even more questionable by empirical concerns discussed shortly. Nevertheless, though "art-as-art" demanded the rejection of religion as an artistic "theme," including interpretation of the canvases in terms of Christian iconography, the persistence of so central a motif in *any* form, however fragmentary, is bound to bear religious associations along with it. The emanation of the shape from undifferentiated darkness enclosing it remains ineluctably allusive (e.g., John 1:5), just as the repetition of negative adjectives and suffixes in Reinhardt's description of art recalls a *topos* in Christian mysticism—cf. the repetition of the negative preposition *sin* ("without") in the darkness described by John of the Cross. The second of Reinhardt's notebook litanies to blackness in fact alludes directly to *La noche oscura del alma*—along with Meister Eckhardt of the *via negativa*— in which the soul seeks for union with God not through sacramental communion with but by utter withdrawal from his creation. Writing in his most incantatory style—the private complement

of the colloquial slapstick of his public satire—Reinhardt conjures black's *"Negative* presence. . . . *Dematerialization,* non-being . . . inexorable, inevitable, infinite. . . . Emptiness. . . . *Void vs. myth,* image, being, light/ Demythologizing [,] *meaninglessness, imagelessness,/ lightlessness, spacelessness, formlessness"* [Reinhardt 97–98]).

The same rhapsodic catalogue mentions Lao Tse and the blackness of Chinese art, with a clear allusion to the primacy of the "Dark Female" or Yin of Taoism. Similarly, the recurrent "no" and the "working or . . . non-working" of the final Technical Rule recalls the frequent use of the Sanskrit a privative and the cancellation of opposites in Buddhist terminology. Reinhardt attended Daisetz Suzuki's lectures on Zen at Columbia; he was devoted to Asian art (from what he called the "architectural mandala" of the Khmer temple to the magnificent Islamic abstraction of Isfahan) and taught courses on the subject for twenty years at Brooklyn College and Hunter College. He found the essence of Asian art in "its timelessness, its monotony, its inaction, its detachment, its expressionlessness, its clarity, its quietness, its dignity, its negativity" [Lippard 1981 182], qualities he obviously sought to emulate in his own later work.

In a conference-call seminar on darkness in art arranged by *artscanada* shortly before Reinhardt's death, he made numerous religious allusions, again to "Lao Tse, 'the tao dim and dark,' and the Kaaba, the black cube in Mecca; then there's the black rock in the dome of the rock in Jerusalem, and what the mediaeval mystic Eckhardt called the Divine Dark. But, as an artist, I wanted to eliminate the religious ideas about black. . . . The reason for the involvement with darkness and blackness is . . . an aesthetic-intellectual one . . . because of its non-color. Color is always trapped in some kind of physical activity or assertiveness of its own; and color has to do with life. In that sense it may be vulgarity or folk art or something like that" [Reinhardt 87]. Klein's dismissal of colors other than blue for their "specific associative ideas" is extended by Reinhardt to *all* colors in the remorseless equation of "life"—as an artistic subject—with "vulgarity."

What is in or on the last canvases themselves? Most viewers seem to find nothing, and various critics have noted that, first of all, the casual spectator literally does not and cannot see these paintings, which require considerable time for ocular adjustment. In my experience, few visitors to museums take that time, and many enjoy Reinhardt's blacks mainly as a joke. When questioned casually, however, some seem uncertain as to whether they are laughing with or at him, though others are more confident of their acuity.

Nonmuseum-goers are pretty much out of luck altogether, since these paintings cannot be even remotely effectively reproduced in books, posters, catalogues, etc., although lecturers are forced to rely on precisely those impossible reproductions for their presentations. O'Doherty suggested in this context that "Reinhardt has not reduced art to its limits. He

has reduced visibility to its limits" [1967 106]. The problem of determinate form greatly increases in Reinhardt's work as value contrasts decrease from the blue and red to the black paintings. The difficulty, in fact, seems to grow even greater as he moves from the oblong blacks of the last half of the fifties to the square blacks of the next decade. Some of the final paintings are all but monotonal as well as monochromatic; value contrasts are here virtually abolished in comparison not only to the high-keyed reds but also to the *relatively* more differentiated oblong blacks. In fact, Reinhardt's policy in repainting earlier canvases that had been damaged on exhibition was to darken them further, to recreate them with even less contamination by visibility.

With the aid of flash or other enhanced lighting, photographic reproductions of the canvases reveal the cruciform shape. From a phenomenological perspective, one might argue that they *invent* them.

The extent to which the square blacks "depict" a cross is more problematic in practice than in theory. In my own experience of the black paintings under normal lighting conditions, the transections and vertical "beams" in the oblong paintings, initially obscure to varying degrees, in every case finally become visible as a whole upon concentrated viewing. In some of the square paintings of the sixties, on the other hand, the overall structure is *never* fully revealed, the gestalt never evident but grasped by only the leap of imaginative compensation one makes in listening to music during a static-filled radio transmission. *Sections* of the borders of the "cross" emerge, often very slowly, upon viewing, but sink back into the mass of darkness as one shifts perspective to other sections of the canvas, trying to follow the outline or proceed from crossbeam to headbeam.

In the last paintings, that is to say, the image is rarefied to the point of evanescence. Reinhardt undoubtedly chose the square as the structural basis of the paintings (both frame and components) as the simplest geometrical form, along with the circle. It has the additional advantage, noted by Albers, of being non-organic, thus non-allusive, whereas the circle might suggest sun, moon, etc. Reinhardt's last paintings adopt the simplest abstract form in order to abstract it further, to dematerialize it by virtually abolishing value contrasts and eliminating even the infinitesimal suggestion of depth that might ensue from taping his canvases (the creation of a miniscule ridge which might define the border between squares and conceivably by reflecting light with its irregularity destroy the flatness of the surface).

The inevitable evocation of Christianity by Reinhardt's crosses or of Buddhist sunyata (emptiness, voidhood) by the dull radiance of the black matte have the support of Reinhardt's religious background/studies, notebook litanies, and the *artscanada* conversation cited above. But interpreters denying any symbolism have the same types of support (his non-practice of Christianity or Buddhism and disclaimers of religious imagery in lectures, interviews, and statements, including the one for

artscanada). One might discount the disclaimers (which Grace Glueck
treated with coy humor in a piece entitled "Mr. Pure" nine years after
Elaine de Kooning's "Pure Paints a Picture": "if you look closely, you can
discern a faint cross—oops, not a cross but a longitudinal band . . .
symmetrically bisecting a latitudinal one" [1966]) in their historical
context, and read them as an attempt by Reinhardt to distance himself
from the rhetoric of the New York School.

The resistance to symbolism is, however, too profound an element of
Reinhardt's writing and painting alike to dismiss easily. His calling was
to liberate art from all that is not art, a vocation he pursued with the
eremetic zeal and ferocity of Blake in his crusade to strip away all that is
not Vision. In doing so, Reinhardt helped establish, unintentionally, the
cooler aesthetic adopted by his successors. Despite the debut dates of the
artists, Reinhardt's blacks have more in common atmospherically with the
later dark cubes and monoliths of Tony Smith and Ronald Bladen than
with the somber presences of Barnett Newman's *Cathedra* or even the late
Rothkos. With their aura of autonomy and indifference they provoke
the objective contemplation of Minimalism rather than the subjective
introspection that was the alleged source—and end—of much Abstract
Expressionism.

Even many careful viewers continue to find his paintings void in a
less spiritual sense. Though Reinhardt might well have taken the criticism
of his work as void of meaning as a compliment, it was not usually so
intended, as when John Canaday noted that his search to "extract an
irreducible essence from color and geometry . . . has led him . . . to the
discovery that not an essence but a void may lie at the end of his search"
[1961].

Rather than interpreting the image or lack of same in terms of
religious iconography it might be more fruitful to interpret it as experi-
enced in its concreteness. What appears to the spectator in the last
paintings is *not* a square canvas of black matte subsumed by an image of
a cross emerging from it in a figure/ground relationship or reasonable
facsimile thereof. What emerges from the nothingness is not a figure or
object of any sort but rather hints amid the nothingness of a coequal
somethingness, a dark iridescence (a "dead, fish-eye glint" to Harold
Rosenberg [Battcock *Minimal* 305]) within the darkness that never fully
manifests itself.

Of course, even this might be misinterpreted, yet again, in religious
terms (as a representation of the duality of immanence and transcendence
in the godhead, or as Manichaean or Zoroastrian—Reinhardt was also
interested in Persian religion—Gnosticism, or as a prophecy of the afterlife
within the apocalypse, and so on). Alternatively, these nebulous and
evasive forms may be seen, in the non-referential terms Reinhardt
espoused, not as a symbol so much as an embodiment of the death of
representation.

That fashioner of false images, accused of fraudulence as early as Moses and Socrates, etiolated over the centuries and millennia, in Reinhardt's last blacks is itself represented as no longer having the force to generate further illusory replications, to manifest itself through even the simplest geometrical form other than fragmentarily. Reinhardt's career represents a progressive simplification of the two primary elements of representation on canvas: form (irregular collage to polygons to rectangles to squares) and color (multihued to brilliant monochrome to drained black). The last paintings approach the disembodiment of the image altogether in virtually monotonal darkness. In this sense they are "the last paintings anyone can make," representational or abstract—the last vestiges of the whole (pre)historical enterprise of showing forth any form real or imagined, the representation of the end of the fundamentally delusory enterprise of representation, and the further abstraction of the abstract art Reinhardt revered all his life not only from the outer/inner world but from the medium of paint itself.

Rauschenberg used the phrase "white as God" with reference to his 1951 monochromes. With their mysterious remoteness and dark lambency, it seems more apt to refer to Reinhardt's later monochromes as "black as God." Whereas the white paintings became among other things a movie screen, Reinhardt's blacks remained an inscrutable presence—one would write an inviolable presence had his fragile canvases not in fact been damaged frequently either maliciously or by spectators pressing their noses against the canvases or stumbling into them in an effort to see clearly what was meant to be seen unclearly. Already marked off by a black frame, the paintings required harsher measures to stave off nonart, and various fortifications were erected to protect surfaces especially delicate due to Reinhardt's method of leaching the oil from his paints with turpentine.

This was a painstaking process involving continual stirring to assure consistency and was primarily less a matter of technique than of aesthetic. Reinhardt's aversion to the later Minimalist sense of space was a corollary of his insistence on the inviolable autonomy of the artwork from the world in the abstract and the concrete. Not only were his paintings rigorously nonreferential but rigorously nonrelational vis-à-vis their own components as well as the specific setting of their public exhibition. As Marden would later use beeswax to reduce the reflectiveness of oil paints, Reinhardt progressively drained his in order to avoid any gloss which might either seduce or reflect its beholders, to avoid contact with the world where his work was exposed with a reluctance seemingly shared with the artist by the paintings themselves. "There should be no shine in the finish. Gloss reflects and relates to the changing surroundings" [Reinhardt 207; cf. 83, 87]. This is the problem with all reproductions of his work, including the most recent retrospective at the Museum of Modern Art and Los Angeles Museum of Contemporary Art, the catalogue

for which contains the most successful or least unsuccessful reproductions of the blacks I have encountered but prints them, perhaps of necessity, on glossy paper that converts them disastrously into dark mirrors.

Although several critics noted that Reinhardt's blacks hung more comfortably with the work of younger Minimalists in exhibitions like "10" at the Dwan Gallery in 1966 than with that of his contemporaries, they had an old-fashioned reserve unshared with the shining stainless steel, mirrors and occasionally bright colors of ABC sculptors. Reinhardt's movement from the monochromatic blue and red canvases which dominated his work in the early fifties (at least one white-on-white was also painted as late as 1955) to the black-on-blacks which exclusively occupied his last twelve years further illustrates a revulsion from that kind of bold opticality.

His blacks also had a different sense of time. In terms of self-presentation, they were diametrically opposed to the kind of immediacy and matter-of-factness sought by some of the later painters and sculptors, the "all-at-once" quality mentioned by Judd and the "immediate . . . apprehension of the gestalt" aspired to by Robert Morris [February 1966 44] and shared even with the bald ingenuousness of neutral-colored grid paintings. Comparing the monochromes of Robert Mangold or Brice Marden with Reinhardt's blacks, one realizes that the difference has to do with temporality as much as colorism. The spray-painting of Mangold and beeswax mix of Marden aim variously to establish an art of pure surface without depth or painterliness, normally in dulled hues. The extraordinarily close color-values of Reinhardt's deliberately dulled pigment, however, *conceal* the structure of the painting, simple and endlessly repeated as it is, from casual view. The painting *emerges*, its gestalt anything but immediate, revealed only to the attentive gaze, and then only fragmentarily. This is a more inherently durational quality than the environmental temporality generated by the sheer size of some of the later sculpture, which like its apotheosis, the World Trade Center, is apprehended at first glance but best experienced at different angles.

The gradual apparition of Reinhardt's blacks is the quality which first leads Rosalind Krauss in an explicitly revisionist article to segregate them from Minimalism altogether. Krauss opens her article by (over)stating that in 1963 "it soon seemed obvious that what [the Reinhardt and Stella blacks] had in common was, nothing." Whereas Stella's concern with pure surface provided the keynote for "capital M" Minimalism (as often, no later painter in the Movement purportedly descended from Stella is mentioned), Reinhardt's "small m'd" minimalism was allied to "pictorial asceticisms of the past" [1991 123]. These too are unspecified, but his unlikely successors in an art not of surface but of perceptual process turn out to be Robert Irwin and James Turrell, "the most effective exponent of the California Sublime." Neither is "interested in surface but transparency" [133], presumably like Reinhardt, whose steadfast rejection of color, light, and environment is seen somehow as spawning Turrell's often

brilliant ambient-light art in a genealogy arguable in theory and safely out of view of the works themselves.

Of Reinhardt's 1963 nomination by Rosenberg as the "intellectual pivot" of the new generation—quickly confirmed by Lippard [May 1965] and Rose ["ABC"], then numerous others—Reinhardt remarked non-committally to Bruce Glaser, "They come from the same place I come from, but not from me particularly" [Reinhardt 22]. His aesthetic was unproblematically Minimalist in its coolness, its simplification, its insistence on the objectivity and autonomy of the artwork. Yet in their temporality his paintings remain ambiguously related to those of Abstract Expressionist contemporaries (notably Rothko), towards whose pretensions, particularly their contamination of art with romantic and psychiatric mythology, he was scathing.

Despite Reinhardt's caustic and cool aesthetic, critic after critic and viewer after viewer of Reinhardt's black paintings succumb to or must consciously resist the sense of mystery they convey. However one may have reacted to the earlier works in the chronological arrangement of a retrospective, one is immediately silenced on entering a roomful of Reinhardt blacks. At first sight the effect of the curator-arranged *series* of blacks is thus as instantaneous as Judd or Morris could desire. But whereas the ABC generation sought nothing beyond that objective wholeness and uncompromised clarity founded on a moral renunciation of illusionism of any sort, the initial experience of the series in Reinhardt is only the prelude to the time-consuming confrontation with the individual canvas—a static as opposed to peripatetic contemplation or reconnaissance.

Though serial, the individual Reinhardt blacks are necessarily, unlike later Minimalist series, durationally experienced as units, not epiphanic but composed of gradual, barely perceptible revelations. The individual canvas is nonstatic in its ever-changing contours, again unlike either the Rauschenberg and Klein or ABC monochromes. They are apocalyptic in the etymological sense, coming out of hiding, but with none of the sudden drama the term now connotes. Frank Stella's motto for his black paintings, "What you see is what you see," is not so much an advance on the aesthetic of the black series Reinhardt had begun a few years earlier as a contradiction of their implicit "What you see is what you don't see (yet)." Despite the relentless demystification of Reinhardt's aesthetic and clinical precision of his technique, Stella's credo of "the whole idea without any confusion" [Battcock *Minimal* 158] remains alien to the subtlety of Reinhardt's fragmentary, phantasmal images. Milton's Hell is cloaked in "darkness visible," Reinhardt's last canvases in light all but invisible, emerging only to the devoted eye. For this reason, they are either a joke, a waste of time, or an aesthetic discipline—in the etymological sense of purely *perceptual* training and also with the more rarefied connotation of an exercise in some sense of the spirit, which grows out of that sensory experience and is not appended to it by fiat, as in the

Rauschenberg and perhaps Klein monochromes. The concentration demanded by the late blacks necessarily alienates the spectator from the functional mode of perception in which he deals with the world, and perhaps even the rest of the museum; in that sense they share their renunciation with him or her. In some sense "the devoted eye" must become devotional.

Nonetheless, the very repetitiveness of Reinhardt's blacks at the same time rejects the Abstract Expressionist sacralization of the individual canvas as the repository of a uniquely inspirational experience, the documentary in pigment of a sensibility immersed in an unrepeatable confrontation with reality. Despite his painstaking brushwork to eliminate traces of brushwork—a literal interpretation of *ars est celare artem*—Reinhardt's attitude has more in common philosophically with later Minimalist sculptural "designers," whose plans were executed by others in foundries. Thomas Hess reports, "When one of his works was damaged, and the museum asked him to repair it, he offered to substitute another version. 'But you don't understand, Mr. Reinhardt,' he was told. 'Our Committee especially chose *this* one.' 'Listen,' the painter answered, 'I've got a picture here that's more like the one you've got than the one you've got" [1963 28].

Despite his satire and this brusque treatment of the erstwhile-fetishized opus as an interchangeable unit, the vocational asceticism of Reinhardt did not allow him to desacralize the artwork as radically as Rauschenberg by contamination with (the rest of) reality. While there is a "theatrical" line of descent from the Rauschenberg whites to the sculpture of Robert Morris, it was Reinhardt who established the viability of the quietist Minimal artwork—with both his obsessively and unremittingly reductive paintings and with critical writings that helped bring the magniloquence of New York School aesthetics down to earth with a thud.

E

Nothing exemplifies the grandiloquence of Abstract Expressionism better than the writings and lectures of Barnett Newman. At the same time, no one's painting was so influential in establishing precedent for the pure opticality of later Minimalism, despite critical theories—primarily his own—to the contrary. Reinhardt shrugged off his influence on later Minimalism; Newman might as readily have attacked as encouraged such a suggestion. Nonetheless, they are *malgré soi* the progenitors of the theory and practice, respectively, of Minimalist painting.

Newman and Reinhardt had much in common apart from chronology. Both were sons of immigrants and raised in New York City (Reinhardt mainly in Queens, Newman in the Bronx—although his Manhattan birth may account for his once lumping Brooklynites and Staten Islanders together with New Jerseyites as "out-of-towners" [Newman 31]). They shared an aversion to defining the artwork by its physical—though they differed on the matter of its rhetorical—context; "People always keep talking about 'environmental art,'" Newman noted testily, adding, "I hope my work is free of the environment" [272]. Both appeared in the Irascibles photograph of fifteen artists that appeared in *Life* magazine in 1951. (Those protesting the Metropolitan Museum of Art's discrimination against Modernism the previous year actually numbered eighteen *in toto*, after Newman had personally recruited Pollock [Naifeh/Smith 602].) In general, Newman was not one to miss out on any chance to be irascible in public. In essays, interviews, and correspondence, he offered forceful opinions on everything, including nothing: "I have always hated the void," he once informed an interviewer who ventured to compare him to Klein [Newman 249].

Newman ran for mayor of New York in 1933; Reinhardt designed magazines ecumenically for both the New York Yankees and the Brooklyn

Dodgers. Both were ridiculed as charlatans (Reinhardt was morally classified with forgers and featured as the sole example of "fakers among the artists themselves" in Ralph Colin's 1963 *Art in America* article "Fakes and Frauds in the Art World" [89]); and true to their hometown spirit, both were energetic and scathing polemicists who gave back better than they got. From the perspective of American art, it is a historical irony that Newman brought unsuccessful suit for slander in 1954 after Reinhardt's lecture caustically satirizing the New York School as hucksters and cynical sell-outs (including, among other characters, "the holy-roller-explainer-entertainer-in-residence") was reprinted in the *College Art Journal*. From the perspective of individual psychology, however, it was inevitable: the town wasn't big enough for both of them.

Reinhardt provided methodological models for later Minimalist technique and, equally importantly, the aesthetic foundations for the later artists so denominated. Though no one could be more out of sympathy with that aesthetic than Barnett Newman, it becomes progressively clearer with historical perspective that it was he who started it all.

Newman arose out of neither the Suprematist nor neo-Plasticist traditions of geometrical abstraction deriving from Malevich and Mondrian. Although he studied at the Art Students League from 1922–26 and 1929–30, he came to professional painting late, in part because the Depression chained him to his father's clothing business from the late twenties to the late thirties. His work during World War II deals with biomorphic and mythological abstraction, like that of most New York artists, and is of no distinction. From 1944 to 1947 he directed exhibitions for Betty Parsons of pre-Columbian sculpture, Northwest Indian painting, and contemporary art (The Ideographic Picture, which, as mentioned earlier, included Reinhardt's work as well as his own). On his forty-third birthday, January 29, 1948, Newman made the breakthrough that had been adumbrated in his paintings and theoretical writings of the previous two years with *Onement I*, a 27"×16" oil, solid red-brown but for an inch-wide vertical red-orange stripe painted freehand in the center.

Although Newman occasionally explored horizontals, this was to prove the formula for virtually all his later paintings, which varied from beanpole to mural dimensions. The 1950 oil *The Wild* is eight feet high but only an inch and five-eighths wide, providing a precedent for shaped canvases of the late fifties and sixties. (In his final years Newman himself explored nonrectangular canvases with the triangular *Jericho* and *Chartres*.) He is best known, however, for his series *The Stations of the Cross* and his large-scale canvases, particularly *Cathedra* and *Vir Heroicus Sublimis*, 8'×18' in flaming red with five vertical stripes or, as Newman preferred to term them, "zips."

The terminological distinction attempted to suggest the unifying rather than divisive effect of the zips, which he insisted, debatably, should themselves be regarded as fields as much as the broad bands of red flanking it. In a 1965 interview with David Sylvester, Newman described

the zip as "a field that brings life to the other fields, just as the other fields bring life to this so-called line" [Newman 256]. Two months before his death in July 1970, he reaffirmed the assertion in an interview with Emile de Antonio: "I feel that my zip does not divide my paintings. I feel it does the exact opposite. It does not cut the format in half or in whatever parts, but it does the exact opposite: it unites the thing. It creates a totality, and in this regard I feel very, very separate, let's say, from other mental views, the so-called stripes" [306].

This may have been a reference to 1960s paintings like those of Gene Davis in which the width of the masked verticals is regularized, sometimes creating a serial effect closer to Ellsworth Kelly than to Newman. By comparison, Newman's usually spare zips, seen close up as he prescribed, have the effect of expanding the length and breadth of the painting while neutralizing its depth by repeating the vertical framing edges within the canvas. Clement Greenberg said that Newman's zips "do not echo those of the frame but parody it . . . the picture edge is repeated inside and *makes* the picture" [1961 226]—an anticipation of Michael Fried's comments on the 1962 Newman/de Kooning show quoted earlier and his more influential formalist analysis of Frank Stella in terms of deductive structure. Sandler called them "accents that energize the continuous area and give it scale, at once making it appear a vast expanse while preventing it from becoming amorphous and inert" [190]. In this sense the zip served to create the unitary effect sought by a number of ABC-generation painters, while generating a kinesis they largely sought to avoid.

What is of greater consequence than the zip's dubious qualifications as a field is the accentuation noted by Sandler. The zip was the only element disqualifying Newman's paintings from the most thorough monochromaticism in the history of art; even Malevich's *Suprematist Composition: White on White* contrasted its inner square with the distinctly off-white/beige ground, while Rodchenko's *Non-Objective Painting: Black on Black* is problematically titled insofar as its central circle is broken into crescents of olive as well as black. The bare-bones simplicity evaded by the zips, which were in fact often painted *over* the larger "fields" they *de facto* divided, would have been radical even by the standards of the New York school, and even of its "color-field" division, a term first invented by Joseph H. Greenberg in 1960 with reference to the staining of Helen Frankenthaler and her followers, and later applied retroactively to members of the first generation of the New York School.

The bibliographical and aesthetic reasons that caused Newman to draw back from the monochromatic brink may be more comprehensible after a glance at the field-work without which later Minimalist painting is finally unimaginable, despite its European forebears in geometrical abstraction. The concept of the "field," opposed to the swaths and skeins of the action painters, is the single most important innovation in Minimalist monochromaticism.

Ironically, however unifying in effect, the zip provides the sole

vestige of compositional relations—and the only argument against accept-
ing the canvases as rigorously Minimal—in the otherwise holistic pattern.
In Newman's sculpture in the sixties the zip was to be translated into
the entire content of the sculptures in *Here II* and elsewhere. In this case,
however, the sole feature distinguishing that sculpture from the unitary
forms by then labelled Minimal was the vestige of a pedestal supporting
the now three-dimensional "zips" unifying or demarcating space instead
of canvas.

Newman, along with Clyfford Still and Mark Rothko, represented the
most viable alternative to the action painting associated with Pollock,
de Kooning, and others. All three constructed their canvases with broad
expanses of color, but each in a radically different way.

Still's often virtually monochromatic canvases were distinguished
texturally by crusty impasto and compositionally by portals, canyons, and
"lightning-bolt rents" [Ashton November 15, 1959] seemingly carved in
brighter hue into a dark, even ominous ground. The power of his work
derived in good measure from the geographical and geological metaphors
suggested by the nonrepresentational depth of his surfaces and the
jaggedness of the contrasting color areas. Still was born and raised in
North Dakota, which inspired his sense of form and color [Alloway 1975
34] and may in part have guided the critics like Robert Rosenblum
[1961 40] who found in his work evocations of the American West.

Given the concerns of his artistic and cultural milieu, his opacity and
jagged disjuncture, fierce contrasts of hue and chroma could not but
have recalled with equal force the geological/archaeological metaphors for
the psyche promulgated by Freud, Jung and other "depth" (the adjective
itself reveals the metaphor) psychologists. The psychic associations of
his abstract illusionism was further reinforced by the sharp value-contrasts
of Still's color areas, which underscored the contextually revelatory or
epiphanic nature of the color against its ground.

If James Joyce's ideal reader had the ideal case of insomnia, Mark
Rothko's ideal spectator was the one who beholding the canvas shared
in the mysterious process of its creation. Rothko was quick to upbraid
Selden Rodman with "The people who weep before my pictures are
having the same religious experience I had when I painted them. And if
you, as you say, are moved only by their color relationships, then you
miss the point!" [Rodman 92–93]. This notion of the magical replication
of the artistic process in its audience has roots in the Romanticism of
Coleridge's *Kubla Khan* and Poe's *The Fall of the House of Usher.* It was
fomented by the very use of the term "Expressionism" after "Abstract"
and by the mythology of "action" painting, in which the canvas became
the latest installment in a personal epic or a psychic garbage-dump,
depending on one's aesthetic.

If the action painting of Pollock conveys the barely controlled chaos
that seems in turn to have gained control of the artist himself around the

time he abandoned the technique in 1953, Rothko's ever more subdued luminosity and darkening palette testifies to the progressively tragic cast of his experience. His early *The Omen of the Eagle* alludes to the Oresteia and several public statements from the early forties onward allude to the tragic as the only source of art. The suicide of an artist described by Rauschenberg as "born depressed" [Rose 1987 46] and by Clement Greenberg as "a clinical paranoid" was his last and least controvertible statement on the matter. Equally if more brutally tragic is the late Rothko's reference to the receptacles/catalysts of his mystical experience as "merchandise" [quoted Naifeh/Smith 632, 763].

Rothko, like Still and Newman, grew up in the tradition of biomorphism. He began to move toward his mature style in 1947, still the *annus mirabilis* of American painting to date, which Pollock opened with his breakthrough into drip painting, followed by de Kooning's second *Woman* series and Rothko's rejection of biomorphism for pure abstraction in the form of the sometimes quasigeometric stains soon to metamorphose into the luminous rectangular structures that became his trademark. Newman continued experimenting with the curved stripes that were to be regularized into zips as vestigial figuration finally disappeared less than a month into the next year.

Despite abundant scumbling, Rothko was more geometrically oriented than Still but no more allied to any tradition of geometrical abstraction than either Still or Newman. Rothko divided the canvas into noncontiguous vertical rectangles, most often two, painted against/over a hazy ground. The slash approximates the complexity of his pictorial juggling with figure/ground relations. In the 1957 *Orange*, for example, the greenish ground or rather frame of the two identical orange rectangles in fact bisects what was initially a single rectangle, the form and hue of which remain apparent. This rich ambivalence included the support as well, since Rothko saturated often unprimed canvas with wash after wash of turpentine-thinned paint. The geological complexity of texture which Still achieved with impasto was matched by the subtle gradations of luminosity Rothko achieved by the superimposition of several layers of thinned pigment. Arguably, his descendants are not the Minimalists but the Abstract Impressionist stainers and sprayers of the fifties and later: Helen Frankenthaler, Morris Louis, and Jules Olitski.

The values of Rothko's ground and rectangles could be close or distant. They were painted freehand with no attempt at regular perimeters, a condition reinforced by Rothko's wash technique. Perhaps most successful in darker and close values, Rothko's rectangles with their soft borders seem to radiate and recede, whereas Still's jagged color patches seem to have burned through the canvas. Even without Rothko's later black-against-blacks, the subtlety of his color contrasts perhaps influenced Reinhardt's progressive monochromaticism as well as its movement from primary tones to black—despite the neo-Romantic aesthetic the younger painter ridiculed.

Newman's aesthetic is equally unapologetic in its Romanticism (". . . if I am anything, I am romantic. There is no such thing as the classical. The Greek artists were a bunch of romantics" [Newman 248]). Newman has always been an ambiguous figure in surveys of Minimalism, mentioned but not included, acknowledged but not claimed for the school. This, however, is an evasion based less on his art—he was a principal stylistic influence on Stella, while even Robert Morris linked him to Cage in their shared absence of "climactic incident" [February 1966 43]—than his rhetoric, which has to a large extent obscured the art and consequently Newman's historical function as the Ur-Minimalist. This may be in part an inevitable if pernicious result of the growing predominance since midcentury of art criticism over art. The critics' medium is words; consequently, they may tend to classify the painters on the basis of theirs, listening to what they say rather than watching what they do. Writing in *The New Yorker* in 1969 on the replacement of the tradition of narrative art by conceptual art, Harold Rosenberg both examined and illustrated these assumptions: "A contemporary painting or sculpture is a species of centaur—half art materials, half words. The words are the vital, energetic element, capable, among other things, of transforming any materials (epoxy, light beams, string, rocks, earth) into art materials. It is its verbal substance that establishes the visual tradition in which a particular work is to be seen—that places a Newman in the perspective of Abstract Expressionism rather than of Bauhaus design or mathematical abstraction. . . . The secretion of language in the work interposes a mist of interpretation between it and the eye" [Battcock *Idea* 151].

It was Newman himself who noted that painters needed aesthetics the way birds needed ornithology. Nonetheless, he devoted considerable energy to describing his own aesthetic and attempting to distinguish it from that of his forebears and contemporaries. First of all, an odd insecurity seems at work in Newman's proud and often embarrassing self-promotion of the skillfulness of his techniques. In 1962 he insisted, "I am always referred to in relation to my painting. Yet I know that if I have made a contribution, it is primarily in my drawing" [251]. He twice failed the sketching test required of art teachers in the New York public school system, and while this may seem one of those risible ironies in the history of philistine culture, it might also be noted—with acknowledgment that art does not equal draftsmanship (Frank Stella once confessed blithely he could not draw a straight line)—that nothing in Newman's work indicates great talent in this area.

The bombast of his aesthetic pronouncements has a similar air of defensiveness about it. The contrast between the true sublime of his best art and the fake-sublime of his essays is founded on the difference between artistic statements made with stark simplicity and aesthetic pronouncements bloated with sententiousness. In a brief but acute 1961 essay Robert Rosenblum investigated the color-field painters and Pollock under the rubric "The Abstract Sublime," finding in *Vir Heroicus Sublimis*

"a void as terrifying, if exhilarating, as the arctic emptiness of the tundra" and in Newman's work in general "awesomely simple mysteries that evoke the primeval moment of creation" [1961 56].

Although the artist "always hated the void," both Rosenblum's title and diction echo Newman's own. In December 1948 Newman published an article entitled "The Sublime Is Now." No later theorist so vindicates T. E. Hulme's dismissive characterization of Romanticism as "spilt religion"; it seems inevitable that Newman gravitated to Old Testament themes and later the series whose full title is *The Stations of the Cross, Lema Sabachthani*. In 1945 he described contemporary American painting as "a religious art, a modern mythology concerned with numinous ideas and feelings. . . . The present movement in America transcends nature. It is concerned with metaphysical implications, with the divine mysteries. These new painters have brought the artist back to his original, primitive role—the maker of gods" [Newman 97–98]. To a large extent, the color-field painters tended to embrace phylogeny, action painters ontogeny, in their exposition of the creative mystery at the heart of the New York School, as illustrated in Newman's statement the same year that "the present painter is concerned not with his own feelings or with the mystery of his own personality but with the penetration into the world-mystery. His imagination is therefore attempting to dig into metaphysical secrets. To that extent his art is concerned with the sublime" [140].

Newman and his colleagues in fact inherited the sublime from its incarnation in the Germanic post-Romanticism of depth psychology—from one perspective a quasiscientific gloss on Goethe. The New York School overall showed a predilection for Jungian archetypes rather than the Freudian esoterica that had been embraced by the Surrealists earlier ("not with his own feelings . . . but . . . the world-mystery"). Newman later revived the terminological dichotomy popularized by Edmund Burke two centuries earlier in identifying the painting of the American "barbarian" artist explicitly with the quest for the sublime, the refinement of European painters with the tradition of the beautiful [170–73].

In no sense, however, did Newman slight the individual uniqueness of the artist's heroic effort, least of all his own. "[T]he struggle is to bring out from the nonreal, from the chaos of ecstasy something that evokes a memory of the emotion of an experienced moment of total reality" [163]. "I work only out of high passion" [248]. "I was asked by a viewer how long it took me to paint *Vir Heroicus Sublimis*. I explained that it took a second but the second took a lifetime" [248]. Newman's normal conversation was apparently frank and amiable; his paintings are brilliantly straightforward and powerful. But while his brush rarely deceives, his pronouncements at times approach virtuosity in their balderdash, which may partially justify his critics' colloquialism as hygienic. The same painting, for example, had recently been described by Frank Getlein in *The New Republic* as "the most asinine thing on board" a Minneapolis exhibition, so vacant of inspiration as to have been "run off by the

janitors with rollers" [quoted Newman 209]. Getlein made this comment, by the way, six years after Rauschenberg had in fact run off the white paintings with rollers though without janitors. Ironically, Newman's reaction to the Rauschenberg whites at Betty Parsons, according to Harold Rosenberg, was to ask, "What's the matter with him? Does he think it's easy?" [Rosenberg 1972 91].

The "asinine" painting, Newman's most famous and certainly among his most powerful, illustrates his ambiguous relationship to Minimalism. Take away the words and it is a massive near-monochrome. However, the imperative clause introduces important qualifications. "The words" include not only the sublime rhetoric with which the artist and others framed the unframed painting but also Newman's signature and date lower left. "Barnett Newman 1950" (he added "+51 BN" later along with the zip farthest right, which would seem to put the authenticity of "a second" in even greater peril) appears in the gestalt of the cadmium field both a blemish and an emblem of the Abstract Expressionist ego, the obtrusive cult of personality imposing itself between the starkly cogent art and the viewer.

In a sense the signature identifies not the artist but the subject. That *Vir Heroicus Sublimis* is another "portend of the artist" is clear in the identification throughout Newman's writings of the artist as the prototype of humanity. Just as Coleridge identified the "primary imagination" as a repetition of primordial Creation, so Newman, more paleontologically than theologically, identified the existential loneliness of mankind with both the cosmic terror of the first man articulating his self-consciousness and with the heroic effort of the artist to express the mysteries entrusted to him. He entitled the 1947 essay that serves as a keynote address for his mature style "The First Man Was an Artist," affirming therein that "Man's first expression, like his first dream, was an aesthetic one. Speech was a poetic outcry rather than a demand for communication. Original man, shouting his consonants, did so in yells of awe and anger at his tragic state, at his own self-awareness and at his helplessness before the void" [Newman 158]. That first man is clearly the heroic, sublime man of the painting, and the artist is the one who "always hated the void" if it is anyone.

That they should be anyone at all is a consequence of words not paint. Newman, like Reinhardt, might have called the work *Red Painting* and obviated the question. Far from stressing his individual genius, Reinhardt remarked laconically that anyone could paint his paintings. But Newman was vastly insecure about his uniqueness—see, for example, his astonishingly aggrieved letter chastising William Rubin for merely suggesting a (quite apparent) connection between his early work and biomorphism [234–36]—and thus never wearied of proclaiming it. Newman's egotistical sublime (to adopt Keats's description of Wordsworth) is magnified exponentially in his series *The Stations of the Cross, Lema Sabachthani*, where he distorts the whole concept of "stations," telescoping the Passion into

Christ's final cry (which appears in Matthew but not the other Evangelists). Newman glosses that cry thus in his catalogue statement: "Lema Sabachthani—why? Why did you forsake me? Why forsake me? To what purpose? Why? This is the Passion. The outcry of Jesus. Not the terrible walk up the Via Dolorosa, but the question that has no answer" [188]. It is the same cry as his primal man, and his *Newsweek* interview suggests the same artist is still doing the crying: "I tried to make the title a metaphor that describes my feeling when I did the paintings. . . . In my work, each station was a meaningful stage in my own—the artist's—life. It is an expression of how I worked. I was a pilgrim as I painted" [187–88].

These cries of embryonic self-consciousness (*Vir Heroicus Sublimis*) and metaphysical abandonment (*Stations*), of the first man emerging from the continuum of nature and the God-man forsaken by God, are both primal ruptures. It seems evident that the representation of these states in the reductive composition of the canvases can only be in the opposition of zips to field, which again calls into question their purported status as a "field" here and in other narrative paintings like *The Cry* and *The Wild*.

Apart from the rhetoric, the expansiveness of Abstract Expressionist canvases linked them to the "vastness" associated with the sublime from Longinus onward. Whereas Pollock periodically seemed to require a massive stretch of canvas in which to immerse himself, Rothko and Newman justified the size of their paintings, rather, as a means of immersing the spectator. Rothko insisted that his large-scale canvas did not aim at the "gradiose and pompous" but at the "very intimate and human . . . you are in it" [Sandler 1970 154]. For his second one-man show Newman uncharacteristically restricted his accompanying statement to a note, typed and tacked to the wall: "There is a tendency to look at large pictures from a distance. The large pictures in this exhibition are meant to be seen from a short distance" [178].

Although Newman clearly wanted the spectator "in" his painting as much as Rothko, rather than offering him the sense of panorama of the large mythological, historical, or topographical paintings of the great masters, Rothko's "intimacy" nonetheless seems as alien to Newman's painting as it is appropriate to his own seductive textures. In its quite nonintimate, fully externalized, instantaneous presence Newman's canvases have more in common with later Minimalists, though his aesthetic, held in common with his contemporary Abstract Expressionists, is antithetical to the objectivism of the younger generation.

Newman explained his absence from exhibitions by Rothko and Reinhardt with "I am frankly bored with the ininspired, or to put it more accurately, I am bored with the too easily inspired" [201]. Nevertheless, the facility of his own inspiration as a painter seems more readily subject to question than that of his colleagues. Newman was in fact widely dismissed as decorative, empty, and fraudulent, and was not, in fact, terribly highly regarded by his contemporary artists, who were less than

assiduous in their attention. In his catalogue for the 1971 Newman retrospective at the Museum of Modern Art, Thomas Hess relates:

> The whole underground art world, just about, came to Newman's opening at the Betty Parsons Gallery, January 23, 1950. That evening there was a party for him at the Artists' Club on Eighth Street; the main decorations consisted of about a dozen card-table tops put against the wall, with stripes made out of old feathers tied down their centers. It was a light-hearted, mischievous reconstruction of the show. When Newman saw the effect his pictures had made on his friends, tears came to his eyes. Did he realize they were poking fun at him? Or was he flattered, as he told the artists that evening, to see that his particular images had been recognized?
>
> Years later, Newman implied that both interpretations are true. . . . He overheard two artists' wives chatting. "What will Barney do next year?" said one. "Easy," was the answer, "he'll just hang the pictures sideways." . . . The whole of the New York art world, just about, stayed away from the opening of Newman's second one-man exhibition at the Betty Parsons Gallery, April 23, 1951. [Hess 1971 87]

For the record, Newman's early exhibitions were critically ignored more than they were ridiculed, while the 1950 show was praised by Aline Louchheim in the *Times* as "serious work which does evoke genuine response" for its "vibrancy, mood, impact"—although "many will jeer mercilessly" [January 29, 1950]. The 1951 show was, unfortunately for Newman, assigned by the *Times* to Stuart Preston, who criticized the "dehydrated canvases" of an art "emptied of content. Content has been replaced by what? What are the feelings that the artist is expressing here? The image of what thought confronts one? Is he proving some new theory of composition, or is he attempting to isolate the pure substance of painting?" His final criticism of the canvases was that "they point to arguments that have more to do with philosophy than with art criticism. For works of art are not made with theories but with paint and stone" [April 29, 1951]. Although Preston had demonstrated the use of the stone as a critical rather than painterly tool, the charge of dessicated intellectualism was to be echoed for years.

After being excluded by Dorothy Miller in her 1952 Fifteen Americans exhibition at the Museum of Modern Art, the dispirited but truculent Newman had refused to show again publicly until 1958 at Bennington College [Tomkins 1975 54]. His next show, his first in New York since 1951 and the first ever at the new French & Company galleries, took place from March 11 to April 5 the following year. His work, wrote Dore Ashton, "speaks largely to the mind" and as such will be "possible . . . for those satisfied with strictly spatial sensation" and for "the new school of vacuists who dally with Zen and are interested in the idea itself of emptiness" [March 12, 1959]. Whether they found his work "possible" or not, some colleagues still harbored the suspicion that Newman was fundamentally a theorist who had belatedly turned artist to illustrate his theories.

An alternative interpretation, however, might be that Newman used his theory to validate an art of minimal technique if not content. An artist of limited sketching skills—even the curved and trunklike proto-zips of the transitional (1947) *The Euclidean Abyss, The Death of Euclid,* or *Genetic Moment* are not especially well executed—Newman may have been led of necessity to his mature style. But this too is finally an extraneous consideration, in no way diminishing the power of that art, which in its very different way is as revolutionary as Pollock's. Newman's own pretensions and the temper of the age prohibited his offering his work in its non-narrative bareness. He clothed it in sublime rhetoric and fancy titles that ultimately advertised his conceptual ambition but obscured a powerful technical simplicity in a period when it had not yet acquired cogency or a sobriquet. The man and the moment had not coincided.

The insecure status of American art itself is a largely ignored factor here. The inferiority complex of American artists vis-à-vis their European colleagues through the first half of the century has been almost universally acknowledged by the artists themselves. If Americans were to achieve independence from Europe, it was more likely to be accomplished with an art that demonstrated a complexity equivalent or comparable to that of prewar Surrealism and earlier modernist movements. In this regard the compositional intricacy of what John Perreault called "globs and streaks of anguished autobiography" [May 16, 1968 15]—revised in Tom Wolfe's "splatters of unchained id" [54]—Pollock's swirls, splashes, lariats, drips, pours, and spills or de Kooning's swaths of paint were more amenable to the demands of the age than the primitive simplicity of Newman's monochromes, high- or low-keyed. If Newman's starkness was too much—or too little—even for his radical artist colleagues, it is no wonder the critics were not awed. As Hess points out, Aline Louchheim's *Times* review of the 1950 Parsons show was "the only favorable review he would receive for years" [1971 87].

At the same time, the artists had to (or hoped to) reach a public that still identified the American tradition as essentially representational. The New York school was about to confront them with radical abstraction, and the danger was the potential equation of representation and meaning and the concomitant belief that both had disappeared simultaneously. This in part led to the rhetorical inflation of the artists' pronouncements and in some cases, notably Newman's, even titles. The subtext to his proclamations of "a religious art, a modern mythology concerned with numinous ideas and feelings" is "This is not just a lot of paint with a line in the middle."

The minimal or non-existent narrative content of the paintings was self-consciously supplemented by the titles and other prose. The minimal technique of the near-monochromes was partially redeemed by the "zips," which—whether they unified or divided the primary field or both—provided enough contrast to stand between Newman and monochromaticism of a far purer order than even Reinhardt ever undertook.

Newman consistently distinguished his field painting from the later formalism, correctly insofar as the zips enabled him to evade while approximating both the irreducible bareness of monochromes and the hard-edge geometry of panel painting.

In what develops in *Vir Heroicus Sublimis* and elsewhere into a similitude of monochromatic panel painting, therefore, Newman comes to foreshadow simultaneously two of the three predominant structures (along with the grid) of Minimalist painting—while remaining within the sublime and heroic tradition valorized by the art world of his time. The defensive nature of the zips may even be hinted at in the odd name Newman gave them.

The most interesting theory of the connection of those zips to Newman's sublime was offered by Jean-François Lyotard, who suggested that the reductive sublimity of Newman's paintings and sculpture equally convey an awestruck sense of the incomprehensible. What they incarnate, however, is not the more traditional sublime of the inhuman expansiveness (oceans, mountains), energy (storms), and mystery (caves, cloudscapes) of natural phenomena, nor the obscurantism of the void, but the miracle of "the instant," the awesome fact that *anything* exists, the fundamental wonder of consciousness in its confrontation with a world independent of itself. "A painting by Newman is an angel. It announces nothing; it is itself an annunciation" [241]. Elaborating on this interpretation, one might read the zip as a primal epiphany, the flicker of consciousness or flash of awareness impinging upon the undifferentiated monochromatic field of the purely instinctual life.

If we follow Hess's reflexive theory of the subject of Newman's paintings as their own creation, that zip represents further the primal artistic gesture, the setting brush to canvas. For this reason Newman is perhaps most effective painting on bare canvas as in *Stations* and least effective in proportion to the traces of facture in his fields. The few paintings in which the brushwork is explicit in the fields fail dismally and look really quite amateurish—a lesson that was not lost on later Minimalists. Thus Newman, the least self-abnegating of theorists, provided—with paintbrush rather than pen in hand—a model for the "anonymous" style of later Minimalist monochromes, in sculpture as well as painting.

Both Newman and Reinhardt exhibited late in life with painters called Minimalist once the term had been (re)invented. Newman showed with Larry Bell, Billy Al Bengston, Robert Irwin, Donald Judd (who dedicated his 1988 Whitney retrospective to Barnett and Annalee Newman), Larry Poons, and Frank Stella at the 1965 São Paulo Bienal and objected to the characterization of the exhibit in the *New York Times* as "new American formal painting" in a letter to curator Walter Hopps: "It was my impression that you were organizing a kind of train, full of the work of young men of high purpose, who, not being too well known, needed me as a locomotive. I have become a cog in a formalist machine" [Newman 186]. Two years earlier he had refused participation

in an exhibition entitled The Formalists at Washington's Gallery of Modern Art and the year before that declined a place in Geometrical Abstraction in America at the Whitney [221]. Newman was honorably included in the Whitney's Geometrical Tradition in American Art exhibition thirty years later, when he was no longer in a position to decline.

His comments on the question of geometry in art, in fact, are among his least convincing and most condescending, sexually and otherwise, as he equates geometrical construction (elsewhere referred to as "modern arabesque" [155] and "this death grip, the grip of geometry" [179]) with decorative and female art: "Whatever the tradition, there always existed in the majority of primitive cultures even from prehistoric times a strict division from the geometric abstraction used in the decorative arts and the art of that culture. It is known that strict geometry was the province of the women members of primitive tribes, who used these devices in their weaving, pottery, etc. No case of any primitive culture shows the use of geometric form for religious expression. The men, in most tribes the practicing artists, always employed a symbolic, even a realistic, form of presentation" [139].

Reinhardt, the major contributor to Minimalist geometricism as well as aesthetics, of course had no qualms about exhibiting in Geometrical Abstraction. His objections to his younger contemporaries had nothing to do with their formalism but much to do with their theatricality and Duchampian contamination of art by life. One had to "choose between Duchamp and Mondrian," he felt [Lippard 1981 184], and there was no doubt about Reinhardt's own preference. Nonetheless, his most successful group exhibition was "10" at the Dwan Gallery in New York in October of 1966 and Los Angeles in May 1967, beside Carl Andre, Jo Baer, Dan Flavin, Donald Judd, Sol LeWitt, Agnes Martin, Robert Morris, Michael Steiner, and Robert Smithson.

Both Newman and Reinhardt benefited in their last years from the climate of opinion established by the art—particularly the sculpture—of the younger Minimalists in the 1960s. More than one critic has noted that Reinhardt's work seemed as integrated when hung with theirs as it seemed out of place amid Abstract Expressionists. After a visit to the Museum of Modern Art with his daughter a month before his death, Reinhardt himself noted drolly of his fragile blacks, "I watched everybody touch my painting, gently, everyone touches it lovingly these days everywhere, not like in the good old days when everyone jabbed at it" [Roob 7].

Newman exhibited *The Stations of the Cross, Lema Sabachthani* at the Guggenheim in 1966, a series of fourteen paintings consisting of black or white lines of differing breadth and contour—some taped, others almost wispy—on bare canvas. The acclaim given this radical enterprise was not unanimous; in *Artforum* Robert Pincus-Witten spoke of "insipidities served up" [November 1966], while John Canaday in the *Times* observed, "It isn't just a matter of charging 50 cents admission for a show that isn't

worth a plugged nickel. Mr. Newman's show is worth a plugged nickel of anybody's money and has something of the same counterfeit nature." He mocked "an exhibition so meretricious that . . . it has become the object of snickers along the art circuit. . . . There comes a point when we must admit that the nonsense can delegitimize the museum, and this has happened to the Guggenheim at last" [April 23, 1966].

Nonetheless, the overall response was more favorable than to his earlier exhibitions, which may be in part a result of the simple survival of his brilliantly reductive art for two decades. William Berkson in *Arts Magazine* wrote, "There is little that does not seem cheap in comparison. . . . A public wall should be made immediately available for their public installation" [June 1966], and Jerrold Lanes in *Artforum* [May 1969] found *Stations* the repository of Newman's inspiration in the sixties and far superior to his other painting of the decade (see below). The recognition of Newman's work was facilitated in the second half of the 1960s by the much-publicized offspring it had generated. Looking ahead, *Stations* in particular may also have helped inspire the New Testament-derived concept for five paintings by Brice Marden twelve years later entitled the *Annunciation* series and executed in Kelly-like vertical panels which together form one symmetrical whole.

Never abandoning the sublime, in 1967 Newman nonetheless sought to stress the continuity between himself and the younger generation, defending those who "reject the metaphysical nomenclature" but "are blessed with a new nomenclature, like 'minimal,' 'literal,' 'primary structure,' 'ABC art,' 'pop'" as not being "without spiritual content or concern . . . empty . . . nothing, as they are now being called by their enemy intellectuals." Like political competitors after the primaries, Newman soft-pedaled the differences in face of the enemy: "No matter how cool everybody sounds, and no matter how disdainful they are of the old art rhetoric, and even though they seem to feel easier with this new rhetoric . . . they're only involved, as I think I am involved still, in a disdain for Art with a capital A—which I think we all share—and the language has changed" [Newman 288–89]. His own language changed temporarily in a playful direction in the series of four canvases he executed from 1966 to 1970, the year of his death, which he called *Who's Afraid of Red, Yellow and Blue*, echoing Edward Albee's recent hit play, *Who's Afraid of Virginia Woolf*, and the children's song to which Albee's title itself had alluded.

Newman was correct in suggesting that the differences of vocabulary were fundamentally greater than those of artistic style. Significantly, in the two later *Who's Afraid* canvases ("II" in 1967, "IV" in 1969—"III" was finished after "II" in 1967 but begun the previous year), his verticals were boldly contrasting primaries, masked and unshaded, reminiscent of Ellsworth Kelly's *Red Yellow Blue* series in style as well as title, and executed not in oils but the acrylics favored by the younger artists.

Jerrold Lanes gave the most severe judgment on the extent to which

the younger painters had in fact diminished Newman's later work. Reviewing Newman's last show, at Knoedler & Company in 1969, of paintings from the 1960s, he called it a "great disappointment" ranging "from mediocre to wretched." He noted that, compared to Louis or Noland, Newman's surfaces are uninteresting and crude; even his color seems gross; the entire conception of the work is rudimentary." Though he found similar deficiencies in Newman's earlier work, Lanes lay at least part of the blame to seduction by Newman's juniors: "It often happens that an artist in his older years will be influenced by younger men, but with the best artists the younger men whose influence they undergo are themselves outstanding and their influence does not involve any lowering of the quality of the older man's work. So if I say that *Chartres*, a triangular canvas done in 1969, reminds me of what Charles Hinman must have been doing in his sophomore year my readers will understand how dismayed I was" [May 1969 59].

More questionable than his repayment of stylistic influence, however, is Newman's belated enlistment in the ranks of those disdaining capital-A Art. (Eight years earlier, in fact, he told Katherine Shortall from *Life* that his interest was not in craftsmanlike construction but "painting with a capital P" [quoted in Naifeh/Smith 690]). His expatiations on spirituality in art took place, after all, at a colloquium grandly entitled "The First International Congress on Religion, Architecture, and the Visual Arts"—during which Ad Reinhardt died alone in his studio of a heart attack, probably unrelated.

In 1966 Lucy Lippard noted the irony that while Reinhardt "anticipated the present 'minimal' style to the letter" [Lippard 1966 25], it owes more to the "color-painting," which "represents a distillation of the Abstract Expressionist mode . . . whereas Reinhardt has completely negated it. A 'cool,' inert, entropic art could not have emerged from a Reinhardt-influenced style because it could only have imitated it; he had already adopted the most absolute program, crossed those bridges." A more profound irony is the disparity between the "present" artists' rejection of the theory and embrace of the practice of their forebears: "A rigorous new art could, however, and did emerge from an eventual rejection of New York School romanticism, the 'esthetic of the Sublime'" [26].

Stylistically, Reinhardt and Newman are landmarks in Minimalism for their reductive reappraisal of the two main schools of abstract painting to midcentury, Reinhardt of the geometric and Newman of the expressionist. Reinhardt ridiculed sublimity, Newman overpainted his canvases with it. Reinhardt denounced narrative, Newman imposed it.

F

If Reinhardt epitomizes the reticence of Minimalism, Ellsworth Kelly inaugurates the brilliance of its Hard Edge contingent. If Newman initiates its radical experimentation in formal reductionism with his field-painting, Kelly introduces the equally crucial elements of structural uniformity and replication. Richard Axsom segregates Kelly from "the Minimalists" (with the tacit assumption that the movement began with its christening) because his "brilliantly hedonistic colors of the 1960s found no correlative in Minimalism's subdued, nearly colorless palette." He further distinguishes Kelly from his juniors because "Minimalist form as a whole was more severely geometrical and immersed within conceptual frameworks" [Axsom 13]. Axsom's comments on both colorism and geometry perceptively indicate very important reductivist tendencies in later Minimalism. Nonetheless, even if we segregate the Washington painters from the younger generation, not all the remaining color was muted (the reds, for example, of John McCracken, Donald Judd, and Carl Andre), while the oblong and grid panels with which Kelly began his mature work in 1952 and to which he returned in the 1960s, though not conceptually generated, are nothing if not geometrically severe.

After he read a review of a Reinhardt exhibition at the Betty Parsons Gallery (his first experience of that artist's work) in the December 1953 *Art News,* Kelly decided to return home after more than five years in France, partly because "I was tired and I was sick, and it was just time to change" [Geldzahler 1964 48], partly in the hope that his own work, on which he had been working quite independently of his American (and European) contemporaries, might gain acceptance. The paintings under discussion in the article included the blue and red "brick" paintings Reinhardt would abandon for the blacks within two years. Had the later paintings been written up, it is questionable that Kelly would have felt

any kinship and consequent hope, since the transformation of his approach to color in 1951–52 might be validly described as an artistic conversion experience.

Overall, Kelly proved less controversial than either Reinhardt or Newman, though his conception was in its way as radical. The explanation may lie in the generally extroverted, engaging nature of his colorism. Stuart Preston of the *Times*, who was ambiguous at best about Reinhardt's monochromes, repeatedly found much to praise in Kelly's, albeit viewing them at least initially as decorative. Of Kelly's May 1956 debut at Parsons, he described as "ideal for a modern building" the "cool-colored paintings" of the "uncompromising geometrist," by virtue of "their spacious architectural character." He concluded that the "emotional aloofness" and scientific precision might put off "persons who regard art as a form of self-indulgence. But no one should fail either to recognize the distinction of this work or to respond to the artist's sensitivity to pure color relationships" [May 26, 1956]. Kelly's 1959 show at Parsons contained "triumphs of refinement and simplicity" [October 25, 1959], while in his 1961 show at the same locale, "These dazzling and unambiguous pictures, excluding in their flawless surfaces any appearance of the artist's manual quirks, cannot fail to magnify Kelly's already considerable reputation" [October 21, 1961]. The aloofness and anonymity Preston found tendentious and unpalatable in Reinhardt presented him no difficulty in Kelly's erasure of facture. In fact, Preston found Kelly's "cunningly contrived geometrical shapes" the high point of the Sixteen Americans show as "a reflection of the increasingly imaginative beauty of new design," while he named Stella's geometrical, aloof, and anonymous blacks as one of the two weak spots [December 20, 1959].

Not even Kelly could please everyone, however. Reviewing the Towards a New Abstraction show at the Jewish Museum in 1963, Brian O'Doherty, after praising Noland, Louis, and Stella, passed terse judgment in another of his eminently quotable quotes—"Ellsworth Kelly just hasn't got what it takes" [June 2, 1963]—and went on to other matters.

Born in Newburgh, New York, in 1923 but raised mainly in New Jersey, Kelly had been stationed in France during World War II, having dropped out of the Pratt Institute after a year and a half to enlist. Reinhardt, the most unremittingly abstract of American artists, had served as a photographer on a Navy carrier. In a similar irony, Kelly, who was to become the most brilliant of American colorists, was assigned to an Army camouflage unit.

After demobilization he spent two years at the Boston Museum School before returning to Paris to continue his studies from fall 1948 through spring 1950 on the G.I. Bill, then on his own. Until 1949, when he turned twenty-six, Kelly resisted abstraction of any kind, either the postwar expressionism foreshadowed by Kandinsky or, more surprisingly, the geometry of de Stijl. Around that time he turned more towards a spare geometrical style, though not abstract in the sense of Mondrian's or

Malevich's. His first major work was the relief *Window, Museum of Modern Art, Paris* which virtually reproduces its subject yet without the title remains as autonomous in its abstraction as if it had been named "Divided Vertical Panel."

Panels began to predominate in his work two years later, appearing in the forms of grids, squares, and series of horizontally adjacent vertical oblongs. The sources for the grid structure were the many Mondrians dating from 1917 and, in terms of strict geometrical symmetry, the small collages of colored paper on cardboard done by Hans Arp and his wife Sophie Taeuber from 1915–18. In the period intervening between *Window* and the 1951–52 panels, Kelly had met Arp, as well as Brancusi, who, though working in another medium, may have provided impetus for Kelly's embracing geometric abstraction and rejecting figuration. The hybrid *Window* is in this sense a transitional piece, like many other of Kelly's works from the end of the 1940s and beginning of the 1950s. Yve-Alain Bois [1992 23–27] points to the important methodological as well as formal influence of Arp on Kelly. After a flirtation with automatism, Kelly was introduced by Arp to chance procedures in arranging the components of the collages and in 1950 created *Pink Rectangle* from pieces of colored paper found in a gutter. The technique provides an interesting analogy to the contemporary "cut-up" technique of William Burroughs's prose and the aleatory music of John Cage and others. According to Bois, Kelly pursued chance operations through *Colors for a Large Wall*, "the last important work to make room for chance."

Insisting that he was working from what he saw, Kelly considered these and even later works not abstract art per se but rather simplified representations of visible reality. This is true of the black-and-white grid painting *Seine* executed in 1951, which is non-representational in its reduction of liquid surface to the graph-paper geometry of miniature squares, yet strongly alludes to the current and depth of the actual river, almost like a topographical map. Significantly, Kelly continues drawing from nature even today, mounting exhibits of his sketches of plants and flowers in the early 1990s.

Kelly is recognized as much for his brilliant color as for his geometric reductionism. E. C. Goossen suggests [40] that this came as something of a revelation to Kelly, as to Van Gogh earlier, when he abandoned Paris for Provence in November 1951, escaping not only the cold but the drabness of the Parisian winter. Goossen argues that it was not only the light of the Riviera that liberated Kelly's palette but also his experience of Grünewald's Isenheim Altarpiece at Colmar. Goossen rightly sees the folding altarpiece as a major influence, along with the simulation of two-dimensionalism in the architecture of Mediterranean doorways, shutters, and reveals, on the panel paintings Kelly began to undertake: "Thus paintings and collages from 1952 and 1953 that seemingly stem from neo-Plasticism or de Stijl actually derive from architectural sources predating twentieth-century 'geometric idealism' by hundreds if not

thousands of years" [46]. Donald Judd, on the other hand, saw Kelly as someone who "can do something novel with a geometric art more or less from the thirties" [Judd 150].

Although Kelly shared none of the metaphysical intent of Mondrian and others, the influence of early geometrical abstraction is undeniable in the structure of Kelly's checkerboard paintings the same year, notably *Twenty-five Panels: Two Yellows* (each panel in three of the five rows of five divided horizontally into light and dark yellow halves, the intervening rows monochromatic) and *Colors for a Large Wall* (composed of sixty-four panels arranged in eight rows of eight equal squares). Fifteen years later, when Minimalist stasis had been established in sculpture as well as painting, Kelly observed, "To me the square is sufficient because of its exact quality. The rectangle and curved forms are dictated by sensibility. The square is in the present tense, unchanging" [Lippard "Homage" 57]. Mondrian's (and van Doesburg's) fondness for pink along with primary colors, in tandem with the structural components he called "my little blocks," is quite apparent there, as it is in Kelly's oblong panel paintings. Futhermore, while geometrical (polygonal rather than rectangular) regularity is an important feature of the altarpiece, it is of a different order than that which distinguishes both Mondrian and Kelly, in which repetition becomes the primary organizational principle of the work rather than merely providing its outline. By employing strict geometrical replication, Kelly adapts the rhythmic quality of neo-Plasticism to a nonhierarchical structure more akin to arrangement than composition.

More importantly, while the radiant panels of the altarpiece represent the life of Christ, Kelly's less subtly brilliant panels represent nothing. The sketch he made on viewing the altarpiece, significantly, was of a horizontal oblong divided symmetrically into one black and one white square, when closed; the unfolded structure contained one blue square, two different-toned yellow squares, and one red square. This emulates both the starkness of the Crucifixion as depicted by Grünewald on the central panel of his altarpiece and the radiance of salvation history that both literally and symbolically unfolds from that central frame and event. Whereas Biblical narrative determines the structure of the altarpiece, narrative is precisely the element Kelly repudiates in any form, unlike the Abstract Expressionists with their mythic and psychological preoccupations.

If Kelly's panels can be said to be about anything, they are about the anti-illusionistic use of color as form. Neither Newman's nor Reinhardt's monochromaticism was so flagrant and untempered. Reinhardt's meticulous and finally infinitesimal tonal contrasts and Newman's bold agonism of field and zip are equidistant from Kelly's straightforward presentation of uniform blocks of unmixed color. In his rejection of their subtlety and drama, Kelly introduced the elements of objecthood and immediacy into Minimalist art. Still relational—virtually the only compositional element is their chromatic relations—Kelly's panels nonetheless initiated the overt formal regularity later pursued as the primary means

of achieving the nonrelational canvas by Frank Stella in his otherwise antithetical early work and by those who followed him into repetitive pattern. When Kelly began his uniform panels, Reinhardt was working with strictly rectilinear but unequal forms, largely rectangles of different dimensions rather than the identical squares to which he devoted himself exclusively only in the sixties.

Donald Judd's dismissive comment on Kelly as "more or less from the thirties" requires scrutiny. In the first place, despite the influence of earlier geometrical abstraction, Kelly's work is unthinkable without Abstract Expressionism. The allover effect sought by painters from the late 1940s onward in ways as various as those of Pollock and Rothko was shared equally by Kelly. John Perreault understood Kelly's context in praising "His Hard Edge counter-move to Abstract Expressionism's emotionally sloppy and anti-plastic excesses," which "was, and still is, an exciting alternative to Dionysian paint-splashing" [March 9, 1967].

Judd called Newman's paintings in 1964 "some of the best done in the United States in the last fifteen years" [200] and two years earlier called Reinhardt's blacks "some of the best being done" [53]. In reviewing Kelly's 1964 show at Parsons, Judd noted the influence of "the pure and geometric art of the twenties and thirties" [130] and in other pieces of the same year described his work as an innovation within "a geometric art more or less from the thirties" [150] and "mainly old abstraction" [202]. In a footnote added in 1970 he commented, "I haven't changed my mind about the paintings I was writing about, the Arpish ones, but Kelly's later rectangular paintings are another case. At the time I had seen one early sectional rectangular painting in a Green Gallery show but didn't know there were more like it and took it for a fluke" [202 n.2]. The "Arpish" paintings are the grids, which Judd presumably disqualifies from contemporaneity on the basis of the busyness of their color relations; even they, however, are structurally more regularized than the geometrical abstraction of the 1930s, and in their all-over structure abjure the figure/ground relationships persisting there as in Albers's later elaboration and, more ambiguously, in some of Kelly's conjoined shaped panels. The "rectangular" paintings are the serial monochromes, on which Kelly had in fact worked even before the earliest *Spectrum* in 1953. One panel painting executed in Senary (*Painting for a White Wall*) consists of vertical monochromes arranged like the seven-panel white painting Rauschenberg had just executed and not yet exhibited across the Atlantic, with the crucial difference of color contrasts between the monochrome panels.

The second of the *Kite* panel paintings created the same year in fact uses pure white panels (not in Rauschenberg's rolled enamel but in brushed oils with negligible traces of facture), alternating them with colored squares of the same width and half the height, the primaries and green atop black squares. In this simulation of line apart from edge as well as in their lightly allusive title, the panels of *Kite II* represent a less

radical experiment than those of *Painting for a White Wall*, something closer to the "Arpish" grid of *Colors for a Large Wall* and others.

Kelly continued experimenting in creating works with panels of different sizes (the vertical construct *Gaza*) and shapes (squares and oblongs in the five-panel *Tiger*). In the next decade he worked similarly with triangular forms. These works seem to me far less interesting than the rectangular panels, at any rate more regressive in their hierarchical relations and the simulation of figure/ground by the interlocking placement of separate panels.

Kelly went back to the formally simplest panel-painting, the oblong series, during the ABC days with numerous works, including his celebrated *Spectrum* paintings, which may represent an advance conceptually but an elaboration formally of *Painting for a White Wall* and the first *Spectrum* fifteen years earlier. As in the case of the geometrical and field paintings of Reinhardt and Newman, the way had been made strait by the younger generation who had had time to emulate the discoveries of their predecessors and found a strength in numbers their forebears had lacked. Kelly's fundamental concept of building the work entirely from uniform verticals of solid color had been treated variously in the assorted shaped canvases of Kenneth Noland, the regular stripes of Gene Davis, and elsewhere. When Kelly undertook panel painting in the early 1950s he was on terra incognita. By the end of the 1960s it was common practice, having been taken up notably by Richard Tuttle with symmetrical constructions of painted wood and plywood and Brice Marden with his wax-mixed oils on square and rectangular canvases in 1964, and the next year by Marden's classmate Robert Mangold with spray-paint on shaped masonite. Even earlier in the decade Jasper Johns had approached panel paintings quasiparodically, quasi-Dadaistically in painting the names of primary colors on panels in colors other than the ones spelled out in paint, perhaps a parallel to his irreverent reprise of the exaggerated brushstroke of Abstract Expressionist gesturalism.

Perreault, like Rose and later Axsom, segregated Kelly from the ABC painters: "Though superficially related to Minimalist styles, Kelly's compositional and even coloristic austerity masks a warmth and sensuousness that separates him from younger, more ice-bound painters." As an example, he found, converting the hedonism Axsom found in Kelly into religiosity, that *Spectrum II* "glows with a warm spirituality" [March 9, 1968 12].

Kelly's panel paintings represent a unique combination of Minimalist monochromaticism and replication. His construction of works from single-toned oblongs set precedents for later painting in vertical bands of color, as well as for panel painting proper. Furthermore, Kelly was influential compositionally in terms of his repetitive structure and a symmetry more radical than earlier geometrical artists—specifically in his use of the grid,

the oblong series and the multi-canvas painting. To glance forward a moment to musical developments in Minimalist style, while the irreducible expansiveness of the monochrome was to be echoed in the sustained tones which inaugurated the style and were later extended into drones, the modular construction of much Minimalist music from 1964 onward is foreshadowed in the repetitive structure of Kelly's panels.

In terms of influence rather than analogy, in the realm of visual art his replication of discrete geometrical forms within the same work predated that of Minimalist sculpture series of Judd and others by over a decade. More specifically, his grid panels are three-dimensionalized in the tile constructions of Carl Andre. Andre's *Small Weathering Place,* dating from 1971, is composed of six rows of six tiles, much like Kelly's five panel-rows in *Twenty-five Panels: Two Yellows* and eight rows of eight in *Colors for a Large Wall.* As Kelly juxtaposed colors in the latter, Andre juxtaposed metals/alloys (six tiles each of aluminum, copper, steel, magnesium, lead, and zinc).

Later on, the influence may have gone from the younger artists to Kelly, provoking the resuscitation of the elongated panels of the *Spectrum* paintings, the constituent oblongs of which might be viewed as a series of conjoined John McCracken planks. In addition to shape, there is the question of contiguity: while the early panels (like *Spectrum*) were adjacent, joined together as if on one canvas, Kelly later experimented with separate paintings within a single work. *Painting in Three Panels* was shown as early as the 1957 Young America exhibition at the Whitney, but each panel is composed differently, and the third is considerably larger. The 1966 *Series of Five Paintings,* on the other hand, features diptychs of equal dimensions and composed of joined horizontal squares each measuring five feet ten inches on a side and colored in order red/ blue, yellow/blue, red/yellow, black/white, and sky blue/green.

Kelly's work is concerned with the juxtaposition more than the interplay of color, often to dramatic effect. Despite their greater extroversion, the blue and red Reinhardts contemporary with Kelly's early panels foreshadowed Reinhardt's blacks in their monochromatic abnegation of the value contrasts that form the basis of much of Kelly's work, although they remain infinitely more relational both chromatically and structurally than the blacks to come. Kelly's chromatic relationism was the antithesis of both Reinhardt's immateriality and Klein's mystical notions of absorption in elemental blue.

As noted earlier, Newman from the beginning considered his zips not dividers of the color field but smaller fields themselves; they might thus be considered vaguely analogous in terms of structure to Kelly's panels, albeit not in a uniform series but rather as very "mini-"panels. However, though contrasts of hue and value exist between the zips and primary field—normally sharp contrasts, though *Abraham* and *The Voice* approximate, respectively, black-on-black and white-on-white constructions—it is fundamentally the size rather than the color of the zips that differentiates

them, whereas the reverse is true of Kelly's panels with their often uniform dimensions. While Newman is minimally inflectional in both line and the traces of tactility in his brushwork, he remains fundamentally nonrelational, aiming at the undifferentiated immensity of the sublime just as Klein aims for mystical representationalism in his "oceanic" blues. Whereas Newman used the zips to establish a force field, propelling the viewer across his murals and back again, Klein's saturation is seductive, provoking the viewer to immerse himself in the canvas. (Not insignificantly, he soon affixed sponges to his paintings.) Kelly's panel paintings, on the other hand, quietly retain their distance and hold the viewer at bay, despite their often ingratiating colors, by means of their emphatic contrast of those colors—a contrast all the more vivid when articulated in strictly regularized forms that preserve the cool of the composition despite the heat of many of the high-keyed colors themselves.

Though Newman would doubtless have disclaimed the influence, Kelly's example seems clear in some of his last work, most notably the second and fourth of four paintings in the series *Who's Afraid of Red, Yellow and Blue*. The title may allude to Kelly as well as Edward Albee and the big bad wolf, specifically his *Red Yellow Blue* series. This was begun in 1962–63 with a panel painting picture composed of a red square in the lower left "covering" the lower left of a larger yellow square which stands in the same relation to a blue square consisting visually of only a reversed and inverted L. More proximately, Kelly's 1966 installment in the series—shown at the Sidney Janis Gallery in March 1967—was composed of three sixty-five-inch-square canvases of pure red, yellow, and blue.

While the first canvas in Newman's series features mottled blue and a central red flanked by bleeding and smeared borders, the second is "aggressively symmetrical" with "knife-edged zips" [Hess 133]. The last in the series is even more reductively symmetrical, with nine-foot squares of red and yellow divided by a twenty-two inch center vertical of blue. Unlike much of Newman's work, there is no shading, and careful masking results in perfect rectilinearity. The overall effect is very much like that of Kelly's panels, in which the rigor of the geometry is inherent in the construction.

The title and structure recurred in 1974 with Brice Marden's *Red, Yellow, Blue* series of three paintings of uniform dimensions, each composed of three vertical oblong panels of uniform dimensions. These canvases represented for Marden, as his series had for Newman, a major stylistic turnabout—clearly, I would argue, in the direction of paths blazed by Kelly. Marden had moved from one-canvas monochromes to two and three-panel paintings in 1968 (initially by taking two discarded canvases from his *Back Series* and joining them flush [Marden 1975 17] and into primaries only six years later with the last of the four *Figure* paintings of squares stacked atop one another that served as the transition into *Red, Yellow, Blue*. A muted palette had, in fact, been one of his trademarks

since he began exhibiting in 1966, along with the beeswax mix that served to help dull his pigment.

In a comparative analysis of Marden's panels and Kelly's, to which they "bear a superficial resemblance" [Marden 1975 20], Linda Shearer notes five major differences. First, Marden used only square and rectangular panels. (Kelly had started that way and branched out.) Second, Kelly developed his constructs from observable phenomena (sometimes), while Marden began from some "vague color idea." This may tell us something of each artist's *modus operandi* but in no way differentiates the paintings themselves. In addition, Shearer mentions later [22] that the colors and structure of Marden's heralded 1973 *Grove Group* series were in fact based on a Greek olive grove near which Marden had been summer-vacationing regularly.

Third, Marden's panels created a more static and integrated effect (at least initially), while Kelly's works were based on contrast. Fourth, the physicality of Marden's waxen surfaces permitted "subtle evidence of gesture," while (almost) all traces of gesture were absent from Kelly's. Fifth, "By never losing sight of Marden's surface, one is forced to see the painting's totality; Kelly's brilliant colors and uninflected surfaces make one acutely aware of the separation of elements." Shearer begins her next sentence and paragraph by mentioning that "By the late 1960's, Marden began to introduce greater contrast of color into his work, without, however, creating the usual optical effects of receding and expanding." As noted, however, by 1974 Marden had moved into primaries, thus following Kelly into color as he had into structure. The primary differences in the panel paintings of the two is Kelly's greater energy, formal versatility, and directness of color and texture.

The hard-edged clarity of line in Minimalism has received more attention than its regularity of surface, a concomitant development of equal significance. Hard-edge is a more salient technique but geared to the same effect, the evasion of painterliness, which is itself part of the larger movement towards objectivity and away from anthropomorphism in Minimalist art. Rauschenberg's rolled whites were most radical in this regard, while Klein's blues vary widely from the seamlessness of saturated cotton to different degrees of mottling to the three-dimensionality of the sponge reliefs, which were next of kin to the sculptures using the same IKB paint and material.

For all its polemical rejection of illusionistic depth, as applauded and encouraged by Clement Greenberg, the New York School is full of nonrepresentational depth, a truth acknowledged by Greenberg in his not so much grudging as hedging acceptance of purely "optical" depth (as opposed to what he somewhat awkwardly labelled "sculptural" or "trompe-l'oeil" depth [Battcock *New* 73]. This revisionism demonstrates the chronologically determined limitations of the ''flatness'' theory Greenberg advanced as a categorical imperative arising from the very nature of the medium of painting, since it was made necessary by his curious distaste

for younger painters like Frank Stella who took anti-illusionistic flatness
to its logical conclusion. Greenberg's theory was at once the logical
outcome of the progressive rejection of narrative in modernism and an
outgrowth of specifically generational predilections for his New York
School contemporaries, whom he championed eloquently when so
disposed. Matthew Baigell writes from a post-Greenberg perspective in
suggesting that Still, Gorky, and Pollock "By 1946 . . . were leading the
way toward a post-Cubist space in which figure and ground had become
one and in which the canvas surface had become a skin that, for the
most part, remained unbroken by the superimposition of forms by
atmospheric depth" [Baigell 309].

Even Gorky's abstractions retained vestiges of illusionism, however,
not only in space but even in figuration, while Pollock's drips often
suggested the turbulent three-dimensionality of whirlpools or tornados.
Toby Mussman notes, "There are at least two ways of looking at Pollock's
paintings, from far away or up close. . . . From far away, the consideration
of opticality is certainly a crucial one; but close to [sic], the issue of
opticality vanishes, and one is absorbed with how the pools of dried paint
have formed and how one color may have become mixed with another"
[Battcock *Minimal* 242–45]. Even Still conjured a sense of depth, creating
it by scabrous surfaces as much as by sharp contrasts of color zones,
just as his fellow color-field painter Rothko evoked depth by his tech-
nique of superimposing washes, often of contrasting hues in complex
relation. Whereas Still's geological forms lead the viewer into the canvas,
Rothko's rarefied pigment functions in a more complex manner, his
rectangles seeming alternately to be submerged within the plane and
hovering over it.

Newman is the least painterly of the group in his virtual monochro-
maticism and fields of bare canvas or pigment applied for the most part
evenly, but the presence of brushstroke in his works ranges from the
glaringly evident in some of the fields and freehand zips to the subtly
apparent in the varied depth of pigmentation of some of the primary
fields (e.g., the blue in *Onement VI*). In the later black-and/or-white
paintings like *Shining Forth (for George)* and the *Stations* series, quality of
line replaces color as the principal structural force, with some zips
proclaiming the brush, others painted between tape, and still others
composed by scraping pigment over a strip of tape before removing it,
creating an effect fluctuating from wispy to murky on either side of the
reserved canvas. These later works are more quietly Minimalist than
Newman's first decade of field painting and more akin to those of the
generation then arising, though not so much as either Reinhardt, who
aimed to erase the painting (process) from the painting (product) alto-
gether, or Kelly, whose hard edge and even surfaces, with horizontal
brushwork visible only on close inspection, move painting toward the
erasure of the brushstroke signature with the spray paint, beeswax mixes,
acrylic matte and other media to be used in the 1960s. And it is Kelly's

bright oils rather than Reinhardt's drained paint that anticipate the use of objective and unapologetic color in and for itself, as a positive fact rather than a dully refulgent negation.

If Abstract Expressionism accelerated the transformation of the canvas from window to "skin"—blemished, tatooed, lacerated, and with a subdermis as evident as an epidermis—Minimalism made the canvas all there was, the apotheosis of the phenomenal. In this sense, too, Kelly, is even more radical than late Reinhardt, with his phantasmal shapes arising from the nothingness with the last gasp of the figure-ground relationship, or Newman, with the vestigial depth cues of his zips. Kelly's lack of inflection and concomitant erasure of subjectivity was the proto-type of Minimalist anti-anthropomorphism. In a sense his unshaded blocks of color achieved a purer objectivity than even Rauschenberg's rolled whites, which are fraught with either metaphysical implications or environmental baggage.

Kelly pursued smooth plane along with hard edge on his return to the United States. His most innovative work thereafter was in sculpture rather than painting, although the various angle sculptures he created were obviously projections of various panel paintings into three-dimensionality. Back home he found himself out of sympathy with both the vogue of action painting that had begun when the style was already past its prime and the combines of Rauschenberg, whom he had called on at the suggestion of John Cage, who had met Kelly in Paris in 1949 and corre-sponded with him since. Kelly's unexcited response to the Rauschenberg combines, which Wollheim used as an example of Minimal art despite their busyness and slag-heap of detail, is an indication of how thoroughly Rauschenberg had reverted from the Minimalism shared by his whites and Kelly's contemporary panels. In any case, Kelly reported that after the meeting he felt even lonelier in New York than before, though his distinctly non-Minimal postcard collages of 1956–57 reflect the influ-ence of Rauschenberg's collages.

Kelly himself tried his hand at white painting with the shaped canvas *White Plaque: Bridge Arch and Reflection* completed in early 1955. According to Goossen, Kelly opted for white because he liked the appearance of the preliminary coat of gesso on the wood [50]. This work was executed in collage in 1951 and executed in wood just after the first image-as-surface flags of Jasper Johns. As in *Window, Museum of Art, Paris,* the shape of the canvas again identifies the image with the support, although in this case the shape is unconventional (extended-semicircles divided symmetrically by a thin oblong horizontal strip) and the "image" is nonsolid, the emptiness of the arch below the Pont de la Tournelle and its reflection in the Seine. This rarefaction of the image represents a step towards its disappearance in the shaped canvases produced later by Frank Stella and Kenneth Noland.

The form of the arches in *White Plaque* may be viewed with equal

validity as cut-off circles. As such they point towards the oddly truncated shapes, be they cropped rectilinear, eclipsed circular, or intrusively parabolic, that were to dominate Kelly's painting for the next decade until a return to squares and oblongs of contrasting hue as the basis of his work in the mid-sixties, when he was no longer alone.

While most of Kelly's collages of colored paper emulated the checkerboard patterns of Arp's, others from 1951 contained only a central horizontal stripe symmetrically dividing a contrasting ground. It is doubtful that Kelly was even aware by this time of Newman's zip paintings begun three years earlier, which had to date been exhibited only twice at the Parsons Gallery three thousand miles away, so it is only in retrospect that his collages seem an almost perverse "response" to Newman, answering his vertical zips with the single horizontal stripe, his mammoth canvas with miniatures. In any case, the simplicity of the structures illustrates the highly reductive proclivity Kelly embodied more dramatically in the larger-scale works. Another collage of 1951, *Color Strips Arranged by Chance* looks like a miniature version of what Gene Davis began painting a decade later, with its forty-two vertical strip(e)s. John Coplans notes, however, that "Kelly never exhibited his collages. He regards collage as an intermediate, secondary process—an *aide-mémoire* to painting—if for no other reason than the lack of scale inherent in the medium" [Coplans 1972/73 40].

Along with the stripes, blocks and oblongs of his panels and collages, the early 1950s marked two other important experiments on Kelly's part. In 1953 he left his brilliant palette behind for a while for black-and-white paintings; one of them, consisting of a white square on a black and a black square on a white, looks back to early Suprematism and forward to a number of artists of the next decade, albeit again in miniature.

By the previous year he had also foreshadowed the line drawing and painting that was another major technique in the later Minimalism of Sol LeWitt, Richard Serra, and others, projecting a volume to be called *Line, Form and Color,* for which he made seven-and-a-half by eight-inch sketches of the simplest line drawings imaginable. Had Kelly completed his project, he might well have hastened the movement to linear reductivism that began to attain full force ten years later. Robert Irwin, Robert Barry, Ralph Humphrey, and Richard Tuttle elaborate on Kelly's linear reductiveness on canvas in media ranging from graphite to dull-hued oils (grey on khaki ground in Irwin's *Crazy Otto*) to Day-Glo.

One of Kelly's experiments, called *Diagonal,* contains merely the eponymous line in ink from the upper right corner to the middle of the lower border of the page. *Horizontal Line* crosses the middle of the page from the right margin to left of center. In the next decade Patricia Johanson was to work similarly in oil, with one or two lines of one of two colors stained into the canvas. She undertook this first in human scale (the eighty-inch-square *Pompey's Pillar* from 1964 consists of a thin vertical line descending from the top to the center of the square canvas),

and then in the massive scale (fifteen and twenty-eight-foot wide canvases) that represents the opposite extreme from Gene Davis's "micropaintings" and that soon led her to environmental sculpture. Her *Minor Keith* and *William Clark* each contain a four-inch band of paint extending almost entirely across the twenty-eight foot wide, eight-and-a-half-foot high canvas, stopping just short of the lateral edges. The influence of Barnett Newman is also palpable in this sense of massive scale, what we might call Minimalist gigantism, though Johanson's geometry is more coolly reductive.

The painting from the ABC period appears in temporal perspective more and more to represent overall a progressive stylization of more inventive earlier work. Newman's monochromes-cum-zips were reincarnated in similarly reductive form in proliferating hard-edge vertical stripes, while other canvas series seem almost a parody of *Stations*. In 1967, before Reinhardt was cold, Mel Ramsden coopted his reticence for Conceptual art in his all-black *Secret Painting*. Unlike Reinhardt's blacks, this one came with the bonus of a sign placed beside it to inform the viewer, "The content of this painting is invisible; the character and dimension of the content are to be kept permanently secret, known only to the artist" [Meyer 204].

Reinhardt's dictum "Art is not what is not art" was subverted in what may stand as an emblem of the history of Minimalist painting: after emerging from the two central strains of twentieth-century abstraction, geometrical and expressionist (the first formalized to opposite effect by Reinhardt and Kelly, the second by Newman), it decayed when that inherent formalism became progressively "immured within conceptual frameworks." The signifier is no longer the canvas but the literal sign placed beside it in a pathetic attempt to justify its (non-)existence. It is a short step from this pretense to Eric Bogosian's deranged Conceptual artist whose only escape from "the System" that "collects men's minds" is "not to do anything," painting and writing masterpieces in his mind... "where They can't see it."

G

In the standard prehistory of Minimalism—i.e., Minimalism before it was so designated—Kelly is often considered under the rubrics of "Hard Edge" and "Post-Painterly Abstraction." The first phrase was coined by Jules Langsner, who used it to refer to California artists John McLaughlin, Lorser Feitelson, Frederick Hammersley, and Karl Benjamin in his text for their exhibition as Four Abstract Classicists at the Los Angeles County Museum of Art in June 1959. According to Lawrence Alloway, Langsner had used the term in conversation the previous year as a more precise synonym for geometrical abstraction in general [1966 13–14]. John Coplans, on the other hand, suggested that by 1964 the term most usefully denoted a period within the evolution of that larger movement dominated by artists who had lived through Abstract Expressionism [1964 31–32]. The second term, "Post-Painterly Abstraction," was used by Clement Greenberg as the title of an exhibition he curated at the same museum in April 1964, just months before Richard Wollheim began the popularization of the term Minimalism with his *Arts Magazine* article.

In 1970 Donald Judd portrayed Hard Edge as "mainly old abstraction. It employs, though somewhat abridged, the new scale and simplicity and has some of the new specificity of color but also uses the old abstract space, composition and color." He described it as "primarily defined by Ellsworth Kelly's work" [Judd 202], but Kelly had disclaimed the designation in an interview with Henry Geldzahler as early as 1964, stating, "I don't like most Hard Edge painting. I'm interested in the mass and the color, the black and the white. The edges happen because the forms get as quiet as they can be. I want the masses to perform" [Geldzahler 1964 47]. Kelly's considerable contribution, still underrated, is in his Minimalist reduction of color-field painting to its bare essentials in terms of surface and texture as well as rigid linearity.

The closest approximation to his style may be that which John McLaughlin arrived at roughly simultaneously and independently on the West Coast. After painting geometrically, like Kelly, for several years, around 1952 McLaughlin hit upon the idea of organizing canvases solely into vertical bands of color. Like Kelly, he worked in oils; unlike him, he divided a single canvas rather than constructing the work from adjacent monochrome panels. In addition, although McLaughlin divided the canvas symmetrically, his constituent bands varied in size, whereas Kelly regularized them. For example, the area left of the vertical axis of McLaughlin's 1952 *No. 31* is divided into white and khaki bands, the area right of the axis into thinner black and khaki bands alternating with broader white areas. The edges are clean and the texture smooth. The effect, finally, is of Mondrianized Newman as much as neutralized Kelly.

A good deal of the work of the artists christened either "Hard Edge" or "Post-Painterly" is similarly quasi-Minimal in style, much of it not, although such a judgment, of course, is not apodictic but predicated on one's definition of Minimalism. Harold Bloom has remarked that our choice of "the last Romantics" demonstrates what kind of Romantics we ourselves are; at the least it reveals our presuppositions about the nature of Romanticism, just as our placement of artists inside or outside the Minimalist canon is predicated on our concept of Minimalism. Apart from problems of chronology, I noted earlier the dubious linking of Judd and Warhol under Rose's "ABC" rubric, and Wollheim's equally problematic inclusion of Rauschenberg's combines under "Minimal Art." For Wollheim, Minimal art is one of either little internal differentiation (certainly not the case with the Rauschenbergs in question) or little labor entailed in the generation of original material (which *does* qualify the Rauschenbergs, and the Duchamp readymades even more readily). Minimalism in my view denotes an art whose principle features are clarity, continuity, and simplicity of composition aspiring to irreducible unity. How much work is put into the creation of the art-object—be it brainwork or handiwork— is as irrelevant as it is indeterminable. From the critic's, as opposed to the artist's, perspective, the correct response to the question put to Newman as to how long it took him to create *Vir Heroicus Sublimis* may be neither "a second" nor "a lifetime" but "What's it to you?"

It is with regard to non-painterly exertions that much attention has been paid to the contribution of Helen Frankenthaler's work dating from the early 1950s to subsequent Post-Painterly Abstraction and Minimalism. Harold Rosenberg noted in 1969, "With Frankenthaler, the artist's action is at a minimum; it is the paint that is active. The artist is the medium of her medium" [Battcock *Idea* 161]. Taking off on an original tangent from Pollock's dripping, Frankenthaler developed a technique of staining unprimed duck with thinned oils, providing in the consequent saturation an elegant simulation of watercolor. With the grand accusation that Frankenthaler had "never grasped the moral and metaphysical basis of Action Painting," Rosenberg found in the results "a distressing flabbiness,

an effect of"—he resumes the play with Minimalist diction—"too little out of too much" [161–62].

From the mid-1950s Frankenthaler's staining was adopted by "Post-Painterly Abstractionists" Morris Louis, Kenneth Noland, and Jules Olitski. All three of these artists began to produce in the early years of the following decade an art that might conceivably be termed Minimal. However, in the case of all three the original impetus provided by Frankenthaler was to work that is, like Frankenthaler's herself, less close to Minimalism than to Abstract Impressionism (to adopt the term originated in 1946 by Alonzo Lansford to describe what Reinhardt called his "Persian carpets" [Lansford 21]). In the case of Louis and Noland, the fluid contours of Post-Painterly staining were gradually subsumed by something more akin to Hard Edge technique as their art modulated from a quasi-romantic delicacy toward the classical clarity, even severity, that characterizes Minimalism.

Frankenthaler's main contributions to Minimalism per se may have been her development of saturation techniques in the service of the flat surface and the boldness of her exposition of bare canvas, several years before Newman began his *Stations* series. Newman himself stated in 1966, "Raw canvas is not a recent invention," citing Pollock, Miró, and Manet [Newman 190]—none of whom had used it like Frankenthaler (or Newman). Combining the two techniques led Frankenthaler to an art that is often powerfully spare but distinctly non-Minimal in its lyrical expressiveness of line and color, and in its complexity of relations. In her suggestions of representationalism and even biomorphism, and the fluidity of her shapes in general, she is far removed from the austere contours of Minimalist abstraction.

Louis found that Frankenthaler completed the liberation of his sense of color initiated by his experience of Pollock. In his series of *Veils* begun in 1954, after seeing Frankenthaler's *Mountains and Sea* in her studio, he applied the thinned pigment—in his case water-soluble acrylics, more rapidly absorbed than oils—by the literal manipulation of the canvas to create irregular vertical stains, specifically by applying the pigment to unsized and unprimed folded canvases stapled to and hung from vertical scaffolds. While this may represent a technical advance upon his influences in terms of the impersonality and the abnegation of painterly gesture, the intermeshing of forms and colors by Louis is the antithesis of their sharp juxtaposition by Kelly and to a lesser extent Newman. The luminescence and often complex relations of his stains are more closely allied to Rothko's superimposed, turpentine-thinned washes and Olitski's later sprays than the mute irreducibility of monochrome panels and fields.

After a lull, Louis resumed the *Veils* in 1957 and continued them until 1960, by which time he had redirected his pigment both centripetally and centrifugally in a series of *Florals* and *Alephs*. In other series he worked lineally in various directions: vertically in *Columns*, horizontally in

Omegas, and diagonally in *Japanese Banners.* Louis remains perhaps best known for the series of *Unfurleds* executed mainly in the second half of 1960. These were anticipated structurally but not technically in the 1959 canvas *High,* which shares a composition based very roughly on three vertical triangles: right triangles facing one another from the left and right borders of the canvas and framing with hypotenuses of paint an inverted and truncated equilateral of bare canvas. The bands of paint are neither symmetrical nor rectilinear here nor in the *While* and *Twined Column* series executed in 1960, in which the bars of paint continue to overlap.

It was in the *Stripe* series, however, begun in 1961, that Louis developed in a structurally more austere and less impressionistic direction by incorporating something of Hard Edge technique. (His 1958 exhibition had been labeled decorative with some justification.) Even as late as 1961 his grouped vertical stripes remained irregular, often tapering candle-like, not reaching the upper edge of the canvas. In the last year of his life they were lined and finally extended from top to bottom of the support— sometimes a result of cropping the canvas. Horizontals were placed in the middle of other canvases and diagonals in yet others, sometimes falling short of the corners of the otherwise bare canvas ("which seems unnecessary," Donald Judd observed [Judd 62] when reviewing Louis's posthumous exhibition at Emmerich in October/November 1962), otherwise—as in the aptly entitled *No End*—extending to the corners. The horizontals were again the product of manipulation of the canvas, in this case turning it on its side. These radically bare canvases were created four years before Newman's *Stations* were first exhibited at the Guggenheim; in terms of paint, Louis employed a colorful palette not nearly as severe as Newman's black and grey or white; in line Louis was here exclusively and regularly rectilinear as opposed to the diversity of Newman's zips drawn both inside and over tape, as described earlier.

There are very interesting technical and compositional questions connected with Louis's hesitance. While the stripes were apparently never masked, Michael Fried quotes Kenneth Noland as suggesting that in his stripes Louis "may have dripped a thin ribbon of paint, about the consistency of syrup, down the center of the intended stripe and then have spread the ribbon to the desired breadth with a putty-knife." More importantly in terms of the self-contained clarity of the Minimalist canvas, Fried quotes Clement Greenberg as stating that "Louis originally wanted the stripes to be cut off by the framing-edge both at the top and at the bottom, but allowed himself to be persuaded [by his mentor Greenberg?] to leave a few inches of blank canvas between the apparent 'end' of the stripes, which often seemed to be where they began, and the edge of the support." When Louis let some of his stripes go all the way, as it were, he posthumously received a blessing from Greenberg, who told Fried that "Louis' original intuitions were invariably correct, and that he was always in advance of his admirers" [Fried 1979 36].

Kenneth Noland was a friend of Louis, who like him was based in

Washington and moved into plastic paints in his development of staining technique. He received repeated high praise from Michael Fried ("a formal innovator of great resourcefulness" [1965 26] and Donald Judd ("one of the best" [Judd 57, 93, 172]) and was dismissed by both Lawrence Alloway ("highly productive, but of what?" [1975 258]) and Lucy Lippard for facile repetitiveness. Both views are correct insofar as Noland demonstrated freshness and bare-boned originality but exhausted it with repetition in a manner Kelly and Newman managed to avoid, possibly through more dramatic variety of color from canvas to canvas within similar formats, possibly through the even greater simplicity of their structures, which resisted cloying.

In his relentless repetition of structural motifs Noland followed the path of Albers, his teacher as well as Rauschenberg's at Black Mountain College. Albers, first of all, provided an important model for strict geometrical abstraction and replication of forms with *Homage to the Square;* in addition, his concern with the optical relationships of color—which drove Rauschenberg into monochromaticism by way of rebellion—bears upon Noland's structuring his canvases primarily in terms of gradation and juxtaposition of color areas. No one of his generation, including Kelly, was more concerned with color relationships; in fact, Noland's constant concern with the interplay more than the colors per se is what distances him from the Minimalist tradition more fundamentally than the lyricism critics have found in his work. His canvases shy away from the unitary quality that marks the style variously in its manifestations from Newman to Tuttle.

Despite Fried's support, Noland grew very much out of sympathy with the theoretical concerns of painting of the 1960s. In 1968 Philip Leider observed by way of compliment that no one was less involved with the "minimal" or "systemic" trends than his subject. In the same *Times* article Noland himself polemicized, "No graphs; no systems; no modules. No shaped canvases. Above all, no *thingness,* no *objectness.* The thing is to get that color down on the thinnest conceivable surface, a surface sliced into the air as if by a razor. It's all color and surface, that's all" [22]. In a prose style recalling Ad Reinhardt, Noland expounded a similarly, if not so radically, reductive aesthetic that at once allies him to early Minimalism and distances him from later developments.

Noland's bar paintings seem less striking with the precedent of Kelly's panels. His early ring paintings have been in part overshadowed by Jasper Johns's more provocative targets. Those were begun in 1954 and first exhibited in 1958—when Dore Ashton reviewed Noland's show at French & Company a year later, she was prompted to ask parenthetically, "what is this target vogue anyway?" [October 16, 1959]. In Johns, image and plane are indistinguishable, providing a source for the Minimalist concept of "objectness" scorned by Noland, while Noland's concentric circles merely occupy most of his canvases, albeit sometimes as much as geometrically possible. At the same time, his staining achieved a different

reductivist end, the textural identification of paint and canvas by the submersion of the former within the latter, while Johns fused pigment and surface by the more complicated means of encaustic, hardly "the thinnest conceivable surface." Noland's technique exposes, Johns's buries the support.

Noland's deeply stained circular forms, begun in 1957, evolved in a manner similar to Louis's, not becoming hard-edged until 1961, as the post-painterly technique of staining was replaced by handpainting from the center outward but within lines drawn around dinner plates and hoops for more regularized, objective contours. These works were called "cat's eye" paintings, perhaps for their sharper definition and less human quality.

The next year he began his best-known series of paintings, the chevron shapes composed of contingent but strictly divided bars of often high-keyed colors. Noland's adoption of shaped canvases when he moved from circles to bars serves to accentuate the flatness of the image by elimination of any figure/ground relationships. Yet Diane Waldman notes correctly that the interplay of contrasting values "tends sometimes to be overly optical and thus disrupts the flatness of the image" [Waldman 34]. Judd had suggested earlier that "Noland's concentric bands are not as specifically paint-on-a-surface as Pollock's paint, but the bands flatten the literal space more. As flat and unillusionistic as Noland's paintings are, the bands do advance and recede. Even a single circle will warp the surface to it, will have a little space behind it" [Judd 182]). The progression/ recession of bands was largely determined by the arrangement of colors, which often proceed from low to high values, although in the second half of the 1960s Noland's palette adopted the restraint and dulling noted by Axsom.

The chevron paintings were followed by square paintings composed of taped bands of colors that were turned on their corner and modulated by 1966 into elongated diamonds. In his 1967 exhibition he turned Barnett Newman on his side, as it were, in large and narrow horizontal stripe paintings. While Judd preferred the circles, Perreault argued that it was not until this exhibition that Noland established himself "as a major artist" [November 30, 1967]. Once again, the question that arises is whether that status was a result of the development of the art or the audience. The size is more expansive than the conception in the horizontals, while both owe an undeniable debt to Newman. The works may in fact have been among Noland's least original to date, but they appeared in the wake of both Newman's *Stations* exhibition and the three much-discussed group shows of Minimal art in 1966 (Primary Structures, Art in Process, Systemic Painting), when the time had ripened.

In the next decade Noland began creating the *Plaid* and *Flare* paintings, the latter of which he has produced into the 1990s. They may represent the subsumption of the shaped canvas he had used intermittently from 1962–1966 and spurned in 1968 by avant-garde decorative

art, a Minimalist reprise of the rococo ogee. In all of these but the horizontal band paintings, Noland opted to cover the surface completely rather than juxtapose pigment and bare canvas. In so doing he moved in the direction of Minimalist holism and lack of differentiation, more pigment in this case being simplified relationship of colors and less relationship between pigment and canvas.

Jules Olitski is another painter influenced by Frankenthaler's staining technique with its contrast of saturated and bare canvas resulting in work amenable to Lansford's Abstract Impressionist tag (Rose in fact calls his "the first fully abstract version of Impressionism" [1975 199]). His often rhapsodic colorism has provoked, like Noland's, fascination ("diaphanous curtains of melting color"—Rose [1970 92]) and even eulogies of its "momentousness" (Fried [*Olitski* 5], who elsewhere speaks of the "preeminence" of Noland and Olitski among their contemporaries, based on their "*feeling*" [1965 37; emphasis his]). Daniel Mendelowitz found his work generally cosmic ("The openness and grand scale . . . convey an awesome intimation of infinite space—or the converse, a spaceless infinity" [454]).

Others dismissed Olitski curtly; Perreault commented, "very overrated at the moment. I do not find his large, misty paintings subtle at all, merely vapid" [November 30, 1967]; and Lippard concurred, "the art world's most manufactured reputation . . . real visual muzak" [1968 180]). While his work is anything but austere, he too may have contributed obliquely to the climate of gestural abnegation—though his spraying is in no sense self-denying—and has been discussed, like Louis, under the rubric of Minimalism [e.g., Mendelowitz 454].

In the 1950s Olitski had produced heavily encrusted paintings using spackle, acrylic resin, and dried pigment. In 1960 he moved from impasto to staining. In late 1964 he experimented with spraying, mastering the technique to his satisfaction in the spring of the next year, still evading the irregularity of the brushed surface by a remarkably subtle use of mechanical means, achieving the "all-over" effect in tandem with complex colorism by blending colors with successive and even simultaneous applications of sprayed paint. According to Fried [*Olitski* 5], he worked "often with two spray guns simultaneously." This vision was described by Barbara Rose as "essentially hedonistic" [1975 199], but Olitski, perhaps under the influence of Minimalist austerity, flirted with monochromaticism, though uniform in neither texture or tone. Olitski's is, like Frankenthaler's and Louis's, and rather *un*like Noland's, a more lyrically evocative and amorphous, less cleanly objective and autonomous art than anything classifiable as Minimalism. The softness of his field effect is tempered—perhaps censured—by vestiges of loosely rectilinear inner frames, or as Lippard put it less sympathetically, "his vapid veils of sweet color are formally mitigated by . . . blobs of nostalgically gummy paint, as though admitting the need for some substance" [1968 180].

A younger painter influenced by Frankenthaler and those she in turn had influenced is Larry Poons, who began exhibiting at the Green Gallery

in the mid-sixties. Like them, Poons based his style on the "all-over" composition of Pollock, but remained closer to that model insofar as he more rigidly avoided zones of prominence, in his case by means of total saturation rather than partial staining of the canvas, and on occasion by use of a grid structure that served to rein in the decorative aspects of his work and ground his saturated color. From 1962 Poons used the saturated canvas as a ground for geometrical patterns, normally small circular forms gravitating to the elliptical by the end of 1963. His various miniature circles and ovals were arranged irregularly but continuously across the canvas, most kinetically when on opposite diagonal axes and ovoid, most statically when gridded and circular. Poons highlighted these primitive figures and their illusory movement, often at opposing angles, over the ground by means of normally sharply contrasting hues, though not necessarily values, that created a strong after-image. Jasper Johns explored after-image in his flags around the same time, and Op was soon to replace Pop Art as the rage of the moment. One might argue that hints of similarly kinetic opticality, however trivialized later, existed in Minimalism as early as the zips of Newman's murals.

Most interesting here is Poons's paradoxical ability to subvert so fundamentally and by such minimal means the optical flatness of the canvas he ostensibly observes so rigorously. Despite his ingenuity, however, much of his early work in the wake of what Harold Rosenberg called Pollock's "apocalyptic wallpaper" seems to evoke the same noun without the adjective. Max Kozloff, on the other hand, was inspired to musical metaphors by Poons: "Compared to the ostinatos of a Bridget Riley, or the sonorous color chords of a Kelly or Liberman, Poons creates rippling arpeggios" [April 1965 27]. In any case, this pattern painting anticipates the repetitive modularism of the Minimalist "process music" that was to arrive in New York shortly thereafter from across the continent and the Atlantic, but seems even closer to decorative art (albeit in 3-D) than does the work of his immediate predecessors. Whereas Olitski became more restrained, Poons developed in the opposite direction: in the late 1960s he became far less geometrical and almost luxuriant in his use of color in what resembled on occasion an extraterrestrial impressionism.

Other Hard Edge painters had no connection to and represented not a development of Pollock but diametrical opposition to his spontaneity as well as gesturalism. Painters like Leon Polk Smith and Alexander Liberman deserve mention with regard to the development of the abstract classicism of Minimalism. Inspired by the stitching of baseballs [Alloway 1966 13–14], Smith was painting tondos as early as 1954, long before the shaped canvas became fashionable, and then moved into rectangular canvases similar to Kelly's contemporary works in their use of arcs, parabolas and elliptical color areas truncated by the edge and contrasted in hue with the broken rectangle of the ground. Whereas Smith's technique of brushing layers of thickening oils aimed to obscure the weave of

the canvas and display the brushstroke, Liberman by 1953 had eliminated gestural residue from symmetrical field painting. As early as 1950 he was constructing paintings composed of circles on a ground, initially painted freehand, later with compass and spray paint. This was part of his program for "Anonymous Art," in pursuit of which he anticipated a division of labor popular among later Minimalists and conceptualists by hiring workmen to execute the paintings and sculptures he designed, as early as the 1949–50 canvas *Minimum*, which further minimized Rodchenko by offering a black enamel circle on a black enamel ground. Brian O'Doherty contrasted the "hard eclipses of Alexander Liberman" and "the eye-rubbing rinds of Jules Olitski" [1967 207], which may stand as respective emblems of the Hard Edge and Impressionistic branches of Post-Painterly Abstraction. By the mid-1950s Liberman had moved into more complex concentric structures, afterimages, and aleatory art.

Numerous others with Minimalist proclivities were denominated as such or as Hard Edge painters during the 1960s. Darby Bannard devoted himself to simple geometrical forms in a field in his paintings from the first half of the 1960s, using housepaint like Liberman and his friend Frank Stella, but using pastels. Al Held produced fields of color, sometimes with a heavy impasto that helped suggest processional rather than recessional space, and with areas of contrasting value and dimensions (e.g., *The Big N*, a white monochrome with two tiny black triangles projecting from upper and lower edges to suggest the letter's contours). Gene Davis was admirably forthright in his acknowledgment of Newman's influence ("'What led you to paint stripes?' 'I had always admired Barnett Newman's work'" [Rose 1971 50]). After having a go at the target trend in the second half of the 1950s, he began in 1959 to codify Newman by substituting for field-*cum*-zips large canvases covered in vertical stripes of dimensions uniform within the given canvas and varying from one canvas to the next. What some found powerful rhythmic statements, others found "primitive linear chatter" and "heartless" [Kozloff 1967 53]. The busyness and proliferation of multi-colored stripes in Davis's principal format renders it difficult to classify him as Minimalist. His most interesting contribution to that movement may have been the truly minimal series of paintings he began in 1966, micro-paintings measuring an inch by an inch and a half, first conceived as simple miniatures, but later considered environmentally and arranged in groups against the ground of the gallery wall.

As early as 1962, Thomas Downing, who like Gene Davis had elaborated on, among other things, Noland's bar paintings, undertook grid-paintings with dots of two colors. This abstract revision of Seurat was influenced, according to the artist, by Noland's use of color. Downing was working in Washington, D.C., where he was associated with Louis, Noland, and Davis as "Washington Color Painters," as they were denominated in a 1965 exhibition at the Washington Gallery of Modern Art. Davis was again a model of terseness in explaining the school thus: "By

1958 everybody was slinging paint; it was a cliché we were all struggling to get beyond" [Rose 1971 54].

Back in New York, Agnes Martin was bringing back the grid with a vengeance at the same time. As influential as the field and the panel, the grid was one of the principal formats of Minimalist painting and sculpture alike, utilized in very different ways by, among numerous others, Robert Ryman, Eva Hesse, Carl Andre, and Sol LeWitt. It had also been adopted in an influential, quasi-representational manner by Jasper Johns in his various number paintings, which are related to Minimalism in terms of their repetition and monochromaticism but are alien to the tradition in terms of both concept and execution. Whereas Martin and others were attracted to the grid for its rigid, all-over regularizing of the canvas, Johns's (very) freehand grids were neither uniform geometrically nor even clear in contour. His monochromes contained a high degree of tonal shading in a manner alien to Martin's neutralizing of color as well as space. Although Brice Marden points to Johns as an inspiration for his grid drawings and at least one smudged, blurred grid painting, Johns's major influence on Minimalist repetitive pattern was probably not his grids (Kelly's and Reinhardt's—not to mention Arp's and Mondrian's—predated them in any case) but the stripes of his flags, which proved suggestive to the young Frank Stella, and the concentric circles of his targets, which inspired the trend noted by Ashton. The degree of visible facture in Martin fluctuated with her medium; Johns virtually advertised his facture in encaustic.

Martin was born in the Canadian prairie province of Saskatchewan in 1912 and moved in 1933 to the United States, later becoming an American citizen. Over a period of over twenty years she studied art and art education off and on at Western Washington College of Education, Columbia University Teachers College, and the University of New Mexico. Until her breakthrough in the late 1950s she had for years painted representational watercolors and abstractions influenced by Surrealism and its biomorphic offshoots, so that her abrupt movement towards the rigorous geometry of the grid appears not an organic development but an abrupt rejection of her early work.

In 1957 she was lured back to New York from New Mexico by Betty Parsons, who had been impressed by her work three years earlier. Martin moved into 27 Coenties Slip, where Ellsworth Kelly and Jack Youngerman already lived—there is an evocative rooftop photo by Hans Namuth of them along with Youngerman's wife Delphine Seyrig, their son Duncan, and Robert Indiana [reproduced in Goosen 65 and cropped in Haskell 1992 166]. Martin, of course, saw Kelly's grid and other paintings, and undoubtedly this helped direct her towards her own quite distinctive path. Ann Wilson points to a stylistically more obvious though non-painterly influence in the fiber-weaving of another neighbor, Lenore Tawney [Haskell 1992 105 and 116 n. 41].

There is little similarity other than formal in the painting of Kelly and Martin. Kelly is unabashed in his color, while Martin gravitated to neutral colors and no color in her pencil drawings, another instance of the movement towards the self-abnegation of the Minimalist palette in the 1960s noted by Axsom. As early as 1960, significantly, she focused on ink rather than paint for periods of time, and in 1964 abandoned colored pencils for graphite. I find her pastels occasionally border on Hallmark confection, while her most successful work is executed in light neutrals. The single most striking room at her impressive 1992 Whitney retrospective was devoted to the 1979 series of twelve square canvases entitled *The Islands,* each composed of horizontal bars of varying lengths executed in gesso, graphite and largely off-white acrylics.

In terms of scale within the grid, Martin was worlds away from Kelly's, relatively speaking, enormous component boxes: her *The Ages* is six feet square and has approximately eight thousand boxes in its grid. Although her grids involve repetition of the same motif in the same dimensions, she evades the rigorous symmetry of the square embraced by Kelly, often by drafting her grids in "rectangles just off the square" [Lippard "Homage" 55] as a counterpoise to her square formats.

The grid format evolved over a decade. In 1957 she painted *Water Sign,* which featured two rows of three circles, and *Wheel,* which repeated the motif of the square within a square that goes back past Albers to Suprematism. The square occupies virtually all the canvas, anticipating a technique Jo Baer and others were soon to work with extensively. Lawrence Alloway notes that the rows of *Water Sign* represent a step toward the repetitive format of the grid [Martin 9], while *Wheel* aspires to "a holistic form with kinship to the form of the canvas itself" [Alloway 1975 102]. It was when Martin combined the two elements of repetition and holism that she began producing full-fledged grids.

In 1958 she produced *White Study,* a twenty-five-inch square containing only two vertical rectangles. The allusion to Rothko is obvious; what makes the work interesting is Martin's Minimalist simplification. Although the rectangles are not lined, they have more regular borders than Rothko's. More importantly, they are stable, neither projecting nor receding from the ground, and in terms of texture are flat as opposed to the three-dimensional porosity of Rothko's layered washes. In her show at Betty Parsons in 1958, Martin concentrated on pale neutral colors before moving into deeper earth tones for her show the following year. The shift was noted by Dore Ashton, who praised Martin's ability "to make statements with the simplest of means that yet suggest the profound experience from which they come" [December 29, 1959]—a Minimalism not (yet) estranged from the emotions.

Although the 1960 *This Rain* is another reprise of Rothko, in the previous year Martin moved closer to the grid format proper in the "rows of uninflected circles" [Alloway in Martin 9] of *Reflections* and *Earth.* Though Alloway says that her grids extended to the edge of the canvas in

1964, this seems already to be foreshadowed in *The Ages,* dated c. 1959–60 by the artist. The six-foot-square grid consists of tiny horizontal bricks in eighteen vertical rows crossed individually by approximately four hundred horizontal lines, all of which are handpainted in oil.

It may have been the strain of that experience—evident in the raggedness of a few of the horizontals—that led Martin in 1960 to turn to rulers and ink in the execution of grids on paper. *Mountain* is restricted to horizontal lines within a trapezoid within, in turn, the square canvas. *Ocean Water* includes verticals, but leaves the left and right borders irregular, suggesting process and lack of closure.

In 1961 Martin seemed to have aimed for the opposite effect, the autonomy of the object that is so central to Minimalist aesthetics. Her square grids were complete and self-contained, all borders equidistant from the edge of the canvas. The unitary effect was finally achieved in 1964 by extending the grids right to the edge, creating in Alloway's words "a single undifferentiated tremor of form, or a plateau of nonform." This was not a terminus in Martin's work, however, since in the 1966 *Desert* the grid again falls short of the framing edge.

In some instances the grid is all there is, apart from the white paper or bare canvas, while in others it serves as a counterfoil to the color. The precision of graph paper is superimposed on the mysticism of the monochrome, the expansiveness of undifferentiated color held in check by geometrical symmetry—what Ann Wilson referred to with good reason as "webs" for the stasis they impose upon the field. The relationship between modular form and undifferentiated color here is antithetical to Kelly's grids, insofar as his monochrome panels *unite* form and color, each panel self-contained and juxtaposed to its neighbors, while Martin's grid format and color field are equally holistic, simultaneous in their expression of a far less dramatically kinetic presence than the chromatic intensity of Kelly's modularism.

Rosalind Krauss has incisively analyzed the grid as an emblem of "modern art's will to silence, its hostility to literature, to narrative, to discourse," finding that "the fortress [the artists] constructed on the foundation of the grid has increasingly become a ghetto" [1985 9]. Like the square adopted by Albers and Reinhardt for its inorganic hence nonallusive nature, the grid serves as an agent of nonexpressive and nonrelational art with its negation of hierarchy and central focus and its geometrical lack of inflection. Ryman has said that he uses the grid primarily "as a visual anchor" [Lippard *Grids*], while in Pop Art Warhol's silkscreen replication of commercial images from dollar bills to soup cans to Marilyn Monroes the grid is a form of design, decoration, or deadpan sardonic cultural commentary—depending on one's sympathies, since the artist was fashionably mute. As opposed to stasis, Alloway finds Martin's grids "half-way between a rectangular system of coordinates and a veil. . . . Martin's seamless surface signifies, for all its linear precision, an image dissolving. The uninflected radiant fields are without

the formal priorities of figure and field or hierarchic ranking of forms, and the skinny grids are set in monochrome colors that make visible the shifting gradients of real light across the painting. The effect is of precision and elusiveness at once" [Martin 9]. This emphasizes Martin's Impressionistic affinities but marks the limit of kinesis in her works, which represents, once again, a severely Minimalist reduction of her antecedents in geometrical form.

The unimposing strength of her work is based on the understatement of her palette and of the intermeshing of the field and grid in a manner more suggestive of contemplative serenity than conflict (Despite its quietly powerful austerity, her work has consistently evoked oddly sentimental analogies. Betty Parsons compared Martin's grids to "heartstrings pulled out, endlessly" [Tomkins 1975 59], while tougher-minded critics have made reference to prayers and dancing sunbeams). Amid the controversy over Minimal art in the mid- and late sixties, Martin fared better than most, doubtless in part due to the less confrontational nature of her simplicity, which represents an extraordinary union of rigor and subdued lyricism. The critics ranged from tersely respectful to thoughtfully partisan; she attracted none of the vitriol directed at others, and proportionately little of the avant-garde accolades. When Judd called her work "simply attractive" in 1962, he acknowledged the adjective "is usually, and is here, used both as a derogation and a compliment" [Judd 73]. When she returned to the Elkon Gallery a year later, he found her work "much better than last year's" for its forceful incorporation of the surface [112] as opposed to the disjunction of the design and support in the earlier work. On the negative side, Sonya Rudikoff quoted Henry James in reviewing Martin's first show: "economy of means—economy of effect" [77].

Martin's most original contribution may have been to advance Minimalist stasis beyond the work of any predecessor, including the chromatic tension of Kelly's grids, the absorption of the viewer in the depth of Klein's saturation, the environmental ephemerality of the Rauschenberg whites, or even the subtle metamorphoses of Reinhardt's blacks. The recurrent structure of Reinhardt's square black painting[s] of the 1960s is also a grid, but ambiguously so since its three-squares-by-three form is compromised by the continuity of the transverse, and since the structure effectively hides itself, resisting more than partial visibility.

Some of Martin's few public clarifications of her aesthetics place her in the tradition of radical reductivism established by the repeated negatives of Reinhardt's polemics, which she echoes more quietly while insisting that her paintings "have neither objects, nor space, nor time, not anything—no forms. You wouldn't think of form by the ocean" [Wilson 49]. The statement is surprising insofar as she claims "no forms" while producing, like Reinhardt, grid after grid, from the 1950s into the 1990s. (There is another similarity in the square format employed, Reinhardt's five feet square, Martin's six.) As Alloway stresses the phenomenology of her canvases, Martin stresses their metaphysics. Neither view fully credits

the rapprochement of oceanic expansiveness and structural fixity, open color and fixed grid, ultimately of two seemingly antithetical versions of stasis, that accounts for the quiet force of her low-keyed monochromes within "webs" which like their organic counterparts are here equally holistic, if not indivisible, in their distribution to the edge of the support. The effect of woven material created by Martin with pencil/graphite on oil/acrylic is quite unlike the minimally holographic nature of Reinhardt's dematerialized blacks.

Lucy Lippard captured the essence of Martin's paradoxical art in citing her "channels of nuance, stretched on a rack of linear tensions" as "the legendary example of an unrepetitive use of a repetitive medium" [*Grids*]. After the magniloquence, obscurantism, and extroverted brilliance of early Minimalist canvases by Newman, Reinhardt, and Kelly, Stella introduced a new unequivocality while Martin offered a new equipoise in reductive abstraction, combining an understated but elementally sugges-tive colorism with a rigorously antimimetic mathematical format.

Taken together, Martin's prose and art indirectly support a redefini-tion of Minimalism not as a mid-1960s "school" but as a reductive movement, dating from fifteen years earlier, which transcended the boundaries between the earlier schools of twentieth-century abstraction it transformed. If we exclude Newman from the Minimalist tradition on the basis of his aesthetics, we must note that Martin revered the work of both her close friend Newman and Rothko ("the most advanced man who ever lived") and "proudly declared herself an Abstract Expressionist" [Haskell 1992 108, 116 nn. 54–58]. Apart from her formal rigor and monochromaticism, she was allied to the early color-field painters, particularly Newman, by her transcendental idealism—which could not be more antithetical to the radical empiricism generally regarded as defining "Minimalist" aesthetics—and by her concomitant mysticism and search for sublimity.

Notwithstanding the greeting-card reactions she has evoked, Martin encountered the sublime not so much in as through nature, which she has approached with yogic devotion. She thus describes her work as "anti-nature" despite the evocations of the natural world (rose, rain, island, river...) in her titles and the pervasive and oft-noted influence of the Canadian prairies of her birth and the Southwestern plains of her chosen domicile. As abstract art her work is anti-nature by definition in formal and stylistic terms; her various aesthetic credos reveal it as anti-nature insofar as it is offered—despite its fragility and evanescence—as a "representation" of Platonic ideas rather than *eidola*, of *noumena* rather than phenomena.

Any definition of Minimalism based on the creative intentions or aesthetic pronouncements of the artists must then exclude so rigorous and inspired a Minimalist as Martin from the canon—which is precisely why the present study rejects that mode of definition. Martin's work has been understandably differentiated from mainstream Minimalism by

Barbara Haskell for its "personal touch and human expression" [1992 107]. As noted earlier, however, every Minimal painter from Newman and Reinhardt to Ryman and Tuttle has at one time or another been distanced from Minimalism on the basis of one quality or another.

We are left with various critical options: abandon the term "Minimalism"; confine it to sculpture among the plastic arts; accept it as a chronologically determined delimiter; or expand it by focusing on the style and form of the art rather than the philosophy of the artists (a subject on which there is in fact little agreement even if one considers *only* sculptors of the mid-1960s). Experience of Martin's luminously reductive art may lead one to view the last alternative as the least objectionable and Martin's often equally luminous prose—like Newman's belligerent yawping—as an intriguing rather than in any way definitive commentary on the art, which would not be diminished an iota if all the prose disappeared overnight.

H

A year before Martin began working in grids proper near Battery Park, two miles north on Eldridge Street on the Lower East Side, twenty-two year-old Frank Stella had made his own breakthrough in monochromaticism and repetitive all-over structure. The black paintings he began in late 1958 were the culmination of the reductionist tendency in American painting begun by Barnett Newman a decade earlier. Stella succeeded in this with an aesthetic antipathetic to the romanticism of the New York School and to what he dismissed as "the old humanistic values" [Battcock *Minimal* 157], and with a technique equally far removed from the transcendental subtlety and reticence of Reinhardt or the bold exuberance of Kelly. Unlike those two, Stella has acknowledged that his black paintings, and his work in general, grew out of Abstract Expressionism, although his attraction to Mondrian as a student at Princeton clearly influenced his approach to the later movement.

Apart from the Rauschenberg white paintings and Klein mono-chromes, Stella's economy of means was unprecedented—a strip of un-primed canvas plus a can of black enamel and a two-and-a-half-inch brush from his housepainting duties. More than Newman's sublimity, Reinhardt's austerity, Kelly's extroversion, or Rauschenberg's neo-Dadaism, Stella's early work set the tone for later Minimalists by rejecting the rarefaction of both technique and diction for a crudely direct style free of narrative aspirations and stylistic obscurantism, while responding to the fluid colorism of much contemporary painting with deadpan monochromes. He described his enterprise in the black paintings as problem-solving rather than self-expression, following Pollock in his concern with creating an integrated all-over surface while rejecting "the romance of Abstract Expressionism," the notion of the canvas as "a record of . . . sensitivity . . . of flux" [quoted Rubin 13]. As a result, Stella produced an apotheosis of

the superficial in the etymological sense, an art of the static, immediate surface with analogies in contemporary music then unknown to him.

His aesthetic attracted coeval critics, notably his classmate Michael Fried and his soon-to-be spouse Barbara Rose, and put off others. Commenting in 1966 on Stella as a "Representative of the 1960's," Hilton Kramer found this reflexive and clinical approach "not . . . very inspiriting. . . . It leaves one with a sense of all that has been lost from the universe of artistic discourse. . . . No doubt his work is currently overrated, but it nonetheless says something authentic—unhappily authentic— about the life of feeling among the cultivated classes in our society" [March 20, 1966].

According to William Rubin, who has expertly analyzed Stella's relationship to the holism of the New York School and its descendants, "Until Stella's last months at Princeton he painted in a vein derived from de Kooning, Frankenthaler, and Kline" [10]. Transitional paintings of 1958 try unsuccessfully to combine the compositional structures of Rothko and Jasper Johns, with rectangles painted over—or overpainted by—horizontal stripes. *Coney Island,* painted in primaries, looks like a flag with stripes yellowed and blue rectangle extracted from the upper left corner by centrifugal force.

Although he is often examined in the context of Minimalism, a movement that represents the most radical episode in the history of American abstraction, Johns was, albeit problematically, representational and perhaps more aligned to Duchampian than Minimalist notions of art as object. His major contribution to planar painting was precisely the "problematically," with regard to his ambiguous identification of subject and image in the flag and target paintings.

Those series also imaginatively and influentially adapted monochromaticism in paintings like *White Flag* and *Green Target* of 1955. The technique of encaustic over-painting—not so much a wash as a volcanic flow—is further evident in the figure series of single numbers and the assorted monochromes with single words breaking the thickly pigmented field (e.g., *The* and *Tango*). In 1956 Johns executed *Canvas,* depicting the eponymous subject within the eponymous object, a kind of fun-house-mirror version of Rothko and prophetic of the 1957 *Grey Rectangles,* which depicted three of them in the same color as the rest of the canvas. Johns began the serial number and letter paintings the same year as these works, perhaps the most closely allied to Minimalism in his corpus. In the earlier flags (begun in "'54, but I'm not certain" [Hopps 1965 33]) and targets, newspapers were half-buried in, and remain fragmentarily visible through, Johns's encaustic; in the later series the numbers and letters remain similarly veiled. His crypto-collage technique is a subtler version of the technique in the black paintings with which Rauschenberg had followed his whites, in which the paint is applied over the crude *collé* surface of newspapers already dipped in the same pigment and glued to the support.

Another important facet of Johns's work was repetitive pattern: the alternation of color bands in the flags; the concentric rings and replicated images in the targets; the enjambed number and letter rows in those series. Given their still ambivalent status as representations or signifiers, these serial forms do not adumbrate Minimalist replication as much as they do Warhol's silk-screening.

Johns's greatest influence on Stella's early work was his flag paintings. With their stripes parallel to the framing edge, they managed to suggest what Michael Fried would later call (before disavowing the term) the "deductive structure" of Stella's early paintings, which he attributed to the influence of Newman. As mentioned above, Newman withdrew from exhibiting after the failure of his second one-man show in 1951, and Stella was unacquainted with his work until he exhibited in New York once again in March 1959 at French & Company after his "comeback" show at Bennington College the previous year. By this time Stella had been working on the blacks for several months. He took both monochromaticism and deductive line to a level beyond both Newman and Johns, constructing his early black paintings, in effect, from nothing else, representational or otherwise.

Initially, however, the black paintings grew out of Johns-like experiments with alternating bands of color, specifically red and black, as in the 1958 *Delta*, which bears the same relation to the black paintings as Newman works like *The Euclidean Abyss* do to the post-*Onement I* structures. Through 1958 Stella groped tentatively, like Newman in 1948, towards a stark rigor. After *Delta* came *Morro Castle*, in which red is still visible, although it has been painted over in black, while areas roughly a foot wide on the left and right borders are solid black, resisting the holistic impulse of the striped pattern. *Reichstag* is the first true monochrome, but leaves solid areas in upper left and right corners and is symmetrical off the vertical but not horizontal axis. Only in *Arbeit Macht Frei*, completed before the New Year, does Stella realize the all-over biaxial symmetry of uniform monochromatic bands that distinguished the series.

In an interview with Emile de Antonio and Mitch Tuchman, Stella pointed to a literary inspiration in the repetition of Samuel Beckett, a cult figure during his Princeton days, whom he described as "pretty lean . . . but . . . also slightly repetitive. . . . I don't know why it struck me that bands, repeated bands, would be somewhat more like a Beckett-like situation than, say, a big blank canvas" [141]. The Beckett influence may be felt not only in the repetition but also in the spareness, detachment, and starkness of the black paintings.

Newman's near-monochromes could be either brilliant or brooding, but his color remained as expressive as Kelly's generally more ebullient contrast of color areas. Reinhardt's blacks are not quite black, just as his monochromes are not quite monochromes. As noted, his blacks were composed of various mixes of dark blue, red, and green, all carefully

drained of oil to avoid gloss. Stella's black was drained of nothing—after experimenting with tint colors he moved in the black paintings to simple enamel housepaint, straight from the can. Noting an acquaintance's judgment that the Abstract Expressionists "would be good painters if they could only keep the paint as good as it is in the can," Stella described his own enterprise as "I tried to keep the paint as good as it was in the can" [Battcock *Minimal* 157]. In a 1962 article lamenting Johns's abandonment of the same "old humanistic values" Stella disdained, Leo Steinberg noted with understandable nostalgia, "After all, when Franz Kline lays down a swath of black paint, that paint is transfigured" [37]. When Stella laid down a swath of black paint, it continued to look pretty much like black paint.

In their strongest canvases, Newman, Reinhardt, Kelly, and Stella *all* restrict themselves to lines echoing the framing edge. In the case of Stella, this is once again immediately apparent; in the case of late Reinhardt, the lines are themselves obscured by the virtual absence of relations between the component squares of his canvases. This obscurantist tendency in Reinhardt was the antithesis of Stella's straightforward statement of means, which became all the more evident in the shaped canvases he was soon to execute. Furthermore, while Reinhardt's squares were perfectly symmetrical and meticulously executed (though painted freehand to avoid the slightest violation of planarity by the miniscule gradation of tape), Stella's freehand technique is undisguised in both the irregular outlines of his bands and their sometimes obviously lopsided placement (e.g., *The Marriage of Reason and Squalor* at the Museum of Modern Art since 1959).

The central question in Stella's black paintings is the evasion of relations. Kelly's technique was to heighten the excitement of his juxtaposition of brilliant colors by presenting them in the same geometrical form, thus achieving uniformity and sharp diversity at once. In Newman the zips set off the fields to which they are contrasted in hue and/or value, again to dramatic effect. Seen at a distance, the zips propel the viewer's gaze back and forth across the canvas; from close up in the large canvases—as prescribed by the artist—they drive it centrifugally, generating the peripheral radiation of the canvas. From either perspective, their effect is to activate the monochromatic field as Kelly, taking off from Mondrian, activates even as he restrains a highly polychromatic field with regularized geometry. In Reinhardt the relations of his near monotones are painfully subtle, in some cases existing only as a function of duration, while Stella, on the other hand, achieves both stasis and immediacy. If Reinhardt demands the spectator's immobility, Stella offers an immobile pattern instead. Reinhardt's forms are revealed only haltingly, fitfully, and in the end only partially, while Stella's entire structure is at once apparent: in his famous phrase, "What you see is what you see" [Battcock *Minimal* 158]. Whereas Newman took pains to inform the audience that what they were looking at was not a line or two on top of a lot of

paint but cosmic mysteries, Stella was content to offer them just lines of paint, still repeating the framing edge like Newman's but all the more emphatically in their relentless proliferation.

The fetishism of flatness in post-Cubist space goes back at least as far as Hans Hofmann's teaching methods but was made a cause célèbre by Greenberg and his followers, notably Michael Fried, for whom the notion, or doctrine, seems to have been internalized almost as a censor. In his comments on Olitski, for example, Fried notes that the painter "contrives an illusion of depth that somehow extrudes all suggestion of depth back to the picture's surface; it is as if that surface, in all its literalness, were enlarged to contain a world of color and light differentiations impossible to flatness but which yet manages not to violate flatness" [*Olitski* 6]. The subtext of these gymnastics seems to be vaguely puritanical guilt over enjoyment of Olitski's rather lush work. On the other hand, there was nothing to argue with in Stella's diametrically opposed severity, although Fried felt impelled to exaggerate the purity of its deductive structure (e.g., it turned out that the notches in the aluminum canvases came after, not before, the painting). Greenberg, with his essentially Romantic sensibility—his chief philosophical support was Kant—was unimpressed by Stella, while Donald Judd, who had just begun his own reductive work in three dimensions, sounded the changing of the critical guard by writing in the September 1962 *Arts Magazine* that "the absence of illusionistic space in Stella . . . makes Abstract Expressionism seem now an inadequate style, makes it appear a compromise with representational art and its meaning" [Judd 57].

Pollock's success in particular had provoked further exploration of nonrelational space, with the dethroning of Cubist central focus along with figuration in his all-overs. Though Reinhardt established "no relations" as one of his many thou-shalt-nots, Stella went beyond even his late blacks in this regard. Whereas Reinhardt's slight gradations of black entail the almost metaphysical compromise of illusionistic flatness, Stella evaded relations by using purely monotonal black within a purely symmetrical structure that "forces illusionistic space out of the painting at constant intervals by using a regulated pattern," as he expounded it in a lecture at the Pratt Institute [Richardson 78]. Unlike Reinhardt, Stella felt no debt to Mondrian for his symmetry, identifying his own composition, along with Kenneth Noland's, as a specifically nonrelational symmetry, not based on balancing one area with another, as in "the European geometric painters" [Battcock *Minimal* 149]. This in part accounts for Judd's comments on Kelly's use of "the old abstract space" and derivation from "the thirties." Even in his more innovative oblong monochrome panels, Kelly's spatial repetition was rhythmic and expansive, predicated on the contrast of (adjacent or divided) geometrical color areas. Stella created a unitary field based on the distribution of monochrome pattern regularized into stasis.

While expressing warm admiration for Noland, Stella noted, "Some-

times all that bare canvas gets me down, just because there's so much of it; the physical quality of the cotton duck gets in the way" [Battcock *Minimal* 160]. His own treatment of the bare canvas, first of all, left less of it, and second, reduced it from a ground by incorporating it into the all-over pattern, all the more so by the irregularity of his brushing in the early stages of the series. The black bands and interstitial canvas are not separated but joined by his initially smudged borders, which provide the unifying effect Newman claimed for his zips. Spatially, those zips divide the monochrome field; while they may unify the canvas temporally in the kinetic terms of driving the spectator's glance laterally across the field, Stella's smudging fuses the component lines on first glimpse, never allowing them an independence that would challenge the nonrelational, unitary effect he sought. At the same time, however, he overpainted the black bands to preclude their absorption into the canvas weave, and used stretchers three inches deep to preclude, in turn, the engulfment of the canvas by the wall while highlighting the separateness and two-dimensionality of the painting.

This was made more obvious in the notched paintings begun after Stella completed the black series in February 1960, and in the hollowed polygons three years later, which seem to have led Donald Judd to wonder whether the canvases were in fact paintings: "Frank Stella says that he is doing paintings, and his work could be considered as painting. Most of the works, though, suggest slabs, since they project more than usual, and since some are notched and some are shaped like letters. Some new ones, painted purple, are triangles and hexagons with the centers open" [Judd 153].

The black paintings, sometimes given their titles collectively in casual dialogues with Stella's friends Carl Andre and Hollis Frampton [Richardson 4], are as black in their humor as in their hue, a reflection of his glum state of mind on his first and rather bitter taste of the post-Princeton life he had apparently looked forward to as a liberation. As examined in detail by Brenda Richardson, the earliest and strongest (i.e., the pre-diagonals) of the series of twenty-three black paintings executed by February 1960 allude to Nazism (the *Reichstag* fire, the Auschwitz portal in *Arbeit Macht Frei*, the Horst Wessel song quoted in *Die Fahne hoch*!); Bedford-Stuyvesant, then already a black slum across the Williamsburg Bridge, where Stella was painting apartment houses for a living (*Clinton Plaza, Arundel Castle, Tomlinson Court Park*); a shipwreck (*Morro Castle*), a madhouse (*Bethlehem's Hospital*), and a mausoleum (*Getty Tomb*); and gay/lesbian bars (*Club Onyx, Seven Steps*).

William (*The Marriage of Heaven and Hell*) Blake and J.D. ("For Esmé—with Love and Squalor") Salinger made a tag-team cameo appearance in *The Marriage of Reason and Squalor*. Anticipating the deadpan use of Catholic iconography by rock groups in the 1980s and later (e.g., Jesus and Mary Chain, Jane's Addiction—Madonna's more emotionally charged, however ambivalent, connection to Catholicism is as obvious as her

abbreviated *nom d'art*), Stella gave his religious roots a jejunely ironic nod in *Sacred Heart* and *Our Lady of Perpetual Help*. These titles were purportedly rejected not for their potential offensiveness but for their lack of cultural resonance [Richardson 26]). All the titles of the series are remote from the neutral (by color/number/year) or mythological titles of the New York School and their successors. "There aren't any particularly poetic or mysterious qualities," according to Stella [Rubin 44], in the black or later striped series. The titles, consequently, are not referential or even evocative but grimly sardonic, perhaps most effective when the rhetoric of Nazi martyrs and "free" concentration-camp internees is linked to the sullen muteness of the canvas.

Anna Chave feels otherwise, regarding Stella's Nazi allusions as displaying a "callow or callous attitude" [Chave 1990 50]. As part of her thesis that Minimalism implicitly reinforces oppressive sociopolitical systems through replication of its forms, from Nazi stadia to erect penises, she links the black enamel stripes of the Andover-Princeton alumnus to Brooks Brothers pinstripes, despite the restriction of the latter to verticals and despite Stella's disclaimers thirty years earlier of earlier descriptions of the black paintings as pinstriped (then offered without direct allusion to clothiers). Chave belabors the Nazi connection [46–50] almost as if demanding some retroactive disavowal of Nazism by the painter. Stella neither glorifies the ideology nor, it seems to me, alludes to it noncommittally. His choice of "Work Makes You Free" or "The Banner on High!" is as sardonic as if John Adams were merely to entitle an opera about Nixon *I Am Not a Crook* (though the title might have precluded the production of fashionably apolitical pablum). Rather than launch an assault against a defeated ideology, Stella lets it indict itself with its own rhetoric. In this he is not, *pace* Chave, comparable to nihilistic teenagers sporting Nazi regalia. Apart from topicality or cultural resonance, *Sacred Heart* and perhaps *Our Lady of Perpetual Help* would have been less effective as satiric titles because insufficiently self-indicting, although the disparity between those traditional icons with the canvases might have rated an easy sneer or guffaw.

Chave's "callow or callous" charge is bolstered by the passing of a mere decade and a half between the death camps and the exhibition of the black paintings. In the case of *Arbeit Macht Frei*, additionally, one might argue that the original motto was itself so criminally sardonic as not to bear the weight of further allusive irony. But to grant a lapse of taste or judgment is one thing and to insinuate Nazi affinities another; the latter strains critical objectivity as much as Stella's titles may, admittedly, strain the blackest sense of humor.

After the black paintings, Stella continued to work in series. In early 1960 he began the white or aluminum or notched paintings. After following Reinhardt into black monochromes, he followed Rauschenberg into whites, again with radically different intentions, means, and results.

In this series Stella, rather than experimenting with different patterns within the rectangular format, let the bands dictate the shape of the canvases, leading him to follow Darby Bannard's suggestion that he simply cut out those sections of the canvas (corners, center, lateral notches) that did not conform to the pattern [Rubin 48–49]. The white paintings are more "minimal" than the black in that all the lines are fundamentally vertical, the texture of the aluminum paint is smoother, and Stella's use of pencilled guidelines makes for a more impersonal regularity in the pattern. The rough-and-ready facture of the blacks is superseded by the industrial streamlining that was to influence Minimal sculpture even more profoundly.

By the end of 1960 Stella had moved into the copper paintings, which he continued through 1961. The first three series were all monochrome, but the same year Stella began the alkyd (or Benjamin Moore) series; these six canvases were even more formally rigorous than the black paintings but more worldly in their primary and secondary monochrome matte, which then developed into polychrome canvases by the end of 1962. In 1963 he returned to monochrome (purple) metallic paint for the series of hollowed polygons. After solid polygons formed of patterned areas in the shape of triangles, wedges, and chevrons, 1964–65 saw the notched-V, fluorescent alkyd, and monochrome running-V paintings. Just as he had stayed within the bounds of monochromaticism for over four years, from late 1958 to late 1962, Stella worked fundamentally in symmetrical formats of varying degrees of complexity for another four years until the irregular polygons begun in late 1966.

This was the year Minimalism became a public phenomenon with the Primary Structures, Art in Process, and Systemic Painting exhibitions, and was precisely the point in Stella's career when, having blazed the next trail for the Minimalism of the 1960s and having begun to achieve both economic and critical success for his efforts, he moved in the opposite direction, towards extravagant colorism and structures. Having produced some of the most unrepentantly Minimal art in existence, he began constructing some of the most glaringly maximal configurations of what developed in the next decade into neo-Gothic shlock.

In a sense Stella evolved away from Minimalist techniques almost as soon as he discovered them. *Arbeit Macht Frei* is the first of the holistically patterned monochromes, after which, by early 1959, Stella had immediately begun moving away from central focus with the division of the canvas into patterns radiating in opposite directions from the horizontal (*Arundel Castle*) or vertical (*Club Onyx*) axis. This entails the diminution of the static feel of the structure. Later that year he moved into diamond patterns, in which the stripes at forty-five-degree diagonals equally evade and acknowledge the framing edges. In addition, as the series developed, lines became more regular in dimensions and contours, spaces cleaner and wider.

By the time Stella first exhibited in December 1959 at the Museum

of Modern Art's Sixteen Americans, the series had been cleaned up
and become more intricate and to some extent more conventional. By
the time of the aluminum paintings Stella was pencilling in guidelines and
was less interested in the imposition of pattern on field than the move-
ment of the individual hand [Rubin 47], which now is no longer straight
but zigzag, while biaxial symmetry is largely abandoned. With the intro-
duction of the notches it is as if the field is being artificially created,
and the holistic effect has become not so much deductive as dictatorial.
The support is sacrificed to the concept, whereas in the ensuing copper
series Stella was to construct the support to match the pattern (zigzag,
cross, L-, T-, or U-shaped).

Stella's miraculously early breakthrough and arrival at the Museum
of Modern Art the year after his college graduation distort the diurnal
reality of his early career, which reaped him small financial reward and
more critical insult than acclaim. Stuart Preston's largely positive review
of the exhibition concluded by acknowledging, "The show has its weak
spots. Frank Stella's pin-stripe compositions add up to very little indeed"
[December 20, 1959]. At the same time, critics like Michael Fried com-
pensated eloquently for the muteness of Stella's early work by expounding
its implications. Newman remarked ironically that the new painters each
came armed with a critic and referred to the new rhetoric which had
replaced his own aesthetic of the sublime.

Stella helped generate that rhetoric in early comments on the "object-
hood" of his paintings, a valid and important observation which he later
felt had been "abbreviated" into another kind of cant [Rubin 15]. While
the term became identified with him, Frances Colpitt notes its prior
use by Johns, Rauschenberg, and critic Sidney Tillim [109]. The historical
significance of Stella's artistic realization of objecthood was its effective
reversal of the Duchampian object-as-artwork into the artwork-as-object.

Preston was a poor prophet in stating that Stella's (and Alfred
Leslie's) work "would provide a very shaky basis for the art of the future,"
since Stella proved the herald of the art of surfaces that was gestating,
which represented a movement from "depth" metaphors in criticism as
well as in psychology. Stella's near-abolition of even optical depth in the
black paintings parallels the resuscitation of theories of art as surface (that
go back at least as far as Wilde) in Alain Robbe-Grillet's theory of the
nonreferential novel and dismissal of the "myth of depth," which was
echoed across the Atlantic by Susan Sontag's polemical espousal of
"transparence" as the highest virtue of art in "Against Interpretation" in
1964 [22–23]. At the same time, Stella's work culminates not only the
reductivist tendency of American painting since Newman but the whole
reversion from romantic subjectivity originated in early Modernism—in
poetry Imagism, in criticism T. E. Hulme and the T. S. Eliot of "Tradition
and the Individual Talent," along with the contemporary development of
geometrical abstraction in art and neo-Classicism in music.

Abstract Expressionism had defined itself against the rationalizing and

technocratic tendency within abstraction, be it Suprematism or de Stijl, in service of a self-searching and self-expressive aesthetic that, following Surrealism, embraced irrationality as a means of revealing psychological truths hidden from normal perception. It held in common with all romantic aesthetics a psychogenic notion of the work of art, which had been ignored by the other-directedness of geometric abstraction, particularly the "Neoplastic conception of the absolute, codified into a set of rules thought of as embedded in nature" [Sandler 150]. The well-known statements of Pollock ("I am nature") and Newman ("Instead of making *cathedrals* out of Christ, man, or 'life,' we are making [them] out of ourselves, out of our own feelings" [Newman 173]) exemplify the radical subjectivity of the aesthetic. It developed in the wake of a similar revolution in the bebop exploration of harmonies culminating finally in free jazz in the mid-fifties, and roughly in tandem with the radical subjectivities of Existentialism and the Beat literature that similarly adapted Surrealist automatist technique ("spontaneous bop prosody," as Allen Ginsberg called it [802]).

Abstract Expressionism was very much the product of its culture, produced by a generation that had seen a worldwide depression and the Second World War (after being raised during the First). Dismissing the rhythmic formalism of geometric abstraction as decorative and superficial, it preferred a gestural version of abstraction that acknowledged, perhaps expressed, a submerged chaos. As an analogy to their revival of quest-romance, the New York School avoided enclosed canvases and explored paintings that seemed to extend beyond the support, whether in the radiation of Rothko's color or the cut-off forms of Pollock.

Newman was most vocal in his denunciation of geometry in order to disaffiliate his own ostensible formalism from unfashionable geometric abstraction and ally it to the sublime of contemporary rhetoric. Both Reinhardt and Kelly, in turn, reacted against the expansiveness of Abstract Expressionism in compositions with strong roots in geometric abstraction that accepted the finitude of the support and, rather than viewing it as a repressive confinement of the creative unconscious, even underscored its geometry in their design of individual or conjoined panels. Stella had been attracted by both the geometric and expressionist traditions in abstraction. He, in his own turn, not only accepted the confinement of the support but made it the basis of his structure in the black paintings. In the whites, then, he reversed the relationship while retaining the identification of image and support, adapting the stretcher to mimic his line.

Stella's black paintings in a sense provided a rapprochement of the two often antagonistic traditions of abstraction in their use of geometric configuration within all-over structure, of regularized pattern imposed upon holistic field. More importantly, he advanced the evolution of the surface in the direction of two-dimensionality that had been initiated by the Cubist shattering of the half-millenium-old window of perspective into layered shards and had been further developed by the Abstract

Expressionist treatment of the surface as "a skin that, for the most part, remained unbroken by the superimposition of forms by atmospheric depth" [Baigell 309]. In Stella the surface was neither a window into an illusionistic world nor a skin for tattooing, but everything, all there was. It is more than a facile oxymoron to note that the (anti-)spatial evolution of abstraction culminated in the concreteness of the object-painting.

I

By 1965 Robert Rosenblum's belief that "the uncommon strength and integrity of Stella's young art already locate him among the handful of major artists working today" [*Artforum* March 1965] was becoming the consensus. Lucy Lippard had rated his exhibition of hollowed polygons at Castelli his "best so far" [*Artforum* February 1964], noting approvingly in the new lingo, "these paintings are real objects." While his work, now explicitly as earlier ambiguously three-dimensional, was the principal direct influence on the radically new object-sculptors, painters had a more difficult time going beyond Stella (Judd even stated bluntly that painting was finished).

One of the few Minimalist painters to follow Stella with anything like his distinctiveness was Robert Ryman, known principally, as mentioned above, for the "achromatic" paintings he has executed since 1965 with initial experiments dating from 1958. Unlike either Rauschenberg's or Stella's white paintings, Ryman's are so entitled problematically, although they characteristically cover (virtually) the entire support like Rauschenberg's and are often painted in bands like Stella's. The differences between the two artists, however, are more important than the similarities. As already noted, Ryman's white pigment frequently interacts with the differing colors of his supports; furthermore, his bands, unlike Stella's, are normally contiguous (the 1965 *Mayco* is a notable early exception in its exposure of canvas at regular, though only roughly rectilinear, intervals) and often expressively brushed, with no attempt made at art concealing art.

Despite the severely restricted palette that is his most salient feature, Ryman in another sense goes against the grain of the reductivist impulse in American art that gathered steam in the third quarter of the century. His emphasis on the quality of the brushstroke is eminently painterly;

even when restricted to horizontal or vertical strokes that echo the framing edge, the visible furrows of his brushwork do so nongeometrically, loosely enough to suggest fine gradients of linearity. Furthermore, the interplay of the distinct colors of his support and pigment, both at his unpainted borders and in those areas of the support left exposed by the brushwork or taped, repudiates strict monochromaticism and provides depth-cues with value relations. As a result his work has a richness of texture and shading absent in the nonrelational rigor of Stella's earlier monochrome series.

Ryman's painterliness is at the opposite extreme from Rauschenberg's use of rollers in his white paintings in 1951 (and his instructions to others for their re-creation in 1962 and 1968). Diane Waldman correctly observes (though contradicted by Rauschenberg) that Rauschenberg's whites were "a Dada gesture—about absence or emptiness—as signaled by the lack of color. Ryman's paintings, on the other hand, are not about nothingness but about an emphatic, if understated, presence" [1972]. At the same time, Ryman was himself not completely alien to the Dadaist tradition of anti-art, as witnessed by his hanging of unstretched canvas and, most dramatically, his participation in the 1970 group exhibition Using Walls at the Jewish Museum, for which he taped his canvases to the wall and let his pigment drip over the tape and onto the wall itself. This literally broke through the barrier between art and "life," e.g., tape and wall as opposed to rectangular cloth, and may be related to stratagems employed by Robert Morris in the 1960s as a form of social commentary.

Apart from Ryman's subtle lyricism within severe rejectivism, later Minimal painting largely repudiates the suggestiveness of 1950s Minimal-ism for a starker facticity than Stella's. He had already completed his black enamel, white aluminum, copper, Benjamin Moore, hollowed polygon, and solid polygon series when in 1964 Robert Mangold executed his *Walls* series and Marden moved into monochromes; the next year Ryman and Richard Tuttle began their mature work. The hallmark of all this work is its lack of resonance, but the technical inflection in much of Ryman's painting makes its position in the late-Minimalist canon somewhat anomalous. When he is not layering pigment with putty knife and sandpaper, his visibly brushed paintings hang no more comfortably with those of his somewhat younger contemporaries than Reinhardt's did with his somewhat older contemporaries in the New York School.

On the other hand, even Ryman's most obvious brushwork may be viewed as a part of the same reductivist aesthetic of economy and exposure of means. You see not only "what you see"—bands of paint—but how they got there, in the normally regular but nuanced, not (melo)dramatically but subtly expressive, wake of the brush across the surface. The terminal rarefaction of abstraction in Minimalism, further-more, is embodied theoretically in Ryman's oft-quoted statement from the 1969 incarnation of Art in Process at Finch College, "There is never a question of what to paint, but only how to paint." In this stance Ryman

seems the heir of Reinhardt with his credo "There is no such thing as a good painting about something." Nevertheless, in an interview four years later, Ryman allied himself with Mark Rothko whose original statement, "There is no such thing as a good painting about nothing," Reinhardt was subverting. Ryman observed that Rothko's work and his own were "both kind of romantic" [Oliva 50].

Stella said he "tried to keep the paint as good as it is in the can." Ryman followed him in trying to keep it as good as it was in the tube, by using generally unmixed whites: "I let the surface be the color" [Phyllis Tuchman 50]. His hanging of unstretched canvas seems to show that material the same deference, while even his unexaggerated but undisguised brushwork may be viewed as an attempt to keep the bristles as good as they are on the brush.

Of the later Minimalist painters, Ryman is the most original and impressive for his creation of some of the most understated lyricism in painting both contemplative and subtle within the rigors of unitary design.

Ryman's work of the mid-sixties was almost ebullient by comparison with that of Brice Marden, who began working in monochrome in late 1964, initially including vestiges of contrasting underpainted color areas or bare canvas on the lower border of his canvas. This calculated exposure of surface/underpainting and consequent evasion of holism may be seen as a reaction to Hard Edge. Ryman used the exposed surface as "the color" for his white paintings; Olitski had used contrasting areas of color and texture at the edges of his spray paintings for definition in his otherwise profusely amorphous compositions. Marden covered the rest of his canvas with a beeswax/oil mix which he distinguished from encaustic insofar as "oil remains the primary binder" [Marden 1975 28; Marden 1981 45], and which he sometimes let drip to the lower edge.

He had been led to this medium by his feeling—as Reinhardt had felt with regard to his own monochromes—that the gloss of oils obscured the painting. Marden's friend Harvey Quaytman suggested the beeswax mix, "which provided exactly the mat, opaque surface and increased physicality Marden wanted" [Marden 1975 13]. His first one-man show at the Bykert Gallery in 1966 featured brown, green and grey monochromes. His 1967 show at Bykert drew a negative reaction from Barbara Rose, who remarked that his "dense rectangles with their dripped lower margins look like the backgrounds of Johns's large paintings" [*Artforum* November 1967].

In 1968 he eliminated the painterly touch of the lower border and reduced his work to pure monochrome as he moved into panel painting. He now used the oil/wax mix to cover not only the entire surface but any traces of its weave or texture. This was the same year that, working as Rauschenberg's studio assistant, he had been assigned to repaint Rauschenberg's white paintings for Ivan Karp. Despite his admiration for Ellsworth Kelly, to whose use of the panel format, as discussed earlier, his

own bears more than a passing resemblance, the immediate inspiration for Marden's exploration of panel-painting may have been this assignment. Marden himself neither repeated the same color in his two and three-panel paintings like Rauschenberg, nor opted for chromatic juxtaposition like Kelly, but collocated the various hues toned down by the wax/oil mix he had used since 1964, along with the flesh and black he had introduced for value contrast earlier in 1968 in his *Back* series. His panel paintings were intitiated, in fact, when Marden decided to join flush two discarded canvases from that series.

After adding flesh and black in 1968, he advanced to primaries by 1974 and on to brighter stripes. Despite their shared impressionist proclivities, Marden offered, instead of the luminescence of Olitski's all-over spray, fields of wax-dulled pigment almost claustrophilic in their self-enclosure. By means of the texture of his layered pigment and his dimmed palette, Marden's initial contribution to Minimalist monochromaticism was to reduce its accessibility, seal the artwork in, very much in accord with the aesthetic of the work as object that had gained currency since Johns, whose encaustic set a precedent for Marden's use of wax, and Stella, who had initially achieved the dissolution of space in part not by burying the canvas but by soaking the pigment into it.

Perhaps the painter who most radically expressed the objecthood of the artwork was Richard Tuttle, who like Stella and Marden began exhibiting rather young. In Tuttle's case, he was twenty-four at the time of his first solo show, a year before Marden's and two before Ryman's, in 1965 at the Betty Parsons Gallery, where he continued to exhibit approximately biannually. Tuttle is known for the unassuming nature of his work: pieces from the seventies consisting of an inch of rope or foot of polygonized wire nailed to the wall. His earliest adult work, circa 1963, was the construction of small paper cubes, three inches on a side, depicting different geometrical forms or configurations. From 1964–66 he explored symmetrical monochrome wooden panels divided by a strip of plywood—a design used by Kelly as early as his *White Plaque* completed in 1955—in six paintings. As in others among Kelly's works, Tuttle alluded to nature in his monochromes, in his colors and titles alike, which ranged from bright orange, *Bridge*; pink, *Flower*; and salmon red, *Fire* to cerulean, *Water*; grey, *Hill*; and off-white gray, *Fountain*. During the same period, Tuttle produced reliefs, also monochromatic, equally suggestive and evasive of geometrical forms: the angularly truncated crescent *Shadow*, the roughly semicircular *Ash Wednesday*, the irregular inverted U *Yellow Dancer*.

Tuttle seemed determined to resist the neatness of the Hard Edge art that had clearly attracted him at some point. He began experimenting in his highly personal version of *arte povvera* in 1967 by abandoning wood for soldered metal in *The Twenty-Six Series* and dyed cloth in *Grey Extended Seven* and subsequent works in the same vein. *Twenty-Six* alludes to the

alphabet (and Rose's "ABC Art"?) but the constituent "letters," which may be arranged on wall or floor, again suggest but evade S and L shapes as well as more pictographic forms. Tuttle's is among the least ingratiating art in existence, yet Perreault found them "not beautiful. But . . . in some sense outrageously 'poetic'" [January 18, 1968 17].

The last adjective, even in quotes, still comes as a surprise, as did Perreault's enthusiasm. A year earlier he had begun his *Village Voice* tenure with an impassioned argument that Minimal art was in serious decline. Apart from Stella, he dismissed all the other painters as "interesting but basically decorative and not really very problematic." While he did not use the word, he suggested the essentially derivative nature of later Minimal painting in noting that the art "is rapidly being strangled by the pseudo-analytical, passé Positivist, pornographically Hegelian death clasp of Greenbergian formalism" [January 12, 1967].

Another artist influenced by Stella's objectivist and the Greenberg-Fried formalist aesthetic was Marden's Yale classmate Robert Mangold, who along with Rauschenberg and Kelly provided precedents for Marden's panel painting. Mangold's early and highly diverse *Wall* constructions are formally quite intriguing, occupying the border between painting and sculpture, again with Stella as a recent model, though works like *Grey Window Wall* go much further into three-dimensionality, simulating without reproducing the architectural form of windows, ledges, etc.

As Stella had used plain enamel paint, Mangold used industrial materials, painting *Orange Side,* for example, on tin sheets after the plywood *Walls.* Lucy Lippard called his early work "industrial naturalism" since "Mangold refers to current industrial iconography in his white-based color and heavily outlined forms, which might be fragments of a huge sign or letter. But he does so without sacrificing the totally non-objective tensions set up by a curvilinear movement and a static declaration of the painting as object" [*Artforum* February 1964]. Lawrence Campbell was reminded of "the sides of trucks" but called Mangold "a brilliant new addition to the New York scene" [*Art News* January 1964], while Michael Fried called his debut "an interesting show by a young painter of evident gifts" [*Art International* April 1964]. While some of the *Walls* were bichromatic, Mangold's *Area* panel series, which followed in 1965–67, was strictly monochromatic. Like Marden's, his colors were dimmed—and would remain so until the mid-seventies—but his medium in the mid-sixties was sprayed oils, used to the opposite effect of Olitski's seductive opulence, an almost forbidding austerity.

In the late 1960s Mangold turned to rolled acrylic in darker values on masonite panels with letters V, W, and X drawn atop the monochrome field. At the same time he executed a series of three "frame" drawings, which led to the two pairs of acrylic "frame" paintings in 1970—a popular 1960s form used by Jo Baer on several occasions as well as by Ryman in two untitled oils on linen dating from 1961. In the early 1970s Mangold

started to explore, still monochromatically, combinations of distorted geometrical forms.

Like other critics writing of art in the sixties, Diane Waldman found that Minimalism produced "In painting . . . few artists of note," but made exceptions of Ryman and Mangold [1972]. "One of the most exciting new painters" had been Lucy Lippard's judgment after his first one-man show at the Thibaut Gallery, which she praised for his "single, bullet-headed images surging across flat, solid grounds with complete confidence and control" [*Artforum* February 1964]. Naomi Spector reacted even more enthusiastically to Mangold's achievement in a statement that bears quoting at length to indicate how prophetic Barnett Newman had been when he spoke of the old rhetoric being replaced by the new. She begins her catalogue essay for Mangold's exhibition at the La Jolla Museum of Contemporary Art with "To look at any painting by Mangold is to see exactly, completely, and only what is there" [1974]—elaborating on Frank Stella's remark ten years earlier: "only what can be seen is there" [Battcock *Minimal* 158].

"There is the monochrome painted surface, and there is the presence of the line or lines which divide it. Everything that is there is essential, and everything that is essential is there," she continues, in an essay itself entitled "Essential Painting." "He has excluded from his work all such concerns as illusion, image, space, composition, climax, hierarchy of interest, movement, emotional content, painterliness, interest in materials or processes, and any sort of association or reference to anything other than the physical painting itself." Spector was writing in 1974, and the solipsistic act she devotedly describes begins to sound like the ideal painting for the Me Decade, an artistic analogue of *Self* magazine (I have no concern for the city, country, planet, or universe, but I'm *looking good*).

"To have produced work of intellectual and visual power with such severity of means is impressive, and he certainly is among the most important of the 'Minimal' artists"—Spector's conclusion is valid, but one is tempted by her description to an equally valid reaction, namely, "So what?"

The achievement of intellectual and visual power (which some might dispute in this and similar cases—I hasten to add that I use Mangold as an example not a scapegoat) is all that even the greatest fan of this work would claim for it. It neither aspires to nor possesses suggestiveness or emotional resonance. The paratactical equation of "hierarchy of interest" or "movement" with "emotional content" itself indicates the one-dimensionalizing at work in this aesthetic, the univocality to which "Minimal, or reductive art" finally reduces itself as it goes bankrupt paying the mortgage on the new academy it has founded.

Spector's "Essential Painting" is entitled with reference to the stripped-down nature of the artwork; in another sense, though, the viewer of the work—or the reader of her oddly rhapsodic Table of Non-contents—might be led to wonder how essential in another sense, how indispensable or

even worthwhile, such an artwork really is. It is an expertly crafted, attractively painted, perhaps visually pleasing form. It is a "real object." It is a good thing.

While late-Minimalist painters practiced their craft, Minimalist sculptors who likewise took off from the object painting introduced by Stella produced in their specific objects, primary structures, and unitary forms even better things, with the advantage of an additional unambiguous dimension to convey the thinghood. More in this case turned out to be more. By the time Minimal sculpture began to be exhibited in 1963, virtually all the best Minimalist painting had already been done. Apart from the continuing work of Martin and Ryman, the most notable exceptions are works not by the artists who arose roughly simultaneously with the sculptors, but by the progenitors of the movement: Newman's *Stations* and Reinhardt's square black(s), which had been his only work(s) for three years and would remain so for four more.

Sound

2

La Monte Young, *Trio for Strings* (1957) (excerpt).
Copyright © 1963 La Monte Young. Used with
the permission of Just Eternal Music, Editions
Farneth International. All rights reserved.

J

On June 22, 1989 three members of the Arditti String Quartet sat onstage at London's Almeida Festival. Playing *ppp* as instructed by the score, violist Levine Andrade barely intruded upon the silence with a C-sharp over middle C and proceeded to hold the note for more than forty-five bars of common time with a metronome marking of an eighth-note at eighty.

After fifty-one seconds of this solitary C-sharp *senza vibrato* and equally without dynamic inflection as far as humanly possible, Andrade was joined by violinist Irvine Arditti playing *piano* but otherwise in the same manner a whole-tone higher. The hushed duet of a sustained major second continued for one minute and seventeen seconds until the third musician, cellist Rohan De Saram, bridged the gap between C-sharp and E-flat with a D-natural an octave lower and the gap between *p* and *ppp* with *pp sul tasto*. The three-note trio continued for one minute and forty-two seconds before De Saram dropped out, exposing again the bare major second. After forty seconds more of that interval, Arditti too returned to silence, and Andrade's once-again solitary C-sharp continued for forty-eight seconds more.

The opening section of La Monte Young's *Trio for Strings*, containing three notes in all, had lasted in this performance five minutes and eighteen seconds. After a rest notated as five bars less a thirty-second, which in this performance marked twenty-four seconds of silence, the musicians proceeded.

The miniature arch-form of the opening of Young's *Trio for Strings* contains the smallest possible number of notes for its setting, barring Cageian non-playing in the manner of *4'33"*. Allowing for the lower octave of the cello—register is inconsequential in Serial exposition—it also

contains the narrowest possible variation within the equal-temperament scale in the half-steps from C-sharp to D to E-flat. In addition, each individual sustained tone is monodynamic, and exists within the austere parameters of *p-ppp*.

Elaborating on Mies van der Rohe's dictum, Ad Reinhardt remarked, "Less in art is not less. More in art is not more. Too little in art is not too little. Too much in art is too much" [Lippard *Ad* 1966 23]. The Minimalist painting of Newman, Reinhardt and others arose amid the proliferating and fetishized complexity of Abstract Expressionist gesturalism. The Minimalist music of Young and others arose during the hegemony of Serialism, in which they had been trained and were assumed, as "serious" rather than "popular" composers, to continue.

I argued earlier that it was in part due to the insecurity of American painting vis-à-vis European art that the convolution of Abstract Expressionist gesturalism received far greater attention than the more reductivist color-field painting that complemented it. Though equally revolutionary, field-painting was too redolent of the American primitive (or "barbarian," in Newman's curiously Whitmanesque boast). In music, similarly, complexity had achieved the status of a professional credential; Serialism, particularly in its American academic institutionalization of received European wisdom, in practice often prized opacity for its own sake as evidence of the ingenuity and sophistication of the composer. Difficulty established one as a "classical" musician in the virtually absolute division between high and low art then prevailing. Composers like Milton Babbitt, who espoused total serialization—i.e., of tempo, rhythm, dynamics, and texture as well as pitch—seemed to regard inaccessibility as mandatory, if not indeed virtuous. Without this ambiance, a curious amalgam of elitism and inferiority complex, it is improbable that the radically reductive enterprise later termed Minimalism that had already taken shape in painting could have found expression in music as well. The spare figures of Minimal music would very likely not have emerged but from the intricate ground of academic Serialism.

The break was far from sudden, however; as it develops Young's *Trio* itself emulates in long tones the Serial presentation of the tone-row. After the not-quite five-bar rest the second section presents three perfect fourths descending in semitones from F-sharp/B through F/B-flat to E/A in violin, cello (three octaves lower) and viola respectively. After another protracted rest, this time more than eleven measures in duration, the third section sustains a minor seventh in the violin (B-flat/A-flat) to which an A-natural in the viola is added, again bridging the intervallic gap. Although the piece has been described as strictly Serial in exposition, two of the three notes had been heard in the previous section. Not until another long rest are the remaining two notes in the chromatic scale, C and G, heard in the cello's open fifth, as if this archetypally simple harmony were reserved for last, exposed in a staff without accidentals only after eleven-plus minutes of sustained tones and intervals. "Heard"

is itself problematic, since it appears only in a barely audible *pppp* with mute.

The minor seventh cannot but sound prophetic to anyone familiar with Young's later work in the harmonics-based tuning of just intonation, in which he was to make unique use of the seventh harmonic as a fundamental structural element. The extended fifth, on the other hand, was soon to recur in Young's work in a totally different context—i.e. no context, as the entire content of *Composition 1960 #7*.

Despite its Serial underpinnings, nothing like Young's *Trio for Strings* had ever been heard in Western music, a piece constructed exclusively of sustained tones and silences. It creates a musical landscape that seems not so much exotic as otherworldly. Terry Riley once compared performing Young's extended rests and long-tones to "being on a space-station waiting for lunch" [WKCR]. The *Trio* unfolds with a sense of suspended time to which the closest analogies in European music may be Notre Dame organum, Debussy's "La Cathédrale engloutic" (which Young hears as twentieth-century organum), and perhaps the slow movement of Beethoven's *Hammerklavier.*

Thirty-one years before the London performance, the *Trio* had its premiere in the home of Seymour Shifrin, a composer and composition professor at the University of California, Berkeley. Earlier in the 1950s, Shifrin had been associated with Milton Babbitt and other progressive New York composers immersing themselves in the Second Viennese School. Far from being a blind devotee or a narrow-minded academic, Shifrin had pursued this interest while continuing to compose in his own largely tonal vein. He was neither unused to nor easily shocked by the vagaries of his students' experiments, but he had drawn the line when Young handed in the *Trio* as a first assignment in his graduate seminar. Young had graduated from the University of California in Los Angeles in June and while preparing for graduate studies on the Berkeley campus in the fall began work on the *Trio*. Shortly after reaching Berkeley in September 1958, a month before his twenty-third birthday, he had completed it. In an interesting synchronicity, the completion of the work thus predates the inception of the black paintings by Stella on the opposite coast by a month or two.

The rookie graduate student was told that if he continued submitting assignments in this vein Shifrin could not give him a grade. Convinced that Young was not really hearing the bizarre structure he had created, and determined, perhaps as charitably as critically, to demonstrate to him the enormity of what he was perpetrating in the name of classical music, Shifrin arranged a student performance to show him the error of his ways.

The piece was performed at Shifrin's home by Oleg Kavalenko, John Graham, and Catherine Graff. The very small audience consisted of Shifrin and his class, including David del Tredici, Pauline Oliveros, Douglas

Leedy, Loren Rush, Jules Langert, and Charles McDermott; Young describes their reaction as polite bewilderment. The most sympathetic fellow student Young encountered in Berkeley, who did not register until the next year, was a native Californian from the Sierra Nevada foothills a few hours northeast. Though he audited some of Shifrin's seminars, Terry Riley was not present that particular day, but thirty years later described the experience of first hearing and then performing Young's music as "an initiation. You're never quite the same afterwards" [AC 111]. Within six years Young and Riley had in very different musical styles laid the foundations of Minimal music.

Young is now widely recognized as the originator of the most influential classical musical style of the final third of the twentieth century. Now that the more rhythmic version of Minimalist modular repetition pioneered by Riley has filtered into everything from film scores to TV commercials, it is almost reassuring to note that a 1987 performance of *Trio* was described by one of the critical champions of motoric Minimalism, John Rockwell, as "unutterably boring" [May 21, 1987]. And during a 1988 performance of *The Second Dream of the High-Tension Line Stepdown Transformer* by the composer who had by then been called both "the daddy of us all" by Brian Eno and "the mother of us all" by Ingram Marshall, people still walked out on Young's work, in Peter Goodman's words, "barely suppressing hysterical laughter" [*Newsday* November 14, 1988]. In thirty-five years Young has not compromised his style in hopes of wider acceptance.

Rockwell noted in his review of the performance of *Trio* that he found greater interest in the contemporary Minimalism of the mature Morton Feldman than the youthful Minimalism of La Monte Young. Since his death Feldman has frequently been referred to as a Minimalist. There is some justification for so classifying him in the very restrained dynamics and the spare texture of much of his work. Two piano pieces of 1957, a pivotal year for Feldman in his development of a distinct voice amid the followers of John Cage, might even be proposed as the first Minimalist compositions in music rather than the long-tone pieces Young had begun writing, *Piano (Three Hands)* and *Piece for Four Pianos*.

The first piece is particularly austere, based upon a series of chords being sounded and allowed to decay slowly, while the second piece echoes chords on different instruments. Thus there is an approximation of the Minimalist repetition of the same notes in the same timbres. Despite its innovative character, *Piano (Three Hands)* derives from the Cageian aesthetic in its incorporation of silence into the musical framework on an equal footing with sounded tones; its acceptance into the same framework of the "noise" of the overtone mix of the decays; and the application specifically to chords of Cage's Zen-influenced dictum of "letting sounds be themselves." Most importantly, in both works the emphasis remains on the discrete musical events of the scores, thus retains a continuity with Feldman's (and Cage's and Earle Brown's)

earlier work, which as Jonathan Bernard points out, "bears a good deal of resemblance" to Abstract Expressionism in its "focus on the gestural and the accidental."

Feldman was a friend and admirer of Abstract Expressionist painters, naming works for Philip Guston and Franz Kline and scoring Hans Namuth's film of Pollock at work. One of his most successful works was the later *Rothko Chapel*, inspired by the minimalized style of Rothko's last paintings for the nonsectarian chapel at Rice University. Feldman's work bears a relationship to Minimal music analogous to Rothko's contemporary relationship to Minimal art: both work reductively and brilliantly within an expressionist style fundamentally alien to Minimalism albeit influencing its development.

Bernard delineates three distinguishing strategies of the Minimalist style in art and music: "(1) the minimization of chance or accident; (2) an emphasis upon the *surface* of the work . . . ; (3) a concentration upon the whole rather than the parts." Feldman's 1957 piano pieces share none of these traits. *Piece for Four Pianos* is more closely allied to indeterminacy, requiring the performers to extract an unequal "series of reverberations from an identical sound source," while *Piano (Three Hands)* emphasizes the dissolution of harmonics akin to the floating/hovering colors of Rothko's washes. Perhaps most importantly, both share a focus on the evanescent sonic event rather than the musical continuum.

To put it another way, what most distinguishes Feldman's work from Minimalism is its greater eventfulness and unpredictability in its acceptance of constant but irregular harmonic and dynamic change within a given composition. What is minimal in Minimalism is not merely the number of notes but their relationship, which is normally static harmonically and regularized durationally. It entails not merely (or necessarily) a low volume level—from late 1959 onwards *f-ffff* became more common than *p-pppp*—but a dynamic fixity pervading the given piece. The embrace of the evanescent in Cage and his followers is alien to the more strictly rejective and rigorously controlled structures of Minimal music.

It is arguable, admittedly, that even Young's *Trio* does not qualify as Minimal music, first of all, on the basis of its dodecaphony, which a priori excludes the harmonic stasis theoretically afforded by tonal organization. Yet the effect of Young's long tones, held for a minute or more, is to reduce harmonic, or any, movement to the point of stasis. The repetition and sustenance of the same intervals similarly reins in the sense of movement from one pitch to another. So too does Young's repetition of those intervals in adjacent pitches, as in the second section of the *Trio*.

Surprising as it may seem, a more serious theoretical obstacle to considering *Trio* the first Minimal composition is its silences. While half-minute rests would seem to be underscoring the spare and minimal quality of the work, they may do so, as in Feldman, at the cost of interrupting the musical continuum. Young's subsequent works like the individual components of *The Four Dreams of China* continue to be structured similarly

around the juxtaposition of long tones and extended rests until 1962, when he moved into the breathless pace of his sopranino saxophone improvisations and from there towards the full-scale continuity of the drone works. As with the painting, the problem here is establishing too rigidly *a priori* criteria. The sense of continuum is indeed a predominant feature of the motoric Minimalism on which Bernard concentrates, and also of Young's work from 1962 onward. But to disqualify the *Trio* as Minimal music on the basis of silence is inadmissibly paradoxical. Particularly in combination with the *p-pppp* dynamic range of virtually the entire *Trio*, the silences are not strongly differentiated from the long tones, which seem to grow out of the silences and generate them in turn. This reciprocity does, in effect, evoke a sense of continuum rather than fragmentation, albeit the work is musically analyzable in distinct sections. As with the art, the primary criteria for describing a piece of music as Minimal are empirical: in this case, how the work sounds rather than how it may be analyzed from the score.

Works sometimes cited as precursors of Minimalism include the "Prelude" to *Das Rheingold*, Satie's *Vexations*, and even Ravel's *Bolero*. Wagner's opening E-flat chord ostensibly challenges Young in duration, but its ominous simplicity functions primarily to provoke anticipation of the complex harmonic—and multi-media—tapestry that follows. Even in earliest organum, the long tones function as the *foundation* for the melismatic complexity of the *duplum;* that contrast between sustenance and virtuosity, along with the conjunction of voices in the *clausulae,* is the real focus in the historical context of embryonic polyphony. Young's sustained tones and intervals, on the other hand, do not function supportively but holistically as simultaneous musical figure and ground. The repetition of the works of Satie and Ravel is of radically different orders, neither with much to do, finally, with the Minimalist repetition that was developed by Riley, Steve Reich, and Philip Glass. Whereas those composers use repetition in distinctive ways as part of an unfolding process, Satie is primarily working with unvarnished repetition as a concept, not to say a spoof, while the lush and rather tawdry Romanticism of the Ravel piece is the antithesis of Minimalist austerity in the vulgar theatrics of its dynamic and rhythmic directionality.

Another contender for the title of first Minimal composition might be the Klein *Monotone Symphony* described earlier. Without reiterating the arguments against assigning the composition of the work to the purported date of its "conception" in 1947 or undocumented "composition" in 1949, the piece, as notated by Pierre Henry, had been played at Klein's monochrome exhibitions the year before Young composed *Trio.* Whether in monotonal or later monochordal form, it clearly ranks, however, with the Satie piece as a conceptual anomaly rather than the fountainhead of any musical tradition.

Not only Feldman but his mentor John Cage has been described with some justification as a Minimalist. The headline of Cage's *New York Times*

obituary went so far—too far—as to list him as "John Cage, Minimalist composer" [August 13, 1992 A1]. If the Feldman pieces mentioned above are related to Minimalism of the long-tone variety, Cage's embrace of any sound and no sound as music paved the way for the half-minute rests of Young's early sustained-tone works as well as noise compositions like his 1959 *2 sounds*. Works like *4'33"* and *0'00"*, discussed earlier, provided both theory and practical models for the concept-art compositions of Young and others in the early 1960s. Even the scoring of Riley's 1964 *In C* "for any number of musicians" echoes that of *4'33"* "for any instrument or combination of instruments."

Cage's early *Constructions* and *Imaginary Landscapes*, both dating from 1939, anticipate something of the structure of Minimalist process music. *Imaginary Landscape No. 1* uses two turntables at variable speeds, a phenomenon productive of numerous Minimalist compositions, notably by Riley and Reich, when applied to tape-recorders. *First Construction (in Metal)* is a percussion piece emulative of gamelan and as such anticipatory of Cage's works for prepared piano, which he envisioned as a one-man gamelan. It features a rhythmic cycle of 4+3+2+3+4 (adumbrating the multifarious adaptations of arch-form in Minimalism) in which the overall structure of the work echoes the structure of the individual units in Cage's "micro-macrocosmic rhythmic structure" [1961 112]. One of the early prepared-piano pieces, the 1942 *Primitive*, even bears a vague melodic resemblance to Reich's later *Piano Phase*, though its opening phrase breaks off its gamelanic repetition in an *ff* martellato on only its fourth repeat. In a sense, that example and the silent *4'33"* illustrate why Cage is not finally a Minimalist—they are, respectively, not Minimal enough and too minimal even for Minimalism.

Young points frequently to gagaku and Webern as the foremost influences on his *Trio*. Gagaku, Japanese ceremonial music for mixed ensembles of largely high-pitched instruments, is described by Isabel K. F. Wong as "characterized by smoothness, serenity, and precise execution without virtuosic display" [Randel 331]. The *Trio* clearly shares these qualities—though not, significantly, the timbral variety of the gagaku orchestra, which includes winds and percussion as well as strings. Most importantly, the sustained intervals that comprise much of the *Trio* are reminiscent of the prevalence of long tones sustained simultaneously by two or more instruments in gagaku, while its prolonged silences emulate the Zenlike spaciousness of the form. The distention of both sustained pitches/intervals and rests exaggerates the Yin-Yang contrast of held tones and silences in gagaku to the limit of coherence. In exposing intervals in so bare a manner, Young virtually abandons the horizontal for the vertical element—perhaps the primary formalist argument against the *Trio*, laying aside subjective variables concerning the inherently boring or entrancing quality of long tones.

Young had been exposed to gagaku as an undergraduate in the music department of UCLA, which was strong in ethnomusicology and had

Japanese specialists in residence to direct a student gagaku orchestra which Young often listened to in rehearsal. His exposure to Serialism came earlier in his undergraduate career at Los Angeles City College, where he was studying with Leonard Stein, himself a student of and assistant to Arnold Schoenberg. Stein introduced him to Webern's work along with Schoenberg's and inspired Young's fascination with Webern's recurrent pitch placements within an atonal texture, as in the Op. 21 *Symphony* (1928) or the Op. 30 *Variations for Orchestra* (1940), as well as the "little static sections" in the early (1913) Op. 9 *Six Bagatelles for String Quartet*, in which Young heard time ticking off as in "a chime or music box" [AC 59].

While most listeners would probably not think immediately, or without prompting perhaps subsequently, of Webern on hearing the *Trio*, Young describes his handling of time in the piece as "like late Webern in augmentation. It is as though time were telescoped: what for Webern would have taken a few minutes, for me takes about 52 minutes" [*30-Year* 6] (the Arditti performance lasted about five minutes longer). Just as many contemporary European proponents of Integral Serialism felt that Schoenberg had not realized the implications of dodecaphony, Young considered Schoenberg's use of the tone-row "naive" in comparison with Webern's coordination of thematic and motivic material with the row, which Young attempted to advance "by making the serial technique synonymous with the audible structure of the work," i.e., by extending each pitch exponentially.

Textural and harmonic differences in Serialism and Minimalism are the features that most immediately place the two in opposition. However, in one sense the principal element of stasis is common to the two, despite the busyness of much Serial composition. In Minimalism that stasis is achieved by means of the extreme deceleration of harmonic movement or its total elimination, the rejection of dynamic nuance (or its restriction to a very limited dynamic range, such as the *p-pppp* of the *Trio* opening), the relative paucity of pitches employed, and most of all the repetition or extension of those pitches in the form, respectively, of modules or drones. Serialism is generally much more harmonically complex, texturally rich, and dynamically inflected, yet the principle of repetition is not only inherent in but fundamental to the concept of constructing the work from a single component, the tone-row, which is relentlessly repeated, albeit in continual variation by means of inversion, retrograde, retrograde inversion, and transposition. Despite the controlling principle of variation, Young has ingeniously compared the use of the tone-row to "the thirteenth-century use of *cantus firmus*," insofar as "we have the same information repeated over and over again, in strictly permuted transpositions and forms" [Kostelanetz 1968 189].

As an undergraduate Young was fascinated by Webern's early, atonal but pre-Serial *Bagatelles*, Op. 9 and *Five Pieces for Orchestra*, Op. 10, which

inspired his *Five Small Pieces for String Quartet,* dated November 1956, shortly after his twenty-first birthday. The spare texture Webern created with long tones and rests most directly affected Young and is most readily apparent in works like the fifth of the *Bagatelles,* although Webern's later work further emphasized the juxtaposition of miniature sonic events with long pauses. Young increased the static ambiance by emphasizing ostinato and pulse figures and especially the Webernesque emergence of intervals from the harmonically neutral texture. This was further influenced by Webern's maintenance of octave placements in the Op. 21 *Symphony* and elsewhere in the later work.

Seven months later, in June 1957, Young wrote *for Brass,* in which he introduced the extraordinarily long tones and juxtaposed silences—the piece features twenty-second notes and rests—that were to constitute the *Trio,* along with the emphasis on perfect intervals and sevenths. It is far less revolutionary a conception, however, in terms of its often rhythmic textures and far broader dynamic range. A year later he wrote *for Guitar,* extending the technique of contrasting long tones and silence, continuing the one-man campaign against thirds and sixths, and concentrating on "identical and similar pitch constellations set in durational permutations occurring at points sometimes separated by long periods in expanded time structures" [*30-Year* 3 4]. Neither *for Brass* nor *for Guitar* is accurately classified as Minimal; they are important transitional works, after which everything was now prepared for the leap into the *Trio,* where sustenance and silence were no longer merely salient features of the work but all there was to be heard.

More specific reminiscences of Webern are immediately—perhaps not evident but present, albeit in slow-motion, in the *Trio.* The half-step bridge created by the entrance of the cello recalls Webern's similar use of semitone connections, while the dynamic markings recall Webern's own multiplication of *p*'s and the *kaum hörbar* ("barely audible") notation of the third piece in his Op. 7 *Four Pieces for Violin and Piano.* On the other hand, while the *Trio* is Webernesque in the paucity of its musical raw material, it is the utter antithesis of Webern in its "telescoped" length. Many a Webern piece could be played in its entirety during a single Young rest.

While the *Trio* seems anything but programmatic, appearances may be deceiving. The simplicity of the title itself, like *for Brass* and *for Guitar,* discourages extra-musical associations, and Young would seem to emphasize further the aura of absolute music in describing the composition as "evolving from the universal truths of harmonic structure" [*30-Year* 7]. Nonetheless, these truths had never been explored quite so radically in composition as opposed to theory. The Serialism in which Young had roots is itself distinguished by a puritanical reversion from the programmatic, a process with obvious parallels in the early abstract painting which developed simultaneously with dodecaphony. Yet it is interesting

that Young traces the Viennese roots of Minimalism back to Schoenberg's *Five Pieces for Orchestra*, Op. 16, specifically the stasis of "The Changing Chord—Summer Morning by a Lake—Colors."

Young himself was to become almost obsessively concerned with chordal permutations in his epic *The Well-Tuned Piano*, where his imagery tends less to the idyllic than to the fantastic. Instead of "Summer Morning by a Lake" Young presents "The 189/98 Lost Ancestral Lake Region," the title illustrating his progressive absorption in harmonic mathematics as well as the mystical proclivity of his work. His titles are permuted along with his chords, moving from the colloquial ("Young's Boogie in Eb") to the paleontological ("Young's Böse Brontosaurus Boogie"). Many of his titles allude to prehistory: the very opening of *The Well-Tuned Piano* is entitled "The Theme of the Dawn of Eternal Time." This is programmatism of a cosmic order, and it is not a literary accretion but intimately related to the harmonic structure of the music, which represents a vast extension of the earlier works. The first version of *The Well-Tuned Piano* was written in 1964, and its titles are as much a product of the later decade as the cool reserve of the earlier works is a product of the previous one. The one exception to the chronological pattern is Young's fancifully romantic "on remembering a Naiad" subtitle of *Five Small Pieces for String Quartet*.

Composer Ingram Marshall has suggested that, despite fundamental differences, Minimalism shares with Integral Serialism a post–World War II reaction against Romanticism, perceived as a contributing agent of mass destruction, much as three decades earlier neo-Classicism represented a stylistic retrenchment after the horror of the literal trenches of the first World War [*AC* 198]. Both neo-Classicism and Serialism replace the expressive theory of composition that is a remnant if not an invention of Romanticism with a more objective concept of the artwork as a formal construct. By its very nature as the basis of a composition, the tone-row itself, even before its elaboration, immediately restricts with its exigencies the element of spontaneous self-expression by the composer, just as it served historically to neutralize the anarchic component of atonality and what Schoenberg referred to as its concomitant "emancipation of dissonance." Along with his Serial exposition, Young's bare exposition of intervallic relationships seems almost puritanical in its self-abnegation. The results, however, are like nothing else in Serialism, for the simple mathematics governing his choice of intervals, combined with the spareness, and for thirteen bars at a stretch, emptiness, of his horizontal as well as vertical texture, suggest an otherworldly purity diametrically opposed to the frigid complexity of most contemporary Serialism and the war-torn continent it expressed and evoked.

Young is fond of Gertrude Stein's statement "The music comes out of the land," and his own land was not Vienna or Paris. Though he has not made the connection, the spaciousness of his work suggests a pristine image of the western frontier where he was born (environmental influences on Young will be discussed later). Beyond that, however, as long

tones extend into theoretically endless drones, Young's wide open spaces are those no longer of Idaho, Utah, or California, where he spent his first twenty-five years, but of the Creation, his mathematics not dodecaphonic but Pythagorean.

Young's movement to the Pythagorean mathematics of the harmonic series is foreshadowed in the works of 1956–58 with the predilection for perfect fourths and fifths they share with the Pythagorean scale and the just intonation derived from it. Half a decade later, Young's research into the mathematics of the harmonic series would lead him towards a deeper identification with the Pythagorean brotherhood's mystical conception of number as all. If the last adjective seems portentous to most, it neither embarrasses nor frightens the composer, who has remarked quite casually that there is "nothing wrong with being mystical" [AC 64]. It was ultimately his mystical proclivities rather than the puritanism of his time that led Young to overturn the academicized Serial tradition by the most radical constriction of technique in Western music, and to redirect a style which had incarnated the anguished fragmentation of Europe toward the expansiveness of America and thence the primal mythic unity antedating either continent. These same proclivities, firmly grounded in mathematical and harmonic theory, led Young from long tones in the 1950s to drones in the 1960s, and from the appropriately spare but deceptively unassuming title of the *Trio for Strings* to the more grandiose Theatre of Eternal Music.

At the first private performance of the *Trio* in fall 1958, "Almost everyone thought that I had gone off the deep end," Young noted many years later [Palmer 1981 51]. Though others were supportive, he felt at the time that only Terry Riley and his Los Angeles friends Terry Jennings and Dennis Johnson understood what he was doing. Riley concurs, vividly recalling that at Young's subsequent presentations at college conferences "composers would laugh La Monte off the stage, because nobody could take that seriously as music—only very few people" [AC 59, 110].

Seymour Shifrin was not one of them. He still obliged Young to come up with a more complex and directional piece in order to receive a grade. Young went as far as *Study I*, which fulfilled the course requirements while including long, spare, meditative sections. According to Young, Shifrin complained that "I was writing like an eighty-year old man, and I should be writing 'young' music with lines and climaxes, and progress and direction" [Vidic 25]. Opting instead for Young music, the composer had already set a clear course. Rejecting the remnants of the taxonomic and climactic structures Western music inherited from classical rhetoric and the Judaeo-Christian metanarrative of history, his music was going nowhere, and not fast.

K

Of the three fellow composers Young has said understood what he was attempting in the late fifties, Dennis Johnson has not made his work public, though he has privately circulated tapes of his piano music from the late 1950s. Young met Johnson at UCLA in 1957. He was walking down the hall and heard a beautiful rendering of the Webern Op. 27 *Variations for Piano*, entered the practice room, sat down, and introduced himself when the piece was finished.

Terry Jennings was almost five years younger than Young but old enough to have a local reputation as both a classical clarinetist and a jazz saxophonist when they met in L.A. in 1953. Young had graduated from Marshall High School, a tough interracial public school renowned for its music program, and had been bowled over by a tape of alto improvisation by an incoming student at Marshall. One night on a gig with the Willie Powell Big Blues Band as alto soloist he found the improvisor, Terry Jennings, next to him on the bandstand. (Child labor, not cabaret cards, was apparently the rule: trombonist David "Gordo" Sanchez, the former classmate of Young's in whose practice room Young and Jennings next got together, was a veteran of Perez Prado's touring band at the ripe old age of fifteen.)

Jennings was a child prodigy and may ultimately have found that a dubious blessing. According to legend, at two years old he was selecting his own records from the family collection, at four was playing Beethoven four-hands, at twelve was alternating Cage's *Sonatas and Interludes for Prepared Piano* with virtuosic jazz on alto, and at thirteen sight-read the E-flat clarinet part of the Schoenberg Op. 29 *Suite* on a B-flat clarinet. Sometime that year or the next, when he undertook saxophone studies with Young's teacher at the Los Angeles Conservatory, William Green, he

is rumored to have found time to write an opera, now lost if ever completed (or in fact begun).

At eighteen he became the first composer to follow in the long-tone footsteps of Young. At twenty he was the featured composer in the first two concerts in the series of avant-garde music Young produced in Yoko Ono's 112 Chambers Street loft, beginning with the long-tone, long-rest *Piece for Two Saxophones* played on altos by the composer and producer. At forty-one he was found murdered behind a supermarket, face down in a puddle of mud, evidently on the wrong end of a drug transaction. Jennings had begun his career as an addict while simultaneously orchestrating Stravinsky for his junior high school orchestra. In the intervening years he had pawned many an instrument, some not his own, for dope. Not long after producing his New York debut, Young saw him on the Bowery, "begging for pennies."

Musical Minimalism in the 1950s consists largely of the work of Young, although by the end of 1959 Dennis Johnson had composed *The Second Machine*, which consists of four pitches derived from one of Young's "dream chords," the quadrads that were the harmonic basis of Young's long-tone works and came to be the entire content of *The Four Dreams of China* in 1962. As described by Young, Johnson's work involved not only Minimal but mechanical aleatorics, with his pitches "presented according to a unique system of permutations obtained from the scores which consisted of matboard constructions with dials to spin and notated strips to slide past windowed openings in the board" [Young *Jennings*]. Johnson, like Jennings, was both gifted and too fragile for the music business—as brutal in classical as in rock music, though the sounds be sweeter. Vocationally he applied his extraordinarily mathematical aptitude (he passed the doctoral comprehensive exam as an undergraduate) to computer science, improvising in his free time.

But it was Jennings, still in his teens, who first followed Young into long-tone composition. What is remarkable in this is not so much his compositional ability as the open-minded perspicacity of a teenager confronted with music so far from either the classical or jazz mainstream and so alien to the virtuosity he commanded at the classical keyboard or on jazz and blues alto. In late 1958 Jennings composed a *Piano Piece* influenced by the long tones, prolonged rests, and harmonies of Young's *for Brass* and *Trio*. Kyle Gann describes it as "dodecaphonic and extremely slow, reveling in a decay of dissonant sonorities" [quoted in Young *From Ancient Worlds*].

In 1960 Jennings composed two works entitled *Piano Piece; Piece for Strings; Piece for Cello and Saxophone* employing drones in modal configuration under the John Coltrane influence that continued to dominate his saxophone style for years; and *String Quartet*, clearly influenced, like Riley's similarly scored piece of the same year, by Young's *Trio*, but with less innovation. Young notes that the June *Piano Piece*, which he published in *An Anthology*, "very clearly references Morton Feldman" [*Jennings*]. The

connection to Feldman's "free-rhythm notation" begun three years earlier with *Piano (Three Hands)* may be clear, but its opening A-flat, A, B-flat in different octaves immediately calls to mind the first three pitches in Young's *Trio,* and the seventh of the nine "measures," consisting of a rest noted as fifteen seconds or longer, leaves no doubt whatsoever of its lineage. Here at least Jennings is adapting Young to a different medium. Young's piano works to this point had not incorporated the severely reductive style as unremittingly as this although the bulk of *Study III* was comprised of long tones and rests. Jennings is in a sense taking the Stockhausen out of *Study III,* reducing it further with the model of Young's own *Trio.* In Jennings's *String Quartet,* however, Young seems to be imitated rather transparently if not quite exactly.

Although the differences did go beyond the obvious one of adding another musician to the string trio, and although Young himself points to the originality of Jennings's octave doublings and unusual voicings, Michael Nyman correctly summarizes the piece by noting that Jennings managed to "extend and slightly simplify the procedures of Young's pieces" [Nyman 1974 121]. The dynamic markings, including the quad-rupled *p,* echo Young's, but the durational notation is now simplified by the omission of bar lines, which Jennings replaces with stopwatch markings superimposed above the top staff to mark elapsed time. Young himself has for years kept a stopwatch in sight during his marathon performances of *The Well-Tuned Piano.*

Jennings's *Quartet* opens with the first violin and viola playing B-naturals two octaves apart and the second violin E over middle C. At 1:35 the first violin drops to C-sharp for a fifty-five second solo. At 2:25 it is silenced for a fifty-five-second duet on, not in, D-sharp (below middle C on viola, two above middle C on second violin). After the exertion of the perfect fifth/fourth, single tone, and octave doubling, it is time to rest for a full minute before returning with reinforcements, the cello playing *pppp* harmonic doubling to the muted second violin's D-sharp, while with a Webernian and Youngian fondness for half-steps the viola sustains a D-natural and the first violin a C-sharp, both also muted. At 12:05 a rest of two minutes and ten seconds begins, which takes us just past the midpoint, in a sense the climax as well as the mathematical center of gravity, of the twenty-eight minute and twenty-second work, which contains a grand total of forty-three notes.

His greatest contribution to the development of Minimal music, like Johnson's, may have been his piano compositions. Young acknowledges that in this area both composers influenced him in turn, Johnson with a very sparc and beautiful six-hour piano work begun in 1959 and entitled *November,* which sounds like something Debussy and Satie might have come up with if they had been shipwrecked with Young and a keyboard for a year. Two years before Young heard it on tape, it had helped inspire Jennings's E-flat *Piano Piece* of November 1960, the slow, spare style of which was also influenced by Young's *Trio* and which clearly influenced

in turn the non-"cloud" sections of his *The Well-Tuned Piano*. Although Young had only heard less than two hours of Johnson's work on a 1962 tape, two years before completing the first version of his *The Well-Tuned Piano*, he includes Johnson along with jazz great Bud Powell among the subliminal influences on its evolution. The opening of *November* in fact strikingly anticipates that of *The Well-Tuned Piano* as it later developed. Along with Terry Riley's all-night concerts, which he began in Europe in 1962-63, *November* provided a durational precedent for Young's master-work, which continues expanding like the universe. It is important to note, however, that by the time he completed the initial forty-five-minute tape Young had already worked in extended durations of works as well as notes, in the *Trio, The Four Dreams of China* and what became known as the Theatre of Eternal Music, as well as some conceptually eternal pieces in *Compositions 1960* examined in this chapter.

Jennings remains best known for the spare repetitive works of the mid-sixties, *Winter Trees* and *Winter Sun*, which influenced Harold Budd and other West Coast pianists in the early 1970s, after which Jennings himself veered towards a neo-Romantic style. The quiet *Winter* pieces may be influenced by the ad lib repetition of phrases of Terry Riley's then-recent and un-quiet *In C*, while its reliance on the sustaining pedal may suggest the influence of Young's drones as well as that of the stasis of modal jazz in which Jennings had immersed himself since the late 1950s.

Riley made two major contributions to early Minimalism: the re-introduction of tonality in tandem with the use of repeating musical modules, the latter derived from his influential work with tape music. The *String Quartet* he produced in 1960 was constructed like Jennings's quartet of long tones but within a tonal context. Prophetically, the key Riley chose was C major, the most emphatic way of making a break from atonality, using a staff without accidentals but now as a key signature. Riley's earlier compositions had been in a Serialist vein, including the *Trio for Violin, Clarinet and Piano* he wrote as an undergraduate at San Francisco State, where he studied composition with Wendall Otey. After graduating in 1957, Riley studied for a year or so with Robert Erickson at the San Francisco Conservatory, then audited at UC-Berkeley before registering officially in 1959. A piece from the same year called *Spectra* emulated Stockhausen's *Zeitmasse* in its use of different tempi for each instrument (Stockhausen used five, Riley six).

Riley describes his meeting Young in Berkeley in terms of finding a spiritual brother. They almost immediately began collaborating musically, Riley playing Young's piano studies and violin in other Young works. Violin was Riley's first instrument, on which he began lessons around his sixth birthday, before moving on to piano two years later. Like Young, Riley had grown up with far greater exposure to popular than to classical music. Young's primal sonic memory is the wind off Bear Lake, but for

Riley, who is just four months older, it was the sound of the radio. He notes that he tried to sing before he could speak, joining in on "Pennies from Heaven" and similar songs on the radio in a whistle-stop town in the Sierra Nevada foothills named Colfax, near which he still lives. When saxophonist Young was studying his Uncle Thornton's swing-band fakebook, Riley was exploring the same repertory on piano. Both played in dance bands in high school and college for spending money before meeting as graduate students. Like Young, Riley was from a modest background, and without his ragtime piano playing would have been unable to keep himself afloat through the bachelor's degree and support his new family through the master's degree.

Whereas Young found the barroom scene constraining and distracting, Riley has said that he prefers it to the regimentation of the classical concert. He took advanced lessons in ragtime piano with Wally Rose while studying post-Serial music in Berkeley, and considered his saloon ragtime no less interesting than his later professorship of Indian music at Mills College through the 1970s. Although Young's jazz background was as strong as Riley's, it was Riley who was to incorporate the jazz element more profoundly into his classical compositions, and who continues to maintain that America's greatest contributions to music have been from jazz rather than the classical tradition.

In 1959 and 1960 Riley and Young worked together with choreographer Ann Halprin. Young had been put in touch with her by John Cage at a time when she was making, in *Birds of America*, what she described as "a specific break with what I had been doing previously as a traditional modern dancer" [Kostelanetz 1968 67]. Although Halprin danced to Young's *Trio*, the sounds he and Riley produced to accompany her troupe were of another order. They were described by Wim Mertens as "unusual sounds . . . held for minutes or sometimes hours on end" [Mertens 21], a tame synopsis since these timbral experiments consisted largely of ear-splitting friction sounds created by metal objects being scraped against glass, wood, or other metal surfaces. John Cage had joined Webern as an influence on early Minimalism seven years after *4'33"*.

Cage was little known and less honored on his native West Coast when Young was first exposed to his work at Karlheinz Stockhausen's summer composition seminar at Darmstadt in 1959. Despite obeisances to Stockhausen's own recent *Klavierstücke*, the score of Young's *Study III* for piano was coolly received by his fellow students as "somewhat radical and abstract" [Vidic 25]. The work, which takes about twelve minutes to perform, was Young's longest piano piece to date. Like the *Trio*, it applied extraordinarily sustained tones and extended rests to Serial composition; unlike the *Trio*, it was not solely composed of long tones and rests, since there are several short gestures reminiscent of Stockhausen and even two passages of fast notes. David Tudor, who with Cage would soon

introduce Young's work to audiences on both sides of the Atlantic, was
scheduled to perform it at Darmstadt at a concert of student compositions,
but the score mysteriously disappeared the day before and reappeared a
day or two after. Tudor's normally meticulous nature leads Young to
wonder whether the seminar director was interested in having the work
presented at all. Stockhausen did praise Young's *Trio* when the composer
with uncharacteristic timidity waited until shortly before the seminar
ended to show him the score. Over thirty years later Young explains his
hesitancy, still with palpable frustration, as the result of his having
experienced enough misunderstanding already at the seminar.

Although Stockhausen's explorations in areas as various as electronic
distortion, precompositional design, and orchestral placement were to
influence his work, the most important experience of the seminar for
Young may have been his exposure to Cage's music as preached by
Stockhausen and played by David Tudor, the pianist and Cage collaborator
in attendance, who within a year gave the first public performance of
Young's works in New York and Europe.

Back in Berkeley in the fall, while working with Riley in the Halprin
collaboration, Young began to produce compositions in which the Cage
influence was obvious. *Vision* was notable even for its name after the
earlier, almost clinically descriptive titles. Cage's Zen concerns with seeing
and nonseeing were in evidence in the performance of the thirteen-
minute piece with the lights out. This practice conduced to a desegregation
of performers and audience that became a feature of Young's perfor-
mances [cf. Cage 1961 40]. So did the positioning of the players around
the room, as in Stockhausen's *Gruppen,* a piece Young admired which
had been premiered just a year before the Darmstadt seminar, and the
"spatial music" of Henry Brant, whom Young also admired. Young
continued his use of long tones on classical instruments, but Cage's
philosophy seems to have affected him in a manner similar to the effect
of Transcendentalism on Ives, for in accordance with Cage's nonjudgmen-
tally inclusive aesthetic, the tones produced were not the subdued
perfect intervals and minor sevenths of the trio but "really wild sounds"
(e.g., "Howl," "Growl," "Herd of Elephants") on an instrumentarium
including both a reedless bassoon and a bassoon reed and crook, with
durations (up to four minutes-plus) determined by logarithmic relation-
ships, reflecting Stockhausen's timbral explorations and pre-arranged
compositional structures. The latter was combined, however, with Cageian
aleatorics, insofar as numbers picked out of the telephone directory
determined the apportionment of the durations. Young's mathematics
soon found a sculptural analogy in the widening intervals within the
serial placement of components in Donald Judd's grooved boxes and
reliefs.

Random digits also controlled the more radically open-ended *Poem
for Tables, Chairs, Benches, etc.,* which involved moving the furniture in

question across the floor, producing a wide range of sonic effects—from cello-like sustained tones and squeals reminiscent of free jazz to (in)voluntary percussion or, to non-Cageians perhaps, a lot of noise.

Quite significantly, though, there was not necessarily a lot of anything in Young's Minimalist version of Cageian experimentalism. Some realizations of the piece have gone on for close to an hour and involved large groups of participants ("performers" suggests a dichotomous and here unidiomatic relationship with "audience," since presumably anyone in attendance who so much as causes his chair to squeak by shifting his position or a floorboard to rattle by fleeing the room thereby becomes a participant in the collective poem). Another midscale realization was used to accompany choreographer Yvonne Rainer's *Three Seascapes.* One realization, however, was solo and, according to the composer-performer, "about a quarter second long. I just moved a bench" [*AC* 62]. According to Terry Riley, their performance of the piece at the Western Student Composers Symposium at Brigham Young University in Provo, Utah on April 30, 1960, provoked not only ridicule but public denunciation by one professor so outraged by the piece that tears came to his eyes when he rose to speak.

Young's next work, in April 1960, was an outgrowth of his live accompaniment for Ann Halprin's dancers. In recorded form, the piece followed Stockhausen into tape composition, using two tapes, each devoted to a different sound. On the first, Young scraped two cans against a glass door while Riley scraped a single larger (no. 10) can against a window. On the second and shorter tape, which normally begins after and ends before the first, Young played a gong with drumsticks. The piece was called simply *2 sounds,* although it originally contained a third sound—a triangle rattled inside a bucket—soon discarded. The piece was in a sense an extract from the months of experimentation with assorted friction sounds Young and Riley had produced for Halprin by scraping metal, glass, and wood against various substances. In one realization Young did not drum the gong but dragged it over the concrete floor while Riley scraped a wastebasket against the wall. This particular performance led the audience to burst into both loud swearing and *The Star-Spangled Banner* in self-defense.

The twelve-minute tape Young made of *2 sounds* was used, in turn, by Halprin's former student Simone Forti to accompany her rope piece in which the performer suspended by a rope was rotated and let go to ride the unwinding. It should be noted, however, that Forti listed the piece as an accompaniment to *2 sounds* rather than vice versa [Forti 64]. Merce Cunningham used the same tape in 1964 to accompany his choreography in *Winterbranch.* The free form of the piece thus proved amenable to the work of quite different sensibilities, since Forti had been dissatisfied at the school of Cunningham, "a master of adult, isolated articulation . . . the thing I had to offer was very close to the holistic and generalized response of infants" [Forti 34]. The title of *2 sounds,* it may be worth noting, itself

set a precedent for titular economy and enumeration in Minimalism: for example, Steve Reich's *Four Organs* and *Music for 18 Musicians*, Philip Glass's *Two Pages, Music in Eight Parts*, etc.

In the summer of 1960, Young left the Berkeley campus for New York on the Alfred Hertz Memorial Travelling Fellowship, in part, purportedly, because some members of the music faculty were anxious to see the fellow travel. If so, they succeeded beyond their hopes, since Young never came back. The raucousness of the audience's response to some of his performances (when not inspired to patriotic fervor and obscenity, they laughed disruptively, tore up programs, slammed doors behind them, and so on) did not create the kind of ambiance the institution hoped to foster. In any case, Young went east to study electronic music with composer Richard Maxfield at the New School, while Riley stayed on at Berkeley another year, feeling very much *persona non grata*, and finished his M.A. requirements while working in the San Francisco Tape Music Center with tape-loops. This led to the next phase of his work with Ann Halprin, as represented by his score *The Three-Legged Stool* for her and in a sense most of his work as a composer throughout the 1960s.

An important transitional piece between Young's long-tone and drone periods is the seventh of the conceptual *Compositions 1960*, ten of which (#2 through 7, 9, 10, 13, and 15) were published in an anthology of avant-garde art entitled *An Anthology of Chance Operations/Concept art/ Meaningless work/Natural disasters/Indeterminacy/Anti-art/Plans of action/ Improvisation/Stories/Diagrams/Poetry/Essays/Dance constructions/Compositions/ Mathematics/Music*, which appeared in 1963, over two years after completion in early 1961. It is commonly known by its minimal nickname, *An Anthology*. *Compositions 1960* was begun in Berkeley before Young left for New York, independently of the "minimal score" efforts of George Brecht the previous year, with which he was not familiar. In *Drip Music (Drip Event)//For single or multiple performance*, Brecht had specified that "A source of dripping water and an empty vessel are arranged so that the water falls into the vessel" [Davis 90]. This is as audible as it is minimal.

The constituent compositions of Young's *Compositions 1960* were created for the most part without musical notation, indeed largely without anything recognizable as music, even within the Cageian acceptance of any sound as music. Young himself has made ambiguous statements which call into question their credentials as musical compositions (see below) or even audible phenomena as opposed to "performance art," that generic no man's land that sounds, as its acclaimed practitioner Laurie Anderson has observed, like a bad translation from the German. *Compositions 1960* is in fact listed by the composer in his résumé as "performance pieces" (which sounds equally comfortable in that language).

The work *Compositions 1960 #9* once again provided an adaptation of Cage by a Minimalist sensibility, in this case Cage's graphic notation (already adapted notably by Feldman, Earle Brown, and Christian Wolff),

in the form of a straight line drawn by Young on an otherwise unlined index card enclosed in an envelope inside the back cover of *An Anthology*. While this could be construed as archetypal Minimalist art like the 1952 line drawings by Ellsworth Kelly it closely resembles, Young has realized it as archetypal Minimalist music by sustaining a single tone in performance.

"#15" in the series, however, ran thus: "This piece is little whirlpools in the middle of the ocean." It was dedicated, appropriately, to Richard Huelsenbeck, one of the original Dadaists, later a New York psychologist, still later a lecturer on Dada. Whether or not one accepts Young's claim to be the first Conceptual artist, this composition goes beyond music and noise alike. Even its silence is of a different order than *4'33"*, which I at my desk may now correctly describe and you in your room now correctly conceive as silent, but which in performance inevitably becomes an environmental, even an audience-participation piece, just as Rauschenberg's white paintings lose their whiteness once out of isolation and on exhibition. The silence of Young's "#15," on the other hand, is absolute and inviolable as long as someone does not choose to perform it musically.

If we take the statement of "#15" as a program rather than a koan, something meant to be performed rather than to provoke meditation, any conceivable realization (dancing in turbulent circles or spinning a finger, gargling, trilling saxophones, toodling flutes...) comes closer to Jules Feiffer and McNamara's band than the spirit of "#15." It is music if we accept not only an infinity of sounds as music *à la* Cage but an infinity of imaginings. I personally do not believe it is music any more than this sentence, although it is a more interesting sentence. The excellence of Marian Zazeela's realization of the piece as an ink drawing suggestive of the whirlpools does not qualify it as music either. Young was forced to extend his definition of music to absurd lengths in order to categorize his works as such. When asked by Kostelanetz whether, "music being any-thing that makes a sound," there was anything that was not music, Young replied, "There probably are very still things that do not make any sound. 'Music' might also be defined as anything one listens to" [1968 203]—a definition which might accept the man in the moon or next Wednesday as musical compositions.

"#2" was not musical in the traditional sense ("Build a fire in front of the audience") but has an immediately audible as well as visual quotient. In one instance, in fact, it was realized in traditional classical instrumen-tation, a ten-dollar violin Young stuffed with matches soaked in lighter fluid and set aflame during a performance of Richard Maxfield's *Dromenon*, which continued unabated during and after the work-within-a-work.

Other conceptual pieces were more specifically scored, namely the two groups of piano pieces written for Terry Riley and David Tudor (who had premiered *4'33"* in 1952), interspersed with *Compositions 1960* in *An Anthology*. The best-known of these, *Piano Piece for David Tudor #1*, the first of three, also dating from 1960, directed the pianist to "bring a bale of

hay and a bucket of water onstage for the piano to eat and drink," while *Piano Piece for Terry Riley #1* (#2 was not published) required the pianist to keep pushing the piano until exhausted, intervening obstacles such as walls notwithstanding. While undoubtedly comical—composer Jim Burton revived "Tudor #1" in autumn 1973 at Hunter College and "his fine pantomiming made the piano really look like a horse" [Johnson April 28, 1974]—the works make statements at the same time, deflating concepts of the artist, and specifically the pianist, inherited from the nineteenth century. The virtuosic showman and romantic martyr reappear as work-horse and farcical Sisyphus. The delicacy of the romantic artist and the mystery of his art may be the objects of parody in the second Tudor piece, which require the pianist to continue trying to open the keyboard cover inaudibly until he succeeds or gives up. The last of the Tudor pieces echoes the whirlpool piece, reading thus: "Most of them were very old grasshoppers"—music that will never disturb the neighbors.

If the piano pieces subvert the interpreter's role, two of the works from *Compositions 1960* subvert that of the audience by confusing it with that of the performer. Both may be interpreted as extensions of Young's mingling of musicians and spectators in *Vision*, especially "#4," which again specifies lights out. Unlike *Vision*, however, "#4" does not follow the extinguishing of the lights with music. The lights are turned off for the previously announced duration of the performance, and when they are turned on again the performance is over and the audience may be advised that their activities have been the composition, "although this is not at all necessary." In "#6" it is more the social ritual of the musical performance that is addressed by Young: the performers onstage mimic the usual activities of the audience, seated in rows if at a concert hall, leaning on a bar with drinks if at a club. Outside the performance space, each patron may purchase either a stage or audience ticket, to further confuse, or simplify, the issue. This contamination of the artistic ambiance and merging of "art" and "life" anticipate by a decade Peter Handke's *Offending the Audience*, in which the actors address clichéd critiques at the spectators.

The only conceptual composition of this year employing any form of standard musical notation, however, was "#7," which offered a G-clef and an open fifth, B below and F-sharp above middle C, along with the instruction "to be held for a long time."

The border between Minimal and Conceptual art may be as tenuous in music as it is in the performing arts (cf. Klein). Arguably, *Compositions 1960 #7* partakes of both realms. On the page it is an image of harmonic perfection, echoing that primal C-G fifth in the *Trio for Strings*, interestingly, just a semitone lower. Its duration is theoretically infinite and has been realized in hour-long performances that paved the way for Young's drone period. Once it is played, "#7" moves from the conceptual realm to the realm of Minimal music—very minimal indeed in terms of technical complexity and ostensibly but *not* necessarily in terms of content.

Performed in New York in 1961 by a string trio, which Young, after his merciless parsimony three years earlier had now taken to the limit of tonal deprivation, it projected to the attentive not only a perfect fifth but "a whole inner world of fluctuating overtones" [Hitchcock 1974 250]. The phenomenon of overtones unquestionably influenced the direction Young was to take shortly thereafter and follow to the present.

Others in the series of *Compositions 1960* were more amenable to the "performance piece" rubric, such as "#5," and "#10." The first of these directed the performer to turn one or more butterflies loose in the performance space. While this might lead to a visual extravaganza, Young appears to have focused on the Zen-like sonics of the piece, unless his question to Tony Conrad, "Isn't it wonderful if someone listens to something he is ordinarily supposed to look at?" is dismissed as tongue-in-cheek or affected aestheticism (an interpretation given support by his attention-calling dress at the time: a black velvet suit and massive black cape).

Young insisted to Richard Kostelanetz, "All my pieces, I feel, deal with music, even the butterflies and the fire" [Kostelanetz 1968 194]. They do so, however, in the manner of the Zen koan calling attention to the sound of one hand clapping, and the inspiration is again Cageian— apart from *4'33"* eight years earlier, in 1960 Cage completed his antitract *Silence* for publication the next year, followed the year after by *0'00"*, the piece mentioned earlier which he once realized by amplifying the sounds of his making and then drinking vegetable juices onstage. The latter work, however, does seem to have been anticipated by Young in *Compositions 1960 #3*, more stripped-down and perhaps more directly confrontational than the lights-out of "#4," to which it is closely related conceptually as well as chronologically: "Announce to the audience when the piece will begin and end if there is a limit on duration. It may be of any duration. Then announce that everyone may do whatever he wishes for the duration of the composition." Young's relatively infrequent *laissez-faire* mode was also represented in "#13," which instructed one to choose any piece of music and perform it as well as possible. (Henry Flynt once cleverly performed "#13" by choosing "#13" as his piece, taking concept art to the next degree.)

Young was also involved in the exploration of alternative performance space, producing the first series of loft concerts on record at Yoko Ono's on 112 Chambers Street in the winter of 1960-61, where Jennings's and Riley's work was performed along with that of other artists soon to be associated with the Fluxus movement, a group vaguely led by George Maciunas which has acquired considerable and in good measure posthumous fame. The group combined Cage, Dada, Artaud, Absurdism, and Spike Jones in a confrontational aesthetic with sadistic as well as Zen trappings, in what today often seems a rather jejune mix. (Robert Morris, who disaffiliated himself from the movement in 1964, a year or so after Young, has said that "The Fluxus performances under the direction of

Maciunas were nothing more than vaudeville, shallow revivals of the Dadaist performances of Hugo Ball and Tristan Tzara" [quoted in Berger 28].) George Brecht played with the context of the musical "performance," offering solos for flute, violin, and piano reminiscent of Young's piano pieces for Riley and Tudor, which involved dis-/re-assembling the first, polishing the second, and putting a vase of flowers on the third.

Rather than placing flowers on the piano, Nam June Paik in turn decided to place the piano on a plane and drop it off. The Asian wing of Fluxus seems especially fascinated by images of destruction, with pieces by Yoko Ono and Takehisa Kosugi frequently referring to and suggesting dismemberment/mutilation in affected deadpan. Ben Vautier was more immediately confrontational, however, in producing audience pieces that locked the audience in or out of the theater, the latter perhaps the more merciful composition.

Young says that he found the pervasive element of destructiveness in Fluxus offensive and simply wanted to try something different. He might well have stayed in the underground limelight by continuing the concept art—the term, by the way, derives from Henry Flynt's essay of the same name in *An Anthology*—which influenced the performance art of Fluxus and thence the continued proliferation of "happenings," celebrated publicly at least as early as Allan Kaprow's *Eighteen Happenings in Six Parts* in October 1959.

Young followed up *Compositions 1960* with *Compositions 1961*, released as *LY 1961* in the form of a miniature book, three and a half by three and three quarters inches. After calculating that he had been completing a new piece on average every thirteen days, on January 6, 1961 he decided to write a year's worth at one sitting. He did this by repeating "#10" from the previous year's collection twenty-nine times. "#10" (dedicated "to Bob Morris," soon to introduce the Minimal forms of monochromatic columns, slabs, and polyhedrons in "Morris gray") had developed the straight-line motif of its immediate predecessor (the vertical line on an index card) with a more explicit command, "Draw a straight line and follow it."

Young's instruction pieces were widely emulated, reaching the overground ten years later when Yoko Ono's collection *Grapefruit*, origi- nally published in Tokyo in 1964 in a limited edition of five hundred copies, was expanded, updated, and reissued by Simon and Schuster with a very literal Introduction ("Hi! My name is John Lennon / I'd like you to meet Yoko Ono"). Ono's often brilliant pieces brought a distinct sensibility to the art-form, sexually ("Walk Piece": "Stir inside of your brains with a penis until things are mixed well. Take a walk") and ontologically ("Blood Piece": "Use your blood to paint. Keep painting until you faint. (a) / Keep painting until you die. (b)"). The book opens with its "Music" section and "Secret Piece": "Decide on one note that you want to play. Play it with the following accompaniment: The woods from 5 a.m. to 8 a.m. in summer," followed by a notation of an F-natural

below middle C "with the accompaniment of the birds singing at dawn."
This is one of the more lyrical works; others more austere take off from
Young's piano piece for Riley ("Orchestra Piece": "Hit a wall with your
head"), harmonic concerns ("Overtone Piece": "Make music only with
overtones"), Minimal style ("Water Piece": "Water" and "Fly Piece": "Fly,"
the latter subsequently used as the title of one of her LPs), and "#10"
itself ("Line Piece": "Draw a line. Erase a line" and "Line Piece": "Draw a
line with yourself. Go on drawing till you disappear"). As noted, it was
common practice for one concept artist to "answer" a composition with
another composition.

In *Compositions 1961* Young answered, or at least echoed, himself.
Compositions 1961 #1 was dated January 1st, *Compositions 1961 #29* Decem-
ber 31st; all were assigned their dates on January 6th (the Feast, appro-
priately, of the Epiphany, although Young seems not to have noticed).
Normally this would seem to suggest disenchantment more than afflatus,
particularly in light of Young's subsequent abandonment of concept art,
which he called the Theatre of the Singular Event, for the drones of
the Theatre of Eternal Music. But boredom was very much a part of the
post-Beat avant-garde aesthetic, and Young did in fact perform "all" the
pieces. He drew a line and drew over it twenty-eight times..."and each
time it invariably came out differently. The technique I was using at the
time was not good enough" [Kostelanetz 1968 205]. Young performed—
he uses the word "played"—all the pieces "composed" from the first to
last day of 1961 one evening in March of that year.

L

In his 1960 *String Quartet* Terry Riley had introduced tonality to long-tone composition, while following Young's use of a traditional string ensemble in his breakthrough into full-fledged Minimalism in the *Trio for Strings*. The next year Riley made his second important contribution to the evolution of Minimalist style in introducing the element of phrasal repetition as a central structural principle in his own *String Trio*. Just as the C-major tonality of the *Quartet* represented an emphatic reversion from dodecaphony, so the unvaried repetition of tonal phrases marked a radical compositional simplification in the context of approved Serial developmental techniques of inversion, retrograde, and transposition of the *prima materia* of the tone-row. At the same time, however, Riley's interest and training in Serialism remained evident in that the tonality of "very simple repetitive motives" was surrounded by a "lacework of chromaticism." The relationship between the two approaches to harmony seems almost symbolic of the development of Minimalism, as the tonal repetition moves to the musical foreground and the chromaticism to the background. For Riley, in any case, "That was the transitional piece" [*AC* 112].

Repetition proved to be as influential an element as sustenance in Minimal music, perhaps more so insofar as those later composers like Steve Reich, Philip Glass, and John Adams who built their works out of repeating structures were more successful in incorporating their work, however begrudgingly, into the classical mainstream than were composers like Jennings, Phill Niblock, Yoshi Wada, and Pauline Oliveros who made significant contributions to music built on various forms of sustenance.

Both techniques have clear analogies in painting. The horizontal as well as vertical stasis of sustenance is the sonic equivalent of the

monochrome canvases that had proliferated for years before Young's long-tone compositions. The modular repetition explored by Riley first with tape and then with instruments is the aural analogue of both the (small-s) serial forms of the panel paintings and the all-over system or deductive patterns of Stella's early work, as well as the later sculpture of Donald Judd and others. Both techniques are about the extension of rudimentary material. All music, other than conceptual compositions, exists in a temporal mode, and sustenance deals with that modality as monochrome deals with space—by an evasion or abnegation of differentiation. Musical repetition deals with time as serial structures in the plastic arts deal with space, by progressing from one unit to the next but without variation, thus providing a more elusive form of stasis.

Young claims to have introduced the element of repetition to Minimalism in his "concept art" composition of April 1960, the previous year, *arabic number (any integer) to Henry Flynt* (originally known as *[X] to Henry Flynt*). The arabic number or X indicates the number of times a sound is to be repeated. Which number and which sound are both left to the performer(s) in Young's characteristically exaggerated version of the indeterminacy practiced by Cage and his followers in open form or graphic notation: Earle Brown, Morton Feldman, and Christian Wolff. The piece is generally realized percussively, whether on keyboard or gong or with "a wooden spoon on a cast-iron frying pan—or with any type of beater on any object" in the description of Peter Yates, who views the piece as a complement to Cage's 4'33" and notes that he has interpreted both works "with pleasure and a not unfavorable audience response" [325-26]. Cage himself found [X] revelatory [*John Cage* 52].

Wiley Hitchcock was also favorably impressed by one realization of the work by Young in which the composer-interpreter hit "an overturned pan with a wooden spoon some 600 times" [1988]—another instance of Young's severely reductive approach to Cageian sound-as-music-as-noise. Whereas Cage's aesthetic embraced a theoretical infinity of sounds as music, Young gravitated again and again to a specific and singular sound-event, on which he focussed normally by means of extended duration, in this case combined with relentless repetition.

An even more extended realization of *arabic number* or [X], if more traditional in instrumentation, dates from March 3, 1961 and was entitled "1698" after the number of times Young played, pounded the same dissonant chord on the piano. Henry Flynt has noted that it was in part by embracing monotony as opposed to wild diversity of sounds within a given work that Young hoped to supplant Cage at the forefront of the avant garde. Flynt has suggested that the deference shown Cage by Young in his later interviews and writings was in good part *ex post facto*—this despite the obvious indebtedness to Cage not only in Young's (problematically) musical compositions but in the lecture he gave at Ann Halprin's summer 1960 dance workshop, which was later published in

Selected Writings. The anecdotal *non sequitur* and hipper-than-thou cool of "Lecture 1960" features Riley (who here appears rather dim), Jennings, and Johnson as the supporting cast (à la Merce Cunningham et al. in Cage's writings for the lecturer/protagonist).

If as lecturer-composer-performer-impressario-editor Young demonstrated more than a dash of exhibitionism, he equally displayed what chronicler Flynt aptly describes as "monastic devotion" [WKCR], working tirelessly as an organizer and in abstruse isolation, sometimes playing the keyboard until his fingers bled. If this was the case with "1698," it seems a digital Gallipoli. The piece is at first grating, then a bore, and at no point particularly inventive, however highly the composer and his circle, who from their correspondence seem to have been, *faute de mieux,* their own biggest fans, may have esteemed it. The product of a brash temperament constitutionally as indisposed to moderation as to disciplehood or false humility, it may be considered an appendix to Satie's *Vexations* half a century later. For the sympathetic it may represent the epitome of Minimalist economy and Young's desire to "get inside a sound"; for the unsympathetic it may have documentary value as a pre-Fluxus period piece despite its obnoxiousness.

Young's *Compositions 1961* represented another form of repetition with its twenty-nine identical imperatives to draw a straight line and follow it. In score the repetition is made more evident by the simultaneous presence of the replicated instructions. In performance, it remains evident only insofar as two or more of the "different" compositions are realized in close sequence, the more compositions performed the more evident, although variations of duration, tempo, medium (e.g., the instrumentation of pencil/paintbrush/file), attack etc. would seem to be crucial in establishing a sense of stasis through repetition rather than proliferating chaos through variation.

In any case, this use of repetition within the context of Cageian and Fluxus performance art is qualitatively different from Riley's creation of a still traditional, if highly experimental, score primarily by means of notated and repeated musical phrases, a technique which looks ahead to his 1964 composition of the piece that led in recorded form four years later to his (and Minimalism's) public breakthrough, *In C.*

Hitchcock argues elsewhere [1988] that Young's drone work dating from 1962 (or 1960 if we include the endlessly open fifth of "Composition 1960 #7") represents an exponential version of repetition—"a drone as repetition carried to the nth degree"—but this seems questionable, since in order for an event to be repeated it has to cease at least momentarily. A long tone is but a tone, though it last forever. This question of drone-as-repetition is also addressed self-contradictorily by Wim Mertens in his book on American Minimal music, in which he states first that "The term *repetition,* however, can hardly be used for La Monte Young's music, since in this case the principle of continuity is decisive," and later in the

same paragraph observes that "Indeed, Young's use of continuity can be considered as a particular form of repetition" [16]. I completely agree and disagree with him.

In terms of phrasal repetition with traditional musical instruments, Young's experiments really begin with the sopranino saxophone improvisations discussed below, which were initiated in 1962, the year after Riley's *String Trio*. His only other (strictly speaking) musical composition involving repetition to that point was *Death Chant*, copyrighted 1962 and so dated in the composer's résumé, but dated 1961 in Robert Morgan's discussion of the work as "especially prophetic" [425]. This composition for male chorus and optional carillon involves the extension of a phrase in uniform quarter-notes from two Gs to two Gs+B to two Gs+B+C to two Gs+B+C+B. The range of the melody is as minimal as its length, not going beyond a fourth. The individual phrases are divided by bar lines, with a repeat sign at the double bar and the notation "to be repeated many times or ad infinitum." This structure in reality seems to be "prophetic" more of the additive process Philip Glass adopted from Indian music to modular construction in the late 1960s than to the repetition and superimposition of unvarying figures introduced by Riley.

The real roots of Riley's *Trio* and subsequent exploration of repetitive structures, through which he became the principal influence on the motoric school of Minimalism that came to the fore in the second half of the decade (*In C* was premiered at virtually the mathematical center of the 1960s, in November 1964), were in tape music: loops, echoes, and feedback in chronological order. The *String Trio* and subsequent works were an outgrowth of Riley's experimentation in the San Francisco Tape Music Center, which led over the course of half a decade through the *Trio* and his tape compositions per se in a direct path to *In C* and the maturation of modular construction.

Tape music was a post-World War II development originating in France with the work of Pierre Schaeffer and his collaborator Pierre Henry, who explored the reproduction and creative distortion of "real world" sounds in *musique concrète* and together composed the 1950 *Symphonie pour un homme seul*. The extra- or protomusical materials in the work were the human sounds of footsteps, laughter, and breathing as well as speech, combined with orchestral sounds. This transformation of what would later be called "found sounds" into what Schaeffer termed *objets soniques* was to distinguish the French tradition in electronic music as opposed to the more radical German tradition of *Elektronische Musik* generated wholly by electronic equipment.

Young's irrefrangibly purist impulses led him from the mid-sixties onwards to concentrate on the latter, with sine-wave generators, oscillators, synthesizers, etc.—creating a harmonic foundation over which live not taped voices and instruments improvised within pre-established parameters. Riley's more freewheeling nature and less theoretical orientation led him to follow in the French tradition. While it was partly by

chance that Riley ended up working in the studios of French National Radio, where Schaeffer had himself worked as a technician, in terms of style it seems as symbolic as Young's trip to Darmstadt.

Before he reached those studios, however, Riley worked closer to home. At about the time he began his graduate studies, Riley also began working with what he describes as "very primitive tape recorders." What most interested him initially was the repetition constructed by tape-looping. He began to distort frequencies by adjusting the speed of the tape. The creation of the repetitive modules of the tape loops gave him the idea of realizing the same process with live instruments. Riley was a founding member of the San Francisco Tape Music Center, where he worked with the cofounders Ramon Sender and Morton Subotnick from 1959 until after he completed his M.A. studies at Berkeley in 1961.

The first such center on this side of the Atlantic had been established in 1951 at Columbia University by Vladimir Ussachevsky and Otto Luening, who gave the first public tape concert in the United States at the Museum of Modern Art in October 1952. With the support of the Rockefeller Foundation, the Columbia studio developed into the Columbia-Princeton Electronic Music Center in 1959, the same year the Tape Music Center was established in San Francisco. The Tape Music Center shared a building on Divisadero Street with Ann Halprin's company and KPFA radio, which two decades later would do a full-scale retrospective of Riley's work, going back to their days of sharing space.

Another reflection of the different temperaments of Young and Riley is in their antithetical attitudes towards their early efforts. Young is a meticulous archivist of his career and laments the fact that he did not bother to save his juvenilia (his first compositions as a teenager were a saxophone waltz and a piece in the whole-tone scale). Riley, on the other hand, has not mourned the many tapes from the early 1960s that have been lost and has said with reference to those that have survived the passing years in deteriorated condition, "I'd just as soon take them all to the dump" [AC 116].

Riley completed tape compositions as early as 1960, including the indecipherably hermetic score of *Concert for Two Pianists and Tape-Recorders* —he and Young were the pianists—but the first tape piece of abiding interest to the composer was produced in France in 1963. While completing his M.A. work at Berkeley, Riley composed the score for Halprin's *The Three-Legged Stool*, called elsewhere *The Five-Legged Stool* (Riley suggests because Halprin might have changed the number of legs for another production). This was the first work in which he composed with tape-loops, in which sonic modules are repeated over and over again by running the same length of tape over the play head of the tape-recorder. This was the primitive origin of the repetitive style Riley was to make famous, the precursor of modular construction and what was subsequently known variously as "process," "trance," or (in pre-laser days) "stuck-needle" music.

Not long after finishing his M.A. work in mid-1961, Riley rejoined Young in New York for a few months, during which time he was briefly associated with the somewhat incestuous concept-art movement, which had *not* yet developed into Fluxus, although that term is inaccurately used to cover the whole period of the early 1960s in downtown art. Young published *Concert for Two Pianists and Tape-Recorders* in *An Anthology*, along with *Ear Piece*, in which Riley continued the Cage tradition with "THE PERFORMER TAKES ANY OBJECT(S) SUCH AS A PIECE OF PAPER CARDBOARD PLASTIC ETC AND PLACES IT ON HIS EAR(S) HE THEN PRODUCES THE SOUND BY RUBBING SCRATCHING TAPPING OR TEARING IT OR SIMPLY DRAGGING IT ACROSS HIS EAR HE ALSO MAY JUST HOLD IT THERE IT MAY BE PLAYED IN COUNTERPOINT WITH ANY OTHER PIECE OR SOUND SOURCE IF THE INTERPRETER WEARS A HEARING AID IT WOULD BE BEST TO MAKE THE SOUND CLOSE TO THE MICROPHONE (OF THE HEARING AID) THE DURATION OF THE PERFORMANCE IS UP TO THE PERFORMER CHILDREN PER-FORMING EARPIECE SHOULD BE WARNED NOT TO STICK THEIR FINGERS TOO FAR INTO THEIR EARS AS THEY MAY SERIOUSLY DAMAGE THE INNER EAR."

And eat your spinach. Riley gave all this up to sail to Europe with his wife and young daughter. He lived in both Spain and France and traveled extensively elsewhere in Europe and Morocco when not earning his family's keep by playing piano at officers' clubs on U.S. bases. Musically, he was most struck at the time by the North African music he could pick up on the radio from his place in Algeciras, only twenty miles northeast of the Strait of Gibraltar, where he lived for three months into the spring of 1962. The harmonic stasis and melodic virtuosity of *maqamat* which had come to obsess Coltrane had a similar effect on Riley. When he actually crossed the strait, wandering around breathing in the culture, he was especially fascinated by the ubiquitous street music and the Islamic calls to prayer from the minarets. Both would exert a strong influence on his later work in its embrace of modalism and devotionalism as well as the collective feel of *In C*, which sounds almost as static in its adapted modalism and as pleasantly chaotic in its heterophony as a soundtrack from an Arab bazaar.

In Paris he played jazz and ragtime piano in the Place Pigalle at Fred Payne's Artists' Bar. At the same time he continued his tape experiments on his own with unsophisticated equipment. Three pieces composed in the little more than two years Riley lived in Europe were *I Can't Stop No, She Moves*, and *Mescalin Mix*, in which he exploited an echo effect he had discovered at the San Francisco Tape Music Center, while experimenting on an Echoplex with Ramon Sender. Riley used the effect to thicken his texture and vary his dynamics in the direction of what he jocularly refers to as a sonic "acid trip." He was to exploit the relatively simple form of repetition thus created in a more sophisticated form shortly thereafter.

Riley continued playing lounge piano in bars and officers' clubs at American bases and occasionally nightclubs. In 1962–63 he worked for an agency hooking variety shows of fire-eaters, jugglers, acrobats. One of his duties was to accompany the floor show; the other was to drive the bus. He also joined up with a friend from San Francisco named Kenneth Dewey. In San Francisco, Dewey, like Halprin, had been experimenting with nontraditional theatrical space, staging events all over town as part of the same opus. In late 1963 Riley collaborated with Dewey and Otto Donner on *Helsinki Street Piece,* similarly staged all over Helsinki, with musical performances, poetry recitals, marching bands, etc.

Earlier the same year Dewey had asked him to direct the music for his theater piece *The Gift,* which had been commissioned by the Theater of Nations, and for which he had gotten in touch with jazz trumpeter Chet Baker and his quartet. Through Dewey, Riley gained access to the Sarah Bernhardt Theater of French National Broadcasting, ORTF.

Riley explained the echo effect from *Mescalin Mix* he hoped to develop to one of the French engineers, "a very straight guy in a white coat, who fooled around and ended up hooking two tape-recorders together" [*AC* 112]. The tape was stretched across the play head of one tape-recorder and the record head of the second, so that as the first machine plays what has already been recorded it is recorded in turn by the second machine, which feeds its results back to the first machine for playback, while it continues recording, resulting in a progressively complex structure. Riley was delighted with the results, his enthusiasm still vibrant a quarter-century later.

When Baker arrived, just after being released from the Lucca jail, where he had served time for heroin possession, Riley was ready with an arrangement of Miles Davis's "So What." He recorded the quartet's account, then recorded the trumpeter, trombonist, and bassist separately, and subjected the results to the time-lag process, transforming the parts into what amounted to unison canons electronically. Riley refers to the thickened textures as "probably my first orchestral piece," though it was "orchestrated" technologically. Despite his extensive earlier experimentation, he feels that the feedback process of *Music for The Gift* "was when I really started understanding what repetition could do for musical form. That's the forerunner of *In C*" [*AC* 113].

The Davis piece Riley had chosen for *The Gift* was taken from the 1959 album, *Kind of Blue,* perhaps the greatest single disc in Davis's illustrious and protean career. The LP followed up Davis's exploration of modal construction in the title piece from his LP *Milestones* the previous year. Modal jazz broke away from prevailing hard-bop and blues-based funk styles in rejecting traditional harmonic rhythm and modulation, replacing chord changes with scales or modes as the basis for improvisation. Whereas the chords might change every bar (or beat) or two, the modes were sustained for four, eight, sixteen bars, or longer. "So What"

contained only two modes per thirty-two-bar chorus, eight bars of IV surrounded by sixteen and eight of I, which permitted Riley maximum leeway in his electronic experimentation by allowing him to extend the echo effect without immediately creating potentially cacophonous polytonality or sharp harmonic clashes between the echoes and the presentation of ensuing material.

Modal jazz had been in the air for ten years before *Milestones*. Pianist George Russell wrote a modal introduction for Dizzy Gillespie's "Cubano Be" in 1947, when the trumpeter was in his Afro-Cuban period and wrote a treatise on the topic, *The Lydian Chromatic Concept of Tonal Organization*. But it was Davis who characteristically transformed the style into a rethinking of traditional concepts of jazz harmony. One could argue an analogy between Davis's pioneering of cool jazz with Gil Evans circa 1950 as a reaction to the tempic and dynamic extremes of the bebop that had dominated avant-garde jazz through the 1940s and his introduction of the static harmonies of modal jazz (often combined with slow tempi and muted dynamics) after the stylistic aggressiveness, including harmonic as well as rhythmic virtuosity, of the hard bop that dominated the fifties.

Modal jazz was to be the most important indigenous influence on the development of Minimal music, soon joined by the less inflected rhythmic propulsion of rock that makes its influence felt in motoric Minimalism, especially that of Glass, who had far less involvement in jazz than his predecessors in Minimal music. Young, Riley, and Steve Reich all played in jazz groups in their teens, and all mention it as a profound influence on their work in the 1960s. Analogies between modal jazz and non-Western musics had not gone unnoticed; it was in this period that Ali Akbar Khan and Ravi Shankar brought raga to public consciousness in the West, and they were followed by numerous other master musicians hitherto unknown outside their own culture. Davis was the catalyst for modal jazz, but it was his sideman on *Kind of Blue*, tenor saxophonist John Coltrane, who was to explore the modalism of the Middle East as well as the six traditional church modes of the West and further revolutionize jazz—and Minimalism—in the process.

Once introduced to the modal style by Davis, Coltrane began studying and practicing charts of *maqamat*, the scalar bases of most music from Morocco to Afghanistan. On his last tour with Miles Davis in 1960, according to fellow band members, Coltrane, normally taciturn anyway, spent virtually all of his free time practicing these exotic modes (on a soprano saxophone he had picked up after hearing Steve Lacy play one) and/or looking out the nearest window.

After he left Davis in April of 1960, Coltrane began assembling his own quartet. In their first studio session on October 21, he put his practice to use in a fourteen-minute recording of Rodgers and Hammerstein's erstwhile-sappy "My Favorite Things" from *The Sound of Music*, offering snake-charming and whirling dervishes in lieu of Julie Andrews's terminal wholesomeness.

In 1962 Young turned to sopranino saxophone, the final step into his drone period. After Atlantic's release of Coltrane's revelatory performance in early 1961, hundreds of musicians ran off to order soprano saxophones like the one Coltrane, hitherto known only on tenor, had popularized overnight. As a tenor, Coltrane was led naturally to the soprano, which was similarly tuned in B-flat. Young was an accomplished alto player and so opted for the even higher-pitched sopranino, tuned like the alto in E-flat and even more suggestive of the Indian shenai (a double-reed often described as an Indian oboe but more closely related etymologically as well as timbrally to the shawm). At Los Angeles City College Young had led jazz combos with soon-renowned jazzmen Billy Higgins, Don Cherry, and others and even beat out his friend Eric Dolphy—who became Coltrane's closest friend as well as sideman at about the same time Young was learning sopranino—for the second alto chair in the college dance band. (Dolphy took first clarinet chair in the college orchestra, Young second.)

Before the sopranino experimentation per se, Young developed his own version of extended blues in which he held the harmonies not for one to four measures but as long as he felt inspired. In the summer of 1961 he recorded *Young's Aeolian Blues in B♭ with a Bridge* on piano with Terry Jennings playing very much in a Coltrane vein on alto sax. (In a performance with his All-Star Band seven years later, Jennings still "improvised over a tonic drone raga-style" with "the ghost of John Coltrane" presiding, according to Carman Moore [1968 28].) Numerous 1962–64 sopranino pieces like *B♭ Dorian Blues* combined, in the heyday of modal jazz, modal structures derived from Greece and Africa. The Aeolian and Dorian modes were a natural for Young's blues revisionism with their similarity to the blues scale in their lowered third (and in the Aeolian seventh) degrees. In the blues, these "blue notes," along with a less ubiquitous blue fifth, are not technically flatted (i.e., by a semitone) but microtonally lowered to create varied expressive effects, and to avoid the half-step to which African music shares an aversion with pentatonic folk music from Ireland to Thailand. There are similar traits in Indian *ragam*, which Young was to study in depth beginning in 1970. At this point, however, the Indian influence was already felt directly as well as through the filter of Coltrane, since Young lists the North Indian shenai of Bismillah Khan and the South Indian flute of T.R. Mahalingam along with Coltrane's soprano sax as his most important models. It is almost as if Young had begun to move in the direction of transplanetary music before attempting to recreate the music of the spheres in his drone work.

On sopranino Young played chordal permutations as remarkably fast as his harmonic movement was remarkably slow. The standard I-IV-I/ I-IV-I/V-IV-I pattern of twelve-bar blues might be extended indefinitely and irregularly, as Young remained within each for minutes at a time, essentially as long as he felt so inspired or inclined. Within each harmony the tones were blown so fast as to simulate, paradoxically, sustained

tones or chords, almost as if virtuosity were attempting to negate itself. As in his confrontation with Cage, Young once again brought what seems a genetically Minimalist orientation to bear on a major influence, in this case the virtuosic profusion of Coltrane.

His sax-playing looked back to his undergraduate days gigging with black blues bands, while his sustained tones looked back to the works like *for Brass, for Guitar,* and *Trio* he had composed during the same period. The classical/jazz segregation of his instrumentarium had now loosened up along with his titles. More importantly, the quasi-sustenance of the double-reed was the principal progenitor of the Clouds of *The Well-Tuned Piano,* which was originally inspired by Young's hope to achieve the same effect more successfully on another instrument. While the enterprise was impeded on saxophone by both the fundamentally monophonic nature of the instrument and the obvious limitations of human breath, the keyboard instrument offered polyphony, greater resonance, and the use of ten fingers working independently rather than two lungs working simultaneously. Finally, the introduction of Indian influence into Young's work through Coltane, Khan, and Mahalingam, led to the further incorporation of that music in the drones of virtually all Young's later work.

In his drone period Young did not abandon blues entirely. One technique of his Dream House installations entailed tuning his sine-wave generators to blues frequencies, one day per measure, resulting not in twelve-bar but in twelve-*day* blues. In 1991, in fact, thirty years after beginning his blues experiments, he went back to the twelve-bar format to record the 58-minute *Young's Dorian Blues in A,* leading an electric quartet on a synthesizer programmed to simulate barrelhouse piano. It was tersely described by blues scholar Robert Palmer: "funky" [WKCR]. After a successful European tour, the Forever Bad Blues Band returned home in 1993 to standing-room-only crowds at the Kitchen.

M

Young's transition from sustained tones into drones proper, both audible and subliminal, was eminently logical, but to understand how the composer became, in the title of Robert Palmer's admiring article, "lost in the drone zone," we must retrace Young's steps to when he was first learning to take them.

There are far less exotic musical influences at work in the *Trio for Strings* than Webern and gagaku. Born to a family of sheepherders in the Mormon dairy community of Bern in Bear Lake County, Idaho, Young grew up practicing and listening to music daily: not Japanese court ensembles or the Second Viennese School but the long-held harmonies of cowboy songs on local radio stations in Idaho and later Southern California and Utah. Apart from some efforts as an infant on harmonica, the first musical enterprises he recalls were tapdancing and singing "I see you there / Hiding behind the chair" around age three [Ron Rosenblum 63] and an unsuccessful attempt as a pre-schooler to master the three guitar chords of "ridin' Old Paint and a-leadin' Old Dan." By the age of five he was singing and tapdancing at the Rich Theater in Montpelier, and at seven he took up saxophone, first playing at Mormon services, later in bands in high school and college. Young fronted his jazz combos in a Lee Konitz style and played from time to time with the Willie Powell Big Blues Band. A further indigenous influence on the drones was his drumming for the dancing of an Apache friend in high school, who exposed him to the repetitive, nondirectional music of native Americans.

Before confronting gagaku at UCLA, Young had encountered the drones of Indian music earlier in his undergraduate career at Los Angeles City College, where Leonard Stein had introduced him to Serialism. But the nonmusical influences on Young's fascination with long tones and drones go back to his infancy. His first memory is the sound of the fierce

winds off Bear Lake whistling through the juncture of criss-crossed logs in the cabin where he was born. One of his favorite pastimes as a young boy was listening to the harmonics created by the humming of the transformer from the power plant near the Conoco station his grandfather ran in Montpelier, as well as "a favorite telephone pole I used to like to stand by in Bern" [AC 88]. The early sustained-tone works, according to Young, were influenced specifically by the whistling of railroad trains across the river from his grandmother's house in Los Angeles as well as more generally by the Southern California "sense of space, sense of time, sense of reverie, sense that things could take a long time, that there was always time" [Swed 37]. As a teenager, working for spending money during summers and after school in a machine shop, he found himself humming, whistling, and singing along with the mechanical drone of lathes and drill presses. Since 1963 he has been doing something quite similar, with greater control and sophistication, as a classical composer.

In 1962 Young extended the sustained tones he had now been investigating in various forms for half a decade even further in *The Four Dreams of China*, which was born on a paper napkin Young took from a restaurant on a cross-country car trip in December 1962. This was two months after the *Trio* had finally had its public premiere on Columbus Day at Judson Hall in Greenwich Village. The hour-long work had been followed, after intermission, by a performance of *Compositions 1960 #7* of equal duration, a preview of things to come in no uncertain terms. In a sense *The Four Dreams of China* represents a rapprochement of the sustained-tone and conceptual works, insofar it adopts the open-ended duration of the concept art with at least some of the greater pitch variety of the earlier works. In addition, every triad and interval of the *Trio* may be analyzed as a subset of the "dream chords" used in *The Four Dreams of China*. These chords, in fact, go back before *Trio* to *for Brass*, the first four pitches of which introduce a dream chord horizontally.

The pitches of each of the *Four Dreams* are reducible to a quadrad, with each performer assigned to just one note. The *modus operandi* here, and henceforth in Young's work, is of improvisation within the parameters of rules governing which tones may be combined and in which sequences, a relationship the mathematically-inclined composer describes as algorithmic. *The Second Dream of the High-Tension Line Stepdown Transformer* (the title goes back to the Montpelier power plant of Young's childhood) for unspecified instruments is the best known of the *Four Dreams*. When the piece is realized on bowed strings, its transitional status between the sustenance of the *Trio* and the drones of the later pieces becomes more apparent. It was premiered on bowed mandolins on May 19, 1963 during a weekend frolic at George Siegel's New Jersey farm, during which Happenings czar Allan Kaprow threw Young off a hay mound where he had been playing sopranino saxophone during the Happeningites' processional [Horowitz 10].

The Second Dream represents further minimalizing of Young's art, since

in lieu of the assorted intervals and solo pitches of *Trio* it contains only four tones of a "dream chord," expressed harmonically as 18/17/16/ 12. "These pitches," Young notes, "may be isolated in the harmonic structures of the sounds of power plants and telephone poles" [*Second* 5]. A 1990 recording released by Gramavision in 1991 featured eight trumpets arranged in two groups, with a member of each group assigned one of the four tones in order to overcome the limitations in sustenance caused by the human need to breathe. By then eighteen years had passed since Tom Johnson had followed the precedent set by Young with *The Four-Note Opera* in 1972.

In the 1963 *Studies in the Bowed Disc* Young returned to the gong, which he had played in *2 sounds*. The new instrument had been designed for him by Robert Morris and was played this time not with drumsticks but with a bow designed for double-bass, in order to achieve greater control and more regularized sustenance of its overtones. In August of the same year Young and artist/calligrapher Marian Zazeela—his bride as of June 22, the first anniversary of their meeting—had moved from the apartment on Bank Street in the West Village where Young had lived since arriving in New York in the fall of 1960 into a loft on the fringes of the area later called TriBeCa. There Young began combining the resonances of the gong and the simulation of sustained notes on the sopranino saxophone or piano with the drone executed by Zazeela vocally and on harmonium and Tony Conrad on violin to the hand-drum accompaniment of Angus MacLise.

It was not until later in the decade that Zazeela's visual contribution became fully integrated with the performances as opposed to enlivening them decoratively. In the early days, Zazeela's light-box (1964) and slide-projections (1965) adorned the performance space. She then began to move from an essentially decorative to a more holistic mode of design, creating light-environments featuring intense light aimed through dichroic filters at quasicalligraphic aluminum shapes hung by ultrafine filaments. The effect is a unique and extraordinary transvaluation of perception: the mobiles seem to hover unanchored, while the shadows they cast in various hues attain an apparent solidity against the light-dissolved walls equal to their literally palpable but apparently disembodied sources. Like Young's music, to which it serves as an almost uncanny complement, Zazeela's work is predicated upon the extended duration necessary to experience the nuances which are its essence. The use of her work in tandem with Young's music has both enhanced its effect and perhaps discouraged appreciation of it as independent artwork, although Zazeela has worked as imaginatively with light as anyone, including luminist pioneer Dan Flavin.

Both Conrad and MacLise were remarkably versatile. Apart from his musicianship on bowed and occasionally plucked strings, Conrad was a Minimalist film-maker trained as a mathematician. Young credits Conrad with his introduction to the mathematical niceties of the relationships

of the harmonic series, which directly inspired Young to explore the creation of musical compositions in just intonation. MacLise, poet and scorer of underground films, like Jennings, died a drug-related death, at forty-one in 1979 in Kathmandu. He had been living in India and Nepal and traveling/studying elsewhere in Asia since 1971, with infrequent trips back to the United States. When he met Young in his sopranino period ten years earlier, MacLise already had a background in Haitian, Latin, ballroom, jazz, and free-form drumming, along with military drumming in marching bands in high school and the U.S. Army. In 1959, after two years of the Army, he gravitated to other realms. His visionary poem *year* rewrote the calendar, giving all the days new poetic names, some of which Young used to date his works ("day of the antler," "the overday," etc.).

To this point Young's instrumentarium was entirely acoustic. The drone was augmented by the arrival of electric violist John Cale, a Welshman who had come over on a Leonard Bernstein Scholarship to study at Tanglewood but left unsatisfied. The first recording of Cale with the four earlier members of the group dates from September 29, 1963. The October 19 performance of B^b *Dorian Blues* features Young on sopranino, Zazeela on vocal drone, Conrad on bowed guitar, Cale on viola, and MacLise on hand-drums; the Christmas Eve performance of *Early Tuesday Morning Blues* includes only the Youngs and Cale.

Cale, a classically-trained musician, was later to become one of the founding members of the Velvet Underground, the rock group affiliated with Andy Warhol which pioneered proto-punk drone-rock under Young's influence. That influence was transmitted through Cale as well as Conrad, MacLise, and Walter De Maria, who were all associated with the band in an earlier incarnation called the Primitives, as was Henry Flynt briefly [Neilson]. Along with their harmonic stasis the Velvets borrowed their relentless volume from Young's drones. In this, Cale's arrival with his electrically amplified instrument had been crucial, as had Conrad's introduction of contact mikes, which enabled Young to realize more adequately his construction, in avant-garde adaptation of rock producer Phil Spector, of a "wall of sound."

The Velvets released their first album in the summer of 1967; that fall Young opted out of a collaboration with Warhol, who had been impressed and perhaps influenced by the Judson Hall performance of *Trio* and "#7." Young had scored three of his films with taped drones at a dynamic level the Lincoln Center authorities would not impose on the audience of the second New York Film Festival. Rather than simply twisting the volume knob counterclockwise, Young quit. If the Lincoln Center management seemed philistine in aesthetic terms, in medical terms it may have been prudent; Young's own hearing has unfortunately diminished prematurely, although he has suggested genetic predisposition. Robert Palmer noted in 1975 that "Not too long ago Young kept a constant sine-wave drone going in the loft 24 hours a day, for weeks and months at a time, boosted to a volume most visitors found decidedly

uncomfortable," not least because it reduced conversation to shouting
[1975 24]. Nonetheless, at this stage in his career Young felt that volume
levels others found numbing were necessary in public and private to
expose both the bass, in this case the foundation of the whole harmonic
structure, and the upper harmonics, so that "combination tones, particu-
larly difference tones, are more audible" [Kostelanetz 1968 212]. These
combination tones formed by the simultaneous sounding of the funda-
mental drone and sung or played overtones were equally crucial to the
sonic immersion (or assumption, to use his own metaphor) of the listener
Young undertook. Though difference tones had been explored by Tartini
at least two centuries earlier (he wrote in 1754 that he had discovered
the *terzo suono* forty years earlier [Randel 181]), no one had seized on
them with more single-minded intensity than Young.

Young has done sophisticated and abstruse writing on drones and
harmony. Ironically, a major influence on thirty years of theory and
distinguished practice of drone music was his decision to keep a turtle, an
animal almost too handy an emblem of his work, as a pet. The drone
brigade found itself tuning to the motor of the aquarium Young had
bought for "49," the inspiration for his first drone epic, *The Tortoise, His
Dreams and Journeys*. Another external influence on the direction of
Young's music was the departure of MacLise for India (and eventually
Morocco, where he studied percussion) on February 18, 1964. With the
drummer gone, the rhythmic element was essentially eliminated, and the
music in a sense was permitted to retrogress towards the unaccented
sustenance of the *Trio* but now increased exponentially in the absence of
any metrical division.

Tortoise is still described by the composer as an ongoing work, though
in abeyance for almost two decades—another illustration of his sense of
time. It was also known in the mid-sixties as *Dream Music* and *Dream
Tortoises* and has had numerous realizations involving voices and some-
times instruments in sustained harmonics over a drone. The drone
represents the first sound the tortoise hears, representing primordial sonic
vibration, increate: in performance the drones are always turned on
before the arrival of the audience, much less the appearance of the
musicians, to create a sense of endless continuum. Young created his
drones first with voices and bowed strings and then with the pure pitches
of sine-wave generators and oscilloscopes to which he had been led by
the mechanical drone of the aquarium motor, which thus served as a
transition between instrumental/vocal and electronic drones. In the
collaborative works, once the drone was assigned primarily to the elec-
tronics, the voices and instruments could be used both more freely and
more sparingly in producing sustained partials. When the Theatre of
Eternal Music was revived in the 1970s, winds replaced strings.

The first tape of the drone music that was to develop into *The Tortoise,
His Dreams and Journeys* dates from April 2, 1964, a private performance
given for Harry Kraut of the Tanglewood Festival retroactively entitled

Pre-Tortoise Dream Music. It featured the voices of Young and Zazeela, Young on sopranino and Jennings on soprano sax, and Conrad and Cale providing the string drone on violin and viola. Only afterwards were the electronic drones added, first in an October 9 performance entitled (again retroactively) *Prelude to the Tortoise.* This was given at what was then the Philadelphia College of Art at the invitation of Dieter Roth (then Diter Rot), an artist who had contributed to *An Anthology.* The first full-fledged installment was premiered by Young, Zazeela, Conrad and Cale at the Pocket Theater, a reconverted burlesque house (soon to become a cinema) in New York at 100 Third Avenue on Thirteenth Street, where the group had performed the year before with sopranino and instrumental drone and Cage had mounted a performance of Satie's *Vexations.*

It was entitled *The Tortoise Droning Selected Pitches from the Holy Numbers for the Two Black Tigers, the Green Tiger and the Hermit.* The literary style of the title owed something to the imagist poems Young had written since 1959 (e.g., "For Diane," addressed to his lover at the time, poet Diane Wakoski, and published in *Selected Writings:* "Came / a tiger / with / dew / on / his / paws"). The cast of characters in the title alluded, respectively, to the Youngs (who in those days dressed exclusively in black), Conrad, and Cale. They presented the piece in six performances on the weekends of October 30-November 1st, and November 20-22, while a two-concert weekend at the same venue on December 12-13 was billed as *The Tortoise Recalling the Drone of the Holy Numbers as they were Revealed in the Dreams of the Whirlwind and the Obsidian Gong and Illuminated by the Sawmill, the Green Sawtooth Ocelot and the High-Tension Line Stepdown Transformer.*

Village Voice dance critic Jill Johnston was in attendance the first weekend and described the performance vividly. During *Tortoise,* Young and Zazeela sang into mikes, seated in front of the large gong Robert Morris had designed "with a black painted bull's eye" [November 19, 1964 14]. They sang into hand-held microphones while the contact mikes Tony Conrad had introduced were affixed to his violin and Cale's viola. During the duet called *Gong Contests* (rather than *Studies in the Bowed Disc*), Young and Zazeela bowed the gong, equipped with two contact mikes, gently from opposite sides. The term used by Barbara Rose in her "ABC" article for Young's work was used by the composer himself in the first sentence of his program note: "Welcome to this presentation of Dream Music." Johnston concluded her enthusiastic article by speculating that "The dissemination of culture by way of original tapes by Young in house, office, and brothel could conceivably raise the culture to an unusual level of sanity" [20].

In late 1965 came both *The Ballad of the Tortoise or Pierced Earrings / Drone Ratios Transmitting the Manifestations of the Tortoise Center Drifting Obsidian Time Mists through the Synaptic Stepdown Barrier* and *The Day of the Antler The Obsidian Ocelot, the Sawmill and the Blue Sawtooth High-Tension Line Stepdown Transformer Refracting the Legend of the Dream of the Tortoise Traversing the 189/98 Lost Ancestral Lake Region Illuminating Scenes from*

the Black Tiger Tapestries of the Drone of the Holy Numbers. The next year saw the first of several realizations of a subset of *Tortoise* known as *Map of 49's Dream The Two Systems of Eleven Sets of Galactic Intervals Ornamental Light-Years Tracery.* By the mid-sixties the titles have come at least a galactic interval from *for Brass* and *for Guitar. Map* is based on three pitches, chanted and at times growled, roughly translatable in scalar terms as the prime, fourth, and fifth.

In terms of the harmonic series, Young had already made a trademark of the seventh partial (or sixth overtone) elsewhere in *Tortoise,* which replaces the fifth partial (fourth overtone) as the chief harmonic building block in *The Well-Tuned Piano.* Young's curious and seemingly inherent aversion to the latter goes back to the long-tone works of his student years, from which the interval of the major third represented by the fifth partial had been banished along with minor thirds and sixths. The seventh partial represents a slightly sharp version of the minor seventh featured after the second long rest of the *Trio* and in inversion in its opening major second. Despite the vast distance Young had travelled, his work retained a sense of logical continuity.

Between the premiere of *Tortoise Recalling* and *Ballad* the performers were christened by Young the Theatre of Eternal Music (according to Young, the first documented use of the name dates from February 1965). The Theatre was conceived of as an open-ended ensemble performing alone and in public—mainly in New York south of Fourteenth Street but as far afield as Pittsburgh on October 16, 1965.

Peter Yates described one performance of what he calls "Dream Tortoises" thus: "one musician [Cale] plays a viola that has been modified to allow the production of sound from three strings with equal intensity, another [Conrad] plays double-stops on a violin reinforced by a resonating string, while Young and his wife vocally produce other tones, in equally strict just intonation, so accurately that the resulting accumulation of tones . . . sounds almost orchestral. Nothing else happens, except when Young from time to time enters vocally with the lowest tone of the ensemble, having the effect of the long *Om* of Hindu ritual. . . . My two hours of listening paid tribute to a unique musical experience. The ritualistic self-sufficiency . . . must be heard to be believed. In sound at least, Young has got very close to the psychological nerve of ritual" [247–48].

On at least one other occasion, at a performance of Simone Forti's "Bottom" in summer 1968, Young dispensed with electronics as he, Zazeela, and Forti together chanted a chord to accompany the second of four slides shown for five minutes with different sonic accompaniment [Forti 85]. Young had disbanded his ensemble on August 20, 1966 after a performance at the Sundance Festival in rural Pennsylvania, and so he occasionally dispensed, in turn, with musicians. *Drift Studies,* begun in 1967, was scored for sine waves tuned to harmonics on two or more oscillators. The title of that piece, which was conceived as a corollary to *Tortoise,* amounts to a triple pun, alluding to the drift of air pressure

within a space, leading to audible changes in volume in different areas; the drift of frequencies in the deviation effect caused by a change in the phase relationship of sine waves; and the sense of drift or levitation of the spectator's body in synchronization with the sine waves. Young later explained his underlying theory to Robert Palmer: when "the composite wave form of the combination tones of the two sine waves gradually, internally and organically, shifts . . . [t]he body intuitively recognizes that information having to do with basic universal structure is coming in as sound" [1975 26].

Young was a solo Theatre of Eternal Music in February 1968 (not counting masses of electronic equipment) in a performance of *Map* at the Barbizon Plaza Theater—the second concert in the "January through June" Festival of which Riley, also solo with equipment, performed the final two concerts four months later. *Map* was reviewed in evocative detail by art critic John Perreault of the *Village Voice*. The February 22 article begins (between a schedule of Ash Wednesday services and an ad warning "Now is the time to plan HOW YOU WILL LOOK IN YOUR BATHING SUIT") by describing the "almost unbearably loud, low-pitched electronic hum. . . . At first even to enter the auditorium seemed too dangerous to risk, for the sound was painfully loud even with the doors closed. Entering was like being hit in the face with a blast of hot wind or like walking into a room full of brine and discovering that surprisingly enough it was still possible to breathe." Onstage was "Young, wearing dark glasses, intoning into a microphone with apparently no voice-like results, only low, loud, endless rumbles, flutters, groans that sounded somewhat like, but did not represent, close-up foghorns, helicopter engines, electric turbines." After describing Zazeela's calligraphic light-projections, Perreault continues: "Nothing happened. It was like hearing a small piece of eternity" [27]. The experience of Young's music, which began so inauspiciously, leads Perreault to observe in closing that "Young's music is the newest, most interesting, most problematic, most demanding music now being produced" [29].

Young's choice of the Theatre of Eternal Music as the name for his drone ensemble(s) connects that work with the performance pieces of the early sixties, entitled with similar ambiguity by Young *Compositions* and The Theatre of the Singular Event. Both enterprises are thus immediately identified as mixed media, and as such they were described to and thoughtfully studied by Richard Kostelanetz in his Youngian-entitled *The Theatre of Mixed Means* in 1968. Young's relationship to the early-sixties ambiance of happenings, Fluxus, etc. was also investigated perceptively by British writer-composer Michael Nyman in *Experimental Music: Cage and Beyond*. Without the precedent of Cage, Young's *Compositions* are as unimaginable as the very different directions taken by later Minimalists without the precedent of Young and his preparation of an auditory context. Nonetheless, at risk of overemphasizing the differences between

Young and Cage, one might suggest that Cage was the terminal anarchist and Young—despite can-scraping and violin-burning, feeding pianos and freeing butterflies—the visionary commandant. Cage once urged us to "say Yes to our presence together in Chaos" [1961 195]; Young was ultimately more concerned with revealing, or imposing, Kosmos.

Cage was committed to breaking down conceptual boundaries in an all-inclusive aesthetic that aimed to heighten awareness of the phenomena of the moment. His music consequently came to emphasize disjunction, the isolation and multiplicity of unique and transient sonic events, the sound of a glissando leading to no coda or the environmental sounds of a silent piece. Even in the *Trio for Strings*, Young was dealing with sonic events prolonged to such length as to engulf the consciousness of the audience. Rather than fine-tuning their sense of the evanescent by refusing to impose connections between fleeting events, he chose to present sonic events in such a way as to drive anything else from the spectator's mind. This is most obvious in his previously unheard-of duration but is also at play in his emphasis on intervals and chords rather than runs or clusters: what is being exposed is not discrete sounds as in Cage but relationships between sounds. Even Young's dynamics aim to dominate the consciousness of his listeners, whether the *pppp* of the *Trio*, which forces them to concentrate totally to hear the music at all, or the *ffff* of the electronic drones which bombard them sonically, blocking out everything else from consciousness. Whereas Cage's music often seems indifferent to whether or not anyone is even listening, Young's often literally prevents one from listening to—and challenges one to think of—anything else.

Kostelanetz's interviews with Cage and Young point out diametrical oppositions in their sensibilities. Cage had reacted predictably to what he regarded as "the police situation" of Claes Oldenburg's *Moviehouse,* in which the artist told people not to sit down, by doing the opposite: "I sat down and so did Duchamp." To the interviewer's questions, "Were you uncomfortable standing up?" Cage replied, "No, I refuse to be told what to do." To Kostelanetz's queries on happenings, Cage observed, "I would like the happenings to be arranged in such a way that I could at least see through the happening to something that wasn't it. We'd be out of the La Monte Young fixation ideal. We'd be in the Duchamp—Fuller—Mies van der Rohe business of seeing through" [Kostelanetz 1968 55–56]. Fifteen years later, around the time Elliott Carter drew an analogy between the Minimalist and Hitlerian rhetoric of repetition, still true to form, he lambasted Glenn Branca's electric-guitar orchestra as "fascist" in its amplified insistence.

Young refers to himself with easy jocularity as a fanatic. Despite a generally relaxed and amiable nature, he is indeed fanatical on the question of artistic control. Just as he immediately abandoned the Lincoln Center project when asked to compromise, so too did he abandon a recording contract with Columbia Records that would have brought him

considerable exposure (see below). But there is more to his admirably uncompromising nature than the rare ability to reject money and fame; Lincoln Center was not asking him to change a note, but to lower the volume. Young may have considered that volume an integral component of his music at that stage in his career and perhaps American history, but it seems plausible to suggest that it was not so much his creativity as his dominance of the audience that was being challenged.

There is a highly autocratic streak to Young's art. Like Cage, he refuses to be told what to do, but unlike Cage he has no compunction about telling others what to do. To this day he will not permit others to move in the room while his piano is being tuned, for fear of the movement of air molecules. There is something of the Artaudian element of Fluxus in Young's pre-Fluxus Berkeley experiments with turning the lights out on the audience and his choice of friction sounds, just as there was in his post-Fluxus raising of dynamic levels to the threshold of pain. Young may find all this necessary for the purest possible realization of his artistic conceptions, but that feeling does not erase the dictatorial element in his perfectionist devotion and the exercise of his organizational instincts, which he considers a genetic inheritance, citing his Mormon namesake, Brigham, as an example.

Young in fact remarked to Kostelanetz, "I am wildly interested in repetition, because I think it demonstrates control" [187]. Speaking of *Tortoise,* he noted "that each time a particular frequency is repeated it is transmitted through the same parts of our auditory system. When these frequencies are continuous, as in my music . . . this could be considered to be or to simulate a psychological state" [217–18]. This interest, which validates Robert Palmer's use of the term "trance music," may have attracted Young to the modalism of Coltrane and Asian music. In another interview, two decades later, with Ljerka Vidic, Young mentioned that Cage had told him they represented "opposite sides of the coin. . . . I'm interested in control and precision and the Yogic approach to concentration, but Cage has . . . the Zen approach . . . to clear the mind" [Vidic 25]. Kostelanetz had found interesting analogies to Young's and Cage's music in the very different modes of sonic envelopment one experiences on entering, respectively, a generator room and Grand Central Station [197]. Young is holistic, his energies devoted to establishing a distinctive context, whereas Cage is more amenable to fragmentation, perhaps more interested in erasing the artificial contexts that are already always there.

The relationship of the two composers to indeterminacy is again revealing. Cage was attracted to indeterminacy for its impersonality, the openness to events not strictly predetermined by the composer branding works like cattle with his distinctive mark. Cage's attitude toward sound has much in common with the aesthetic of later Minimalism, in its insistence on the artwork as object rather than bearer of the composer's or audience's emotional needs. On the other hand, for Morton Feldman, stylistically the closest to Minimalism of the Cageian disciples employing

graphic notation and open form in the service of indeterminacy, it provided a sonic technique "as free and spontaneous as the way the abstract expressionists combined colors" [Morgan 365]. Young in turn characteristically subsumed indeterminacy into precompositional design, leaving room for improvisation but within strict parameters. In *Second Dream*, for example, he does not tell the performers either when or how long to play, but he restricts each of them to one tone and establishes beforehand which tones may be played simultaneously. With a strong improvisational background in jazz and blues combos, Young was able to accommodate indeterminacy in his drone ensemble as well as in his performance pieces, but in a manner finally in the service not so much of either impersonality or expressiveness as of control.

The foregoing pages document Cage's influence on Young as well as their temperamental differences, while perhaps understating the mutuality of influence as well as admiration. As early as 1961 Cage said to Roger Reynolds that Young was "doing something quite different from what I'm doing and it strikes me as very important" [*John Cage* 52]. The influence itself was by no means all in one direction. Just as Young helped lead his teacher Stockhausen towards the overtones of *Stimmung* and similar works, his sustenance influenced Cage works much later, notably the 1989 string quartet *Four*. When I met Cage briefly for the first and last time after a performance of that work at the Museum of Modern Art five days before his death, he responded to my asking whether Young had influenced the piece with an enthusiastic "Oh yes!"

Much of Young's work is still comprised of variations on the techniques developed in his drone works of the mid-sixties. For example, some compositions involve the selection and tuning of electronic pitches, which he first created on the sine-wave generators to which he was initially attracted for the unwavering perfection of their frequencies, and more recently on computer-controlled synthesizers. Young's first sine-wave generator was tuned to an interval of the aquarium motor's drone a quarter century before he tuned seventeen frequencies in 1989 in a work on Rayna synthesizer for an installation at the Dia Foundation, *The Romantic Symmetry (over a 60 cycle base) in Prime Time from 122 to 144 with 119*. Later works are constructed, in turn, over *that* base, for example, the March 1990 *The Lower Half of the Map of The Eleven's Division in The Romantic Symmetry (over a 60 cycle base) in Prime Time from 122 to 144 with 119*—realized in four performances by the most recent incarnation of the Theatre of Eternal Music, known as the Theatre of Eternal Music Big Band, including several musicians half Young's age. This procedure of constructing new works from old by adding or subtracting the musicians was Young's procedure as far back as 1967, when he used chords from *Tortoise* tuned in sine waves for the "sound environment" *Intervals and Triads from Map of 49's* etc. Another constant is the epic conception, which permits performances only of sections of the full work; the full title of

the work from which *The Romantic Symmetry* is drawn is *The Symmetries in Prime Time from 122 to 144 with 119.* Yet another constant is the distinctly un-Minimal titles.

Crucial to the holistic effect sought by Young in his performances has been the partnership of his wife, particularly since her concentration on light-art since the late 1960s. Once experienced within the context of Zazeela's light environment, in fact, Young's music seems reduced when heard on disc in another setting, which may account in part for both his insistence on Zazeela's collaboration in his musical presentations and his relative indifference to producing commercial recordings, which has served to obscure his accomplishment and restrict his audience. To date only five recordings of Young's work have appeared: a 1969 German recording of a section of a realization of *Map of 49's Dream* from July 31 (Young and Zazeela singing over a sine-wave drone) and a 1964 performance of *the volga delta* on a gong bowed by the couple; a 1974 French Shandar recording of *Drift Study* and a section of *Tortoise* here called *Dream House,* both realized in New York in 1973; and Gramavision recordings of an October 25, 1981 performance of *The Well-Tuned Piano* (released five and a half years later); the December 9, 1990 performance of *The Melodic Version of The Second Dream of the High-Tension Line Stepdown Transformer* by the Theatre of Eternal Music Brass Ensemble led by Ben Neill; and a 1993 Bad Blues Band CD, *Just Stompin'.*

In one sense, of course, records are no place for eternal music, stereo compact discs at present permitting but an hour and a quarter or so of uninterrupted sound. But what context *might* be appropriate? The obvious answer, eternity, would pose no problem for Blake, who insisted eternity was, however obscured, literally at hand. Young and Zazeela's installations simulated, if not eternity, at least extraterrestriality by protracting musical events beyond normal concepts of duration and by dematerializing reality, manipulating lights and mobiles to abolish the distinction between shadow and solid.

The first continuous sound environment was set up in September 1966 in the couple's loft, with electronically-produced periodic waveforms maintained almost uninterruptedly until January of 1970. The first public sound-light environment, or Dream House, was created at Galerie Heiner Friedrich in Munich in July 1969. Later sound-light installations have been set up for weeks, months and years at a time, the electronic frequencies sounding continuously, the musicians appearing sporadically to sing/play along.

In early 1970 the Youngs set up a Dream House at Rice University in Houston, sealing off the performance space with a black curtain though dressing no longer in black slacks and turtlenecks but in long white robes. Young continued to refer to his work generically as "Dream Music" in an interview for the *Village Voice* with Ron Rosenblum, who proved the ideal Youngian listener: "Twice during La Monte's four performances I went into . . . trance, each lasting 45 to 75 minutes of clock time, as

I later calculated. I had no sense of going into a trance, but I knew when I came out I had been in one" [65].

The most ambitious Dream House by far was set up from 1979 to 1985 at 6 Harrison Street in the old Mercantile Exchange Building, in what had been offered to Young and Zazeela by the Dia Foundation as a permanent center for their work. Dia in turn is funded by Schlumberger heirs, who have also been generous to Rice. The oil glut of the mid-eighties finally sank the project of providing eternal music a permanent base on earth.

Young's Eternal Music alludes, of course, to the concept of the eternal music of the spheres, which, again like Blake's eternity, is not a transcendental entity but an immanent presence obscured by habit. The concept is as old as Pythagoras in the West, and Young's effort is thus as radical, in the etymological as well as technical sense, as that of any Occidental music. By this point in his career its extra-musical ramifications had become explicit. The territorial claim to "eternal" music invited obvious sarcasm, given maximal-length minimal-action performances that by normal standards were eccentric at best, but it seems as if the implicit program of his music from the *Trio* onwards had become clear to the composer himself.

While pleased that his music has produced extreme emotional states in his auditors, Young has disclaimed any intentions to produce any state other than ecstasy, etymologically the "standing-out" from what Keats called the habitual self. The rejection of Abstract Expressionist psychological narrative in Minimalist painting is echoed in the composer's description of the affective element in his work: "happy, sad, amorous, angry . . . this is not really what I mean. What I'm thinking of is the feeling that one has each time he hears a piece of music in the same mode. . . . The feelings that I'm really interested in . . . are those patterns of vibrations" [Pelinski Spring 1984 18]. This implicitly rejects the traditional symbology of modes that led to Plato's banishing from his ideal society all but the Phrygian and Young's beloved Dorian (which were viewed by Plato as promoters of moderation and courage, respectively) in Book IV of the *Republic*.

While acknowledging that his music "takes me to the highest state of meditation" [AC 66], Young is Pythagorean in describing his musical aims in mathematical as well as mystical terms. He has stated that he aspires in his work to "the profound feelings [that] have to do with these universal structures which consist of vibrational systems," while glossing a Sufi story in which God lures the reluctant soul into the body and the world with music: "the reason for coming to earth is to study music, because music is capable of presenting the most perfect model of universal structure because . . . the ear perceived vibration as such and transmits it, as vibration, directly to the nervous system and to the brain. If you want to understand vibration, you can best understand it through music. The entire essence of universal structure can be portrayed and understood

through vibration, to the degree that you can understand it" [Pelinski Summer 1984 21].

In *The Untuning of the Sky,* John Hollander describes two versions of the music of the spheres.

> In the Republic, Book X, Socrates' relation of the myth of Er includes mention of this Pythagorean myth; it describes the heavenly spheres bearing "on the upper surface of each" a siren, "who goes round with them, hymning a single tone or note. The eight together form one harmony. . . ." It is not, of course, that we are to think of *a chord of eight tones* here; rather, the "harmony" is an ordered intervallic relationship among all of these tones, more in the manner of the intervals obtainable by step or skip in a scale. The singing siren that produces the tone on each sphere, of course, becomes beautifully adaptable, eventually, to membership in a Christian angelic choir. But the more common version of the myth, such as is put down elaborately by Aristotle in *De Caelo,* maintained that it was the rubbing against each other of the supposedly hard, glassy celestial spheres that produced the sound. In answer to the objection that no mortal had ever heard that music, it was often retorted that the constant droning of that noise deadened the ears of earthly inhabitants by custom alone, and that because it was so constant, it was inaudible. [29]

Both versions have parallels in Young's work. Young's sirens are the different harmonics to which he tunes his sine-wave generators, oscillators, and synthesizers, e.g., the seventeen, not eight, different frequencies in *The Romantic Symmetry.* His choice of the 60-cycle base in that work, like his choice of four pitches for *The Second Dream of the High-Tension Line Stepdown Transformer* twenty-seven years earlier, involves a similar recognition of the dulling force of habit, insofar as the electrical system of North America functions on that frequency, which is consequently always in the air (and ground), inescapable if usually only subliminally audible. Young seemingly adopts the attitude of if you can't beat them join them, but co-opts the frequency in an attempt to open up ears that have been deadened by it and other ephemera of a noise-saturated culture. Telephone lines and power cables are recruited in the service of music and of eternity.

N

In the development of Minimalism, 1964 was as important a year for
music as 1951 was for painting. By the time the Theatre of Eternal Music
gave its first performance of *The Tortoise, His Dreams and Journeys* in
October, back in the Bay Area Young's former classmate Terry Riley had
begun rehearsing the work that was to bring the notes from the under-
ground to local record stores at the end of the decade: *In C.*

Riley, his wife, and their daughter were met by Young at the dock in
New York when he returned from two years abroad in February 1964. The
bullet that killed President Kennedy also put an end to Riley's *Wanderjahre*
of street theater and Moroccan bazaars, ORTF engineers and fire-eaters.
After the assassination on November 22, the officers clubs where Riley had
been making his living playing lounge piano were closed out of respect.
With his means of support evaporated, he had no choice but to go home.

During his brief stay in New York before returning to San Francisco,
Riley heard the Theatre of Eternal Music just making the transition
provoked by the departure of drummer MacLise the same month, as well
as a solo piece his friend was working on when not practicing with the
ensemble. Young had begun the piece shortly before the arrival of Riley,
who had been back in California for months by June 8, the date Young
finished taping the first complete version—complete in the provisional
sense, for the work-in-progress Riley heard, *The Well-Tuned Piano*, remains
in a profound sense a work-in-progress almost three decades later.

The 1964 tape lasted forty-five minutes. When Young began per-
forming the work live in the mid-seventies an average performance
would last three or four hours. The 1981 performance released in 1987
by Gramavision on five CDs/LPs/cassettes ran just over five hours. During
his thirty-year retrospective at the Dia Art Foundation in 1987, Young
gave a series of seven performances of the work on consecutive Sundays

beginning on March 29, all of which ran even longer, with the last clocking in at six hours and twenty-four minutes. What is more important than the stopwatch here is the fact that even at that extended length, more than eight times that of the original tape, Young was obliged to eliminate and abridge several of the numerous themes he has generated over the years.

Young's jazz background bears strongly upon *The Well-Tuned Piano*, each realization of which is with reason listed as a separate work by date. Young plays from memory, and the themes antedate the performance, but this does not negate the improvisational nature of the work. The themes serve, rather, as the raw material for the specific performance, much as chord changes served as the basis for varied realizations of his tunes as a teenage altoist. The direction of a given performance and the duration of his exploration of a given chordal area may be strongly influenced by the desire to explore more recent themes or the precision of the tuning of specific intervals. The final 1987 performance concentrates at great length on the "Orpheus and Eurydice" theme, which is absent from the Gramavision recording altogether, while that recording contains numerous themes heard briefly or not at all in the later performance, for all its length.

The adjective in *The Well-Tuned Piano* represents a disavowal of the equal-temperament system of tuning that had dominated Western music for two centuries. The noun is of interest insofar as the composer evolved what is now his best-known and most highly praised work on an instrument on which he had only had a year or two of formal training. As a student he had worked out his harmony exercises on piano, but his first instrument remained saxophone and clarinet his second. The saxophone and piano were linked in the early phase of the drone works, in which Young would improvise over the drone on either instrument. On piano, Young played in a static, rolling style which led to the more sophisticated techniques of *The Well-Tuned Piano* and its "cloud" sections, in which the notes are played so quickly as to create a fog of overtones, the individual note losing its identity in the mass.

Though an apparent anomaly in his work up to 1964—with the exception of the twelve-minute *Study III* in 1959, his only works for the instrument to date had been conceptual or short notated pieces—*The Well-Tuned Piano* was in a sense anticipated not only by the drone explorations from the sopranino improvisations onward but by the long-tone pieces of the second half of the 1950s. The proclivity toward perfect consonances in the sustained-tone works foreshadows Young's abandonment of the compromises of equal temperament for the alternative tuning of just intonation. Riley notes that despite Young's serial practice in the California years he was from the beginning instinctively gravitating to intervals that were in tune on the piano [AC 111], thus the surprising evasion of major and minor thirds.

The most important connection, without doubt, is the relationship

between sustenance and harmonics. The longer a note is held, the more exposed become its overtones. In just intonation, as in the harmonic series, every interval can be expressed as a rational fraction; in equal temperament the octave is artificially divided into twelve equal parts in the service of tonal organization, permitting one to play in any key without retuning and to execute modulations that would grate unbearably in just intonation—but at the cost of vitiating to varying degrees (2 cents for the fifths, 13.69 cents on the major thirds) every intervallic relationship except the 2:1 octave. The partials in the overtone series are generated from the fundamental in a mathematical relationship that is in fact *negated* in equal temperament in any interval other than the octave by the mathematically irrational tuning of the constituent fundamental tones themselves. The *composite* waveform of these notes in equal temperament is thus both irregular and unpredictable, while in just intonation it is periodic and repeatable.

In the O-tonality version of just intonation adopted by Young in *The Well-Tuned Piano* and virtually everywhere else since, every key is tuned to the frequency of a harmonic of a given fundamental and connected to a single rather than triple string. Thus every tone is related to every other as the numerator or denominator of a whole-number fraction, provided the tuning is precise—often after weeks of preparation devoted to achieving that precision. Consequently, not only the harmonics of each individual note but the sum and difference tones reinforce one another dynamically in a cumulative effect that provides a quintessential illustration of both less as more and the whole as greater than the sum of its parts. In purely quantitative terms, the dynamic level reached by the single strings in just intonation exceeds that of triple strings in equal temperament. Very much in the Pythagorean tradition at the inception of classical Occidental music, Young's rigorous mathematical devotion is subordinated to the exploration of "universal structure" in the creation of otherworldly sonic events.

In music with standard durational values the ear adjusts easily to the irregularity of intervals based on irrational numbers rather than fractions (if it is in fact a matter of adjustment rather than infantile, or for that matter prenatal, indoctrination: a C-major scale sounds quite bizarre to Asians not previously exposed to Western music, while in our film scores or commercials a simple sitar scale remains enough to suggest mysterious forces dissolving the ego if not the cosmos). In music like Young's based upon sustenance, the extended durations expose the inherent defects in artificially compromised intervals. Young pointed out tellingly to Ramon Pelinski that it was no accident that once European music adopted equal temperament it began phasing out sustenance progressively [Spring 1984 15], opting logically for pointillism with the establishment of the radical democracy of pitches in the twelve-tone system [16]. Equal temperament in a music of sustained and nonselective intervals would amount to a *prima facie* demonstration of that tuning's inadequacy. Thus

Young's *Well-Tuned Piano* is a belated answer to Bach's *Well-Tempered Clavier*, implicitly exposing it as a misnomer, albeit a more attractive one than, say, "The Serviceably-Distorted (or The Cunningly-Compromised) Clavier."

At the same time Young's retuning the primary instrument of common-practice tonality is another example of the rejective simplification of his Minimalist sensibility, eschewing the harmonic busyness of irregular beating for a harder-edged system based on whole-number mathematical ratios. It may also be seen, once again, in the context of Young's relationship to Cage, who had led the avant-garde Young had in a sense been transforming into the arrière-garde of the underground since his arrival in New York. It may be no accident either that Young followed Cage's precedent in what it is valid to call redesign of the piano. Cage's nuts-and-bolts-laden "prepared piano" dates from 1940. With its distortion of the tone of resonating piano wires to simulate nonpiano timbres, Cage aimed to create a one-man gamelan. In the simulation of horns, gongs and voices that result from acoustic peculiarities of equal temperament, Young's "well-tuned piano," in turn, may resemble a one-man orchestra-*cum*-chorus.

Other ostensibly exotic peculiarities of the tuning include the strikingly microtonal intervals between keys (144/147 is the smallest used by Young in recent tunings, while he has tuned 112/113, about an eighth of a semitone, on a Rayna synthesizer in his recent *Symmetries*), which are a logical conclusion of the rejection of the arbitrary division of the octave into twelve half-tones in equal temperament. On first hearing, Young's well-tuned piano sounds irredeemably *out* of tune; yet after one fully immerses oneself in the work, it is difficult to listen to any *other* keyboard music during a period of adjustment which may last for hours or days. There is, then, a very real connection between *The Well-Tuned Piano* and the concept-art pieces with their subversion of normal perception in the cause of expanding consciousness.

Young has credited Tony Conrad, a trained mathematician, with introducing him to the integers, and also mentions the explorations of Harry Partch, Ben Johnston, and Lou Harrison as influences on his move into just intonation. On another level, the decision seems an inevitable consequence of personality as well as aesthetics. A year after the Lincoln Center controversy, Young had a major imbroglio with Columbia Masterworks, withdrawing angrily (in this case with eminent justification) from what might have been a commercially rewarding recording contract. He and Zazeela had been recorded by engineer David Behrman singing out on Long Island, with the resonant frequencies of the Atlantic substituting for electronic and instrumental drones in this instance. The singing recorded well, the ocean poorly.

Columbia Masterworks President John McClure proposed to overdub the singing with another recording of the ocean; Young insisted on re-recording the voices as well, singing in real time with a real ocean and its

real frequencies; Columbia refused to go further over (presumably low) budget; Young refused to let them "paste" ocean onto his singing. Despite some discussion about releasing *The Well-Tuned Piano* instead—impractical first of all in that it was a monophonic tape when mono LPs were being phased out by stereo as efficiently as stereo LPs would be supplanted by CDs in twenty years—Columbia never released any of Young's work, while it did release that of Riley and Steve Reich, whose reputations soon overshadowed Young's as a result.

This constitutional inability to compromise his music in any way, shape, or form makes Young's rejection of the harmonic deal-cutting of equal temperament seem psychologically foreordained. As Young phrased it to Robert Palmer more colloquially, "If you want to go through life making adjustments, saying, 'Well, he meant to give me four dollars, but instead he gave me $3.25,' that's your business" [1981 55], on other occasions adding the warning that this way of doing business is a good way to go broke. His rejection of compromise with Columbia, obviously, had done nothing for his personal economy, though accepting the compromise might well have left him bankrupt morally and creatively.

The custom-made Bösendorfer used only by Young for his performances of *The Well-Tuned Piano* is *sui generis*. As noted, it contains only single strings to attain the clarity and perfection of tuning Young seeks; it also contains an additional bass octave, its lowest C being four octaves below middle C. Every key is tuned to a harmonic of an E-flat ten octaves below the lowest E-flat on the extended keyboard. This missing fundamental functions as a subliminal drone (at that frequency it would be inaudible to the human ear even if somehow playable) almost fourteen octaves below middle C. By the broadest definition, then, the piece may be included among the drone works.

Despite the theoretical and technical intricacies of harmonics and triadic permutations involved in its composition and a recurrence of material compared by more than one critic to Wagnerian *leitmotiven*, superficially the structure of *The Well-Tuned Piano* is quite simple. Even the proliferation of titles for Young's thematic permutations may be somewhat misleading insofar as the same chord occurring in a different register may be given a different name. The ostensible form of the work is an alternation of spare thematic sections (the first eighty seconds of the Gramavision recording contain sixteen notes, all from the three tones of "The Opening Chord") with the dense textures of the aforementioned "clouds," explained by Young most tersely as "a very strong acoustical array of harmonics that fill the air in such a way that it sounds as though there's a cloud" [Schaefer 75]. Less poetically, the individual tones are played so rapidly as to be subsumed by the massive array of mutually reinforcing harmonics generated along with acoustical beats. "As I played some of the longer sections of very fast permutations and combinations of specific sets of pitches, it actually became possible to hear the composite waveform of some of the sets. Extraordinary periodic acoustical beats

became suspended in the air like a cloud over the piano, sometimes even filling the entire space during the energy accumulations of the longest passages" [*Well-Tuned* 8]. Young synchronizes his phrasing to the acoustical beating of proximate frequencies "in such a way that it became a type of resonance system" in which "the positive pulses created by the rhythms of the hammers are synchronized to reinforce the positive pulses of the waveform of the frequency of the acoustical beats, which in turn determine the frequency of the rhythm of the hammers."

This reciprocity illustrates Young's Minimalist technique of eliciting complex results from limited resources: a simple triad—arpeggiated, accelerated, and permuted—generates an entire frequency spectrum. The work is structured, then, as a series of exfoliations of constituent triads or quadrads, which are presented initially in their naked beauty before condensation into harmonic clouds. As each cloud dissolves, we are returned inexorably to the sound of a single note, with which the work ends—with such poignancy and nobility as to vindicate all the dead ends and banal misconceptions in the history of Minimalist understatement. Riley, who has described *The Well-Tuned Piano* as "a cosmic overview of life's tragedy" [Rich 1987 58], observes with equal admiration, "In the end the whole piece comes down to two things, the single notes and the clouds. Only La Monte could get away with that!"

The 1964 tape of *The Well-Tuned Piano* has next to nothing of the profundity of its later evolution, largely because it is in this form an experimental transition piece in which the clouds dominate virtually the entire realization. Structurally, the 1964 *Well-Tuned Piano* is a series of clouds juxtaposed to a few sparer sections and silences, often with distractingly sloppy abruptness. The extended rests recall the *Trio* and *Second Dream*—although they are used in those works with far more conviction, while the sopranino pieces, as mentioned above, clearly provide the model for the clouds arising from Young's keyboard, in which velocity once again negates itself in the simulation of sustenance—here not merely of tones or chords but of the composite waveform of the frequencies set into resonance.

In the few slow sections of the tape the further influence of Young's drone work may be heard in turn: simple, pacific, often inexplicably grave resonances of intervals whose bare exposure is all the more naked in context of the surrounding clouds. In this sense the 1964 *Well-Tuned Piano* may be heard as a summation of Young's highly experimental career to date: the long-tone compositions, the concept art, the sopranino and drone works. It did not become the masterwork it is until those divergent, even warring, influences were somehow reconciled over time, and a truce declared in the psychomachia of earlier compositional selves.

Of enormous impact on the work has been the study of Indian music Young undertook in 1970 with Pandit Pran Nath, which gave him a sense of music as organic efflorescence ("raga" signifies both the realized musical work and the organization of pitches that is its foundation)

that is nowhere in evidence in the 1964 *Well-Tuned Piano*, from its opening *in medias res* to its sudden stops and starts. In addition, Pran Nath is most recognized for his mastery of the slower *alap* sections of raga performance; it seems incontestable that Young's exposure to this on a daily basis inevitably veered his work away from virtually exclusive concentration on the breakneck tempi of the clouds and towards the spare expository sections of pristine beauty. In any case, when Young dates the work "1964-present," the most important component of the date is the hyphen.

Because of Young's perfectionism, *The Well-Tuned Piano* may be the most difficult and expensive solo piece on any instrument to mount. He requires weeks to fine-tune the piano (a painstaking process which has recently been facilitated by computer) and will only perform the work in the setting of Zazeela's masterful light-environment *The Magenta Lights*. In the early days, he notes, it was all he could do to get anyone to play the relatively brief tape publicly at museums, galleries, etc.—forums which also proved far more common than the concert hall for his colleagues in the reductive style, well into the next decade.

He had resigned himself, in fact, to limiting performance of the work to rolling the tape until in 1974 Fabio Sargentini produced an East-West Festival at his Galleria L'Attico in Rome. Young and Zazeela had done a Dream House sound-light environment the year before for him, and Sargentini wanted something different and less expensive, so Young suggested a tape concert of his sopranino saxophone work and *The Well-Tuned Piano*. Sargentini "made some sort of deal . . . with a music store" [*AC* 67] and got hold of a Bösendorfer Parlor Grand. By then, Young says, he "had not seriously practiced the piano for many years" [*Well-Tuned* 7] and had "*forgotten* the idea of playing the piece live—this was *ten* years after the initial tape." He gave two performances, roughly two and a half and two and three quarters hours long, on consecutive nights in June. "Fabio bought the piano and had me sign it and made it available exclusively to me for the rest of my life for performances of *The Well-Tuned Piano*," the next two ensuing a few weeks later [*AC* 67].

The piano was flown over for the American live premiere performances in New York in 1975 (eleven performances at the Dia Foundation in April and May). For its German premiere a year later, Radio Bremen provided the Bösendorfer Imperial which Dia then bought and had remodeled to Young's specifications. In September 1978 Young gave his first four American performances of the work on the instrument at Dia in New York. The next year the Foundation bought 6 Harrison Street and the piano remained there until it closed six years later. The October 25, 1981 concert that was released by Gramavision five and a half years later, was Young's fifty-fifth performance of the work.

On November 1, 1964, five months after Young completed the Ur-tape of *The Well-Tuned Piano*, the Sunday *San Francisco Chronicle* announced

the latest concerts in a series of evenings devoted to the work of local composers and produced by Morton Subotnick at the San Francisco Tape Music Center on Divisidero Street. "Works to be performed include 'Music from the Gift' (with Chet Baker), 'I' (with John Graham), 'Shoe Shine,' and 'In B-flat or is it A-flat.'"

Riley was well known in Bay Area performance circles, and the house of about five hundred was packed on Wednesday for a program entitled "oneyoungamerican" the night after Lyndon Johnson overwhelmed Barry Goldwater in the Presidential election. The four works mentioned in the notice are rarely heard, and except for *Music for The Gift* now largely forgotten. *I* was an unlooped tape-piece in which Graham inflected the word menacingly, narcissistically, etc. *Shoe Shine* was a looped tape-piece working off Junior Walker's hit single *Shotgun*. John Gibson describes the first (dated July 1964) as "a great piece" and the second (June 1964) as a "fun-house" that shook the walls. *In B-flat or is it A-flat* (October 1964) was so named because of the tape distortion of jazzman Sonny Lewis's tenor sax. In the program notes, the Dewey commission is still entitled "Music from *The Gift*" and dated July 1963.

Two other works were performed, though not mentioned in the preview. One was listed as *COULE* but apparently known as *Coulé*, a bilingual pun on "cool" and the French word for both a slur in musical notation and a plunge in swimming. It was described as a "continuously being composed . . . piano improvisation upon a mode"—which could describe much of Riley's work up to 1980. The final piece, *In C*, was dated October 1964.

The musicians included the composer, Jeannie Brechan, Werner Jepson, James Lowe, and Steve Reich on keyboards, Ramon Sender on Chamberlain organ piped in from a second-floor studio, Jon Gibson on soprano and Sonny Lewis on tenor sax, Pauline Oliveros on accordion, Mel Weitsman on recorder and trumpet, Stan Shaff and Phil Winsor on trumpet, and Morton Subotnick on clarinet. Anthony Martin, also onstage, modified two projectors in what he calls "a rhythmic/melodic light composition" of dots, lines, shapes, and colors modulating in "one-on-one time" with the music. Another packed house on Friday and a rave review by Alfred Frankenstein in the *Chronicle*, subsequently excerpted for the Columbia LP cover, followed.

Frankenstein entitled his piece "Music like None Other on Earth" and prophesied that Riley "is bound to make a profound impression with it. . . . This primitivistic music goes on and on. It is formidably repetitious, but harmonic changes are slowly introduced into it; there are melodic variations and contrasts of rhythm within a framework of relentless continuity, and climaxes of great sonority appear and are dissolved in the endlessness. At times you feel you have never done anything all your life long but listen to this music and as if that is all there is or ever will be, but it is altogether absorbing, exciting, and moving, too" [November 8, 1964].

Frankenstein immediately perceived the ritual element in Riley's work, comparing it favorably to Chavez's attempts to reconstitute pre-Columbian ceremonial music. He was also the first to apply the term "primitiv[e/istic]" to what would become known as Minimal music—he admiringly, most others dismissively. He concluded, "The style discussed here reached its peak in a piece for instrumental ensemble called 'On C,' which stayed on C for the better part of an hour but left one refreshed rather than satiated. . . . 'On C' was the evening's masterpiece, and I hope the same group does it again."

It had been an event, but they didn't. *In C* was performed infrequently in the four years that passed before it was released at the end of 1968 by Columbia Masterworks. The recording featured Riley and ten members of the Center of Creative and Performing Arts at the State University of New York at Buffalo. In New York, the group had performed it at Carnegie Recital Hall, the concert which stirred Columbia's interest, while Toru Takemitsu and Cornelius Cardew mounted performances in Tokyo and London around the end of the decade.

The decision by Columbia Masterworks director John McClure to release the work was undoubtedly encouraged by the rage for simplicity in the visual arts (although to date the term Minimalism had been applied in music only to Young's work, and then indirectly, by Barbara Rose in her article on "ABC Art"). The Primary Structures, Art in Process, and Systemic Painting group exhibitions and numerous solo shows had enshrined Minimal as the trend of the year in 1966, following Pop and Op in the two preceding, and when the disc was being edited the *Village Voice* was describing the new season as "Mostly Minimal" [September 19, 1968 18–19]. In addition, the free-form communal exuberance of the work embodies the brighter side of the paranoiac and jubilant, lacerated and ecstatic sensibility of the 1960s, which has been simplified beyond recognition in the various mythologies of the era that have since proliferated. The extent to which the ecstasy and jubilation, induced chemically or otherwise, were an overcompensation, even a reaction-formation, in the context of the cultural ravages of riots, assassinations, and the Vietnam War, is still downplayed, resulting in an incoherent popular conception of the era as being alternately—rather than simultaneously—the best and the worst of times.

In popular music, the success of the Beatles has often been linked to the downcast mood subsequent to the Profumo scandal in England and the assassination of President Kennedy in the United States. The popularity of Columbia's *In C* is undoubtedly similarly linked to its sense of collective ecstasy, free-wheeling improvisation, and trancelike repetition not unamenable to chemical alterations in consciousness. Its ebullience came as a much-needed lift in a year that witnessed the assassinations of Martin Luther King and Robert Kennedy, the siege of Chicago, and the election of Richard Nixon, none perhaps designed to fill one with longing for the latest experiment in academic Serialism. If Young's drone music

suggested the revival of some primordial ritual, Riley's motoric music called to mind whirling dervishes reincarnated as California flower-children. The cover art for Columbia by Billy Bryant combined, quite appropriately, the repeating patterns of a musical staff with multiple perspectives of what might be a psychedelic cloudscape, vaguely reminiscent of the more colorful ones popularized by Peter Max.

Today the work continues to sound as inseparably a product of its times as any of the Beatles albums, yet remains as fresh. It was a stunning departure for American classical music, the antithesis of both the hyper-serious dodecaphony in which the composer had been trained *and* the neo-Cageian cacophony he had generated with Young for Halprin. The genesis of the work has been described by Riley as an inspiration, and his discovery of modular construction proved just as radical and successful a concept as Young's creation of the *Trio for Strings* six years earlier out of sustenance and silence.

Riley states that all the motifs of the first section of *In C* came to him one night on the bus going to play ragtime piano at the Gold Street Saloon after his return to San Francisco under economic duress. He acknowledges, nonetheless, that the concept, like Young's *Trio*, represents an evolution from his earlier experiments. In both cases, too, fundamental influences from outside the European classical tradition made themselves felt.

Despite the radical nature of Young's long-tone works, he was determined to have them viewed within the context of classical music. The works of the late 1950s are not only atonal but follow traditional classical structures: Young insists that the *Trio* itself was organized in terms of exposition-development-recapitulation-coda [*30-Year* May 18, 1987 5], albeit his sense of duration may have served to obscure the connection to sonata form. As noted above, Riley's early compositions were also Serial. The title *In C*, apparently innocuous, is contextually revolutionary, as Riley announces the abandonment not only of Serialism but atonality in embracing the simplest key signature. There was, however, no deliberate allusion on his part to Schoenberg's (to some shockingly) ecumenical statement, of which Riley was in fact unaware until the late 1980s, that good music remained to be written in the key of C major.

If the most important precursor of *In C* was *Music for The Gift*, another important transitional piece was the second of the *Keyboard Studies*, which has been dated variously by both the composer and his commentators. The collection as a whole is dated 1965 by Riley in his resume, but the composer is the first to acknowledge that his recollection is imprecise. When asked about the reviews of performances in the mid- and late sixties, for example, he laughs that he rarely even read a newspaper at the time. Grove American gives 1963 twice [IV, 48]; in *Notations* Cage gives 1966 as the date for No. 2—i.e., the year he heard it in New York; while Mertens follows Daniel Caux in accepting 1964 [Mertens 39];

and Nyman gives "around 1964" as the date of inception [1974 124].
Clearly the series, including several studies untranscribed, was composed,
in part as *études* or modal five-finger exercises, in units at irregular
intervals over the course of several years.

The second in this series of warm-ups for Riley's virtuosic improvisa-
tions is the first example of *transcribed* modular composition (as opposed
to the electronically fabricated phrasal repetition of *Music for The Gift*) and
as such anticipates the fifty-three fragments of the score of *In C*, which
also consists of a single page. Riley wrote out fifteen figures containing
from three to eight notes on eight staffs, with the first figure employed as
a bass ostinato throughout as the player experiments with superimposing
the remaining figures as they are gradually integrated into the
improvisation. The improvisational element in Riley's characteristically
freewheeling approach to indeterminacy is accentuated when the piece is
realized on two or more keyboards.

Even *In C* has been played in at least one solo version, by a pianist,
though the communal verve of the piece is one of its salient features,
whether performed, as it has been, by the Shanghai Film Orchestra, the
Kronos Quartet, or an ensemble of electric guitars. Rebelling not only
against atonality but the tradition of specific instrumentation deriving only
from the seventeenth and predominating since the mid-eighteenth
century, Riley laconically noted the piece as being "for any number of
musicians," none of whose instruments were specified. Riley's casual
description of the score itself as "a sort of launching pad" for improvisa-
tional interplay represents a turning away from the academic fetishism of
the score as an emblem of the abstraction of music from sounds into form
and an embrace of a more jazz-like approach to the tune or the changes
as raw material. *In C* rejects an aesthetic of cerebration for one of celebra-
tion that coincided with the mood—or the needs—of its time.

Though Riley, uninterested in repeating himself as opposed to his
fifty-three phrases, never pursued the ambiance in later works, with *In C*
he created a whole new variety of Minimalism. If Young's concept art
left a theatrical bequest to his music, his work nonetheless retained
a strongly recondite and meditational aspect—no one was likely to use
either the *Trio* or *Tortoise* as party music. Riley, inspired by Young's bare-
bones technique, created the extroverted complement to its pensiveness.
From its first notes *In C* exposes a different musical universe. Here the
lack of accidentals on the staff indicates the key of the title rather than
the absence of key. Dynamically, it is a fairly steady *f,* like his preceding
works, rather than the finely etched *p-pppp* calibration of the *Trio,* and
instead of time suspended in *pianississimo* the piece opens with a steady
"pulse" in octaves, the two highest Cs on the piano keyboard alternated in
steady eighths. Instead of three strings in minor seconds Riley opens
with a repeated and repeated slurred ascending major third—an interval
which Young, significantly, had banned from the *Trio* along with sixths.
Instead of droning strings emanating from and subsiding into long silences,

Riley opened with fragmented permutations of the tonic chord relentlessly repeated, and instead of mystical isolation, collective exuberance. For all they have in common, the two pieces are virtual antitheses, as if Riley were deliberately engaging in what literary critic Harold Bloom calls a clinamen, or creative swerving from the influence of one's chief precursor in order to establish one's own territory and creative autonomy.

The *Trio* was the first work in full-blown musical Minimalism after the transitional pieces *for Brass* and *for Guitar*. *In C* was the first work to bring Minimalism to a wider audience. Young originated Minimalism with the monodynamic sustained tones that were to evolve into full-fledged drones as his work developed. Riley popularized it with rhythmically contagious repeating modules set in an immediately recognizable tonal context to a motoric rhythm. By the time Riley began composing *In C*, Young had already left both dodecaphony and standard tonality behind, along with the equal temperament that had eliminated the competition in the West two hundred years earlier, and turned to the harmonic series and just intonation. Riley returned to the C-major tonality of his own *Trio*, after experimenting with C Aeolian in *Keyboard Studies*. In his later collaborations with Indian musician Krishna Bhatt, Riley was surprised to find that Bhatt tuned his sitar to C, although he must have felt at home.

In terms of Asian influences, Young's *Trio* had been most directly affected by Japanese gagaku, while the drone works are more Indian in their inspiration. (He acknowledges that *The Well-Tuned Piano* could now be considered a Western raga.) *In C*, on the other hand, is quite reminiscent not only of the Levantine heterophony Riley had experienced strolling the streets of Tangier but of Indonesian gamelan, though it does not derive in any specific sense from that tradition. Its sense of exuberance and even raucousness is more akin to Balinese than Javanese gamelan, the latter known for its restraint and slower sense of time (although West Javanese or Sundanese music is more percussive and uninhibited than the classical court gamelan of central Java). It has nothing directly to do with gamelanic techniques for interlocking structures, yet its use of repeating and overlapping modules as the basis of the composition is gamelanic in style. It does not require Indonesian instruments—though they are certainly not excluded by Riley's scoring "for any number of instruments"—but is often executed on mallet instruments; the Columbia release featured three vibraphones and two marimbas prominently among the twenty-eight instruments used in the twice overdubbed recording.

A gamelanic feel of Javanese *saron peking* or Balinese *gender* is evoked on the recording even before the entrance of the first module by the Pulse created by Margaret Hassell's drumming on the two upper Cs of the piano. Another illustration of the difference between Young and Riley is the radically divergent keyboard repetition of Riley's Pulse, which never varies throughout the piece, and Young's pot-banging or "1698" piano realization of *arabic numeral (any integer) to Henry Flynt*. Despite superficially

shared stasis, the unvaried repetition of the first is buoyant, of the second emotionless. Riley's Pulse is a support; Young's repetition is a concept. Many listeners continue to find Minimalist repetition in general a form of torture, and if there is an example to vindicate this view it might be *arabic numeral*. Young with characteristic single-mindedness takes his concept to the limit, or past the limit, and, one feels, attempts to dominate the listener almost brutally. There is a strong element of conceptual exhibitionism and unconcern/disrespect for the audience here. The Pulse of *In C*, on the other hand, may be repeated two, three, or ten times longer but to a different end, not "getting inside a [single] sound" but establishing a solid foundation for what becomes a structure of shifting modules analogous to the bits of glass in a kaleidoscope. Its simple alternation of octaves invites the listener to tap his feet, while Young's repeated dissonance dares the listener to try to think of anything else.

The jazz influence is thus, again, more to the fore in Riley than in Young's classical work, though both had worked professionally as jazzmen. First of all, Riley was looking for a way to translate his experience with Chet Baker's jazz combo in *Music for The Gift* from tape to live performance. He describes the recording of *In C*, in fact, as a kind of wild jam session, although its forty-three-minute length was according to some accounts only half that of the Tape Music Center premiere (not Frankenstein's, however, who may have attended the shorter of the two performances, which he describes as lasting "the better part of an hour"). "For three hours"—the studio time parsimoniously allotted by Columbia to demonstrate its commitment to new music, which permitted three takes—"we just sat there and blew our heads off" [*AC* 117].

Young, quite unlike Riley, was anxious to escape the gritty milieu of jazz and blues, and his compositions almost programmatically eschew anything suggestive of their rhythmic verve as he moves into the more self-consciously rarefied realm of "serious music." Even when he returned to saxophone in the sopranino improvisations begun in 1962, the resultant works owed less to the American jazz tradition—apart from the structure of twelve-bar blues—than to the Indian and Middle Eastern music in which Coltrane had already immersed himself. The jazz influence, that is to say, was itself in good part a translation of Asian music, Coltrane a filter through which that influence passed. Coltrane, however, remained irresistibly propulsive even within static harmonies throughout his modal period, while Young embraced and extended the static elements in the style: the difference is manifest in their respective drummers, Elvin Jones and Angus MacLise. Less analytically, *In C*, like Coltrane, swings, while in its drone simulation Young's sopranino, like the White Queen, runs as fast as possible to stay in one place.

The score of *In C* was as shocking as its bare-bones tonality, consisting of a single sheet containing fifty-three musical figures. Each musician plays the fifty-three modules in order, each one for as long as he likes with rests as frequent as he likes before proceeding to the next module.

The construction of the piece is overtly influenced by modal jazz, with Riley very slowly modulating from one harmonic area to another in the course of the piece, first from tonic through subdominant into dominant seventh. The work is largely diatonic: its only accidentals are F-sharps signalling the modulation to E minor and B-flats evoking the dominant minor in which the piece concludes. With the complex overlapping of modules the harmonic movement is not nearly as simple as the frequent description of the piece as "variations on the major triad" suggests— relatively little of *In C* directly explores the tonic—just as Coltrane's modal style incorporated not only the seven notes of a given mode but notes from chords harmonically related.

Another clear indigenous influence on the work is the rock'n'roll which had by 1964 filled the AM airwaves for a decade. Its slow-moving and generally predictable chord progressions provided another model of decelerated harmonic movement, as did the repeated tonic rifts and hooks of the black music then just acquiring the "soul" rubric (a segregationist category like "race records" in the 1920s but one embraced if not invented by blacks). Perhaps even more importantly, both these forms of pop were based on a mercilessly regular (and hopefully irresistible) pulse.

It has been noted by both Nyman [124] and Mertens [41] that while the capital-p Pulse is explicit in *In C*, it was implicit in *Keyboard Studies No. 2* in its four-note ostinato. It became explicit only as a result of the difficulty of keeping the musicians together as they explored their individual module of the moment. Unlike the through-composed long-tone pieces of Young with their rigid dynamic strictures, the skeletal score of *In C* represents the naturally more easy-going and casually anarchic temperament of Riley. In a sense *In C* foreshadows the maximalist game experiments of John Zorn from the mid-eighties onward, although Zorn's game-plans consist of content-less schemata, not notated fragments.

During rehearsals for the premiere of *In C* the freedom inherent in the score became a problem insofar as the musicians found it hard to preserve ensemble amid the fun. One of them, himself a drummer, suggested that a steady, purely rhythmic figure might facilitate the cohesion that was lacking. He came up with a suggestion Riley liked and adopted drumming out Cs on the keyboard as a way of keeping time. The musician who "just threw out the suggestion—it was Terry's piece" was Steve Reich, the composer who took Minimalism into its next phase—phasing.

O

Although Steve Reich played electric Wurlitzer at the premiere of *In C*
and had begun musical studies on piano as a child, he was not primarily
a keyboardist like Riley. At age fourteen he switched to drums and as a
drummer led student combos, with bop drummer Kenny Clarke as his
stylistic model. Born a year after Riley and Young in New York, Reich
had an upper-middle-class and bicoastal upbringing, dividing his preschool
years equally between his mother's apartment on Manhattan's East Side
and his father's in Los Angeles, where he continued to spend his vacations
during his school years. His parents had divorced when he was a year
old; half a century later Reich taped the governess with whom he had
criss-crossed the country precociously, along with a Pullman porter of the
time, then combined their voices and their implied pitches with a string
quartet arrangement and recorded train sounds. The result was the
masterful *Different Trains*—the other trains being those on which his
fellow Jews in Europe, who appear as witnesses in the second part of the
work, were being herded into the darkness of cattle cars while the
schoolboy Reich was staring out the window at the Great Plains and the
Rockies.

Reich, Young, and Riley, profoundly and distinctively American
composers, embody the ethno-religious diversity of the nation: Reich is
of German Jewish descent, Riley of Irish-Italian Catholic, and Young
of Swiss Mormon. All shared a family background that was musical but
to no profound degree, certainly not in the area of classical music: Young's
uncle played alto professionally in swing bands; his father also played
saxophone in his spare time and according to the composer "absolutely
beat me if I made a wrong note" [AC 56]. Riley also had a maternal uncle
who played bass in bands, and the Italian side of his family, with whom
Riley was raised, featured music at holiday get-togethers. Reich's mother

sang professionally, appeared in the annual *New Faces* shows, and wrote
the lyrics for the popular song, "Love Is a Simple Thing."

Reich qualifies as a westerner, like his Minimalist predecessors, only
in that he lived west of Central Park from kindergarten until high school,
between preschool years on the East Side and high school years in the
Westchester suburbs. He was from a more advantaged background, at
least economically, than his rurally raised colleagues Riley and Young
(who matter-of-factly describes his parents as "hillbillies"). As a result,
while as children Young was listening more or less exclusively to cowboy
songs and Riley to pop tunes on the radio, Reich had a taste of what he
calls "the middle-class favorites" in the nineteenth-century classical
repertory. More contemporary music—both Stravinsky's *Sacre* and bebop—
seems to have assaulted him simultaneously with puberty. When he
responded by putting piano on hold and taking up drumming, lessons
with Roland Kohloff, then principal tympanist with the New York Phil-
harmonic, were arranged.

Young and Riley were enrolled as music majors from their first day
as freshmen at Los Angeles City College and San Francisco State; Reich
entered Cornell, at sixteen, as a philosophy major and graduated as such
with honors, writing his senior thesis on the later Wittgenstein. He did,
however, continue jazz drumming in Ithaca at the Black Elks and other
venues, while his taste in classical music, in part under the influence
of William Austin, veered away from the Haydn-to-Wagner repertory to
which he, like most, had been first exposed. Returning to New York,
he studied composition with jazz musician Hall Overton before entering
the Juilliard School of Music in 1958, where he mothballed the trap
drums for propriety's sake, studied wtih William Bergsma and Vincent
Persichetti, who had also taught Overton, and met among other classmates
Art Murphy from Ohio and Phil Glass from Maryland, whose paths
would cross his again. He wrote some simple pieces for string quartet
and a small orchestral piece and at the end of his studies began his first
twelve-tone piece. This was inspired by Stockhausen's lecture at Columbia
University espousing Serialism as the music of the future. It was a brief
(three or four minutes) piece for string orchestra, in which Reich used
the tone-row but, more significantly, generated his piece not by inversion,
retrograde, or transposition but repetition of the row.

In 1961 Reich left Juilliard and decided to take up graduate studies
at Mills College in Oakland, anxious for a change of scene and what
he anticipated as an easy M.A. Mills retains a reputation for attracting
renowned visiting professors, and in Reich's time those were Darius
Milhaud and Luciano Berio. Nonetheless, Reich found his time at Mills
boring and frustrating, valuable largely insofar as it drove the young
composer in the opposite direction. The aging and infirm Milhaud, "a
kind man, a nice man," was more inclined to reminiscence than analysis
and contributed "less than zero" to Reich's musical education in the
semester he spent with him. Reich had greater contact with Berio over

two semesters: "Serialism was hot, whether you liked it or not—and I didn't, but I wanted to learn what the latest thing was, I wanted to learn the technique, I wanted to learn about magic squares, and Berio was a living, breathing, major player." Reich seems not to have found him particularly inspiring as a teacher, not nearly as much so as Overton and Persichetti, who according to Reich strove to educe the student's vision rather than imposing their own. Reich found himself instinctively as unattracted to twelve-tone music, though he dutifully continued trying to compose in that vein, as he was attracted to jazz, and especially to John Coltrane, who was simultaneously revolutionizing the perspectives of Young and Riley.

During Coltrane's modal period from the end of the 1950s to the middle of the 1960s, the saxophonist was performing constantly, whether at home in New York or on tour. He drove himself even when his health began to fail, in part out of a profound sense of responsibility for the livelihood of the sidemen he had recruited (including in 1961–62 Young's comrade Eric Dolphy, who died three years before Coltrane in June 1964 at the age of thirty-six). Reich was living in San Francisco and often went to Jazz Workshop several times a week to catch the mesmerizing saxophonist, who, it can be said without hyperbole, was playing jazz no one had even imagined and doing so with a single-minded concentration and overwhelming energy that was a spiritual as well as musical statement long before he began adopting specifically religious titles for his compositions.

Then back across the bay to the tone-rows, which Reich found increasingly frustrating. On viewing Reich's ostensibly twelve-tone string orchestra piece, Berio went so far as to suggest to his student that if he wanted to write tonal music, he should write tonal music. This may have been his most valuable influence on the young composer, along with providing world-class examples of the kind of music Reich became progressively convinced he did not want to write.

What he wanted to write was still uncertain. In his last semester at Mills, Reich became associated with the San Francisco Mime Troupe, which provided him the vast relief of finally providing a connection between the composition of music and its being heard by an audience. It also provided a connection to working artists he found more interesting if less elegant than their academic counterparts. Reich did the music for light shows and a production of *Ubu Roi* staged by the Mime Troupe in the deconsecrated church in the Mission that served as their headquarters. The proto-Dada antiplay was designed by William Wiley (who would later design the jacket for Reich's first solo LP) and scored by Reich for clarinet, strummed violin, and kazoo, the latter played through a Pacific Gas and Electric plastic traffic marker on unofficial lease as a megaphone. It was comprised of a repeated fanfare, the import of which was synopsized by Reich after an impromptu reprise in 1992 as "Goodbye, Luciano! Yes, it'll be so tonal you won't be able to bear it."

In early 1965 Reich also used the ending of Stephen Foster's "Massa's in De Cold Cold Ground" and set a fragment of his "Oh Dem Watermelons" in five-part canon as part of the Mime Troupe's "minstrel show," presented as an illustration of the racial stereotypes implicit in both the original music and the original minstrel shows. Reich's "Oh Dem Watermelons" canon accompanied the projection, in the middle of the minstrel show, of a quick-cut film of the same name by Robert Nelson, featuring watermelons flying into Superman's arms, being smashed, being caressed by a naked woman, etc. It was the middle of the 1960s.

Reich's thesis at Mills embodies the profound conflict between his training and instincts at this transitional stage. It was a twelve-tone jazz piece scored for piano (played by Reich), bass, drums, tenor sax, and trumpet, combining what the composer describes as "weird licks" with a fixed beat—"a really low-level piece I would choose to forget."

After obtaining his M.A. in June 1963, Reich opted to pursue cab-driving rather than college teaching. He had begun primitive experimentation with tape in 1962 but during the next year became more committed, in part through association with the San Francisco Tape Music Center, and began manipulating recordings he made of his fares and other San Franciscans. Working with a mono Wollensak, the first commercially available tape recorder in the United States, then a mono Viking, in late 1963 he completed his first piece, the score for an experimental film, also by Robert Nelson, called *The Plastic Haircut*. This sound-collage used an old LP narrating "The Greatest Moments in Sports." "I'd record a bit, stop the tape, move the needle, and then start taping again, so there was hardly any splicing," Reich explained to Michael Nyman in 1970. The piece "turned into noise through over-dubbing with loops, rather like a surrealist rondo" [Nyman 1971 230].

In February 1964 he completed his first tape piece using a musical instrument, *Music for Three Pianos or Piano and Tape*, a work later discarded but significant as a foretaste of his work after 1966. The direct influence on the piece was Stockhausen's *Refran*, in which Stockhausen had adapted to vibraphones the slowly decaying chordal structures of Morton Feldman. Reich created a cyclic structure of echoed chords, some jazz-derived, which he now describes as "somewhere between Morty Feldman and Bill Evans." The chords played by the first piano are repeated (either exactly or in rolled, broken form, etc.) by the second and third, resulting in a repetition of notes in the same timbre, but without repeating rhythmic patterns or the fixed beat of the thesis piece.

As his commitment to tape grew, Reich acquired a Sony 770 in 1964, then a state-of-the-art stereo machine, and a Uher portable—both on installment with co-signer Phil Lesh, who had been a fellow student at Mills, was then a postal worker, and would soon be the bassist for the Grateful Dead. Reich ran a mike from the Uher, half the size of an attaché case, tucked under his driver's seat, up to the dome-light of his

cab. He took the results of his bugging the cab and crafted them into
a three-minute quick-cut collage of door-slams and the daily crises of his
fares entitled *Livelihood*.

In fall 1964, Reich began a more important tape piece using voice.
Tipped off by a friend, he brought the Uher and a shotgun mike to Union
Square to record a young black street preacher named Brother Walter
quoting Scripture and prophesying apocalypse in quasimusical declama-
tion. After taping him, Reich's problem was what to do with tape that
could match the raw material itself. He considered collage and also
attempted musical transcription of Brother Walter's implied pitches— a
technique he would not perfect until a quarter-century later in *Different
Trains*.

Some months before leaving Mills, Reich had begun to form an
improvisation group. He supported his studies with a graduate assistant-
ship, as well as by teaching rock'n'roll progressions in San Francisco's
Hunter's Point ghetto ("teaching them their own music . . . kind of a
funny position to be in") and theory and composition at a community
music school on Kapp Street in the Mission. One of the students, violinist
and later philosopher George Rey, joined the group, along with cellist
Gwen Watson, keyboardist Tom Constanten (who joined the Grateful
Dead after Pigpen's death), and saxophonist and later composer Jon
Gibson, who had played in Reich's thesis and calls him "a major influence
on my thinking and also supportive of my work" [*In Good Company*].

The quintet often played in a percussive style that may have repre-
sented an uncomfortable mix of jazz and Stockhausen; it was initially
conceived as improvisational, illustrating Reich's attraction to jazz and
desire to distance himself from academic composition. After months
of weekly sessions of largely subjective and extempore improvisation,
Reich felt the group had reached a dead end. He attempted to remedy the
situation in November 1963 with *Pitch Charts*, in graphic notation derived
from Berio's *Tempi concertati* but providing a semblance of tonality in
that it remained within given pitch groups for periods between cues. The
series of boxes that served as markers in the score went so far as to
specify the notes to be played but not so far as to specify the rhythm or
manner of their playing.

The ensemble gave a performance at the San Francisco Mime Troupe
one night in early fall 1964, featuring pure improvisation along with
Pitch Charts, and pieces by Tom Constanten and Phil Lesh. Reich noticed
that one member of the audience, a local celebrity from his association
with Ann Halprin, Ken Dewey, and La Monte Young, as well as for
his own tape and piano work, walked out at intermission.

Reich lived on Wool Street in Bernal Heights, which he describes as
then "a wacko blue-collar area with seedy undertones." He had learned
from a mutual friend, jazz trumpeter Bill Spencer, that Riley lived on the
same street. Next day he paid a visit to his garage studio, introducing

himself, Riley recalls, with a bang on the door followed by "Why'd you walk out on my concert?" After this inauspicious introduction, the two sat down to talk and despite very different personalities and personal rhythms reflective of their upbringing in Manhattan and the Sierra foothills, hit it off. They discussed their shared interest in tape and Riley showed him the one-page score of *In C.* Reich immediately offered the services of his ensemble. Of the other members only Gibson ultimately performed in the premiere; otherwise the improvisation ensemble was on its way out.

Gibson needed no prodding. Twenty-eight years later, still the only musician to have played in ensembles of the four major figures of early Minimalism, he refers to Riley as both "brilliant" and "a great guy." Apart from valuing Riley's friendship in a period in which he felt very much at loose ends, Gibson states, "I was at Terry's disposal, deeply impressed by him as a person. . . . He provided a turning point in my whole way of thinking about music and life." In terms of very practical return he provided Riley lessons on soprano sax—to which he had been converted in high school not by Coltrane but by Steve Lacy's work on *Gil Evans & Ten*—lessons Riley would soon put to good use.

The bus-ride epiphany that had progressed to unique figural notation on the page was a step closer through Reich and thence Gibson to being heard outside Riley's head.

Reich completed his piece with Brother Walter in January 1965, two months after the premiere of *In C,* and it is from this point, the mid-1960s, that his distinctive contribution begins. Just as Riley unhesitatingly credits Young with revolutionizing his whole conception of music, so Reich is equally forthright in acknowledging that the experience of *In C* radically changed the direction of his music. This is evident as early as the Brother Walter piece, which became known as *It's Gonna Rain.* The title is taken from Brother Walter's citation of God's warning to Noah: "It's gonna rain after a while." The text of the entire first section of the work consists of the first three words of the warning, repeated through tape-looping. As noted, Reich had been instinctively drawn to tone-row repetition when working in dodecaphony, but *In C* clearly provided a model for the more extended repetition of modules. Initially Reich considered dis- and reassembling Brother Walter's dialogue collage-style, as per "The Greatest Moments in Sports," but as the *In C* rehearsals continued, his strategy changed in the direction of repetition through tape-looping in a more all-encompassing manner than in *The Plastic Haircut.* The results of his subsequent decision to concentrate on a few phrases repeated hundreds of times warrants in its reductivism the Minimalist tag that Reich and Riley both, understandably, find largely irrelevant or misleading when applied to their later work but accept with less enthusiasm than resigned equanimity when restricted to their early efforts.

Brother Walter helped Reich resolve a generic as well as stylistic impasse, insofar as he had been seeking a way to set to music the work

of the American poets he most admired: William Carlos Williams, Charles Olsen, and Robert Creeley. All were marked by their colloquial rhythm as well as diction, and Reich's challenge was to preserve their distinctively American speech in a formal musical setting, which he had been trying and failing to achieve since Juilliard. He found that he could not impose any recognizably musical framework without sacrificing the vitality of the language to its exigencies. It was not until almost twenty years later that he found a satisfactory solution, using fragments from Williams' *Orchestra* collection as the text for *The Desert Music*. In 1965, however, his alternative was to set unmediated speech rather than recitation, in this case the highly musical preaching of Brother Walter. This represented a rapprochement of the technique of *musique concrète* that had dominated tape music to date with a specific concern for the vernacular.

It's Gonna Rain opens with the unmanipulated reproduction of thirteen seconds of Brother Walter and his streetside congregation, followed by the repetition of the title (accompanied by a fragment of pigeon warble) for seven and a half minutes. Brother Walter inflects "gon' *rain*" as major thirds repeated over and over, coincidentally the same interval as the opening module of *In C*, which consists solely of a slurred C-E. (In this regard it is entertaining to begin the CBS and Nonesuch recordings of the two pieces simultaneously, listen to the first forty-five seconds of *In C*, then switch circuits for the next forty-five of *It's Gonna Rain*.) The second part of *It's Gonna Rain* begins like the first with forty seconds more of unedited and inimitable arioso by Brother Walter, moving *all'attacca* into Reich's arrangement, here employing tape loops considerably longer than those in the first part. The unison canon is thickened in texture from two to eight voices as Reich complicates the phase relationships exponentially.

In *Mescalin Mix* Riley had manipulated an echo effect, but in *It's Gonna Rain* Reich made extensive use of the "beating" or fading echo created when pitches at microtonal intervals are sounded simultaneously. By this time the effect had also been created by Young in the sometimes miniscule pitch variations from one key to the next of his *Well-Tuned Piano*, and he was to explore the phenomenon much more extensively and subtly when the piece was revived in the 1970s; in Reich's work the beating too was created by the phase relationships, minor but audible differences of pitch in identical tapes having been created by the slight disparity in the velocity of the tape-reels. In fact, Reich was to eliminate those differences, if only in the conceptual realm, in a 1967 piece called *Slow Motion Sound:* "very gradually slow down a recorded sound to many times its original length without changing its pitch or timbre at all." His essay on the piece opens by acknowledging that it "has remained a concept on paper because it was technologically impossible to realize." It seems to have remained a minor obsession with him: he included it in his book, *Writings on Music* [15] in 1974, while making no mention of any works prior to *It's Gonna Rain*; even its partial realization in the "live"

Four Organs in 1970 seems not to have exorcized it completely, since Reich brought it up again in an interview months later [Nyman 1971 231].

In *Music for The Gift* Riley had created an orchestral texture with the artificial construction through tape of instrumental canons, but Reich's work represented an advance in using phase relationships as the controlling structural principle of the work and in employing human speech rather than instruments. Riley had encountered the natural tendency of tape recorders to run at slightly different speeds, which causes identical material to be replayed at slightly different tempi—particularly when one was using one- or two-hundred-dollar machines far below state of the art, even as it existed in the early and mid-sixties. Reich was to systematize the phenomenon, whereas Riley in characteristic fashion had been playing the tape-loops in reverse, changing their speed randomly, and so on.

In adopting Riley's tape technique to Brother Walter's discourse, Reich found the machines "moving ever so slightly out of phase, because of slight differences in belt tension, or maybe some dirt" [Henahan October 24, 1971 II, 26]. He methodically exploited this by manipulating identical tape-loops played on two tape recorders in such a way as to very gradually "extract" one voice from another, as one of two identical tapes fell farther and farther behind or crept farther and farther ahead of the other until the process—anticipating, interestingly, the symmetrical arch-form of Reich's later works—would reverse, the distance shrinking back towards unison. This was the case in the first part of *It's Gonna Rain;* the second part fades out with no hint of restored unity, as is appropriate to its chiliastic content. Earlier Reich had mulled over various means of controlling the tapes to establish a sufficiently complex relationship between them to provoke interest. In the end, he essentially conceived and set up the process and then left the machines to themselves: the only human element in the process, as opposed to the text, was Reich's thumb on the rim of the tapes, slowing them down to his specifications. *It's Gonna Rain* had its first public performance exactly twelve weeks after *In C* at the San Francisco Tape Music Center, paired with *Music for Three or More Pianos or Piano and Tape* and *Livelihood*.

Rather amazingly, Reich eliminated the second part of *It's Gonna Rain* from the premiere on Wednesday, January 27, 1965. He describes this period as one of soul-searching and abiding depression and feared that in the apocalyptic relentlessness of the piece he might be "inflicting my neuroses on the world at large." In any case, the performance at the Tape Music Center—announced in the *Chronicle* as "a concert of electronic works by Steve Reich"—was fairly well-attended and received, with the now-long-since-discarded *Livelihood* garnering most of the attention, largely for its accessibility. In an off-the-cuff review of "a promising young composer," Dean Wallace described the concert in the *San Francisco Chronicle*. Wallace found Reich's "stuff . . . reasonably tame . . . and . . .

notably lacking in that over-rated attribute, originality. But it has two signal qualities that raise it several notches above the mill-run—a sense of humor and definite feeling of formal balance."

After the minstrel show and a stint working at the post office, the composer went back home to New York in September 1965, feeling he was on to something but failing to see how it fit into the music scene that was too Cageian for his taste downtown and too dodecaphonic uptown. Unlike both Young and Riley, youthful admirers and emulators respectively of Webern and early Schoenberg and mutually of Stockhausen, Reich seems to have been temperamentally unattracted to atonality from the start, though he felt obliged to explore it. He was equally out of sympathy with Cageian aleatorics and the sometimes vaudevillean theatricality it engendered. More suprisingly, he did not seek to collaborate further with Riley when he in turn came to New York a month or so later, in part because of Riley's feeling that his techniques had been expropriated by Reich. Although in later years Reich has been careful to acknowledge the precedent of Young as well as Riley, at the time he clearly had no interest in their work in the Theatre of Eternal Music.

Despite his subsequent study of African percussion, Balinese gamelan, and Hebrew cantillation, Reich's primary interest in them vis-à-vis his own work, was in absorbing their structural procedures rather than emulating their scales or instruments. He has made frequent disparaging allusions over the years to the superficiality of the "sitar in the rock band" syndrome, and he has also spoken dismissively of "singing 'Indian style' melodies with electronic drones" and "this search for acoustic effect today where one repeats say piano tones over and over again until one can hear the third, fifth, seventh, ninth or higher partial" [Nyman 1972 21; 1976 303]. He called the latter a "1970s version of programmatic salon music," and his interlocutor took him to be referring to "composers like Charlemagne Palestine" [1976 303–04, 307 n. 15].

A few months after his return, Reich was approached by Truman Nelson, who had heard Reich worked with tape and asked him to edit ten hours of tape for a benefit. Reich explained that he was not a tape editor but would give it a try. The benefit was to finance a retrial of the so-called Harlem Six, who had been convicted of murdering a Jewish woman who owned a candy store in the Bronx. They had been beaten by the police after their arrest. The tapes contained assorted statements and narratives of all concerned, from the Six to their relatives to the police. Reich was struck by a sentence in Daniel Hamm's description of his treatment at the Twenty-eighth Precinct. To ensure his transfer from station house to hospital, his injuries had to be visible. He enterprisingly squeezed open a bruise on his leg to "let some of the bruise blood come out to show them."

Reich's piece opens with Hamm's eight-second statement, followed for another twelve and three-quarter minutes by phased "come out to

show them." Reich first looped the phrase and played the loop on one tape recorder, then recorded it on two channels of a second tape recorder: a full reel of straight duplication on the first channel and on the second channel reproduction delayed by slightly retarding the supply reel with his thumb. He repeated the process with the double-tracked tape, then spliced the two and four-voice versions together, then proceeded to divide the tape again into eight voices for the frenetic conclusion, very much in the same vein as that of *It's Gonna Rain*.

It "premiered" at the Town Hall benefit in April 1966 while the hat was passed and enough funds collected for the defense of Hamm and his comrades in a retrial granted on the basis of the mishandling of the initial defense by their court-appointed lawyer. Hamm, who had been involved in the incident but did not commit the crime, was acquitted of murder with four of the others; he subsequently went on to Columbia University instead of Sing Sing.

As in the second part of *It's Gonna Rain*, the number of voices in *Come Out* increases from two to eight. Due to the briefer material, the repetition is even more relentless than in *It's Gonna Rain*, which is appropriate to the polemical content. The piece, however, seems more dependent upon extramusical concerns than *It's Gonna Rain*, and in general does not represent a stylistic advance, except perhaps in the direction of minimalism of means. Today Reich stresses, however, that it is a "refinement" of the "rough-and-ready, down-and-dirty" *It's Gonna Rain* and "more musical in the conventional sense of the word" than its predecessor, which may account for its generally higher esteem.

Come Out does, however, together with *It's Gonna Rain*, represent as important a document of American culture in the 1960s as *In C*. If Riley's piece sounds like a score for a Love-In, *Come Out* reminds us of other contemporary events: the Watts riot in fact followed hard upon Reich's composition of *Come Out*. Riley's repetition is trancelike and exuberant, while Reich's is in its way, despite the rhythmic variation of his phasing, as grimly relentless as Young's *any integer (for Henry Flynt)*, but more troubling than annoying, suggestive not of severe compositional self-indulgence but of severe grudges being held out there in reality. While Reich, who was committed to the civil-rights movement from his teens, feels his contribution to the case was appropriate at the time, he acknowledges that if confronted with a similar situation today he would handle it differently.

It is not merely coincidental that Brother Walter's apocalyptic weather forecast came on the heels of Bob Dylan's "A Hard Rain's A-Gonna Fall" (released May 1963), the grimly surrealistic complement to the more lyrical protest song "Blowin' in the Wind" on the same album, *The Freewheelin' Bob Dylan*. It *is* most probably coincidental that *Come Out* was released by the same company in the anthology *New Sounds in Electronic Music*, on the Odyssey budget label of Columbia Masterworks as part of a mass of Christmas releases in 1967, predating the release of *In C* on

Columbia Masterworks by a year, but having little of its impact. Master-
works then issued *It's Gonna Rain* under its own rubric, together with
Reich's *Violin Phase,* on the 1969 *Steve Reich: Live/Electric Music.* Along with
In C, the LP set a precedent for later Minimalist albums in featuring
original cover art by William Wiley in lieu of the usual photograph,
reproduction of an old master, etc. More recent Reich record covers have
included artwork by his wife Beryl Korot and Roy Lichtenstein, while
Sol LeWitt designed the jacket for Philip Glass's *Music in Twelve Parts (Parts
One and Two)* and a painting by Glass's late wife Candy Jernigan appeared
on *Dance 1-5.*

Five years after working together on *Ubu Roi,* Reich and Wiley had
collaborated again in the multimedia piece *Over Evident Falls* at the
University of Colorado in August 1968. *Pendulum Music* originated there,
Reich says, when he had soaked in the atmosphere to the point that
he began to twirl a microphone cord like a lasso in Wiley's Boulder studio
and discovered the effect of its feedback as it crossed the path of a
speaker. It was incorporated into the performance accompanying a snow-
fall (of Ivory Snow flakes) in black light; the second part featured a
now-discarded tape piece called *My Name Is,* in which Reich distorted
various taped voices providing that information, while Wiley passed cards
with some of the resulting nonsense syllables or contextually meaningless
words across the black-lighted stage on a clothesline.

Reich found the title *Live/Electric Music* an acceptable characterization,
though after completing *Pulse Music* he also accepted a reviewer's applica-
tion of the title as a generic description of his work [Nyman 1971 229].
(To this point the only application of the adjective "Minimal" to music
was Barbara Rose's implicit extension of the term to Young's *Dream Music*
in her essay on "ABC Art.") *Live/Electric* indicates the shift of direction
Reich underwent after *Come Out.* After three years of experimenting
variously with taped voices, Reich applied phasing to instruments. During
the night of May 21-22, 1966, a month after the *Come Out* benefit, Reich
dreamed a melodic pattern, woke up, picked up a melodica, taped himself
playing the melody, looped it, and completed the piece the same day. It
was called simply *Melodica* and was the last of his pure tape pieces, which
Reich played at the Park Place Gallery the next month.

The gallery, strongly associated with Minimal art, had been founded
as a cooperative and opened its first exhibition on December 1, 1963.
Its landlord, Columbia University, evicted the gallery from 79 Park Place a
few months later. In early 1965 it reopened at 542 West Broadway,
retaining its name. Reich's concerts were part of the attempt of the
cooperative to foster interchange by experimental artists in different
media. The gallery closed for good a few months after Reich's second
concert in March 1967. His first tape concert is unmentioned in his
appendix to *Writings About Music,* where the first listed performance of
Melodica is March 1967 at Park Place—actually its second performance

during a presentation devoted otherwise to live (rather than tape) music. Reich notes that "important" performances are listed, which may explain his similar elimination from the appendix of a performance of *Violin Phase* at the School of Visual Arts as part of a series of evenings produced by Robert Rauschenberg before the Paul Zukofsky performance at the New School in April 1969.

Reich gave performances on Friday and Saturday night and Sunday afternoon, May 27–29 and attracted a fair crowd and an intelligent review from Carman Moore in the *Village Voice,* who noted his "utilizing simple musical means to a complex end," citing the transformation of the "sh" sound in "Come out to show them" into an approximation of maracas. Moore found the work simultaneously "strident, reiterative" and suggestive of "a raga exercise, distorting and distorting to incandescence" [June 9, 1965].

By the time *Come Out* had itself come out on LP in December 1967, Reich had become so depressed by the limitations of his medium that he had begun "to feel like a mad scientist trapped in a lab" [Nyman 1971 230]. The release of *Come Out* was in effect a going-out-of-tape-business sale. He had already completed his first "live" piece.

P

Riley returned to New York shortly after Reich in fall 1965 and lived there with his wife and daughter until early 1969. They found an apartment on Grand Street off the Bowery, across Sara Roosevelt Park, a kilometer-long traffic island of near-green between Chrystie and Forsyth, from the Eldridge Street digs where Stella had begun his black paintings. Although his first project was another collaboration with Ken Dewey, he was also interested in working further with Young and in gaining greater exposure for his music. He soon began joining in on rehearsals of the Theatre of Eternal Music, which at that point still included John Cale. Cale's last performance with the Theatre came in December, Riley's first performance in February 1966. Riley sang with the group for about a year, restricting his keyboard and saxophone expertise to other projects.

The latest joint project with Dewey was a theater piece called *Sames,* presented at the Film-Makers' Cinematheque in November 1965. The work was very much in the tradition of mixed-media presentations at the Judson Memorial Church that dated from the early 1960s, of which Meredith Monk's subsequent work perhaps represents the most significant advance. Dewey dressed six actresses as brides and had them remain immobile onstage while he projected films on the walls and ceiling of the theater. For the audio portion Riley used both straight loops and his "time-lag accumulator" system, which employed the technology discovered during *Music for The Gift,* now extended to a series of tape recorders looping tapes over both playback and recording heads. The raw material in this case, as in *It's Gonna Rain,* was speech, but unlike the narrative of Brother Walter, a man with a message if there ever was one, this speech was restricted to meaningless phrases: "I," "That's not me," etc.— an outgrowth of the speech-piece *I* that had been played at the *In C* premiere.

During his three years in New York he saw but did not collaborate professionally again with Steve Reich, and although they remain on good terms, several associates confirm that at the time he was annoyed that Reich was gaining recognition by exploiting ideas he had originated. The debt of the Reich tape pieces to Riley's work was noted by others, as was Riley's undelighted reaction, even back in San Francisco. Reich himself puts it bluntly: "There was definitely strain. Terry felt that I was ripping him off, just the way I felt later that Phil [Glass] was ripping me off. We saw each other, but it was not comfortable."

In 1967 Riley was commissioned by the Swedish Royal Academy of Music to compose an orchestral-choral work for students and complied with *Olson III*, which characteristically left the students considerable room for improvisation. In 1969 he was commissioned by the Dilexi Foundation to score a half-hour video by sculptor Arlo Acton and producer John Coney, resulting in the award-winning *Music with Balls* for KQED TV in San Francisco. The next year he collaborated with both Danish television on a stereo color video and with Swedish television in a concert filmed in darkness with heat-sensitive infrared cameras. In 1970 Columbia also released on LP *The Church of Anthrax*, a collaboration with his predecessor in the Theatre of Eternal Music, John Cale. Essentially a progressive rock album with some Coltrane-influenced soprano sax by Riley, it had been recorded the same week as *In C* in a midtown church Columbia used frequently as a studio.

Riley had made his first recording in 1966 for the small company Mass Art Records, a piece called *Reed Streams* on reed organ and *Dorian Reeds* on soprano. In the literature on Minimal music there has been some confusion over the dating of Riley's *Dorian Reeds*. Grove American [IV, 48], for example, dates it 1964 and lists it under "improvisational works" before *In C*, but the composer states that it was written after *In C* and most probably completed in 1965. It continues the modal and modular experimentation of that work and *Keyboard Studies No. 2* by constructing an endlessly repeated "continuum" figure from an A-Dorian scale combined with other motifs in tape delay to create a varied and progressively complex rhythmic texture by the superimposition of cellular melodies. *Dorian Reeds* also follows the open-ended instrumentation of *In C* and thus may also be entitled *Dorian Winds/Brass/Strings/Voices/Mix* etc. as the occasion warrants. The number of players/singers is not specified, again as in *In C*, leaving open the possibility of solo performance with tape delay. The Pulse which became explicit of necessity in the ensemble work *In C* is again implicit in *Dorian Reeds*, as has been noted by both Nyman [124] and Mertens [41]—here in the seven-note modal "continuum" figure as in the four-note ostinato of *Keyboard Studies No. 2*.

The Mass Art recording was a preview in a sense of Riley's second Columbia LP in 1969, which contained on one side *A Rainbow in Curved Air* for assorted overdubbed keyboards and on the other *Poppy Nogood's Phantom Band* for soprano saxophone with time-lag accumulator and

some long tones on electric organ underpinning the modal modules with hints of drone. The latter piece was composed in 1967 before the recording of *In C* the following year, and represents the culmination of a half-decade of saxophone experiments, some of them forgotten even by the composer, others remembered by him fondly—e.g., *In B-flat or is it A-flat?* with Sonny Lewis, so entitled for the tape distortion. Although Coltrane had had a major influence on Minimalism since 1961 in the modal sax playing of Jennings and then Young, *Poppy Nogood* was the first and clearest presentation of that influence on disc, in the choice and style of the soprano saxophone—both incantatory and still exotic (at least to patrons of Columbia Masterworks as opposed to Impulse! Records). Riley performed it three times in New York in June 1968, almost a year after Coltrane's death, first at the Intermedia Festival at the Brooklyn Academy of Music, and twice at Steinway Hall to close the "January through June" Festival.

Riley inaugurated the renovated Electric Circus on St. Mark's Place, the Haight Street of the East (Village), and just as rapidly deteriorating as its counterpart, on April 14, 1969. The concert was a variation on his second Columbia disc, which it was doubtless designed to promote (unless the *Times* senior music critic suddenly took it into his head to take a stroll downtown one spring eve). Riley improvised on live/taped organ in his first piece, and in the second on "some sort of reed instrument" (that Harold Schonberg did not recognize a soprano saxophone more than eight years after the release of *My Favorite Things* and his aforementioned appointment indicates the extent to which classical music continued to segregate itself). According to Schonberg, Riley was accompanied by David Rosenboom, who had played viola on the Columbia recording of *In C*, on violin and percussion. He was also accompanied by the spirit of La Monte Young, who provoked him to raise the volume so high that "eardrums started to flap" and to pull "a plug from one of the amplifiers, to create an open circuit . . . the longest pedal-point in history" (Schonberg apparently had not heard Young either).

I find the review—"The Medium Electric, the Message Hypnotic"— one of the most interesting Minimal music received in the 1960s. The image of Schonberg at the Electric Circus may itself account for much of its appeal: the article is finally as much about the musical establishment he represented as it is about the music. Despite being out of sympathy, Schonberg struggles to be fair—and momentarily hip in describing Riley's ability to play "like mad" and his "thing" as "repetition of pattern to the point of hypnosis"—but finally cannot overcome his profound distaste. Analogies to Indian music are made; Riley's ingenuity is noted; his stamina draws something bordering on awe ("His left hand . . . must be made of one of the new unbreakable synthetic plastics"). Schonberg's final emphasis, however, is on the "dullness" and "pain" he finds the salient features of Riley's "basic esthetic" [April 15, 1969].

A Rainbow in Curved Air, composed the previous year, anticipates

Riley's work of the next decade. Riley abandoned composition for most of the 1970s and appeared on disc only in improvisational guise in a series of virtuoso keyboard performances. Otherwise, he devoted his time to studying and teaching Indian music. Blessed with a nature not consumed by ambition, Riley felt no sense of either blockage or deprivation; on the contrary, he felt that he was finding in Indian music a profundity absent from contemporary music, and that his abandonment of composition was in line with the tradition of oral transmission of Kirana and Indian music in general.

He did not return to composition per se until the end of the decade, at the behest of David Harrington, the leader of (what was then an earlier incarnation of) the Kronos Quartet, for whom he has since composed several works, including the two-and-a-half-hour *Salome Dances for Peace*. While Young continued on the path he had first charted, in any meaningful sense, Riley's Minimalist period began with his first *String Quartet* at the beginning of the decade, and ended with *Poppy Nogood* at the end of the 1960s. Riley pursued modalism and modularism alike in ever-more exotic form in his brilliant keyboard work of the 1970s, which is often more evocative of the Middle East than of India, and he often used a drone-tone as a harmonic base for his virtuosic improvisation. Despite the repetitive phrasing and motivic permutation that pervade that improvisation, its texture is generally too rich to be called Minimal music with any degree of accuracy.

Although like Young, Riley began intense formal study with Pandit Pran Nath in 1970, and taught Indian music for most of the decade at Reich's alma mater, Mills College, his titles frequently allude to the dervishes evoked in his whirling modal patterns (e.g., *Persian Surgery Dervishes*, which he performed to a packed house at the Whitney Museum on April 5, 1973 before recording it as a two-disc set for Shandar, and *Descending Moonshine Dervishes*, released by Kuckuck). Perhaps as a result of his immersion in Moroccan music and an earlier and more crucially formative stage of his career than Indian music, Riley's keyboard work continues to sound more Levantine than Indian until *Songs for the Ten Voices of the Two Prophets* in 1982, when he put his vocal training to use together with his undiminished keyboard skills.

By 1966 Reich was more interested in dealing with instruments in live performance than on tape, with which he had begun four years earlier, three years after Riley. It had become a central preoccupation, and Reich is frank in stating that he had begun to ask himself whether phasing was any more than a gimmick if it could not somehow be applied to a broader context. He sought that context by first recording and tape-looping one piano part: a single measure of 12/16, with the twelve notes derived from only five distinct pitches presented in ascending order (E-F#-B-C#-D). He then sat down at the piano to play the part of the second tape-recorder himself as the tape-loop rolled. The first minute or

so in unison was easy, but he found that the intense concentration necessary for the fine calibration of subsequent tempic separation from the tape (a sixty-fourth, a thirty-second, a sixteenth, an eighth—all within roughly half a minute—then back again, in a kind of tempic cancrizans) was difficult to achieve and satisfactorily approximated only when he literally closed his eyes to avoid distraction. Despite his inability to match the mechanical regularity of the tape-recorder, Reich was satisfied that phasing was indeed translatable to live performance.

He proceeded to notate *Piano Phase* in a conventional score with prose explanation of the process (which he later traded Richard Serra for his sculpture *Candle Rack*). Reich had reunited with his best friend from the Juilliard days, Arthur Murphy, who, Reich states unequivocally, had the best ear at Juilliard, though their classmates included Philip Glass and Peter Schickele. Murphy was a close friend of Bill Evans, a major contributor to the landmark *Kind of Blue* and the development of modal jazz with his impressionistic voicings within modal structures, whose improvisations Murphy transcribed for publication. Reich and Murphy began to practice with the tape rather than with each other, since neither had possession of or access to two pianos—this was before the days of portable plug-in keyboards—until the night before the premiere at Fairleigh Dickinson University in January 1967. Reich felt immensely relieved and vindicated by the results, which he summarizes as "Look, Ma—no tape!" He was to continue this phase of phasing for four more years, culminating in *Drumming*.

Discussing *Piano Phase*, Reich alludes to Young's acknowledgment of his early debt to Webern and echoes it, albeit the connection between *Piano Phase* and the static intervals, spare texture, and structural intensity of the *Orchestral Variations* is even more abstract. "They sound apparently different," he agrees, "but somehow their universe is not so entirely different. The Webern suggests that you could (a) have very little going on and (b) be enormously organized. Of course, the Serial people took this one way, and I took it quite another. There is a relationship in *thinking*, and with a composer like me who gets the drift of someone's thought *divorced* from their sound, the relationship to Webern can be considered even closer."

During the same period Reich composed *Reed Phase* for soprano saxophone and tape and *Improvisation on a Watermelon* for two pianos, alternately improvising over the suspended dominant seventh chord from *Oh Dem Watermelons*. Both were subsequently rejected. Like the first piece, *Violin Phase* was a clear outgrowth from *Piano Phase*, with exponential thickening of the texture from two voices to four, as the piece develops from a solo to a quartet. The first three violins phase the same bar of 12/8 while the fourth adds in two sections of the piece what sounds like a countermelody but is drawn from the various resulting patterns of the phasing. The result is greater melodic interest and rhythmic impetus than in *Piano Phase*. Arguably, the fourth violin represents

Reich's first step away from the reductive simplicity of his early Minimalist style towards the greater eventfulness of his work after 1973. Thus it does not seem terribly out of place on the ECM record in which it appeared between two works from the late 1970s, *Music for a Large Ensemble* and *Octet*. The performance by one violinist rather than four, Shem Guibbory playing with his taped selves, also looks ahead to the solo counterpoint technique of live/tape works Reich wrote for soloists Pat Metheny, Ransom Wilson and Richard Stoltzman, and its extension to the Kronos Quartet of *Different Trains*. Another innovation in *Violin Phase* is its eschewal of the cyclic structure of earlier phase works in that there is no return to unison playing at the conclusion.

In 1968, however, Reich temporarily returned to unison conclusion with a vengeance, and primarily to technological concerns. The piece *Pendulum Music*, dating from August of that year, is another pure process piece. As mentioned earlier, it began while he was working on *Over Evident Falls* with William Wiley at the University of Colorado and discovered by accident the feedback created by passing a microphone in front of a loudspeaker. Reich described the first realization of *Pendulum Music*: "We stuck a broomstick pole between two chairs and masking-taped the mike cords over three Wollensaks" [Nyman 1976 304]. As the piece evolved, four microphones suspended on cables are released simultaneously and left to swing a few inches in front of four loudspeakers, each of which is connected to the same amplifier as the microphone swinging before it. The resultant feedback is varied by the relative proximity of each microphone to its speaker. The sound reflects the phased diversity of the individual pendulum arcs as well as their sporadic and final unity when the microphones come to rest before the amps in a drone of feedback.

From 1968–1971 the piece was performed by various artist/composer/ filmmaker/dancer friends of Reich, including Bruce Nauman, Richard Serra, and Laura Dean, who might as well have been Tom, Dick, and Harriet insofar as the only job of four of the performers is to release a mike and sit down. The fifth performer, usually Reich, turns on the amplifiers to predetermined levels at the beginning of the piece. Any of the performers may pull out the power cords of the amps to end the performance. Sometimes Reich had less than four fellow performers simply because he had less than four mike-amp-speaker combinations available.

Reich's process music was related to similar undertakings of the time, notably those pioneered by Alvin Lucier, noted for his exploration of unconventional sounds and processes, from magnetic fields to bird-calls to oscillators. By 1965, in *Music for Solo Performer*, he had translated alpha waves to instrumental sounds in sequence through electrodes on the temples of the "soloist," amplifiers, filters, and loudspeakers placed next to percussion instruments, which are set in vibration by the amplified

brain waves. *Queen of the South* in 1972 consisted of vibrating sand from a metal plate with amplified voices; in 1973 coffee grounds, grain, and purple Tang were added to the sand, the plate became three sheets of wood, plastic and metal, and the voices were replaced by electronic sounds. In the same year he created *Vifarb Hyperb* by moving loudspeakers around the performance space. Like Young and Reich earlier, Lucier explored the effects of the simultaneous sounding of proximate frequencies in 1984 *Spinning*, the raw material of which is a single tone from each of two facing loudspeakers. Like Reich, he went directly to human speech for the tape piece that remains his best-known work, *I am sitting in a room*, composed in 1970.

It was first performed on March 25th of that year at the Guggenheim Museum in tandem with Mary Lucier's (Alvin Lucier's wife) *Polaroid Image Series*. The aural and visual works both explored the process of decay of an image in serial reproduction. Lucier taped himself making a statement, which is both libretto and explanation: "I am sitting in a room, different from the one you are in now. I am recording the sound of my speaking voice, and I am going to play it back into the room again and again until the resonant frequencies of the room reinforce themselves so that any semblance of my speech, with perhaps the exception of rhythm, is destroyed. What you will hear then are the natural resonant frequencies of the room articulated by speech I regard this activity not so much as the demonstration of a physical fact but more as a way to smooth out any irregularities my speech might have."

The final sentence seems either disingenuous or deluded, but the results are compelling. Initially the statement was played back and recorded fifteen times and lasted about as many minutes. In 1972 it was extended as an accompaniment for Violet Farber's dance *Dune*. In the 1980 realization released on LP by Lovely Music the next year, each (re-)recording of the full statement lasts about eighty-one seconds with end-pause. By its seventh appearance, the statement sounds like a tale from the crypt. Seven more and it is only fragmentarily decipherable. By Side Two of the LP, recitation 17 or repeat 16, the text may be followed only with libretto for those who have not memorized it. In the course of sixteen more recyclings, the wordless monologue (or dialogue/debate with the room) becomes utterly inhuman, as if modulating through *musique concrète* to *Elektronische Musik*. His stammer transformed into white noise, Lucier commits sonic suicide, long before theories of "the death of the author" were current. There is something eerie as well as inspired in his piece, which without polemicizing of any sort manages to suggest dehumanization, mechanization, and the alien objectivity of reality, very much in the spirit of the sculpture of Serra and Judd. In its repetition and limited means, *I am sitting in a room* ranks with the finest achievements of Minimal tape music. Furthermore, in its ambient conversion of speech modules into drone frequencies, it unites the two principal structural components of Minimal music in general.

In the same technological vein, 1968 saw progressively more elaborate incarnations of Riley's time-lag accumulator in festivals at the Philadelphia College of Art and Amagansett. The composer describes it as "A tiny maze of sound chambers and mirrored rooms which contained microphones to capture fragments of conversation and automatically arrange them into sound collages of repeated patterns." It represents the extension of his tape-work from the echo effect of *Mescalin Mix* to the quasi-orchestral techno-canons of *Music for The Gift* to a full-scale environmental installation that may have been inspired in part by the Dream Houses Young and Zazeela had begun. In the summer of 1969 Riley installed his most complex version yet at the Nelson Atkins Gallery of Art in Kansas City. He had been invited to participate along with seven other artists in the Magic Theater festival sponsored by the Kansas City Performing Arts Foundation and was given the support not only of funds but of a bevy of local schoolgirls (in 1969 they still came in bevies) as assistants in polishing up the installation before the opening. Other exhibits included the 6,000-light-bulb "Infinity Chamber" of Sidney Landsman, apparently the big hit of the show, and the spectator-activated "Electric Peristyle" of James Seawright. The Magic Theater came to New York, specifically Automation House on East 68th, the following March, and was promoted rather lamely as a model of the peaceful coexistence of artists and technicians, perhaps by way of belated response to C. P. Snow's delineation of the two cultures.

The same year marked Reich's invention, with help from Bell Labs, of the "phase shifting pulse gate." Reich seems to have resorted to this in his desire to escape from tape and facilitate live performance of his process music. His idea was that "if a number of single tones were all pulsing at the same tempo, but with gradually shifting phase relations, a great number of musical patterns would result. . . . If the process of phase shifting were gradual enough, then minute rhythmic differences would become clearly audible. A given musical pattern would then be heard to change into another with no alteration of pitch, timbre, or loudness [cf. the description of Reich's 1967 conceptual piece *Slow Motion Sound* above], and one would become involved in a music which worked exclusively with gradual changes in time" [Reich 17]. He used the phase shifting pulse gate in only three public performances of his *Pulse Music:* in April 1969 at the New School for Social Research, where Reich was teaching, and at a concert at the Whitney Museum of American Art on May 27, where it was immediately preceded by *Four Log Drums*, then followed by *Pendulum Music* and Paul Zukofsky's reading of *Violin Phase*. The device was then put in what proved to be permanent storage, though Reich played a tape of *Pulse Music* at the second of *Two Evenings of Music by Steve Reich* at the Walker Arts Center on May 11 and 12 the following year. For all his own precision, Reich found the exactitude created by the device to be "stiff and un-musical" [25].

On the other hand, Donal Henahan, reviewing the Whitney performance for the *New York Times* long before he succeeded Schonberg as its chief music critic, seems to have found little to choose from among what he described as four "electronically assisted ragas." A "full half hour" of *Violin Phase* on the heels of a ten-minute "interlude" of *Pendulum Music* was "as much fun as watching a pendulum" [May 28, 1969 28]. Henahan seems to have been equally nonplussed and prescient in noting that the composer "carries his celebration of repetition to lengths we have known previously only at second hand, from Oriental music." It was not ragas but gamelan Reich would begin studying in depth three years later, and it was Henahan who two years before that compared the insistent hammering of Reich's *Four Organs* to gamelan [May 9, 1970].

The two works on the program are so closely related that *Four Log Drums* may be considered an offshoot of *Pulse Music*, written immediately after it in May 1969, when *Pulse Music* was notated. *Pulse Music*, written for the phase shifting pulse gate, opens with the simultaneous sounding of D-E-G-A above middle C and middle C and B-A-E below. The constituent notes gradually move out of phase in eighths, as notes are extracted one by one, sounding separately before the decomposing chords, then enter into complex phase relations at eighth-note distances before the reconstitution of the chords at the conclusion. In *Four Log Drums* each of the two-note instruments is tuned to constituents of the aforementioned chords, initially repeating eighth-note patterns at the interval of a fifth (E-B, A-E, C-G, D-A in ascending order of pitch, which is the order of presentation) with an eighth-note rest between entrances. They proceed through various phase relationships as single notes and as fifths to the concluding simultaneous sounding of individual fifths by all four drums. This is of course equivalent to sounding the opening pitches of *Pulse Music*, which then began *all'attacca* at the Whitney performance. Reich regarded and regards both works as failures [Reich 73], has not performed them again, and does not want them performed again. The Whitney performance represents, with its shotgun wedding of primitive instruments and sophisticated electronics, a period of transition from technological to purely instrumental and live performance: "I felt very clearly then that I did not wish to have any involvement with electronic music again" [55].

A week before the first and last live performance of *Four Log Drums* and the second and last of *Pulse Music*, Reich had performed in the work of Philip Glass, one of his four log-drummers, as part of the same "Anti-Illusion" show for which the Whitney Museum had invited downtown artists in several media. It included Richard Serra's sculpture, films and lead-casting; Barry Le Va's floured floor; a film by Michael Snow called *Dripping Water*, during which water dripped into a plate; Bill Bollinger's *Stone* (a large stone); Eva Hesse's hung cloth; Neil Jenny's bowls of dog food; Carl Andre's *Reef* of fifty pieces of orange styrofoam; some proto-performance art by Bruce Nauman and Meredith Monk; and Robert

Morris's *Money*—he borrowed fifty thousand dollars at the beginning of the show, opened a bank account with it, and returned the results at the end of the show, during which he exhibited the paperwork involved.

John Perreault liked "Rafael Ferrer's leaves and ice piece at the Whitney entrance. I felt his hay, grease, and steel piece was a little too dramatic, however" [May 29, 1969 16]. The first was composed of dead leaves and fifteen blocks of ice, melting on top of them; the second consisted of twenty-seven bales of hay torn apart in two and a half hours, steel weights, and grease stains on the wall (with some hay stuck to the grease). Art critics Hilton Kramer [May 24] and Grace Glueck [May 25] were both contemptuous of the show in the *Times*, the latter referring with a sigh of relief to "a concert of music by Steve Reich, whose pulsating pieces actually have a beginning and an end"—itself a debatable point with regard to the featured work, *Violin Phase*.

Q

Philip Glass was born in Baltimore, where he worked off and on from the age of twelve in his father's record store. His grandparents were Orthodox Jewish immigrants from Russia, and he jokes that he is a musical blue-blood since an uncle played in vaudeville and Al Jolson was his father's second cousin. He began studying violin at six and at eight entered the Peabody Conservatory as a flute student. He later took up piano and left for the University of Chicago at fifteen, even younger than Reich on his precocious departure for Cornell. Glass too studied philosophy, along with mathematics and music, and graduated in June 1956 at the age of nineteen years and four months with a B.A. in Liberal Arts.

His compositions during this period show the influence of his independent teenage study of Ives and Serialism, including his first piece, a dodecaphonic string trio—interestingly, his first memory of classical music at the age of four or five is of the Schubert E-flat Piano Trio [Coe 72]. He went on to study at Juilliard from 1956–61, receiving a diploma and an M.A. in Music Composition. Like Reich, whom he met there in 1958, Glass studied with William Bergsma and Vincent Persichetti (and at the summer 1960 Aspen Festival with Milhaud, with whom Reich would study at Mills).

During his spare time as a student and later, he gravitated more to art than to music circles and remains convinced of their greater vitality and the more interesting ideas and personalities of the visual artists in the 1960s. He did, however, head to the Village Vanguard frequently to hear Coltrane, although he agrees that the influence is less evident in his work than that attested by Young, Riley, or Reich. In 1992 what he recalled, appropriately, about Coltrane was that "when everyone else in the band took a break, sometimes he'd just stay there on the stage,

playing repetitive scales over and over, and when they came back he'd still be there playing."

His first encounter with Minimalist musicians, ironically, had little to do with music per se. In 1961 he headed down from Juilliard to Yoko Ono's loft on what would have been either May 19 or 20 and encountered a performance by La Monte Young of *Compositions 1960 #10* and *Compositions 1961*, both of which had been premiered at Harvard on March 31. "He wasn't playing music, he was just drawing a line. I thought it was amazing that anybody would do it. That was very avant-garde to me at the age of twenty-three. I was *shocked* by it and I remembered it."

Glass was and is less impressed by Young's more conventional (i.e., audible) compositions. He left the February 1968 Barbizon Plaza performance after half an hour. "I didn't get it. I like and admire La Monte but I can't sit through it. It's too slow for me. It's the tortoise. La Monte *is* the Tortoise." In assessing Young he states, "He's an essential figure as a conceptual artist" but shrugs off his "musical ideas." Young, like Reich, objects to Glass's refusal to acknowledge the influence of his Minimalist forebears and summarizes Glass's contributions to classical music as "record sales."

After Juilliard, Glass next headed for Pittsburgh on a two-year residency in the public school system as a Ford Foundation fellow and composed marches for school bands, a six-minute *Convention Overture* for community orchestra, a ten-minute *String Quartet* (1963) rated as "moderately difficult" for high school players and including, interestingly perhaps only in retrospect, a hint of repetitive figuration from its opening bars. The laudable goal of the Ford Foundation program was to bring classical music out of the mausoleum and to the people, particularly our young people—an effort in which Glass later proved more successful than any classical composer alive. By his mid-twenties, he was able to have approximately seventy works performed and twenty published by Elkan-Vogel—all "modern tonal," since his Serial interests had ended before he left Chicago, and all since disavowed, including *Divertimento for Flute, Clarinet and Bassoon, Diversions for Two Flutes and Bass Trombone*, and a *Fantasy* and *Serenade* for solo flute.

He then won a two-year Fulbright to study with Nadia Boulanger in Paris, which he described as starting over from square one. Boulanger was a rigorous, often imperious figure, by no means prodigal with encouragement for her charges. Glass recalls that during their first meeting, when he showed her his assorted opera, she praised one measure of his music and nothing else over the next two years [Glass 15]. Six to eight students were invited—uncertain whether they were there because they were the best or worst of her students or represented both constituencies—to special "Black Thursday" morning sessions where they were presented with "some fiendish musical problem she had dreamed up for us" [16]. For these conundra and her regular lessons, Boulanger drew principally upon music from the Renaissance to Mozart, with special

emphasis on that composer and Bach and little mention of anything after Beethoven.

Glass was not impressed by the official avant-garde of the day, referring to Paris as a "backwater" [14] and the Boulez-led Domaine Musicale series as "a wasteland, dominated by these maniacs, these creeps, who were trying to make everyone write this crazy creepy music" [Rockwell 1984 111]. Just as Glass's appreciation of Boulanger's pedagogy seems to have grown less grudging with the passing years, so his more recent description of the Parisian avant-garde of the mid-sixties is more tempered but no more admiring: "insular, overconceptual, dry and academic" [Glass 14].

Its influence on Glass's mature style was largely negative, driving him in the opposite direction as Reich had been driven by Berio. A more positive encounter was with Ravi Shankar, the sitarist who had so inspired John Coltrane that he named a son after him, and whom Glass met in person rather than through the filter of modal jazz or LPs. He confesses to have had no knowledge of Indian music when he was hired in 1965 by director Conrad Rooks to transcribe for Western musicians Shankar's score for the acid-head epic *Chappaqua*. The encounter with the Indian compositional techniques of additive process and cyclic rhythm as an alternative to Western subdivisions of the beat and regularized demarcation of measures came as a revelation to the young composer, though he did not yet incorporate them into the more traditionally "modern" music Shankar asked him to compose for sections of the score.

The influence of Indian music is not obvious in his other compositions of the Paris period, although it is brilliantly evident in those he composed after his return to New York in 1967, soon after which he was exposed to Reich's pulse music and undertook further studies of Indian cyclic rhythms with tabla master Alla Rakha in the winter of 1967–68. It is the successful merging of Asian and domestic influences, including those like rock and jazz that had influenced Reich, that distinguishes Glass's mature style, which may be dated from late 1967, while the previous two years are crucial but largely transitional.

The first piece of music Glass still includes in his corpus was the music for a production the same year of Samuel Beckett's *Play* performed by a troupe later known as Mabou Mines and directed by Lee Breuer who, like Riley and Reich, had worked at the San Francisco Tape Music Center. Coincidentally, Glass scored his work for two soprano saxophones. This was not in tribute to Coltrane but a result of asking Jack Kripl, who later played for years in the Philip Glass Ensemble, what instrument he had on hand. ("'I've got a soprano saxophone,' he said. 'Great!,' I said.") In *Music by Philip Glass* he describes the piece as "based on two lines . . . having only two notes so that each line represented an alternating, pulsing interval. When combined, these intervals (they were written in two different repeating rhythms) formed a shifting pattern of sounds that stayed within the four pitches of the two intervals" [19]. It would seem, then, that Glass arrived independently at a kind of process music with

certain analogies to the interlocking modules of *In C* and the musical patterns created by Reich's phasing, albeit this initial effort is rudimentary. Glass's characterization—"a very static piece that was still full of rhythmic variety" [19]—could be applied equally to the work of Riley and Reich at the time. In 1992 he described the work as "a conceptual piece based on very reductive, repetitive pattern" but could remember neither the notes nor pattern. When I tried singing a pattern, Glass obligingly allowed, "It might be *those* notes!"

His first piece in the new style is described somewhat differently in Robert Coe's important 1981 article on Glass: "The score included 10 20-second phrases based on repeated musical figures for two instruments, each phrase separated by 20 seconds of silence" [76]. This account, presumably based on Coe's interviews with Glass at the time, sounds more like a description of his 1966 *String Quartet,* discussed below.

Glass pursued his discovery of repetition in *Music for Ensemble and Two Speakers,* the ensemble a pattern-producing wind sextet and the speakers his first wife, JoAnne Akalaitis (later director of the Public Theater), and Ruth Maleczech declaiming a soufflé recipe, foreshadowing the curious libretto of Glass's *Einstein on the Beach* a decade later. Equally importantly, the two pieces hint at the theatrical direction in which his music was to develop. In mid-1966, however, Glass returned to more traditional forms with what was simply entitled *String Quartet.* This may have been in part to convince himself that he had not gone as irretrievably overboard as most of the musicians and student composers around him seemed to feel.

Nonetheless, *String Quartet No. 1,* as the sixteen-minute work is now listed despite the published 1963 effort in the form, is structurally a truly radical piece of work. It is scored in common time and with bar lines, but Glass takes care to mention in his performing notes that the function of the latter is "to divide the music into legible units" rather than "imply a rythmic [sic] pulse." This reservation is significant in terms of the highly motoric style he was to develop on his return to New York, as is the abundance of chromaticism and dissonance remaining in the piece relative to the relentlessly diatonic structures he would later develop. Another ambiguity is the key signature without accidentals, which may be interpreted as a highly dissonant A minor, although each of the twelve tones is exposed in quasi-Serial fashion in the first two sections. Glass now accepts this interpretation on intuitive grounds, agreeing that he was not really thinking atonally although adapting Serial strategies.

Already glaringly present in the work, however, are figural/phrasal and modular repetition and strict sectional subdivision of the work into its component modules. All four instruments play repeated, but syncopated, figures and phrases throughout the entirety of the piece—quite unlike the unison playing that distinguishes his New York works. No player plays more than a single note at a time, and the repeated cells

vary in complexity from the same note played *arco* and *pizzicato* every three beats to simple phrases lasting from three to eleven beats. The work is divided into two movements ("Part I" and "Part II"), which are in turn divided by double-bars into twenty and sixteen sections, respectively. The sections last from seven to ten measures, each seven-, eight-, nine-, and ten-measure component given a metronome marking of quarter-note at eighty, eighty-eight, ninety-two, and one hundred, respectively. One result of this is the creation of more uniform sectional durations despite the variety of constituent measures: each section thus lasts—at least according to the mathematics of the score—between twenty-one and twenty-four seconds, with "a pause of 1 1/2 to 2 seconds at the double-bars"—not twenty seconds, as per Coe's article.

In the opening eight-measure section, the first violin is silent, while the second repeats a phrase composed of an eighth rest; an F-sharp quarter-note, G-sharp tied eighth and dotted quarter, and F-sharp eighth, all slurred; followed by an eighth rest and a quarter-note F-sharp slurred to a tied eighth and half-note G-sharp. The viola figure consists of a quarter rest, half-note C, and slurred quarter-note E and C and half-note E. The cello simply alternates half-note Fs, dropping an octave, followed by a quarter rest. The cells overlap but irregularly, given their respective lengths of eight, seven, and five beats. They are repeated unvaried, the second and third thus left incomplete at the first double-bar.

In addition to unvaried repetition within sections, each of the sections or modules is itself repeated *in toto*, as the entire work consists of eight such sections repeated as follows: 123454321 67876 123454321 67876 12345432. It is thus arranged in symmetrical blocks, with larger symmetries shared among the blocks and the entire piece almost completely symmetrical off the axis of section S in Part I (the second appearance of "5"). Repetition—albeit of a very different kind than in his New York works—is, then, already thoroughly pervasive in Glass's work by "Aug. 1966," the date on the score, on the level not only of musical figures and phrases (with four single-instrument tacets, the eight sections or modules are composed entirely of twenty-eight single-instrument cells) but also of the larger formal components of the roughly twenty-second sections of modules themselves.

Equally significant, nonetheless, is my "almost" before "completely symmetrical." First of all, Part I and II are not symmetrical to each other per se, since the division between them, marked by two minutes of silence, does not occur at the axis "S" but after the next section "T." Furthermore, in his decision not to repeat the "1" section as the last of the work, Glass quite deliberately evades perfect *overall* symmetry among the modules—and with it a sense of formal resolution more aligned to traditional expectations of recapitulation-*cum*-coda. This looks ahead to his beginning and ending *in medias res* the even more reductive works he would begin composing in New York the following year.

Another significant preview of things to come is the composer's

dynamic markings, which are common to all instruments within and throughout each section. Twenty-three of the thirty-six sections are marked *mf*, while in each of the two parts two sections are marked *f* and one *pp*, with four in Part I and three in Part II marked *p*. The milder dynamic levels (and their always concomitant sparer textures) are already underrepresented, while the dynamic stability and uniformity is already established in embryonic form. What was to change most markedly later on, along with the adoption of diatonic motorism, was the synchronization of voices in unison or parallel-interval playing.

After finishing the quartet (which had its world premiere a mere twenty-two years later by the Kronos Quartet) and his studies with Boulanger, Glass left Paris. He traveled to North Africa, then spent several months in India and points north. According to Annalyn Swan in *Time* in 1978, Glass had previously, like Riley, vacationed in North Africa (a photo of him and Akalaitis on a Spanish beach across the Strait is dated "summer of 1964" in *Music by Philip Glass*) and there found in "the repetitive element of non-Western music another way of composing." Fourteen years later he said that he had in fact visited several times ("It was easy to hitchhike down from Paris" to the Strait) and adds that he may have been influenced by "all the strings playing in unison in three octaves in African orchestras" but that the architecture had a greater impact on him with its repetition of pattern as an alternative to the representation of images prohibited by Islam.

On Saturday, March 18, 1967, just after his return to New York, he found yet another influence on attending the second of three nights of Steve Reich's music at the Park Place Gallery. Reich played the tape of *Melodica* for the second time at Park Place, perhaps as a transitional piece between his tape and instrumental works. He and Murphy performed *Improvisations on a Watermelon* on electric pianos, while Philip Corner and James Tenney were added for a four-electric-piano account of *Piano Phase*, and Jon Gibson had a solo on *Reed Phase*, a piece disclaimed by Reich but revived successfully by Gibson on his 1992 CD *In Good Company*. The last two works were respectively identified as *Four Pianos*—solely for the occasion Reich anticipated the title of his *Four Organs* three years later—and *Saxophone Phase*. In the March 23 *Village Voice* Carman Moore wrote, "The Friday show was a well attended and glittering affair with prism sculpture all around the white room. So strong was the effect of 'Four Pianos' that one of the listeners, who were all sprawled on the floor, fell into a howling kind of fit from which he emerged, shaken but otherwise (I think) undamaged after the piece concluded." Moore does not mention that it was St. Patrick's Day.

Glass had not seen Reich or Murphy since Juilliard but understandably felt commonality of interest. He showed *String Quartet* to Reich, and they subsequently got together frequently, usually alone, sometimes with others, to critique and play each other's music. After playing in Reich's improvisation group and in the premiere of *In C*, Gibson had continued

playing with Riley in San Francisco, premiering at a later Tape Center performance Riley's *Tread on the Trail* ("five different sets of melodies of equal length, each one constructed as a mirror image of itself" [Gibson 1992]), and New York. As a composer he was at this point involved primarily with tape, an interest he shared with Tenney, the composer with the most established reputation of the five in 1967, who had also been working with computer compositions. Along with Richard Landry, the four were to form with Glass the core of the Philip Glass Ensemble before it was so named in 1971 after Reich's departure.

Between 1967 and 1971 Glass performed in Reich's *Pendulum Music, Four Log Drums* (Glass: "a disaster—but we *all* have disasters"), and *Four Organs,* Reich on electric keyboards in Glass's *How Now, In Again Out Again, Music in Contrary Motion, Music in Fifths, Music in Eight Parts,* and *Music in Similar Motion.*

Combining what he had picked up in Paris and on return to New York, Glass produced *Strung Out, Music in the Shape of a Square* (discussed below), and *In Again Out Again* in 1967. The technique Glass explored in the last work was superimposing measures of 5/4 over 4/4, which eventually got *in* sync after five bars or twenty beats and then quickly *out* again—in what seems both a development of the syncopated repetition of figures in *String Quartet* and a mathematically rigorous adaptation of the calibration of Reich's phasing, perhaps less subtle and more aggressive both in terms of the friction immediately created and the rapidity of its metric (ir-/de-)resolution. No one today, including Reich ("A dog of a piece") or the composer, speaks highly of that particular work.

According to *Music by Philip Glass* [20], the first New York performance of Glass's music came in September 1968 at the Film-Makers' Cinematheque, which had moved from 125 West 41st Street to 80 Wooster Street in (what would soon be known as) SoHo. The date is incorrect, and the program/personnel given contradict the evidence of the ensemble's log, a fact which may be as significant as the venue.

According to the log, which gives date as well as month and is confirmed by the musicians, the performance occurred on May 19, 1968, and in fact followed performances at Queens College on April 13 and at the New School on May 9. The Cinematheque, the site of the Riley/ Dewey *Sames* three years earlier, was, more importantly, typical—since very little Minimalist music was performed at all in traditional concert halls for another ten years—i.e., when it was only problematically Minimalist. Glass jokes that when he performed at the New School on Twelfth Street in those days he thought he was "uptown." Up until the 1980s the setting for Minimalist music was less often concert halls than lofts, churches, galleries, museums, and universities. Reich's work had been performed across Europe, from Stockholm to Madrid, and as early as May 1968 at Tokyo's Orchestral Space Festival (*Piano Phase,* also recorded for Victor of Japan), yet it was not until 1971 that he became the first of

the group to approach the uptown mainstream with a performance of
Drumming at Town Hall in December 1971, after its Museum of Modern
Art premiere and a second performance at the Brooklyn Academy of
Music. Glass would follow him to Town Hall two and a half years
later.

By then the Philip Glass Ensemble had also performed at the restaurant/bar/rock club Max's Kansas City (June 19, 1973, *Music in Changing
Parts* and *Music in Twelve Parts,* Parts 2 and 3) in the midst of a tour of the
five boroughs, playing in parks under the auspices of the New York State
Arts Council. Glass continued to confound traditional expectations. Even
in 1976, two years after Glass's uptown debut in Town Hall, the premiere
of *Einstein on the Beach* at the Metropolitan Opera House was initially
reviewed in the *Times* not by its music critics but by theater critics Clive
Barnes and Mel Gussow. In September 1985 they performed at the
Ritz with Rubén Blades y Seis del Solar as supporting act, and the next
March they appeared on *Saturday Night Live* in place of the usual rock
group.

At the first American performance of Glass's mature work at Queens
College, Glass and Reich performed *In Again Out Again* on keyboards.
Strung Out was also performed at Queens and was the only work by Glass
performed at the New School on May 9. After Glass's unreviewed and
unadvertised "debut" at the Cinematheque ten days later, the next public
presentation of his music came in November at Yale University, a tape
concert presented by the Pulsa group. Though no one was mindful of the
fact at the time, this was an event of some significance insofar as it was
the only time the four major figures of 1960s Minimalism were presented
in tandem, Young represented by a tape excerpt from *Tortoise,* Riley by
Dorian Reeds, Reich by *Melodica* and perhaps another tape piece, and Glass
by *Strung Out.* Glass himself was not present but represented by Steve
Reich, acting as his temporary press agent.

The tape had been recorded by Dorothy Pixley-Rothschild, who had
performed it most probably at Queens College and the New School and
certainly at the Cinematheque, where Jon Gibson performed the solo
Gradus on soprano saxophone and a flute duet, *Music in the Shape of
a Square,* with Glass, who also played a piano solo on *How Now.* Unmentioned in *Music by Philip Glass* but mentioned in the log of the ensemble is
In Again Out Again, in which the composer and Steve Reich again played
a keyboard duet. (The ensemble log lists all three with Pixley-Rothschild
as the personnel, and Reich did not perform otherwise at the Cinematheque; *How Now* was not performed as an ensemble piece as on some
later occasions.)

In the case of Reich, severe disenchantment with dodecaphony and
prior experimentation with both aggressively (and in context of his
graduate training, perhaps defensively) tonal music and the technologically achieved repetition of tape-loops had prepared him for the encounter

with Riley's modular structure, which finally drew him over the line into terra incognita.

Glass was at a similar point when he arrived in New York. He had embraced tonality at the age of eighteen—much younger than Riley (twenty-five) or Reich (twenty-six)—for what his scores call a "modern tonal" style deriving from Copland et al.; he had been exposed to the powerful influence of Indian music; he had opted for reductive repetition, albeit in a severely limited context, first in his music for the Paris production of Beckett's *Play,* much as Reich had in his equally minor composition for the Mime Troupe's production of *Ubu Roi* seven thousand miles away two years earlier; he had expanded the technique of figural/phrasal repetition both durationally and contrapuntally as the controlling structural principle of *String Quartet.* Yet he had not employed unison repetition, rapid-fire tempos, and highly reductive diatonicism—all of which were equally essential to his mature style—until his return to New York and exposure to the phasing of Reich with its fast, often diatonic, pulsing unison canons.

With regard to the possible influence of Riley's *In C,* Reich had the score and a tape of the San Francisco premiere.

Reich in February 1992: "I undoubtedly played the tape for Philip."

Glass in September 1992: "No, I never heard the tape. Steve showed me the score after I wrote *Two Pages* and asked where I'd gotten the idea for writing in modules. I first heard Terry at the Electric Circus" (in the April 1969 performance discussed in the previous chapter).

In any case, unlike *String Quartet,* the New York works are tonal and harmonically static and emphasize a fixed beat throughout rather than adjusting tempo with each new subsection every seven to ten measures. It would be unfair and misleading to suggest a Minimalist "genealogy" from Young to Riley to Reich to Glass, but one might suggest a line of transmission of influence in that chronological order, perhaps the inverse order of their current notoriety. It is not merely because of their age (Riley was born June 24, 1935; Young October 14, 1935; Reich October 3, 1936; and Glass January 31, 1937) that the four have been considered since the late sixties, and are still generally considered, the major figures of the first generation of what became known as Minimalism.

Glass has objected to this categorization as journalistic shorthand which misrepresents the collective nature of the "very intense generational search" [AC 157] that was transpiring—an objection which Reich considers a "smokescreen" cast over Glass's direct debt to others, particularly himself. In fact, new-music critics classified the composers (and no others) together by the end of the 1960s, and as early as 1971 British writer Michael Nyman referred to "four" composers "who have, quite remarkably, concentrated [on?] intensely small areas of musical activity which they subject to a microscopic scrutiny" [Nyman 1971 229]. Although the musicians performing the work of these composers were often

composers in their own right, from the beginning they were not only out of the limelight, but in terms of Minimal music followers rather than leaders. The generational search, as opposed to the search of a few individuals, in reductive musical forms is really more a phenomenon of the 1970s.

A more serious objection to canonizing Glass along with Young, Riley, and Reich as the "Fab Four" of the first generation of Minimalists might be earlier rather than later chronology, insofar as Young had originated the Minimalist style almost a decade before Glass adopted the diatonic and motoric *musique répétitive* originated by Young's associate Riley. Arguably, the first generation of Minimalism began in California around 1957 and ended there with the departure of Riley and Reich in fall 1965. After that date the impulse clearly shifted to New York, where Young had now fully organized (and named) the Theatre of Eternal Music and where the repetitive style that was henceforth to prove more influential than the long-tone or drone style, took root in the form of process music and flourished in the work of numerous composers over the next decade.

At least equally important, nonetheless, is the distinctive nature of Glass's repetition, which in *both* Paris and New York was of a quite different sort than either Riley's layered modules or Reich's de-/re-synchronized phrases. Glass was to pursue unmitigated repetition more relentlessly than any of his predecessors—again excepting Young's *arabic number,* which consists of a single repeated sound as opposed to successive repeated and notated modules. In Riley's *In C* the modules were repeated largely without variation, but with inflection and intervening rests at the discretion of the player; thus their pattern of interrelationship was in constant flux. In *String Quartet* Glass had overlapped his often chromatic and dissonant figures with strict metrical regularity within the larger modules of the lettered sections. In his subsequent works the musicians either repeat the same module in unison or at synchronized parallel intervals before progressing to the next. Consequently, the strictly repeated unit or module is the *only* thing heard until the next one, whether in solo or unison ensemble performance.

Strung Out, dated July/August 1967 in the manuscript score, a few months after Glass's return to the United States, demonstrates radical differences from the *String Quartet.* Of similar length, it contains only a single line, written in steady eighths, exploring the continuum effect to which he had been exposed in Reich's work. Its even greater reductiveness is also evident in its comprehensive dynamic and harmonic stasis in a structure of diatonic *mf* growing out of the opening five-note figure: E-G over middle C slurred, E-D-C an octave above. *Strung Out,* though through-composed unlike Glass's subsequent works in modular form, already represents a step in that direction. First of all, the overall structure of the work is founded on literal *da capo* repetition; second, the melodic line uses recurrent phrases and pitch patterns; third, the swerve from

pure *da capo* repetition in the conclusion of the work entails a more insistent form of repetition that foreshadows the rest of Glass's work.

About half a minute from the end of the score there are two consecutive boxed figures in adjacent diatonic steps: the first CBC DED, the second CB CDE. The second figure is itself a reduction of the first, which it varies by changing the slurs. According to the score, arriving at the figures on the *da capo* the player repeats the two together eight to ten times, then the second alone eight to ten times, "thereby ending the piece." Glass's subsequent pieces were constructed entirely out of this sort of modular repetition, additive/subtractive structure, and figural displacement. His conclusion is a subversion of the entire narrative tradition of Western music, just as Minimal art had rejected psychological and mythological narrative of Abstract Expressionism along with the naturalistic narrative of representational art. Instead of the apocalyptic coda, Glass offers more of the same and the same and the same and more of the more of the same.

The scoring for amplified violin also points away from the traditional scoring of the *String Quartet* and towards the use of rock amplification which was to characterize Glass's music, and which accounts in part for his "cross-over" success with the nonclassical audience. It is written in running eighths with some triplet figures but without bar-lines or accidentals—or the remaining white-notes A and B. Its five pitches are presented initially in two figures (E and G above middle C; E an octave up descending in whole tones to D and C), with the C sometimes "shared" with the lower figure, which is otherwise repeated unvaried as a quasi-ostinato underpinning the permutations of the upper pitches.

Like most earlier Minimal music, *Strung Out* is static harmonically, dynamically, and timbrally. The tempic regularity, and frequent rapidity, that had distinguished the earlier music is here taken to the next degree as Glass sets a metronome marking of a quarter-note at 144, adding the simple and prophetic instruction: *mechanically.*

In a sense, both *Strung Out* and *Music in the Shape of a Square* are multimedia or performance-art pieces insofar as they entail a strong visual element. The first title, like Young's *Drift Studies* a triple pun, alludes to the instrument, the junkie term for desperation, and the score itself which was strung out along a wall, with the violinist obliged to promenade while playing. When Paul Zukofsky performed it at the New School (along with Reich's *Violin Phase*) on April 18, 1969, the score was "strung out on about 20 music stands in a kind of square S" and Zukofsky had to "start upstage left and make his way to down[stage] center," in Carman Moore's account [May 1, 1969 28].

The second title alludes with appropriately Satie-like irreverence to the French composer's own *Three Pieces in the Shape of a Pear* (Glass says no one got the joke) and had flautists Glass and Gibson following scores similarly tacked to the wall, Glass's outside and Gibson's inside a ten-foot square—both equipped with contact mikes.

Moore's review of Zukofsky's recital was kind to the performer and Reich, less so to "Phillip" Glass. He found that "Mr. Reich's clarity and logic appeal to me much more than Mr. Glass's sudden wanderings." *Strung Out* started "from a 'Rock a bye Baby' kind of tune" and "went on for about 15 minutes in a string of episodes which seemed occasionally to jump the track of logic." The joint performance and review of their works helped establish the perception of the composers as stylistic "Siamese twins" that persists even today when their styles are leagues apart. Concluding his review in the *Village Voice*, Moore observes somewhat awkwardly but for the time both perceptively and sympathetically, "The aesthetic of this style seems to involve the transporting of the compositional laboratory process to the stage. It survives with the public because of its repetitious spell and its beat. It is great for meditation and allows you to relax or jump in at any point and turn your attention to the music as it grows and changes. To the composer it represents a return to scrutinizing the fundamentals, and while I don't consider the style a boundless source of aesthetic pleasure, short spells of it are fascinating."

Moore was the most open-minded and sympathetic newspaper critic the music had in New York, until Tom Johnson took over as new-music critic in November 1971. Both Moore and Johnson were composers, as were the *Voice*'s later new-music critics. Johnson's rave review of Reich's *Drumming* was only his second column (after a review of the English free-form quartet AMM Music two weeks earlier). It was not until John Rockwell, who had been writing favorably on the music for the *Los Angeles Times*, joined the *New York Times* almost exactly a year after Johnson joined the *Voice* that that paper began regular coverage of downtown music. Without the support of these two critics, the acceptance of this type of music would undoubtedly have been delayed considerably, despite the earlier and important support provided by Moore and Alan Rich. By noting, first of all, the existence of the music, and secondly the warmth of the small audiences it attracted, these critics helped to augment those audiences with the curious, who in many cases became the converted.

As a young man Glass had a more favorable response to Cage and his followers than to the didactic severity of the European avant-garde. His characterization of his early work as "intentionless music" [Battcock 1981 298; Kostelanetz 1989 122] may owe something to Cage, but for the most part the Cageian element, if visible in *Strung Out* and *Music in the Form of a Square*, is inaudible in his work. The one exception may be *1+1*, which appears as the last of his 1967 compositions in *Music by Philip Glass* [210] but may have been completed early the next year. The contact mike returns here, but now affixed to a tabletop, which is tapped rapidly in patterns based on what he calls two "building blocks": (a) sixteenth-sixteenth-eighth and (b) eighth. Glass's poem for table offers three possible combinations for alternating the two cells in additive or complementary additive/subtractive structure: ab abb abbb abb ab...;

abbbbb aabbbb aaabbb aaaabb aaaaab...; and bbbbba bbbbbaa bbbbbaaa
bbbbbaaaa... The Cageian influence may be present here in the skeletal
nature of the score as well as the instrumentarium; and after specifying a
"fast" tempo, the score concludes with "the length is determined by the
player."

Two Pages for Steve Reich is incorrectly dated 1966 in Richard
Kostelanetz's *On Innovative Musicians* [123]; according to *Music by Philip
Glass* [211] and American Grove [II, 230], Glass wrote it immediately
after *1+1* in 1968, but it was probably completed a bit later, since several
signed scores of *Two Pages for Steve Reich* are marked "February 1969" or
"Feb 1969" and it was dated "2/69" in Glass's program notes at the
Whitney Museum, by which time the title had been abridged to *Two
Pages*. The piece, written originally for unison electric keyboards later
doubled by winds, works with melody but in almost as severely reductive
an additive/subtractive style as the purely percussive *1+1*. Again in
steady eighths (originally quarter-notes, apparently), it progresses through
a series of 107 repeated melodic modules. Whereas Riley's units in *In C*
were triadic permutations, Glass works instead from the horizontal
foundation of a five-note ascending figure (G-C D-Eb-F), which is per-
formed thirty-four times before Glass adds first an additional four-note
figure G-C-Eb-F (played eighteen times), then a three-note figure G-C-Eb
to all the foregoing (played fourteen times) then another figure to all
of that, namely the two-note G-C cell that opens the piece. When the
initial unit has thus been almost tripled in length (from five to nine
to twelve to fourteen eighth-notes) the figures are subtracted in reverse
order of their addition, so that modules 1, 2, and 3 are symmetrical,
respectively, with 7, 6, and 5 off the axis of the fourteen-note fourth
module—yet another variant of arch form in early Minimalism.

The piece then explores another and longer symmetrical cycle by
adding not a figure but a single note to the foundation figure in successive
modules, and so on. The piece does not, however, end in a final state-
ment of the initial figure but abruptly truncates the brief fifth cycle which
has progressed from C-D-Eb-F (module 104—the G has evaporated
during the third and fourth cycles) through *G-C D-Eb-F C-D-Eb-F* (105),
+D-Eb-F (106), + Eb-F (module 107, which concludes the score by repeat-
ing module 4 but ignoring the process of subtraction in modules 5–7).
While most Minimalist music to date resisted directionality and climax,
Glass was most extreme in composing works with not only a minimum
of event but *no* sense of lead-in or fade-out but rather an unremittingly
stable texture. The instruments/voices do not join in one after another as
in Young's long-tone works, Riley's *In C*, or some of the Reich tape pieces;
nor are they superimposed upon a pre-existent drone as in Young's later
works; nor do the unison keyboards effloresce into canonic complexity as
in the time-lag and phase works. They are all/both there together from
the very beginning and still there at the very sudden end.

On May 20, 1969, a week before Glass appeared in *An Evening of*

Music by Steve Reich, Reich appeared on electric clavinette in *An Evening of Music by Philip Glass,* also part of the Whitney's "Anti-Illusion: Procedures/ Materials" show, along with Glass and Murphy on electric organ, and Gibson and Landry on amplified soprano saxophones. *How Now,* dated "2/ 68" in the program notes, was reviewed by Robert T. Jones in the *Times* next day as "a six-note doodle" which "finally ended some 20 minutes later as uneventfully as it had begun" [43]. Glass recalls it today with "warmer regard" than other pieces of the period but finds it "overly didactic." Richard Serra's three *Films* were shown as part of the "Extended Time" works in the exhibition; they studied a hand grabbing at objects, a hand holding a roll of cloth until dropping it from exhaustion, and hands trying to untie a rope binding them by the wrists.

After an intermission, James Tenney was added on electric piano for what was now called simply *Two Pages.* Jones found *Two Pages* "was much the same sort of thing, only without the variety of the first. It sounded like the world's longest 'vamp 'til ready.'" Jones, who seventeen years later assisted the composer in the writing of *Music by Philip Glass,* concluded by noting, "The music and film were stylistically limited enough to be merely trivial, lacking even the sophistication to raise them into the class of the primitive" [May 21, 1969]. In the *Voice* John Perreault merely referred to "delightful music by Phil Glass and three short films by Serra" [May 29, 1969 16].

In a forgotten 1968 piece called *Six Hundred Lines* Glass unsuccessfully grappled with the demons of notating the repetitive music to which he was now committed—an incredible chore, especially when he was writing for ensemble. He thought he had found the remedy in technology, and made a slide of each score page which he projected on a screen, advancing them with a pedal mechanism. As any slide-lecturer could have warned him, "The problem was that the slides would go backward instead of forward, get stuck. . . . " The solution was to extend the modular construction of the through-composed *String Quartet* to modular notation proper in *Two Pages.*

Interesting but less important experiments in 1969 were Glass's collaboration with Serra on another hand film called *Hands Scraping,* a four-hands piece starring their own, and an installation in the Jersey marshes called *Long Beach Island, Word Location.* Glass created fifteen-minute tape loops of the word "is," which were played on thirty-two speakers stationed on thirty acres in such a way that only one speaker was audible from any given location [Serra 14].

The title of Glass's book with Jones echoes a series of compositions he began at this time, all of them instrumentally and generically nonspecific: *Music in the Form of a Square* (1967); *Music in Fifths, Music in Contrary Motion, Music in Similar Motion* (described respectively by Reich as "a very good piece," "not a very good piece," and "one of my favorites"), *Music in Eight Parts* (all 1969); *Music for Voices, Music with Changing Parts* (1970);

and *Music in Twelve Parts* (1971–74). Nyman [1974 128] begins a similar list chronologically with *Music in Unison,* but Glass remembered nothing of such a work in February 1992; it may possibly refer to *Two Pages,* which was composed in unison and completed at the time assigned to the phantom composition. Glass admits he may have referred casually to the piece as such, which seems likely in view of its titular abridgment.

Among the 1969 works, *Music in Fifths* replaces the single line of *Two Pages* with parallel fifths throughout and otherwise resumes its exploration of additive structures. *Music in Contrary Motion* (composed in Nova Scotia in July) adds a quasidrone of alternating E and A to the two principal voices, opening with a diatonic ascent from A over middle C to E in the right hand and symmetrical descent from E to A below middle C in the left. The piece is again in running eighths marked "fast, steady." *Music in Similar Motion* (composed in November in New York), yet again in eighths, begins with an octave doubling on two staffs and concludes with the initial phrase extended from eight to thirty-two notes, now in four voices still in similar motion but at varying intervals, from an octave to a minor seventh in the left hand and a fourth to a minor second in the right. *Music in Eight Parts* extends the contrapuntal structure to eight voices and thus represents a step toward the more expansive and success- ful structures of the 1970s. Otherwise Glass dismisses it.

Music in Fifths is an extended assault against the ban on parallel fifths, but the other pieces entail progressively greater harmonic complexity and dissonance. Arguably, then, by the end of the 1960s Glass was already moving rapidly away from the reductivism of his first Minimalist works. The fifteen-minute *Music for Voices* was written in the same style but scored for male and female singers. It was used as a curtain-raiser when the Philip Glass Ensemble performed at the Loeb Student Center of New York University on November 15, 1972. The voices were still those of the Mabou Mines troupe—i.e., largely untrained voices, which would continue to be the case as late as *Einstein on the Beach.* Glass advocate Tom Johnson reviewed the concert favorably, but noted that the singing was out of tune [November 23, 1972 46].

The January 11, 1970 *Times* "Who Makes Music and Where" [II, 18] announced Friday's concert by "SONIC ARTS GROUP—Guggenheim Museum, 8:30 P.M. Philip Glass, electric organ, with David Behrman, Jon Gibson, Richard Landry, James Tenney, Beverly Lauridsen, Arthur Murphy, and Steve Reich," along with a picture of Glass trying to smile despite a necktie. It was captioned "Philip Glass plays the electric organ in a 'live/electric' sonic event. . . ." "Sonic Arts Group" thus erroneously ap- pears as the working name of Glass's ensemble, although the Sonic Arts Union had been formed in 1966 by Alvin Lucier, David Behrman, Gordon Mumma, and Robert Ashley, and in fact soon performed in the same series of new-music concerts at the Guggenheim. In his liner notes to the Shandar recording of Reich's *Four Organs* and *Phase Patterns,* Daniel Caux also refers to Reich's participation in "un festival de nouvelle musique

auquel participaient également Philip Glass et le 'Sonic Arts Group.'" None of the musicians ever recalled the group as so named. Glass remarks, "I would never have used that name" since the other group was well known. The error belongs to the *Times,* which somehow confused the names of two ensembles in the New Music series. Caux, who was not fluent in English, understandably repeated the error.

No mention of the Sonic Arts Group (or the Philip Glass Ensemble) is made in the *Times* in Peter G. Davis's review, which was as negative as Jones's. Davis classified Glass with "the neo-primitive school, along with such kindred spirits as Steve Reich and Terry Riley," despite the non-primitive instrumentation of three electric organs, clavinette, two soprano saxophones, a viola [played by Behrman], and a cello [played by Laurid-sen], all amplified. Davis found that the rhythmic displacement of *Music in Fifths* "is rather like trying to rub your stomach and pat your head at the same time and the results are just about as rewarding." He accepted the piece, along with *Music in Eight Parts* and *Music in Similar Motion,* as wallpaper music—"a useful accompaniment to some other activity, but sitting and listening to it in a concert hall seems rather a waste of time" [January 17, 1970 22].

Glass played at the premiere of Reich's *Four Organs* at the same museum in May 1970 (a rehearsal for which was recorded and released by the French record company Shandar with a live performance of *Phase Patterns* at the opening of the University Art Museum at the University of California six months later) and after a weekend break at the Walker Arts Center in Minneapolis. In Minneapolis Glass also served as one of the microphone-droppers in *Pendulum Music* on May 11 and 12, after having done so within a few days of the Guggenheim performance at the Paula Cooper Gallery. Reich appeared with Glass's ensemble in Minneapolis on May 13 (*Fifths, Eight Parts, Similar Motion*) and 14 (*How Now, Eight Parts, Similar Motion*)—his farewell performance with the ensemble.

It was clear by this point that sides were being drawn. Glass had the advantage of wanting to maintain a permanent ensemble while Reich's needs for musicians fluctuated from piece to piece. Although Jon Gibson signed a contract with Reich guaranteeing him priority in case of conflicting engagements, he eventually moved to the Glass camp since his primary skill was with wind instruments and Reich was moving in the percussive direction of drums and mallet instruments.

In March 1971 they went on a jointly promoted European tour. Glass had seen the potential of Europe as a market on his three-city tour with Serra. Reich had further been apprised of the European scene by Gibson, who had sung and played tenor saxophone in Europe with Young's resurrected Theatre of Eternal Music.

The six, minus Reich, who was present, played Glass's *Music in Fifths* and *Music with Changing Parts* at the Kunsthalle in Dusseldorf on March 3, and *Music in Similar Motion* and *Music with Changing Parts* on March 8 and 10 at the Wimbledon College of Art and the Royal College of Art in

London. Glass had been to Germany independently the previous month for a performance of *Music with Changing Parts* on February 1 at the earthily-named Kuhgasse in Duren with Gibson, Murphy, Landry, Robert Prado, and Barbara Benary.

Murphy and Reich performed *Piano Phase* on March 7 at the Institute of Contemporary Arts in London, and later in the month at the Semaines Musicales in Orléans and at the Théâtre de la Musique in Paris, with Glass, Steve Chambers, and Gibson (on maracas) aboard for performances of *Four Organs* in Paris and London and for *Pendulum Music* in London (Michael Nyman wrote that many found the "high volume... unbearable in such a small space" [May 1971 463]). The same group performed *Four Organs,* along with *Phase Patterns* (minus Glass), on a BBC broadcast. The reception was enthusiastic, especially in Paris—where Reich's work was advertised as "American underground music" by the same impressario who had presented Albert Ayler and Cecil Taylor as well as Karlheinz Stockhausen. In the liner notes quoted above, Daniel Caux refers to "'New Music' ou, encore, 'Underground Music,' du fait que, très peu jouée dans les salles de concerts de musique contemporaine, elle s'est plutôt developpée d'une façon marginale." By the time they got back to the American underground, Reich and Glass had ended their collaboration with little amity.

The subsequent bitterness extended to threats of legal action that obliged CBS Records to change the liner notes by Robert Palmer from the original Tomato issue of *Einstein on the Beach.* In 1992 Reich said of their acquaintance at Juilliard, "our basic chemistry was not good from the day we met, but it became artificially good when he was interested in what I was doing" in the late sixties.

Seven months later Glass noted, despite his earlier comments on the generational search, "At the time there were so few people doing this kind of music. You can't imagine the enormous support it provided to have other people around. For years we were the only people that could talk to each other about this, the only people who knew what was going on. Then it stopped. There wasn't that much work to go around. I think people got nervous about money and about fame. And it was difficult."

R

After the Whitney performance Reich wrote next to nothing for six months, then continued the live compositions with *Four Organs* and *Phase Patterns*. *Four Organs* was written in the winter of 1969–70—artist Sol LeWitt purchased the original score a year later so that Reich could buy glockenspiels for *Drumming*. *Four Organs* is not a phase piece per se, though it is clearly related to the process of progressive disassembling of strict unison playing (in this case left unreassembled as the isolated chord, its components extended in sequence, aspires finally to drone status) and may be seen as a further outgrowth of the conceptual *Slow Motion Sound*, now in the context of a prolonged experiment in calibrated augmentation of live instruments.

It proved to be one of Reich's most controversial works; its premiere at the Guggenheim on May 7 and 8, 1970, with Reich, Glass, Murphy, and Chambers on organs and Jon Gibson on maracas, elicited a rave review from Alan Rich in *New York* magazine. Rich had praised *Come Out* in similar terms on its release ("a 13-minute study in mounting obsession," *Time*, December 8, 1967 52]) and four months later in the first issue ever of *New York* magazine ("a powerful study in musical obsession" [April 8, 1968 114]). In May Rich called the Guggenheim concert "superb," noting "the shattering effect of the change . . . when the repeated figure takes on an added beat about 15 minutes along" in *Four Organs* and "the wrench that almost knocked me out of my seat" during *Phase Patterns* [*New York*, May 25, 1968]. In the *Times*, on the other hand, Donal Henahan "wondered . . . if they really need bother, when machines can do it so much better" [May 9, 1970 15]. The audience for the two concerts— which also included Murphy and Reich on *Piano Phase* and a twenty-minute preconcert "warm up" of *Phase Patterns*—were in good part drawn from the downtown art scene and responded with partisan fervor.

The same works were played the next week at the Walker Arts Center after a travel weekend, preceded on Monday by Gibson on *Reed Phase,* on Tuesday by a tape of *Pulse Music. Four Organs* closed the first half each night and was received respectfully. The second half of Monday's show opened with *Come Out,* Tuesday's with *Melodica,* in both cases followed by all five musicians on *Pendulum Music* and all but Glass on *Phase Patterns.*

In Europe the reaction to *Four Organs* was enthusiastic. This changed drastically at Reich's mainstream concert-hall debut when the work was performed by Reich and members of the Boston Symphony at Symphony Hall on October 8 and 9, 1971. It was the first of the orchestra's experimental "Spectrum" series (which conductor Michael Tilson Thomas had wanted to call "Series X"), a theme concert of "multiples" pieces. The concert offered multiples in terms of musical universes as well as instrumentation: Reich followed the Mozart *Notturno for Four Orchestras* and the Bartók *Music for Strings, Percussion and Celesta* and preceded Liszt's *Hexameron* for six pianos. Tilson Thomas, who manned one of the four Farfisa organs along with Reich, Ayrton Pinto, and Newton Wayland, gamely tried to break *Four Organs* gently to his audience. In an interview with Michael Steinberg published five days before the first concert he described Reich as "a New York-type composer in the forefront of the rebellion against the continuous use of all 12 pitches. He uses as few notes as possible, but they are beautiful notes." He warned that "Listening . . . will be a bit like learning to look at one of Ad Reinhardt's black-on-black paintings" [Steinberg October 3, 1971].

Immediately before the piece was performed, he advised the audience in one of his intelligent ingratiations *à la* Leonard Bernstein that it "really asks more of you than almost any other piece in the program. It's a piece, really, for virtuoso listeners." He explained its rejection of the "literary time" of Western music and drew an analogy to Eastern music. The performance was rather funereal, running five minutes longer than the 15'35" Shandar recording. At its conclusion, there were loud cheers, loud boos, and whistles; as the radio announcer urbanely put it, "There seems to be a difference of opinion in the audience" [Lincoln Center Research Library performance tape]. Steinberg noted briefly that the work "got boos and bravos" but devoted the better part of his concert review to the piece, which he found "most limited . . . and, I would guess, hardly likely to grow on one, but I also find it very engaging as a sort of ear-sharpener" [October 9, 1971].

When the Symphony brought the work to Carnegie Hall on January 18, 1973, however, the reaction was more ferocious. Reich feels that in a sense Thomas was asking for trouble by programming *Four Organs* with traditional fare; the concert was recommended, ironically, as "a veritable musical smorgasbord" by Richard F. Shepard in that morning's *Times* "Going Out Guide." (J.C. Bach's *Symphony/Overture in E-Flat for Two Orchestras* replaced the Mozart *Notturno:* the Bartók and Liszt remained.)

The New York City audience for the Boston Symphony represents perhaps the most conservative classical-music faction in the city, composed of lovers of the standard, particularly nineteenth-century, repertoire: the virtual antithesis of the art-student-and-downtown-artist avant-garde audience Reich's works had enjoyed at the Guggenheim and later in Europe.

Harold Schonberg noted in a *Times* review unflappably entitled "A Concert Fuss" that the audience reacted to what was billed as a "rock organ quartet" "as though red-hot needles were being inserted under fingernails. After a while there were yells for the music to stop, mixed with applause to hasten the end of the piece. At the end there were lusty boos. There also was a contingent that screamed approval. At least there was some excitement in the hall, which is more than can be said when most avant-garde music is being played" [January 20, 1973 36].

Michael Tilson Thomas vividly describes the assorted protests, pleas, and threats that arose during the performance, including an elderly lady banging her shoe onstage demanding that the music stop [Williams]. Reich's recollection is vaguer, he explains, because he was facing away from the audience, concentrating on the music and counting to himself to keep his place. He was only aware of "a lot of noise" and defers to Thomas's account on the basis of the latter's location and conductorial expertise at keeping a discreet eye on the house. An oft-repeated account has one music-lover, midway through the again quite slow (Schonberg timed it at "21 minutes") performance, crying out, "All right—I'll confess!"

I'll confess in turn that *Four Organs* has attracted me little more as musical experience than Young's *arabic number*. If Young's unvaried-as-humanly-possible repetition is a trial in an almost Kafkaesque sense, Reich's chordal deconstruction-through-augmentation also tries one's patience with its rather inhuman ingenuity. Though it is theoretically more interesting, technically more challenging, and sonically more complex, it still seems the closest to concept art of any work in Reich's canon, with its roots in *Slow Motion Sound* undisguised. Nevertheless, Henry Flynt apparently never tires of the work addressed to him by Young, and both Peter Yates and H. Wiley Hitchcock were impressed; Alan Rich and many others have found *Four Organs* thoroughly compelling.

What is commonly remarked erroneously of *In C* can be said accurately of *Four Organs*, namely that the score is based on variations on a single chord. In Reich's work, as the piece develops, the musicians gradually sustain first one then the other notes comprising the chord longer and longer, the temporal equivalent of "a horizontal bar graph" in Reich's vision [Reich 25]. While the note-values are wildly extended (the live equivalent of "slow-motion"), the pitches never vary, which provides a sense of stripped-down continuity. In addition, the use of a dominant eleventh chord imbues the work from the start with a disorienting aura of *in medias res* and at the end a sense of irresolution or floating in time. Reich cogently explains his choice of chord in terms of

its inherently paradoxical nature: "It contains the direction in which it *wants* to go and the arrival point simultaneously. It has the driving force of 'I've gotta move!' in the bass, and the soprano voice doubled at the octave saying, 'I'm already there!' It's a magical chord, and Thelonious Monk used it a lot. It's a model of tension."

As in much Minimalist music, little virtuosity and enormous concentration are demanded of the players, who are here aided by a fifth musician keeping crucial time with maracas—the "Pulse" of *Four Organs*. (In performances with the Boston Symphony there were four maracas-players from the Symphony's percussion section.) The construct of repeated units decays finally into the approximation of drone—which is also, interestingly, the case in the very different techno-drones finally created when the spoken phrases and sonic arcs in both Lucier's *I am sitting in a room* and Reich's own *Pendulum Music* are absorbed respectively into the immobility of the room and the state of equilibrium.

Phase Patterns, written immediately after *Four Organs* in January 1970, might be seen as an extension of the Pulse Reich suggested for *In C*, in which the two top Cs on the keyboard are drummed in alternation. In *Phase Patterns* each hand plays groups of two to four notes in the paradiddle pattern of LRLLRLRR, with organs paired to alternate the same note-groupings in a complementary RLRRLRLL pattern. It is no coincidence that by this time Reich had read, at the suggestion of Gunther Schuller, the Rev. A.M. Jones's *Studies in African Music*. He introduced himself to master drummer Alfred Ladzepko of Ghana's Ewe tribe (coincidentally the same tribe studied by Jones) at Columbia University and after two lessons with him, a munificent seven-hundred-fifty dollar grant from the Institute of International Education, and a larger loan from his local Citibank, Reich was off to study *in situ*. When he came back from Africa, the drumming on the keyboard had been supplanted by drumming on drums, the instrument he had taken up with puberty and abandoned with adulthood.

In late 1970 both Reich and Glass were embarked on marathon projects. Glass had begun *Music with Changing Parts* and Reich *Drumming*. Curiously, both were to run in early performances from an hour and a quarter to an hour and a half, four or five times the average length of the previous works of either composer. The length of *Drumming* has been reduced by a third over its recording history. The month of the premiere at the Museum of Modern Art, Reich also took the work to the Brooklyn Academy of Music and Town Hall, where it was recorded and released non-commercially on two LPs by Multiples, Inc. It was recorded in the same format again in 1973 by Deutsche Grammophon. In 1987 Nonesuch recorded the work a third time and released it as a single LP (and CD).

Reich was intrigued by *Studies in African Music* not because the music was so exotic but so kindred to what he had been doing. He was struck not only by the repetition of regular patterns in the drumming but the

superimposition of conflicting patterns with different downbeats. It is reflective of Reich's preoccupation with formal concerns that Jones's explication of the structure of the music made a greater impression on him than his earlier, relatively casual experience of the music itself.

At the Accra campus of the University of Ghana, Reich felt swamped by the experience of African music: "I stopped composing totally, even in my head. I didn't have any ideas. I was overwhelmed by their music, like being in front of a tidal wave. . . . I became submerged" [Wasserman 48]. He left composition in abeyance while he took daily lessons with another Ewe master drummer, Gideon Alorworye, practiced with and transcribed the tapes of the lessons, and attended the rehearsals and concerts of the Ghana Dance Ensemble. This involvement may be of interest insofar as he was later to be involved with scoring dance pieces for Laura Dean's troupe back home, and the dance-like character of his post-Ghana music—unlike the sixties compositions—is one of its salient features.

Reich remained in Ghana only five weeks, after ill-advisedly opting for sandals, thus inviting mosquitoes and contracting a "mild case" of malaria—"that's when you *feel* like you're dying but you're not" [*AC* 42]. He survived a potentially lethal misdiagnosis by a Peace Corps doctor and was rescued by a female African physician.

Though he planned to write a piece for the assorted African instruments he had brought back, he found that this ultimately entailed self-conscious ethnomusicology and so confined his expression of that interest to playing some African music with members of his ensemble. Feeling confirmed in his percussionist's instincts by the African experience, he composed a work where percussion instruments were for once stage center. He worked for a year on the four parts of *Drumming*: for bongos and male voice; marimbas and female voices; glockenspiel, piccolo, and whistling; and all of the above.

Drumming may be said to inaugurate the 1970s as Reich's chamber music decade, after the tape music and groups of identical instruments (live or taped) in the subsequent phasing compositions of the sixties and before the orchestral/choral pieces introduced in the eighties with *Variations for Winds, Strings, and Keyboards*. Despite *Clapping Music* (1972) and *Music for Pieces of Wood* (1973), scored as the titles indicate, his forces were to expand throughout the decade: *Drumming* was performed by first twelve, then thirteen musicians, while the 1978 *Music for a Large Ensemble* featured thirty, with *Music for 18 Musicians* intervening in 1976; in 1979 Reich began composing *Variations* for the San Francisco Symphony, and he has done large-scale works for others since. In 1970 he Xeroxed and distributed his prophecy, "Most orchestras will wither and die"; in 1971 the Boston Symphony and New York Philharmonic got in touch and he changed "Most" to "Many" [Henahan October 24, 1971 II, 26].

In the 1960s Reich, like Riley and Glass, had been blithely dismissed by the *Times* (which had ignored Young's existence), but he had received

critical support from Carman Moore and Alan Rich. Rich's review of *Four Organs* set the tone for the more positive response Minimal music would receive in the seventies. *Drumming* won Reich his second unqualified rave: from critic/composer Tom Johnson in the *Village Voice,* reviewing the premiere of the work at the Museum of Modern Art on December 3, 1971. The performance received a standing ovation, which Johnson tried to explain in his column, proposing in turn the precision of the playing, "the simple white-note scales...refreshing to ears grown weary of dissonance," the "joyous" scoring mix, the political interest of its combination of "African and European elements," the sensuous directness of the music, or its "human quality, which I sometimes find lacking in Reich's work" [December 9, 1971 47].

Although *Drumming* represents a major breakthrough in Reich's work in terms of structure and instrumentation, Reich has often stressed its continuity with the earlier pieces. In 1973 he described the piece as "the final expansion and refinement of the phasing process" [Reich 58], even while pointing to technical innovations including the substitution of beats for rests or vice versa, along with the gradual combination of timbres within characteristically static rhythm and pitch and the integration of voices in imitation of instruments. In 1992 he reiterated that *Drumming* is very much a process piece.

The first technique would seem to be drawn from African hocketing and the others are also present in African music; his use of 12/8, in addition, echoes Jones's metrical notation of Ewe music. The most important quality of African music Reich was able to incorporate, however, was its sheer vitality, and he has progressively downplayed the technical influence over the years, undoubtedly by way of resistance to his being often regarded—or unregarded—as a musical exotic. He feels he developed the hocketing on his own, while correctly noting its presence in Mediaeval as well as African music and suggesting the possible influence of dialogues with his sculptor friends concerning negative space. Harmonic complication by means of extraction rather than addition of notes is a recurrent practice in Reich's work (e.g., the bass in *Four Organs*, the ambiguous resolution of *The Desert Music*), which allies it to the tonal ambiguity of the French tradition with which he identifies not only his own work but twentieth-century American musical developments as diverse as Gershwin, bop, and film music.

The extension of his instrumentarium to include diverse timbres, notably the mallet instruments which have since become a trademark of Reich's work, was eminently logical. He wanted to be able to develop harmonically the pitches of his drums, tuned just above middle C. Of mallet instruments available, he used marimbas to raise the range of available pitches by two octaves. The top of their two-octave range in turn impinged upon the bottom of the glockenspiels' range, which extends to the top of musical pitch limits. The doubling of mallet instruments by female voices in the second section and by whistling and

piccolo in the third was deduced equally logically, merely by listening to
the interlocking harmonics created by groups of marimbas and glocken-
spiels, which resonate respectively like . . . female voices and whistling.
Realized in flesh, they thus serve to double the acoustical by-products of
the instruments, supporting the designation of *Drumming* as "process
music" along with *It's Gonna Rain* or *Piano Phase*, albeit a far more
complex example of the genre: the whole sonic panorama evolves from
examining the musical consequences of the tuning of the titular drums.

Nothing in his earlier work, from the tape-loops to *Four Organs*,
comes close to the infectious vivacity of *Drumming*, particularly its master-
ful final section, in which Reich manages to recreate in his own distinc-
tive voice and precise notation the collective buoyancy of *In C* seven
years earlier. Like *In C*, the work is blatantly tonal, centered on F-sharp
major through all four movements, and without Riley's modulations. But
to avoid the overminimalizing of the Minimal and the harmonic synopsis
to which *In C* has been subjected, it should be noted that despite the
unchanging key signature, Reich hears the opening of *Drumming* as G-
sharp Dorian, and D-sharp Dorian when the B-sharp in the third section
ostensibly moves the piece temporarily into C-sharp major, and he stresses
that the piece closes on a C-sharp dominant.

Formally, *Drumming* is more systematic than its African antecedents—
a literary ballad vis-à-vis a folk-ballad tradition—and more cumulatively
directional than *In C* in the meticulousness of its thickening of textures
and combination of instruments in the final section. Whereas Riley
described the exuberance of even the studio recording of *In C* as deriving
from "blowing our heads off for three hours," Reich's structure insinuates
itself more fastidiously but just as irresistibly. The two works reflect the
very different sensibilities of their composers. Riley is fundamentally a
Romantic, a mystic, and an improviser by nature, who finds it unappeal-
ing to "do anything unless there's some kind of inspiration" [*AC* 108];
Reich is above all a Classicist, even a formalist, and unrepentantly pre-
meditative—his ensemble work leaves room for improvisation during
performance only in the quantity of repeats, and *before* the performance
in the choice of resultant patterns to be doubled. In his Whitney program
notes, Reich was at pains to aver that he was "not interested in improvi-
sation or sounding exotic" [Reich 44 and elsewhere]—an emphasis which
may have been inspired in part by the desire to assure, in the critical
apartheid of its age, that his work would be heard (and reviewed etc.)
under the classical rather than jazz or international music rubrics.

As Reich developed his use of vocalists throughout the 1970s, his
treatment became freer, often suggestive of regularized scat. The word-
lessness of the vocals is intriguing as a pervasive characteristic of Minimal
music: Young's Theatre of Eternal Music prominently featured singing
over drones, but singing pitches not words; Glass was similarly to feature
songs without words when he added vocalists to his ensemble with
Music for Voices a year before Reich. But if Reich's vocals vaguely evoke

scat, Glass oddly recalls the Swingle Singers in sections of *Music in Twelve Parts*, where the composer used a technique later made famous in *Einstein on the Beach*, the use of numbers and solfège as the choral text when Glass, having thus rehearsed the largely untrained chorus, decided to leave his pedagogy exposed in these mnemonic notations of rhythmic and pitch patterns.

Neither Glass nor Reich presented sung text per se until the 1980s, in another interesting coincidence, with the setting of Sanskrit and Hebrew in *Satyagraha* and *Tehillim*, respectively. As late as his 1982 *Grand Pianola Music*, John Adams had a full chorus singing wordlessly, before moving to John Donne and Emily Dickinson in *Harmonium*. That work marks, not coincidentally, his transition into a more expansive mode after his Reich-derived Minimalism (though his later *Nixon in China* has clear debts to Glass). Meredith Monk, discontentedly but inescapably associated with Minimalism for her use of drones and repeating lines as an accompaniment, perhaps an anchor, to her extended vocals, has used words only fragmentarily and adamantly a-logically when she has used them at all.

S

One might argue legitimately that pure, bare-bones musical Minimalism expired just after the 1960s, before relatively few had heard the works and long before the term had been generally applied. After completing *Four Organs* and *Phase Patterns* by spring 1970, Reich had gone to Africa, after which he immensely expanded his timbral range along with his duration with *Drumming* (which he nonetheless included in February 1992 among his early "radical études"). Glass had finished *Music for Voices* and was beginning to complicate his counterpoint in the more complex and much more lengthy *Music with Changing Parts* (incorrectly dated 1973 by Mertens [74]). Young and Riley, on the other hand, had by this time set composition aside and begun their immersion in Indian music. Young composed no new works from *Drift Study* in 1967 until the 1980s, though he resumed work on *The Well-Tuned Piano*, virtually creating it anew beginning in 1974, and rescored *for Guitar* in just intonation on its twentieth anniversary in 1978. Riley taught at Mills College and improvised internationally on keyboards.

Glass has been commercially the most successful of the composers discussed and his numerous records for CBS have topped the classical "charts." Ironically, he found even less interest from mainstream recording companies than his colleagues until his work had become safe for demography in the 1980s. Glass was thus driven not only to form his own ensemble like Young and Reich but to start his own record company, Chatham Square Records—named after the Chinatown studio of Richard Landry where they often rehearsed and financed by the Hebrew Free Loan Association set up on the Lower East Side to aid deserving immigrants (in this case from Baltimore). The first record released under the Chatham Square imprint, the two-disc *Music with Changing Parts* (1001/2), was recorded one weekend in late 1971. It was followed by the single-

disc (Chatham Square 1003) coupling of *Music in Similar Motion* and *Music in Fifths*, also recorded at a mobile studio owned by John Lennon's Butterfly Productions, of which the Ensemble's sound mixer, Kurt Munkacsi, had learned while assisting at one of Lennon's recording sessions [Glass 21].

Obviously, then, Glass felt that *Changing Parts* represented the best he had to offer. He had also used it to introduce his work, hitherto unknown, in England in March, where Michael Nyman reviewed it briefly but enthusiastically in the *Musical Times* [1971 464]. The year before he had been to Europe as an assistant to Richard Serra, who was giving exhibitions in Holland, Switzerland, and Germany. In Amsterdam, Köln, and Bern, Glass played keyboard solos (*Two Pages* at the first two, *How Now* at the third) and Michael Snow showed his film *Wave Length*. At the Amsterdam performance a member of the audience decided to play along with Glass, a collaboration the composer (who had wrestled in the 118-pound class as a freshman at the University of Chicago) quickly and unequivocally ended—by one account punching with one hand while playing with the other [Coe 78]. In 1992 Glass confessed, "I needed both hands. I punched him—of which I'm not proud. I didn't get him really good but enough to knock him off the stage. Later I asked Richard Serra, 'Where were you when I needed you?' He said, 'You were doing all right by yourself.' But the funny thing is that after the performance the same man rose to announce, 'And *now* we will have the discussion.' I told him, 'To me this is *not* a prelude to a discussion.' To him everything was just fine."

As mentioned, *Music in Changing Parts* was Glass's longest piece to date. The title refers to the quasi-improvisational element in the work, specifically the scattering of eleven "changing figures" among the eighty-one modules of the piece. These figures, marked "C.F.," are meant to provide a skeletal framework for what the musicians might play rather than a rigorous notation of what they must play. During these sections of the piece "individual players were permitted to play one note for the length of a breath . . . a note they heard emerging from the pattern of the music" [WNYC]. This was Glass's version of the improvised (in rehearsal, at any rate) addition of resultant patterns to the texture of Reich's ensemble works. He was to use the same technique in Part Four of *Music in Twelve Parts*, which he began in 1971 and finished three years later.

Music in Changing Parts initiates a new phase in Glass's work after the radically stripped-down, intensely but narrowly focused compositions of the past three years. At this point his composition, rather than exploring a single technique in one piece and another in the next, begin to demonstrate a more cumulative sense of development, incorporating the discoveries of their predecessors. *Music in Twelve Parts* is a compendium of what Glass considers his Minimal period—i.e., 1965–1974—but *Music in Changing Parts* is itself a kind of summing-up of the sixties, with its extensive use of the parallel fifths, similar and contrary motion of his

previous works (and titles). As such its place in the Glass corpus is remarkably similar to that of its almost exact contemporary, *Drumming*, in Reich's.

John Cage once defined "composer" as someone who tells other people what to do. Feeling that was morally questionable, he opted for throwing yarrow stalks and presenting illustrations of Thoreau, while continuing to accept his pay. Riley, with no consciousness of Cageian allusion, expressed disinterest in working with ensembles in 1987 because "I'm not good at telling people what to do" [AC 120]. He has collaborated in multimedia performances with artists from Ann Halprin and Ken Dewey to the jugglers and fire-eaters of his European days to the dancers and acrobats known as the Daughters of Destruction with whom he toured in a multimedia version of his saxophone piece called *Poppy No-good's Phantom Band Purple Modal Strobe Ecstasy*. He has worked with numerous musical ensembles, from high school dance bands to the Theatre of Eternal Music to the Kronos Quartet. However, he is the only one of the four commonly recognized composers of the first Minimalist generation not to have led his own ensemble.

Reich and Glass began forming their temporarily linked groups in 1966 and 1967, respectively, and named them after their falling-out in 1971: Steve Reich and Musicians and the Philip Glass Ensemble. Young of course had begun his drone troupe back in 1963 and named it the Theatre of Eternal Music at the end of 1964 or beginning of 1965. Just as Young's instructional concept-art compositions influenced those of Yoko Ono, later collected in *Grapefruit*, the flexibility of his ensemble may have influenced the concept of John Lennon's Plastic Ono Band. The multimedia presentations of Young and Zazeela certainly influenced Andy Warhol's Exploding Plastic Inevitable, which may be the immediate inspiration for the name of the Lennon-Ono group. All three Minimalist ensembles were formed in part by necessity, since no mainstream classical unit in the sixties would/could drone, phase, or cycle rhythms without a gun at its collective head. It was in fact really not until the end of the 1970s that Reich and Glass began writing for traditional orchestras, opera companies and so on: the chamber-orchestra setting of Reich's *Variations for Winds, Strings and Keyboards* and Glass's second character-opera *Satyagraha* premiered respectively on May 17 and September 5, 1980 in San Francisco and Rotterdam. And what they were writing at this point is labelled Minimal only problematically.

The obligatory self-reliance on their own limited resources as younger composers led necessarily to some of the high-tech feel of their performances. It was difficult to hear the small ensembles without amplification and, more importantly, it was logistically harder to work with acoustic keyboards. Reich and Murphy had been reduced to practicing separately for the premiere of *Piano Phase* for want of two pianos in the same locale. Had they been his preference, Glass would have been hard put

indeed to find even three or four spinets, whereas electronic keyboards were more readily transportable. Once they were adopted, the other instruments had to be amplified similarly in order to be heard. Thus his trademark volume may have been a product of logistics as well as the rock-saturated ambiance of the late sixties.

The Theatre of Eternal Music may sound primordial but requires several tons of twentieth-century equipment. In the small quartet incarnation of three vocalists and violin that performed in 1966, Young, Zazeela, and Riley sang into condensor mikes, while Conrad's violin was plugged into one pre-amp and the turtle motor and sine-square wave oscillator into another. The two pre-amps and three mikes were connected to a custom mixer connected through a third pre-amp to an amplifier feeding four large Argus X 450 speakers and six Leak Sandwich speakers.

Reich, who had focussed on acoustic instruments, still found himself lugging a roomful of equipment across Europe on tour—which finally helped drive him to *Clapping Music* for low-tech relief, hands being fairly easy to transport. It was composed almost as a breather after *Drumming*, and is variously dated by him late 1971 and 1972 [Reich 64, 75]. One pair of hands maintains the same pattern (one-two-three one-two one one-two), notated in eighths, from start to finish, while a second moves progressively farther ahead then gradually back in sync. Reich's phasing ended pretty much as it began in Part One of *It's Gonna Rain* seven years earlier. *Drumming* had suggested a new direction for his subsequent works. At about this time, however, Reich began a relationship with choreographer Laura Dean, who was thinking along similar lines in her own medium, developing works based on repetitive and sometimes geometric patterns. In two performances at NYU's Loeb Student Center on April 28, 1973, Reich revived *Clapping Music* along with *Phase Patterns* to accompany Dean's "Walking Dance" and "Square Dance," respectively.

In "Notes on Music and Dance" written at this time, Reich remarked wryly, "For a long time during the 1960's one would go to the dance concert where no one danced followed by the party where everyone danced. This was not a healthy situation." Dean and he aimed to remedy it with "a return to the roots of dance as it is found all over the world: regular rhythmic movement, usually done to music" [*Writings* 41]. Since Dean is commonly identified as a "Minimalist" choreographer, it is significant that her highly kinetic work was offered as an alternative to, even a reaction against, specifically the earlier "Minimalist" choreography of Yvonne Rainer, Simone Forti, and Steve Paxton, whose "any movement is dance" concept Reich here identifies as "the precise equivalent to the basic idea of composer John Cage: any sound is music." The Dean/Judson Group dichotomy Reich insightfully delineates further illuminates the division within Minimal music between the early concept/drone works of Young (with roots in Cage) and the later motoric process music developed by Reich and Glass (with roots in Riley).

Interestingly, when the topic of Minimalism in the plastic arts is brought up, Young, who collaborated with makers of inert art like Robert Morris in the early sixties, thinks first of Barnett Newman, while the allusions of Reich and Glass tend to begin with Stella (Glass had met fellow Fulbrighter Barbara Rose in Paris) and gravitate to their associates in later Minimalism, process art and conceptual art: Sol LeWitt, Richard Serra et al.

As Reich developed his use of metallophones and other mallet instruments, the international flavor was to become more reminiscent of Indonesian, specifically Balinese, than African music. The collective element that came to the fore in his music with *Drumming* owes a larger debt to non-Western music than to *In C,* despite the roughly gamelanic aura of that piece. Reich's next major work, *Six Pianos,* with its shifts of key from D to E Dorian to B Minor, may vaguely recall the limited and gradual modulations of *In C,* while Mertens speculates on the possible influence of Glass's abrupt tonal leaps in *Music with Changing Parts* [77], where a semitone drop to A-natural leads to tonal ambiguity between A Major and C Dorian. In any case, this kind of ambivalence is a constant in Reich's work from the seventies onwards, recurring, for example, in 1983 in his conclusion of *The Desert Music,* which the composer analyzes as a triple ambivalence of tonic, relative (Dorian) minor and dominant as a vehicle for the uncertainty of his theme, the human future.

In any case, however limited its harmonic range remains, *Six Pianos* nonetheless represents a step in the direction of the greater harmonic experimentation in *Music for 18 Musicians.* It is not, however, a major work, with something of the air of a *jeu d'esprit* about it—Reich mentions he was inspired by the idea of writing a piece for all the pianos in a store. *Six Pianos* shares transitional status with *Music for Mallet Instruments, Voices and Organ,* another diverting rather than commanding work, between the pure Minimalism of the pre-*Drumming* works and the post- or problematically "Minimalist" Reich of *Music for 18 Musicians* and beyond. His ensemble performed the two pieces, billed as works in progress, along with the by-now old reliable *Piano Phase* (this time on the marimbas of Russ Hartenberger and James Preiss), in four concerts at the John Weber Gallery from May 12–17, 1973, before Reich went west to study the Balinese music that had already left its mark on *Mallet Instruments.*

Tom Johnson entitled his *Village Voice* review "A galleryful of spinets" and commented briefly, "Reich's Work in Progress for Six Pianos is perhaps the most subtle music he has written, and I like it very much, although my favorite Reich work is still the 90-minute *Drumming*" [May 24, 1973 41]. In the *Times* John Rockwell praised the "focused but extraordinary sonorities and . . . complexity of 'Work in Progress for Six Pianos'" and the "more complex and coloristically lavish" *Mallet Instruments,* but was equally struck by "the size of the audience and the warmth of its response. It was an important concert" [May 19, 1973 28].

The performances came on the heels of the second New York per-

formance of the work that had led Reich in the direction of *musique répétitive*. After Riley's sold-out solo concert of *Persian Surgery Dervishes* at the Whitney on April 5, *In C* was played at the Washington Square Methodist Church on April 25. Johnson found Riley's Persian surgeons lacked "the intellectual depth of the more calculated pieces by Riley's former colleagues, Steve Reich and Philip Glass" [Riley and Glass had in fact never worked together], but had "a warmth and a personal lyricism which is quite enticing and accessible" [April 12, 1973 51]. He judged the account of *In C* unsuccessful, although "singer Meredith Monk, trombonist Garrett List, and clarinetist Daniel Goode [who conducted] were all excellent" [May 3, 1973 46]. John Rockwell seemed to feel Riley was improving but largely repeating himself as a keyboardist [April 30, 1973 30], while the performance of *In C* "threatened to fizzle out altogether" [April 27, 1973 28]. That Johnson's sympathies, like Rockwell's, were primarily with the Easterners rather than the Westerners was clear in a July 26 article entitled "A La Monte Young diary," in which his highest praise for *Tortoise* was that it was no longer as dynamically abrasive as earlier, though he praised Young himself as "a beautiful man, a sincere composer, and unquestionably one of the true originals of our time" [41].

Reich's music through *Drumming* was harmonically static, either in the augmentation-to-drone of *Four Organs* or in the innovative unison canons, with some added vocal doubling and resultant patterns (and acoustic beating), of the taped and live phase pieces. *Six Pianos* expands his palette tentatively into three harmonic areas over the course of twenty to twenty-five minutes, and *Mallet Instruments* explores four in slightly less time. Its four sections move from an F Dorian to an Ab Dorian to a Bb Minor to an Ab dominant eleventh chord (repeating the use of the dominant eleventh in *Four Organs*, and again ending the piece with a sense of continuum more than finality). Other important innovations in *Mallet Instruments* are the juxtaposition of 2/4 in the second section to the 3/4 of the others, and the more varied use of the female voices, which here double not only the repeating patterns of the marimbas but the long tones of the electric organ. Texturally as well as harmonically, Reich has come a long way from pieces composed solely of phased unisons.

But not nearly so far as he was to go in *Music for 18 Musicians*, a radiant work which for me remains his masterpiece and the high point of ensemble music of the 1970s by composers identified as Minimalist, as *In C* was of the 1960s, and perhaps John Adams's *Fearful Symmetries* of the 1980s. It may be immediately objected that Adams's piece goes beyond the boundaries of Minimalism with its sophisticated orchestration and harmonic range, with shocking half-step modulations etc. I would agree, but a similar argument may be advanced vis-à-vis *Music for 18 Musicians*. Adams's piece displays continuity with its Minimalist roots primarily in its repetition—though abrupt modulations were a feature of Minimalism going back to Glass's *Changing Parts*. The primary reason it

is referred to as "Minimalist," however, is that it bears the name of a composer who has written elsewhere in a style much more strongly influenced by Reich, Glass, and occasionally Riley. Reich himself has said that if one were introduced to his work with *The Desert Music*, the term "Minimalist" would never occur to one. "I could write a piece that would be a dead ringer for Mahler and they'd say, 'Ah . . . this is a new kind of Minimalism!'" Riley, unaware of the jest, observed similarly months later, "I could write a piece like Beethoven and they'd call it Minimalist because my name would be on it" [*AC* 45, 110].

Yet even *The Desert Music* opens with Reich's trademark pulse-figure followed by voices repeating a pitch in *diminuendo* eighths reminiscent of recurring clarinet figures in *18*. There is necessarily continuity in the work of these composers as in their lives. One ignorant of Glass's music would probably recognize *Music in Fifths* and *Satyagraha* as deriving from the same source (though sections of the later work would prove problematic). The disc of solo piano music Glass released in 1989 more than any of his later work confirms the continuity with his past. He toured as a solo pianist that year, as he had in 1969; the disc comfortably included *Mad Rush*, written fifteen years or more before the rest of the program.

Nonetheless, Glass has said that "For me, minimalism was over by 1974" [Jones 1985], and the date may be tentatively applied to Reich's Minimalism as well. In the summers of 1973 and 1974 Reich formally studied the Semar Pegulingan and Gambang forms of Balinese gamelan, first with I Nyoman Sumandi on the Seattle campus of the University of Washington during the summer program of the American Society for Eastern Arts, then in Berkeley at the Center for World Music established by Bob Brown in a deconsecrated church. His preliminary private study was both a logical outgrowth of his attraction to mallet instruments in *Drumming* and an influence on *Mallet Instruments*, which, though completed in the spring of 1973 before he went west—as he is at pains to point out—is as clearly evocative if not derivative of Indonesian music as *Drumming* is of African. Even when interviewed by Emily Wasserman for *Artforum* in early 1972, he was much concerned wtih Balinese music and its relationship to the pulse and observable process of his own work. Here, as with African music, his primary concern was with structure, although the colorism of *Mallet Instruments* undoubtedly owes a debt to gamelan. "Balinese music," he explained, "involves creating a continuous pulse by the interlocking of two independent and separate parts, which have rests or silences in between. The interlocking of simple separate parts to produce a flowing continuity is a distinctly Balinese feature which appears in the gamelan music at a very very high speed. This is ensemble music of a totally different sort than African music . . . in which you have two different rhythms conflicting and overlaying each other" [Wasserman 45].

His next step was to combine the foreign influences evident in *Drumming* and *Mallet Instruments* with his abiding interest in jazz and his

growing interest in more ambitious harmonic and other textures in the watershed *Music for 18 Musicians*. As the composer points out in his liner notes to the LP of *18*—originally recorded for Deutsche Grammophon before Reich was persuaded of the deeper commitment of Manfred Eicher's ECM (Editions of Contemporary Music) Records—the piece represents a departure in terms of instrumentation, harmony, rhythm, and structure. The use of four voices, clarinets, bass clarinets, pianos, marimbas, xylophones (substituting for the earlier glockenspiels for dynamic balance of metal with wood mallet instruments in the expanded ensemble), motor-less vibraphone (listed as "metallophone" and used previously in *Mallet Instruments*), violin, cello, and maracas is far more ambitious than anything hitherto attempted by Reich. Furthermore, "There is more harmonic movement in the first 5 minutes of 'Music for 18 Musicians' than in any other complete work of mine to date." The rhythm is based on a confrontation of mechanical and organic: steady pulse in the percussion instruments and durations determined by human breath in the vocals and winds. Structurally, Reich works off "a cycle of eleven chords played at the very beginning of the piece and repeated at the end."

Reich worked on *18* from May 1974 to March 1976. Nineteen seventy-four may then serve as a convenient marker for the city limits of Minimalism, beyond which we enter the suburbs of the movement. Both Reich and Glass are convinced that the works that will be remembered came later. Early Minimalism, however, includes among its enduring landmarks Young's *Trio* and *Tortoise*, Riley's *In C*, and Reich's *It's Gonna Rain* (Glass's *Music in Fifths* has numerous and more devoted adherents than I), while the transitional period from spring 1970 to spring 1974 is notable for *Drumming*, *Music with Changing Parts* and *Music in Twelve Parts*. The expansionist and dubiously Minimal period from 1974 to the end of the decade is noteworthy most of all for Reich's *18*, Glass's *Einstein*, and Young's elaboration of *The Well-Tuned Piano* from its skeletal framework into the most important piano work of its time, ranking with Cage's *Sonatas and Interludes* and Sorabji's *Opus Clavicembalisticum*, just as *18* is the most inventive ensemble work and *Einstein* the most successful opera of the period.

In the post-Minimalist period beginning in 1980 (Glass's *Satyagraha* and Reich's *Variations*), of the four principal figures, only Young continued to work primarily in a Minimalist vein, while Reich's solo/tape "Counterpoint" pieces and Glass's piano miniatures and *Mishima* quartet may be validly so described. Riley, Reich, and Glass moved into expansive structures and orchestrations to make major musicocultural statements that at times provoke profound admiration and at others equally profound nostalgia for their earlier economy of means.

Music in Twelve Parts is an overdetermined title. The 1971 version consisted of only Part One of the final version. The "twelve" derived from

the vertical structure of the work, written in twelve voices (two each for the three keyboards and one for each of the six other instruments) and twelve "figures" or sections. This was apparently not obvious since, according to Glass, a composer friend asked him after hearing the work when he was going to write the other eleven parts [WNYC]. The answer—then unknown to Glass, who thought his friend had made a good suggestion—was over the next three years. Part One was first performed outside of Glass's studio at Yale on April 16, 1971, followed by the New York premiere on May 4 at the Whitney Museum. The just-completed work finally premiered at Town Hall on June 1, 1974. Glass's assault on Uptown filled 1,200 of 1,400 seats, according to *Music by Philip Glass* [52], while John Rockwell's *Times* review two days after the performance mentions an "audience of some 700 . . . large for music of this sort" [39]. In any case, it was a remarkable success, considering that until recently, Glass says, he had been content with a gallery turnout of twenty-five, although his "debut" at the Film-Makers' Cinematheque had drawn four or five times that. Whatever their numbers, the Town Hall audience, Rockwell notes, "stood and cheered at the end," unfazed by the temporary knockout of the amplification by a photographer friend's stumbling over the cord and unplugging it—Richard Peck notes it was the first *a cappella* performance by the horns.

Glass and Reich had enjoyed larger audiences than earlier by this time, but mainly in Europe, and still at relatively small venues. Into the 1980s Young's drone performances usually drew forty to a hundred people, on a slow night even less than the aforementioned twenty-five. During the composition of *Twelve Parts*, the Philip Glass Ensemble began functioning as a regularly touring unit, albeit more in the style of a rock group than a classical ensemble with their long hair, casual dress, and massive amplification equipment. This was fraught with pitfalls in terms of not only the Establishment press but the Customs Service. Their itinerary required several crossings of the Canadian border and confrontations with a border patrol notorious for its suspicion of American exporters of hippiehood. On one occasion the ensemble was retained for hours when a typically painstaking search uncovered a plastic bag of white powder in one of the suitcases (the uncontrolled substance being the baking soda an ensemble member used to brush his teeth).

The individual parts preceding the whole of *Music in Twelve Parts* had been presented all over North America and Europe, first in the composer's studio at 10 Bleecker Street. This was one of several abandoned buildings rented to an arts foundation by the city for a dollar a year. The foundation in turn rented space to artists at low rates (Glass paid a hundred fifty dollars a month for the seventh floor) and the profits realized were funneled back to the artistic community in the form of sponsorship of performances, etc., an agreeable arrangement for all concerned.

Later in 1971 parts of the work were performed at Yale, the Whitney (along with the music for *Red Horse Animation* for Mabou Mines), the

Nova Scotia College of Art and Design on August 24, 1971, and on October 28 at the home of Park Avenue art collectors justifiably horrified when one of the downtown crashers rested his cigarette on the frame of a Reinhardt. The venues of 1972 included La Mama, Hofstra University, the Village Presbyterian Church, 112 Greene Street, the University of California in Irvine, the Pasadena Art Museum, Cal Arts, Portland State University, the Vancouver Art Gallery, Pacific Lutheran University, University of Washington in Seattle, Western Washington University, the Walker Arts Center, the St. Louis Art Museum, Rhode Island University, the Castelli Gallery, Wallraf Richartz Museum in Köln, Radio Bremen, Duren's Kuhgasse, Galleria L'Attico in Rome, the Spoleto Festival of the Two Worlds, the WBAI-FM Free Music Store, the Loeb Student Center at New York University, and Amsterdam's Mickery Theater. At the Italian festival, "Some of the musicians publicly boycotted me—Mr. Menotti even walked out during the performance" [Glass 105]. According to the account in Robert Coe's article, "someone tried to cut the power supply" [78].

The performance of Parts Four to Six at the Village Presbyterian Church as part of the Spencer Concerts series on March 26, 1972, four months after Tom Johnson began writing for the *Voice*, provoked an important article which began, "One of the important new trends in music is the area I like to refer to as hypnotic music. It has a hypnotic quality because it is highly repetitious, and employs a consistent texture, rather than building or developing in traditional ways. Usually pieces in this genre are rather long, and they can seem tedious until one learns how to tune into the many subtle variations which go on underneath the sameness of the surface. Then very new and exciting musical experiences begin to happen" [April 6, 1972 42]. After comparing the "jolting" transitions unfavorably to *Music with Changing Parts*, Johnson enthused, "both pieces are really wonderful in so many ways," citing the rich and sensual textures, modal subtlety, and finesse of details—all of which, particularly the finesse, had escaped most ears to date. In his concluding praise of this "overwhelmingly joyous" music, Johnson risked a good deal of credibility: "Although the music does not resemble anything by Bach, it sometimes lifts me up the way a Brandenburg Concerto does."

In 1973 parts were performed at 10 Bleecker, Donald Judd's SoHo loft, Oberlin College, the Yale Art Gallery, the parks of the five boroughs (Van Cortlandt, Clove Lake, Cunningham, Prospect, and Central Parks—the latter at the Bandshell, *not* the Sheep Meadow), Max's Kansas City, Battery Park, the Festival d'Automne, Houston's Contemporary Arts Museum, the University of Southwestern Louisiana, Dartmouth, and Boston's School of the Museum of Fine Arts.

The group performed *Music in Changing Parts* and *Music in Twelve Parts*, Parts 2 and 3, at restaurant/bar/rock-club Max's on June 19, 1973. Max's had opened in December 1965 and attracted both Warhol's Factory-hands and Minimal artists from the Green and Park Place galleries; in its, and their, early days, Dan Flavin and Donald Judd traded artworks for

food and drink. Glass recalls, "We played on the second floor for the door [the sum of cover charges]. If we made three hundred and divided that up so that everyone got fifty bucks, we were thrilled." This was in the midst of the tour of the boroughs under the auspices of the New York State Arts Council and the Parks Department, for which "we got maybe six hundred a performance."

As interesting as the locale was the response of the audiences, particularly in comparison to the cold disdain shown Glass by his colleagues in what passed for avant-garde music circles uptown. When I said of his early reviews, "They murdered you," Glass laughed, "They *still* murder me." Into the 1980s he was still being bombarded not only by critics but by fellow composers like Samuel Barber, Elliott Carter, and Ned Rorem. "They hated this music and I *loved* their music. I *still* love their music!"

On the scene in the previous decade, roving reporter John Rockwell noted the "quite spontaneous pleasure" of the audience at the Prospect Park concert in Brooklyn: "even when some of them looked on indifferent, they were not hostile about it. It was a most instructive experience" [June 28, 1973 58].

There was distinct hostility, however, at the Clove Lake performance. In Glass's recounting, "A man literally tried to stop the concert by yelling, 'They're not musicians! They can't play! I'm a music teacher and I *know* they're not really playing their instruments.' We had a permit from the Parks Department, so the police came to throw him in jail. Meanwhile, Richard Peck began playing all these complicated scale exercises while this guy kept screaming that he couldn't play." The musicians found the situation hilarious and persuaded the police not to arrest the heckler.

In Van Cortlandt Park "there was a Latino family having a big picnic and one of the younger kids came up and asked me, 'What do you call that music, man?' And I said, 'I don't know.' And he said, 'I call it Buddha rock.' That's what he *said*."

Otherwise Glass remembers the reaction of those in attendance as ranging from laughter to indifference to confusion to sincere interest. "All kinds of people showed up. I went to the Parks Department myself. I had to do it. No one else would play my work and the only way to keep an ensemble together was to perform. If I could hold it together for twenty weeks the musicians could qualify for twenty-six weeks of unemployment. Forty-six paychecks a year!"

The Paris festival peformances were perhaps more important long-term since they led director Michel Guy to commission what developed into *Einstein on the Beach* after he became Secretary of State for Culture in 1974. In 1974 before the full performance at Town Hall, parts were performed at the Contemporanea festival in Rome, the Kitchen, and Philadelphia's Institute of Contemporary Arts.

The work itself was almost an illustrated handbook of techniques

developed to this point by Glass, who has himself called it a "catalogue" of his ideas on structure, ornamentation, harmonic movement and chromaticism. The opening slow movement (initially the whole of *Music in Twelve Parts*) explores resulting patterns in the simulation of a drone fifth from interlocking melodic lines in the twelve voices, while Part Three explores the similar generation of pulse and Part Four approaches improvised resulting patterns as in *Music in Changing Parts*. Parts Nine and Ten focus on ornamentation and chromaticism, Two on overlapping rhythmic cycles in multiples of six, while Five and Six explore various cycles played off against recurrent two- and three-note rhythmic figures. Thereafter he was to work primarily rather than sporadically in theater of different sorts, and he feels that with that new focus his "Minimal" period per se ended, since the theatrical aesthetic was "additive rather than reductive, which in this context is almost counterproductive or counterindicated" [AC 156].

There are other reasons for agreeing with the composer's demarcation of his Minimalism with the conclusion of *Twelve*, as of Reich's with the inception of *18*, which dates, conveniently, from the same month as the completion of *Twelve*. Both works represent the abandonment of the restricted harmonic movement or actual stasis that was among the salient characteristics of Minimalism, which had reacted to Serialism by holding a harmony *ad infinitum* or *ad nauseam*. The sudden clashes of massive stretches of held harmony in works like *Changing Parts* and *Six Pianos* have little in common technically or structurally with the eleven harmonic shifts in the first section of *18* or the adaptation of traditional harmonic technique in *Twelve*, the last two parts of which, in John Rockwell's vivid description, "suddenly erupted into functional, root-movement harmony— in other words, full-fledged tonality. From there, the way was open to the large-scale tonal organization conducive to opera" [Rockwell 1984 115]. Before the premiere, Rockwell warned "hard-line Glassians" they "may find the last two parts a betrayal of Glass's austerely minimal aesthetic" [May 26, 1974 21]; reviewing the premiere in the June 3, 1974 *Times*, however, Rockwell noted that "the last two parts didn't sound so radically different." Glass's next work was named, aptly, *Another Look at Harmony*, and its two parts were subsumed into *Einstein on the Beach* as its first scene ("Train") and dance ("Field/Spaceship").

If Virginia Woolf was permitted to aver that human consciousness changed "in or about December, 1910," we may be permitted to suggest the same for the collective Minimalist consciousness in or about May 1974, when Glass completed *Twelve* and Reich began *18*. During that same month, significantly, Young completed an eight-day Dream House with the Theater of Eternal Music at the Kitchen and was hard at work for the live premiere of *The Well-Tuned Piano* the next month in Rome. The Dream House represents the continuity of his interest in drone music from the mid-sixties to the mid-seventies (and into the nineties); it

received respectful praise from Tom Johnson in a Sunday *Times* feature [April 28, 1974 II, 13] and a favorable review from John Rockwell: "this is overtly mystical music. If you are at all susceptible to such experience, the sound will seem to fill up every crevice of the room, and the intensity of the experience will make any nostalgia for such older Western musical expectations as shape, contrast and climax seem blissfully irrelevant" [May 2, 1974 67]. Having been invited just a few months earlier to perform *The Well-Tuned Piano* live, after another Dream House at Galleria L'Attico, during which Young had played Sargentini the forty-five-minute tape, he was now immersed in the process of transforming the work into virtual unrecognizability while quadrupling the duration, turning an experiment in tuning and drone-simulation into an epic.

I suggested earlier that some continuity exists between the Minimalism of 1958–73 and later work, most obviously in the case of Young's drones, Reich's "Counterpoints" and the Glass piano solos and *Mishima* quartet. It is equally evident in the long static stretches of some of the Glass operas, and according to Reich in sections of his *The Cave*, as of this writing scheduled to premiere in Vienna in 1993. Elsewhere Glass has experimented with polytonality in orchestral structures, just as Riley has long since abandoned modular repetition for motivic development and similarly complex orchestration. Yet his extended permutations of motives connects Riley's recent work to his youthful compositions, just as Reich's progressive expansiveness has been counterbalanced by the return to live-phasing roots in the solo counterpoint pieces for flute, clarinet, and guitar, while in *Different Trains* he combined that technique with the tape experimentation he had begun even earlier. As the sophistication of the piece demonstrates, however, the more things change, the more they change.

T

In Part One I suggested that by the time the term Minimalism had been (re)introduced in the visual arts in 1965, the best of Minimalist painting had long since been done. By the time the term was affixed to the music, the period of strict Minimalism was long since over and the composers had evolved in distinctly non-Minimal directions. In print the term had first been applied to music—and then not directly but by extension—by Barbara Rose in her 1965 "ABC Art" article, with specific reference only to Young's "Dream Music," and a nod to the restrained dynamics of Morton Feldman.

Art critic John Perreault's 1968 article on Young also referred in passing to Young's focus on "sounds in isolation or within minimal nonrelational sound contexts" [29]. In his negative review of the premiere of *Four Organs*, Donal Henahan wrote, "Mr. Reich is still obsessed with taking his minimal art as far as it can be taken, and without diluting its abstract purity. His music, therefore, is all pattern and no color, which seems unnecessary" [May 9, 1970 15]. Henahan thus extended Rose's analogy to music other than Young's and did so more specifically than Perreault's relatively casual adjective, though still not in a specifically denominative manner.

When Emily Wasserman interviewed Reich for *Artforum* (May 1972), she first asked him about the relationship between his work and the "Conceptual art" of his friends Michael Snow, Bruce Nauman, William Wiley, Richard Serra, and Sol LeWitt. Reich then discussed analogies between his music and the "process" art of Serra and Snow. When Wasserman asked him about LeWitt, Reich replied, "There is some relationship between my music and any Minimal art" [48] but proceeded to focus on LeWitt's precompositional conceptualism rather than his Minimalism per se.

It is worth remembering that the Whitney "Anti-Illusion" show during which both Reich and Glass first performed uptown was not concerned with Minimalism but with post-Minimal process and conceptual art, as emblematized by Rafael Ferrer's ice melting on leaves at the entrance to the museum. Reich's first major essay/manifesto, entitled "Music as a Gradual Process" and published in the "Anti-Illusion" exhibition catalogue, clearly aligned his music to art going by the same name. The piece opens, "I do not mean the process of composition, but rather pieces of music that are, literally, processes." What distinguished Reich's processes from Serial and Cageian processes was their audibility: "What I'm interested in is a compositional process and a sounding music that are one and the same thing." The conceptual connection is apparent in his statement, "Though I may have the pleasure of discovering musical processes and composing the musical material to run through them, once the process is set up and loaded it runs by itself" [Reich 9–10]. Reich uses the noun "process(es)" no less than twenty-nine times in a seven-hundred-word statement.

Reich has suggested on occasion, followed in print by at least two critics, Dan Warburton and Jonathan Bernard, that Michael Nyman might have coined the actual phrase "Minimal music," while Glass has attributed it to Tom Johnson. Warburton (who prefers the term "solid-state music") writes that "despite persistent efforts to find out, it is still unclear who first coined the term. A BBC interview with Michael Nyman [in autumn 1983 on Radio Three's 'Music in Our Time'] proudly proclaimed Nyman the originator, though he has since refused to commit himself on the matter, understandably not wishing to be the target of the pent-up wrath of many of his fellow composers," [141] even more understandably since he did not originate the term.

As far as I can determine, it was first applied explicitly and directly to the music as a movement or shared style in 1972 by Johnson. In the *Village Voice* (September 7, 1972) Johnson began his article "Changing the meaning of static" with "I've heard people refer to the 'New York Hypnotic School' several times now, and have been trying to figure out if it is a good term or not." As already noted, he had in fact begun his review of Glass at the Spencer Concerts five months earlier by noting, "I like to refer to [this kind of music] as hypnotic music" [April 6, 1972], so Johnson himself is clearly a man of the "people." The odds seem further stacked in favor of the term since "New York Hypnotic School" has already appeared as the underlined super-title of the piece, and indeed Johnson now finds himself "beginning to think it is valid."

The adjective had appeared as early as April 1969 in the review of Terry Riley at the Electric Circus by the distinctly unhypnotized Harold Schonberg, and of the "hypnotic or boring—depending on one's reaction to that sort of thing"—characterization of Glass at the Guggenheim nine months later by the obviously bored Peter Davis. Johnson balks at including Frederic Rzewski, Philip Corner, and David Behrman under the

"Hypnotic School" rubric with Young, Riley, Reich, and Glass, and excludes Gavin Bryars ("it's a little difficult to consider him part of a New York school since he lives in England"). He also omits "a number of other composers writing hypnotic music . . . because they have not yet attracted . . . significant public attention. And there are no doubt many others that I don't know about."

Johnson describes the differences among the four composers, then their "same basic concern, which can be described as flat, plastic, minimal, and hypnotic." "Flat" is applied to their form, "static" to their pitches and rhythms (not their dynamics). "Minimal" is applied to "the very small range of contrasts within their pieces," despite "hundreds or thousands of variations" that "may occur. People frequently try to equate minimal music with minimal painting, but the two are actually quite different, even though the word 'minimal' seems appropriate in both cases. A minimal painter employs only one idea—a straight line, for example. The material itself is minimal. But these composers employ a great many ideas or variations. It is the degree of contrast between them which is minimal." What is uncertain here is whether Johnson is inventing the phrase "minimal music" or repeating it, whether he has heard "people frequently" use the phrase or merely compare the composers with the producers of "minimal art" (e.g., Wasserman or her readers in the four months since her article was published).

In any case, no sooner had Johnson inked the term that was to go down in history than he implicitly dismissed it. The next sentence in his article reads, "'Hypnotic' is probably the best word for this music, because it comes closest to describing the effect that it has on the listener." Had a consensus developed around Johnson, I would be citing him as the critical originator of the term "Hypnotism" generally applied to the leading Hypnotists Young, Riley, Reich, and Glass—which in itself explains why the phrase never caught on and one had to be borrowed, quite belatedly, from the plastic arts.

An equally valid candidate to preserve the analogy with those arts would have been "process[ism/ists]," which unfortunately sacrifices in euphony what it gains in accuracy, at least vis-à-vis Reich (phasing, radical augmentation, systematic hocketing) and Glass (additive/subtractive structure) and some of Riley (the tape and time-lag works, possibly even *In C*) and Young (the frequency tuning, drift studies, etc). "Minimalism" was a more inclusive term insofar as the rest of Young's work and Riley's then-current keyboard improvisations would have proven less amenable to labelling under "process."

As things worked out, they were not subject to it. Nyman, now an established composer in his own right, and one strongly influenced by both Reich and Glass, had begun writing on the two in 1971 for the *Musical Times*. The seventh chapter of his book *Experimental Music: Cage and Beyond* was entitled "Minimal music, determinacy and the new tonality." It was published in England by Studio Vista and in the U.S. by

Schirmer in 1974 and as publishing schedules go, probably completed a year or so earlier. (The most recent works of the group discussed directly in the chapter are the 1971 *Drumming* and *Music in Changing Parts*, though at one point he alludes to Reich's work "until 1973" [131]). Nyman writes of "Young's minimal alternative," "minimal process music" [119], and less denominatively, the "quite minimal" rules of Riley's scores [125].

John Rockwell had referred casually to "the minimal allure" of Reich's *Clapping Music* in the August 1973 *Musical America* [MA 32] and on May 26, 1974 repeated the adjective in the *Times* in referring to the "minimalist fascination with cool lucidity and sparse understatement" shared by Reich and Glass, and to the latter's hitherto "austerely minimal aesthetic" [21]. In the January 31, 1974 *Village Voice* Johnson referred to Charlemagne Palestine's tape-music as "perhaps the most extreme form of musical minimalism I have yet encountered" [44]. In the June 13 issue he then reviewed the Town Hall performance of *Music in Twelve Parts*, noting, "I have already written about . . . the static or minimal or hypnotic style of his [Glass's] music" [55]. None of these terms had been used in his review of the Philip Glass Ensemble at the Kitchen in the March 14 issue, while their performance at Max's Kansas City the previous June 19 had led him to apply his still-favored phrase, "hypnotic music," in the July 5, 1973 *Voice*.

Johnson, Rockwell, and Nyman's use of the word—seven years or more after Rose's, remarkably—did not cause either a terminological or musical revolution largely because the music itself had yet to attain mainstream acceptance as classical music, despite greater "respectability" along with wider exposure.

As Young had earlier won an unlikely place in *Vogue*, Reich made its English edition in February 1972 as the subject of an article by the ubiquitous Mr. Nyman. His music had also been the subject of a *Times* feature by Donal Henahan in October 1971 (now less confidently dismissive than earlier), in advance of a performance of *Phase Patterns* by Steve Reich and Musicians in a Boulez/New York Philharmonic-sponsored concert series, and of another article by Reich himself in September 1973. Even when Nyman interviewed Reich again for a 1976 *Studio International* piece in which the focus was on analogies between music and visual art, Minimalism was still referred to in passing, with greater reference to "process painting."

It was not until after the success of the 1976 debut of *Music for 18 Musicians* (Town Hall, April 24) and the sensation of *Einstein on the Beach* (Metropolitan Opera House, November 21) that mainstream critics began looking in earnest for a label for this strange enterprise, and Minimalism overtook the runner-up, Robert Palmer's "trance music," and slowly became a household word, at least in more progressive households. Even at this point, however, the label was up for grabs, although Peter G. Davis's "neo-primitive" seems to have lasted as long as his 1970 review. Although the coverage increased exponentially from 1977 to 1981,

almost a dozen years after his Guggenheim review, Davis managed to retain a remnant of condescension in his November 30 *New York* article entitled "Simple Gifts," which found Glass "on the verge of romanticizing his minimalist vision" [77]. By this time several critics had already dismissed "Minimalism" as inaccurate, Joan La Barbara first and most forcefully in 1977: "the term not only no longer applies, but is purely laughable to describe such rich and complex music" [MA14].

In 1982, when Reich, Glass and their colleagues were featured in the largest national news magazines, the case still remained somewhat uncertain, though this year marked the clear tipping of the scales in favor of "Minimalism." The February 1983 *High Fidelity/Musical America* deline-ated "An Outburst of Minimalism" from erstwhile Glass-basher, now true-believer Robert T. Jones just after *Time* magazine's "Best of 1982" listed *Tehilim* as its representative of "the year of Minimalism" [January 3, 1983 80]. By then, predictably, articles on the composers had begun to concen-trate almost equally on their Minimalism and their remoteness from the Minimalist aesthetic. The scales may have been tipped with Michael Walsh's *Time* article on Glass on August 10, 1981, also identifying Reich and Riley "in the minimalist camp." On October 25 Robert Coe's feature on Glass followed in the *New York Times Magazine*.

Back in 1966 Carman Moore had compared Reich's tape pieces to "watching sea waves; only so much can happen, fascinating though it be" [June 9, 1966]. The cover of Reich's Shandar disc in 1971 featured a photograph of sea waves. Writing for Columbia University's *Spectator* in November 1978, Tim Page tried out different metaphors to describe the ECM recording of *Music for 18 Musicians,* concluding with the similarly elemental "Steve Reich has framed the river" [November 2, 1978]. Three years later, he resurrected the metaphor, extending it to the Minimalists as a group, in "Framing the River: A Minimalist Primer" for the November 1981 *High Fidelity/Musical America* [64–68, 117]. Along with Walsh's and Coe's, Page's insightful article helped bring Minimalism to the masses and also served to indicate that it had developed into an ongoing tradition by featuring the work of John Adams (born 1947); it nonetheless set, along with Walsh's piece, an unfortunate precedent in relegating Young to the fringes of the movement (asking "Whether or not La Monte Young was a true Minimalist" is like asking whether Schoenberg was a true dodecaphonist). Many subsequent articles on the subject, to their discredit, mentioned Young in passing or not at all.

Page called "minimalist music" "the most popular, if not the most apt, label for this style" [64], while mentioning "pulse music," Palmer's "trance music," "modular music" (Richard Kostelanetz), "space music" (predictably popular in California), and "stuck-record music" (similar terms had appeared in *Stereo Review* and the *Penguin Guide*). On December 6 Donal Henahan took note of the craze, comparing it to the vogue for insipid Baroque thirty years earlier, and suggested yet another alternative to "Minimalism" in his title, "The Going-Nowhere Music and Where It

Came From." The two senior *Times* critics of the era scorned the music—
four years later Harold Schonberg, by then serving as cultural correspon-
dent, continued to treat it as a fad that offered the listener "nothing" in
"Plumbing the Shallows of Minimalism" [February 21, 1985]. John
Rockwell, joined for a time by Robert Palmer and Tim Page on the paper,
continued to support the music. On March 14, 1982 Rockwell delineated
"The Evolution of Steve Reich," mentioning "the similarly minimalist
composer" Glass, noting that "Starting in the late 60's, both . . . emerged
as leading exponents of what has variously been described as 'minimalist
music,' 'trance music,' 'pulse music,' 'steady-state structuralist music,'
or any number of equally unsatisfactory terms."

Two weeks later Annalyn Swan's "The Rise of Steve Reich" appeared
in *Newsweek* [March 29 56] with a photo of the composer captioned
"Reich at rehearsal: Up from minimalism" and a description of freedman
Reich as "along with Philip Glass . . . the leading composer of stripped-
down, hypnotically repetitive, so-called 'minimal' music." Swan informed
us that "For a 'minimal' work, 'Tehillim' is remarkably varied,"
as the terminological cart began to be placed almost invariably before the
musical horse.

Rockwell's "Evolution" had quoted Reich to the effect that "minimal-
ism may be long gone. . . . 'If you want to say minimalism as a move-
ment is dead, I'd say 'hear, hear, but *I'm* not dead.' If you're tied to
a movement you go down with that movement" [II, 24]. Despite similar
mild disavowals and even disdain from the composers, this anachronism
was convenient for them as well as for the journalists insofar as it is
easier to gain exposure as part of a movement, however arbitrarily or
even erroneously defined. In the court of high-cultural consumerism, not
having heard of an individual composer may be punished as a misde-
meanor but ignorance of an entire *movement* is clearly felonious.

Tom Johnson's "The Original Minimalists" appeared in the *Village
Voice* on July 27, 1982, and the jaded, borderline-sarcastic tone of the
piece, compared with his earlier enthusiasm, adumbrates his departure
from New York the next year. Ironically, the point of the article is to offer
"a more valid list of original minimalists" [69] than the "Riley/Reich/
Glass" of the popular press (he notes that Young has already been
somehow excluded)—ironically insofar as in the article in which he had
popularized the term he only included under the rubric "Riley/Reich/
Glass" and Young, a selection which enjoyed the precedent of the first
sentence of Daniel Caux's liner notes for the Shandar *Four Organs/Phase
Patterns*.

Johnson argued that "For several years the pieces Reich has been
turning out aren't really minimalist. There is relatively little repetition in
his recent scores, and he has left those simple minimalist scales for a
much fancier harmonic language." Glass is similarly dismissed, albeit on
the exaggerated claim that "One of the main characteristics of minimalism,
perhaps the most essential one, is that the music is supposed to go on

over just one chord, or even just one pitch." More dubiously, he suggests that "Riley's style has not changed much for at least 10 years, and it seems unlikely he will drift very far beyond the general boundaries of minimalism"—a judgment that may have been based on the recent Columbia issue of Riley's keyboard *Shri Camel* but not on the string quartets he had been composing for two years by the time of Johnson's article, which Johnson had most likely not yet heard.

By the time Michael Walsh's more extensive *Time* article, "The Heart is Back in the Game" (the title quotes Riley), appeared on September 20, the battle was pretty much over. "The style goes by many names: 'trance music,' 'process,' or 'system' music, 'steady-state structuralist' music and, even less flatteringly, 'going-nowhere' and 'needle-stuck-in-the-groove' music," Walsh observes, but these ostensibly once-competitive terms have now been sent to the sidelines. The head of the article reads "Hypnotic and infectious, minimalism is emotional in its appeal" [60]. "Art-Rocker Brian Eno, whose own music has been influenced by the minimalist aesthetic" observes Blake-like, "Minimalism sees the world in a grain of sand" after we learn that "Reich's style of music" is "called minimalism," which is identified as "a joyous, exciting—and sometimes maddening—amalgam of influences as disparate as African drumming, the Balinese gamelan, and new wave rock."

The (now new-wave) cart is again placed before the (now Minimalist) horse. Minimalism had influenced rock as early as the mid-sixties when Young's drones were transmitted via John Cale and others to the Velvet Underground, thence to a host of punkers enamored of their belatedly fashionable nihilism. The drones descended from the eternal music of the spheres through "Heroin"'s repeated tonic/dominant-*cum*-drones-on-the-common-tone to the Ramones' "Gimme Gimme Shock Treatment." Minor-mode Minimalist repetition, on the other hand, appeared opposite Krzysztof Penderecki's anguished microtonality in the 1973 score of *The Exorcist* in the form of Mike Oldfield's "Tubular Bells." Riley's influence was felt there, and his second Columbia album proved eponymous to the group Curved Air, while, contrariwise, the leader of King Crimson, Robert Fripp, was to rechristen Riley's time-lag system, without undue humility, "Frippertronics"—fifteen years or so after its birth. The influence was not all in one direction, however, since Glass's ideas of amplification from the late sixties derive more from rock than any classical source. Tom Johnson, in fact, issued a complaint back in 1974 that is still echoed: engineer Kurt Munkacsi "as usual" cranked the sound up too far, adding "a freak-out 60s veneer which actually contradicts the sensitive harmonies and the highly controlled playing" [March 14 41].

Ironically, some of the most pretentiously arty "art-rock" had Minimalist roots, including a day-trip by erstwhile "glitter-rock" performer and chronic trendie David Bowie in the 1977 *Low* (symphonized by Glass in 1992). By then Tangerine Dream was borrowing its style from Reich and Glass as clearly as Curved Air was borrowing its name from Riley, taking

repetition to a further level of techno-freakishness with the automatic replication of harmonies and rhythms at the touch of a button. Reich remarked to Page years later, "I should be receiving royalties for the theme to 'Adam Smith's Money World,' and the whole soundtrack to the film 'Risky Business,' supposedly by a group called Tangerine Dream, was an out and out ripoff of 'Music for 18 Musicians.' I should have sued" [June 1, 1986 II, 24].

By the 1980s, swarms of musicians American and European, innovative and clueless alike, had latched on. Mertens mentions in passing Nyman and Gavin Bryars in the U.K., Louis Andriessen in Holland, Richard Pinhas and Urban Sax in France, Peter Michael Hamel and Michael Fahres in Germany, Karel Goeyvaerts, Frans Geysen, and Dominique Lawalrée in Belgium, and among European rockers Klaus Schulze, Kraftwerk, XTC, Public Image Ltd [11], the Third Ear Band, Soft Machine, and "the Berlin-based Agitation Free [which] included . . . *In C* in its repertoire" [16]. In the U.S., the disco phenomenon, ironically, may have paved the way for acceptance of the New Wave music that represented its initially cultish antithesis or antidote. After the inhumanly steady bass-heavy beat of disco the relentless mechanics of Minimalist-influenced rock were less shocking. The latter, however, managed to present themselves as the antithesis of disco by adapting the mechanical repetition to higher registers in vocal phrasing and guitar riffs, offering themselves as the cool (and smart) alternative to hot (and stupid) disco. Most significantly, Talking Heads had employed the motoric repetitiveness of Glass to impressive effect.

Classically trained, a composer of disavowed symphonies in the early seventies, crossover (in media as well as marketing) artist Laurie Anderson accompanied her vocal on "O Superman" with a single repeated tone marking each beat and worked frequently elsewhere in repeating lines. The influence is present throughout the occasionally inspired, often merely gimmicky, music of Jean-Michel Jarre and much of so-called "New Age music," a category which as of this writing may be vanishing along with any hope for a New Age. This form of highly commercial mood music arose, significantly with no identifiable advent of any new age other than the encroaching *middle* age of the youth-worshipping generation born after World War II. It domesticated Minimalist repetition to such an extent that it is difficult to say whether New Age music represents the Mantovani or the Sominex of baby-boomers. Its utterly specious claims to expand consciousness, while inducing *un*consciousness, represent the last gasp of countercultural ideals for refugees to the same suburbs they once fled in youthful derision.

In the 1970s numerous musicians working in a classical vein were drawn to the style, including several members of the Reich and Glass ensembles, such as Richard Landry and James Tenney, and most notably in this context Jon Gibson. Gibson began working in tape seriously

after working with Reich and Riley and from 1968 to 1973 gathered natural sounds for "A 16-Track Multi-Textured Environmental Soundscape" entitled *Visitations*. Featuring overlaid percussion, flutes and synthesizer, it was described by Tom Johnson as "some of the densest music I have ever heard" [December 20, 1973 45]. The genre has since been overdone but Gibson's early experiment remains musically engrossing. The same may be said for *Cycles*, a 1973 pipe-organ piece whose pedal and overtone mix now seem like a bridge between those of Young, with whom Gibson had played in 1970, and the ambient music of Brian Eno and later New Age knockoffs.

While instrumental or found-sound long-tones and drones pervade *Visitations* and *Cycles*, Gibson was led in the direction of process and repetition in *Untitled*, the flip die of *Cycles* on his album *Two Solo Pieces*, released like *Visitations* on Chatham Square. He played alto flute in this piece, more allied to Reich and Glass, exfoliating a melody through repetition for eighteen minutes. His wind-playing proved generally more impressive than some of the reductivist percussion he examined in the self-describing *Single Stroke Roll on Drum* he premiered at Paula Cooper in December 1973, almost five years after the premiere of *Cymbal* at the Los Angeles Municipal Junior Arts Center in January 1969, in which a similar technique had been applied to a suspended cymbal. At the Kitchen in January 1972 he presented *Voice/Tape Delay*, taking off from Riley and Reich, and *Untitled Piece for Cymbals, Bells, Drums, Flutes, and Oscillators*, later called *Fluid Drive*, a live version of *Visitations*. In the fall he experimented with two amplified flutes playing from opposite ends of Seagram Plaza during a festival sponsored by the company.

Tenney had composed atonally but with repetition of lines as early as the 1959 *Monody* for solo clarinet, and worked with tape as early as the 1961 collage *Blue Suede*. He was a leading figure in the Tone Roads group in the late sixties, while playing in the ensembles of Reich and Glass. In 1969 the anomalous *For Ann (rising)* was about as minimal as it gets, consisting of a single tone gradually and almost imperceptibly ascending, while other works in the late seventies took off from Reich and Glass.

Former collaborators of Young and Riley also worked in the same vein. Terry Jennings and Dennis Johnson were mentioned earlier as Young's first followers. Jon Hassell, who played trumpet in the Theatre of Eternal Music and on the Columbia *In C*, composed under that joint influence as early as the 1969 *Solid State*, and during Young's April 28-May 5, 1974 Dream House at the Kitchen presented his own music one night while performing with the Theater of Eternal Music. By that time he had also begun to explore large-scale outdoor musical environments. David Rosenboom, the violist on the Columbia *In C*, for a time wrote pieces derivative of that work before immersing himself in assorted varieties of process music. Daniel Goode, clarinetist and leader of the ill-fated April 1973 performance of *In C*, was by then composing in a similar vein himself. In the early seventies Yoshi Wada employed electronic and

wind drones in a manner derived from Young, also adding voices on occasion.

Maryanne Amacher, Rhys Chatham, and Ingram Marshall—three young composers working in the New York University Composers Workshop directed by Morton Subotnick in the early 1970s—were to contribute in very different ways to the evolution of later Minimalism. Amacher experimented not only in extended durations but in long-distance concerts, once informing the audience assembled at the Kitchen that the music was being played in Boston and they would have to concentrate in order to hear it. Chatham, who was named music director of the Kitchen at the age of twenty-two, was an associate of Young and incorporated the influence of rock as well as drones. In his score for Robert Streicher's solo dance *Narcissus Descending* he set a single electronic drone-pitch and varied the overtones dynamically. He followed Young into gongs with his 1973 *Two Gongs* and in a Paris performance of Young's *Poem for Chairs, Tables, Benches, etc.* served as concertmaster and "first chair." Marshall explored *musique concrète*, and his live/tape compositions in particular, at once austere and grimly lyrical, have a humane quality absent from much Minimalism, combined with an aversion to sentimentality unshared with some of its later offshoots. Inspired by the Reich tape works in 1973, he created the text-sound piece *Cortez* and others. In the late seventies he began to integrate with telling effect his interests in both long-tone and repetitive Minimalism, electronic music, European Romanticism, and Indonesian music, which he had studied *in situ* in 1971. His 1976 *The Fragility Cycles* is one of the finest post-Minimal compositions and matched by subsequent works like *Fog Tropes, Gradual Requiem*, and *Hidden Voices*.

Charlemagne Palestine has maintained that he developed his piano technique without ever having heard Young play *The Well-Tuned Piano* (or any piano), but his repetitive strumming of the piano in the early seventies in a search for overtones—also present in his vocal work—shows similar interests, as does his use of drones (e.g., tape pieces with sustained chords or sustained tones fluctuating microtonally). While still in his teens, the prodigious Palestine (né Charles Martin in Brooklyn) was appointed bell-ringer at St. Thomas Church down the street from the Museum of Modern Art, and developed into a virtuoso carillonneur, which would naturally have provoked further exploration of sustained tones and harmonics in any case and are directly linked to the tubular bells he worked with in the early 1970s. His vigorous "strumming" technique was applied to both Bösendorfers and harpsichords, and his keyboard music grew wilder as the seventies progressed. There are similarities to a Young piece like the "1698" realization of *arabic numeral* in his *The Lower Depths: Descending/Ascending*, in which Palestine virtually assaulted the keyboard for an hour with preternatural endurance. This primal expression was foreshadowed in some of the voice and body

pieces in which he ran around galleries or banged his head against floors/ walls while wailing or sustaining tones. There is something of Yves Klein in all this, but more proximately it developed concurrently with a performance art that included in its more infamous forms Vito Acconci masturbating and Rudolf Schwarzkogler castrating himself piece by piece (and killing himself in the process, proving less was not necessarily more).

Palestine also took up the experimentation in drone intervals and drift originated by Young. In 1974 Lizzie Borden described "recent performances" given by Palestine that "have begun with an electronic sonority of one interval of a fifth (C/G) reinforced twice, and ten minutes later another reinforced fifth one major third higher (E/B) realized on an electronic synthesizer. The speakers are placed differently for each concert. In a recent performance at the Sonnabend Gallery, they were secreted in a closet, a stairwell, and in a room closed to the audience, so that the sound was filtered by these containers. The sonorities create a space of complex wave shapes with many overtones, of densities varying from place to place" [49].

In the early 1970s Philip Corner, who had been active in both Fluxus and Tone Roads and had provided the music for dance performances by Yvonne Rainer, experimented with economy of means in pieces such as one involving blowing into jugs in front of microphones, before turning his interest primarily to Indonesian (-influenced) music. Phill Niblock, a filmmaker and a self-trained musician, began an ongoing series of pieces in which he clipped off the attacks of vocal or instrumental sustained tones, spliced them in multi-track stereo, and played them loud in marathon concerts at his Centre Street loft, which he has also offered as a performance space to other musicians over the years. His tapes have often been accompanied by live performers mixing with the audience while harmonizing long tones. In its monodynamic sustenance, if not its dissonance, his work offers an interesting variation on Young.

Tom Johnson's own *The Four-Note Opera* premiered in May 1972, the titular heroes being A, B, D, and E—real naturals all. The next month he noted in a review of Buffalo's SEM Ensemble at the Kitchen, "I hear a lot of long static pieces these days, and when they are done well, the results can be quite moving. But when they are not done well, they are just long and static" [June 15, 1972, 37]. His advocacy was never undiscriminating. His 1982 list of "Original Minimalists" includes "Maryanne Amacher, Robert Ashley, David Behrman [excluded in his 1972 article], Harold Budd, Joel Chadabe, Philip Corner [excluded in his 1972 article], Alvin Curran, Jon Gibson, Daniel Goode, William Hellerman, Terry Jennings, Garrett List, Annea Lockwood, Alvin Lucier, Meredith Monk, Charlie Morrow, Gordon Mumma, Max Neuhaus, Phill Niblock, Pauline Oliveros, Frederic Rzewski [excluded from his 1972 article], Steven Scott, Richard Teitelbaum, Ivan Tcherepnin, Yoshi Wada" and

Young himself [69]. In addition to composers listed earlier, others men-
tioned by Page in "Framing the River" as influenced by Minimalism
include Beth Anderson, Laraaji, Jeffrey Lohn, and David Hush.

Jay Clayton, who has sung for years with Reich, and Laura Dean,
who has lived and worked with him, have both subsequently composed
in a Reichian vein with Glass affinities. Pauline Oliveros, a classmate of
Young and Riley in Berkeley who performed in the premiere of *In C*,
worked at the San Francisco Tape Music Center and became its director
when it moved across the Bay to Mills College in 1966–67, has employed
modality, sustenance and repetition in works scored for unconventional
ensembles (e.g., twenty-two accordions and percussion in *The Wanderer*).
The 1975 composition carried on the tradition of "instructional" concept
art; its original score read, "Sustain a tone or sound until any desire to
change it disappears. When there is no longer any desire to change
the tone or sound, then change it"). Oliveros has become best known for
her use of environmentally created drones and delays, which might be
called site-specific music after the sculptural term—playing and recording
in such locations as an underground reservoir in Köln, and the bombproof
concrete cistern at Fort Worden, Washington, to exploit their otherworld-
ly reverberation. Young's influence is again manifest.

The multi-talented Meredith Monk is with Oliveros the most signifi-
cant of the female composers popularly associated with the Minimalist
style, though she not only dislikes the label but finds it inaccurate. Monk
was probably best known as a dancer and choreographer in the sixties
and early seventies, during which time she in fact resisted what she
perceived as the somewhat doctrinaire polemics of dance colleagues
associated with reductive style. The Minimal tag is affixed to her music
because of her reduced instrumentation and its typical relegation to drones
and repeating modules, which are closely allied, respectively, to Young's
Tortoise, and early Reich and Glass. The crucial difference is that they
serve Monk primarily as accompaniment for her anything-but-minimal,
virtuosic, semi-improvisational, extended-vocals, whereas in Young the
similarly wordless chanting is restricted to predetermined sustained
intervals and in early Reich and Glass the modules *constitute* the piece.
Monk has, furthermore, worked primarily in additive rather than reduc-
tive multi-media (even her first composition in 1966 had the emblematic
title *16 Millimeter Earrings*), notably in the operas *Quarry* (1976), the
"apocalyptic cabaret" *Turtle Dreams* (1983), and the recent *Atlas* (1991).

In the discography to Chapter Four, "Meet the Minimalists," of
his valuable 1987 survey *New Sounds*, John Schaefer lists another thirty
composers postdating the area of our discussion of Minimalist origins. By
then the voice of the people had clearly been heard; it is unlikely that
the author lost a moment's thought on entitling his chapter "Meet the
Modularists" or "Meet the Steady-State Structuralists."

In addition to "intentionless music," Glass once said he preferred
"music with repetitive structures" [Page 1981 64]; Reich has similarly

opted on occasion for "structuralism" and *"musique répétitive,"* but "basically I wouldn't go with any [term]." Riley describes himself as "probably the last person to ask" about vestiges of Minimalism in his work. Young is the only one of four who acknowledges that he is a Minimalist, adding, "but that's only one of the things I am" [*AC* 45, 123, 69].

All four proved to be lots of other things. If their work had ended in May 1974 like Minimalism proper and this survey, the term would be a footnote in music history, something like Fluxus, and the survey would not exist.

Space

Richard Morris, *Slab* (Cloud), 1962. Grey plywood,
6'×6'×11". Photograph by Jacob Burckhardt.

U

In my childhood, fears of the Iron Curtain and the scientists behind it lit up the silver screen with endless low-budget invasions by regimented extraterrestrials as superior technologically to earthlings as they inevitably proved inferior morally. McCarthyite terror of infiltration and covert indoctrination inspired a subset of the genre in which unscrupulous aliens became all but indistinguishable from their incorrigibly upright (small-town, lawn-mowing, cheerful, hat-wearing, white) victims. Most often, however, our not-so-good neighbors from the stars were depicted as humanoid mutants.

As I came of age, earth was visited yet again in Stanley Kubrick's *2001: A Space Odyssey*—this time with greater consequences than just another hostile takeover attempt. *These* aliens were neither monsters of organic mutation nor totalitarian robots, neither vegetable nor mechanical nor near-human in crustacean make-up and/or what passed for futuristic couture at the time. Instead, the nonhuman arrived at last in utterly nonhuman form: black monoliths ten feet tall. They were not invaders from Mars, Alpha 7, or Planet X. It was not the invasion of the body snatchers, the star creatures, or the saucer men. It was the invasion of the Minimal sculptures and if not civilization, anthropomorphic art as we knew it was at an end.

The 1968 film was made in the heyday of what three years earlier had first been referred to as Minimal art. Michael Steiner, Ronald Bladen, and John McCracken had by then all produced very distinctive works that nonetheless bore a family resemblance to Kubrick's space invaders. The apemen in the first segment of Kubrick's film were no more non-plussed by the apparition of monoliths on the savannah than many of

their descendants had been at their recent apparition in galleries and museums.

That reaction continued the tradition of ridicule directed at the radical experimentation of early Minimalism, in music as well as painting. Newman's divided monochromes, Reinhardt's invisible paintings, Kelly's color blocks, and Rauschenberg's problematically empty canvases had all been undertaken by the end of 1951, Stella's monochromes and Martin's grids by the end of the decade. The painters who followed in or around 1962 bear the same relation to these predecessors as the generation of musical Minimalists in the 1970s do to theirs. They are essentially variations on a theme, sometimes imaginative variations. The techno-drones of Phill Niblock and the site-specific acoustic drones of Pauline Oliveros are two of the more intriguing appendices to Young's work from the mid-sixties onward. The mid-sixties areas of Robert Mangold and sealed surfaces of Brice Marden are two of the more interesting variations on the monochrome painting of the 1950s.

More compelling elaborations of the various holistic features of the painting appeared in three dimensions. The indivisibility of monochrome painting was reincarnated in monochrome sculpture of irreducible geometry like Tony Smith's and Robert Morris's, work which was the antithesis of the expressive assemblage of the then-dominant work in its medium. The holism of panel paintings was three-dimensionalized in John McCracken's planks, and their serial replication was echoed in the factory-made forms of sculpture like Donald Judd's and Ronald Bladen's. Line-drawings and stripe-paintings were translated into imaginative spatial definition in Dan Flavin's luminism. The self-generating and self-contained structure of Stella's work provided the foundation for Carl Andre's floor and wood pieces, just as the grids of Martin and others are the immediate precedent for Sol LeWitt's enamel cubes.

Not only does the work of these younger artists spring from that of earlier painters, but some of the earlier painters themselves progressed into sculptural forms. Klein, of course, had done his IKB monochrome sponge reliefs and sculptures in the 1950s hard on the heels of his similarly colored canvases. In the sixties both Newman and Kelly produced sculpture of note specifically derived from their work on canvas. The elongated vertical beams of Newman's *Here* series are basically three-dimensional zips, now presented as a relationship of steel to space instead of color-band to color-field, while Kelly's reliefs and *Angle* sculptures are structurally elaborations—arguably simplifications in purely geometrical terms—of the paintings he had composed for years by combining monochrome panels. The progression of the mid-sixties series of four *Angles* from the earlier pair, composed of perpendicular canvases, to the later pair of painted aluminum seems now a metonym of the evolution of Minimal sculpture from the painting. Similarly characteristic of the development of Minimalism is the replacement of oil by acrylic paint after the first *Angle*.

As mentioned in the first chapter, then, my concern with the sculpture is minor in the context of this survey of the origins of Minimalism, since the three-dimensional art is fundamentally an outgrowth of earlier work in its sister medium. [cf. Krauss 1977 esp. 253–67; Haskell 1984 91–95]. After tracing the painting from 1948 to the 1960s and the music from 1958 to the early 1970s, we retreat chronologically for a look at the sculpture, which begins in 1961, and follow its development and reception up to 1966, the Minimal Year of the Primary Structures exhibition and others, when the art began to receive regular coverage, albeit mainly negative, from the establishment press. The conclusion of this survey thus largely coincides with the public recognition of the art which had been termed Minimal just the previous year after increasing if divided critical attention since 1963, which is also reviewed for its documentary and/or critical value. Beyond that, the reader is referred to writers like Frances Colpitt and Kenneth Baker, who, as noted earlier, follow the movement, respectively, up to the late 1960s and 1980s.

While Colpitt's book is arranged by key issues in her area of interest, Baker organizes his material loosely chronologically by artist. He too notes the affirmation by Minimal sculpture of Stella's early work as a "watershed" in its "emphatic objectivity" [35], which "other artists would soon elaborate and amplify" [34]. While Baker points to Brancusi as an earlier example of reductive sculpture, he begins his account of Minimal sculpture per se with Carl Andre, with whom Stella attended prep school and shared his studio during the creation of the black paintings. Andre had been influenced by works of Brancusi like *Endless Column*, and had emulated them in *Last Ladder, Pyramid, Cedar Piece*, and *Chalice*, all dating from 1959–60. Whether these geometrically abstract pieces, which involve symmetry and serial replication, have the irreducibility of Minimal sculpture may be debated. The element of assemblage in *Cedar Piece*, for example, is evident, though neutralized by both the geometry of the arrangement and material sameness of the components.

The *Elements* series of uncarved cedar beams in different quantities and arrangements, on the other hand, must be considered Minimalist by any but the most restrictively "unitary" conception of the term. However, this series presents chronological problems similar to those noted in Klein's work, since it was not realized, due to lack of funds, until 1971, eleven years after its "conception" by Andre. *Cement Piece*, composed of parallel pairs of cement blocks stacked atop one another at right angles, amounts to a low-cost rehearsal of the wooden *Pyre* in *Elements* in 1964–65; by the time Andre returned to Minimal forms around that time, after a period of being "sidetracked into making accumulations of poured cement and raunchy assemblages of detritus, which he later destroyed" [Baker 42], others had not only conceived but displayed Minimal forms. At the time of Andre's first show in 1965, Morris, Judd, Flavin, and Truitt had already been exhibiting for two years.

Andre's most original contribution was in taking their removal of

sculpture from the pedestal a step further, by conceiving of floor-level art more unconventional than even the columns, slabs, and boxes that had by then been placed on the floor without pedestal by Morris, Smith, and Judd.

Andre's experience as a brakeman on the Pennsylvania Railroad from 1960 to 1964 has been interpreted variously as influencing his "boxcar" replication of bricks, blocks and tiles (David Bourdon suggested it "confirmed him in his use of regimented, interchangeable units" [October 1966 15]) and, by Andre himself, as relieving him of "the typical American sculptor's romance with the gigantic" [quoted Baker 42]. *Lever,* first shown at Primary Structures and still perhaps Andre's best known piece, in fact takes the roughly boxcar-like shapes of firebricks (137 according to Baker, 139 according to Bourdon) and places them in a row, but joined frontally rather than lengthwise. Andre described even this piece to Bourdon as "putting Brancusi's *Endless Column* on the ground instead of in the sky." Although Anna Chave has included *Lever* in her critique of the phallicism of much Minimal art as reinforcing the sexist power structure of the society, Andre's work is at least ambiguous in this regard, as seems evident in her use of parenthesis: "it offers a schematic image of coitus with the floor serving as the (unarticulated) female element" [1990 46]. However, the placement of the bricks *atop* the floor does not seem especially coital.

Andre denied "emphatically that his work has even implicit sexual meaning" and rejected the "priapic" nature of "most sculpture . . . with the male organ in the air. In my work, Priapus is down on the floor. The engaged position is to run along the earth." Nonetheless, Bourdon too saw *Lever* as "a 34½-foot erection" [104], though the proportions of the bricks individually or together are hardly phallic. Chave follows Bourdon in using the title of the piece to support the phallic interpretation, but the party-line Freudianism that reads every lever, stripe, or Yellow Brick Road as a phallos is at least debatable, while the lever as a "long rigid tool used to pry or lift an object" [Chave 46] does not perform those functions in the manner of its more vulnerable would-be significant.

I find the principal theme of Andre's floor-work its fundamental redefinition of perceptual and symbolic space, particularly in the context of the museum or gallery, in which the gaze of the spectator is traditionally raised above the purely functional, diurnal space of the floor to ritual space, the transcendental realm of "high" art—adopting Eliade, from the profane to the ersatz sacred. Andre's subsequent title pieces were even less phallic and undifferentiated from functional space in their objecthood as their height was diminished from a few inches to fractions of an inch. In 1989 Andre provided a more minimal analysis of his work: "My sculptures are masses and their subject is matter" [Marshall 18].

Along with the influence of Stella's "object" art, the structural influence of the Arp checkerboard collages and, more proximately, Ellsworth Kelly's panels, which Andre in a sense revived horizontally,

should be mentioned. A work like *Small Weathering Piece* recalls Kelly's 1951 *Colors for a Large Wall* twenty years earlier: Andre arranges component squares of identical dimensions and contrasting colors (derived in his idiom from the six metals used rather than Kelly's different pigments) in symmetrical rows (six rows of six rather than Kelly's eight of eight). As in Kelly's painting, the arrangement of colors is irregular, although Andre represents each equally by six tiles.

Boxes multiplied like rabbits in the 1960s, with vague precedent in Joseph Beuys's 1957 neo-Dada *Rubberized Box,* which is in essence no more Minimal than Rauschenberg's black paintings (the agglutinative surface here composed of tar and rubber rather than black paint and newspapers). By 1961 Walter De Maria and Robert Morris, both contributors to La Monte Young and Jackson Mac Low's *An Anthology,* were creating radically reductive sculpture usually more conceptual than Minimal in essence. De Maria had been working in what might be termed a Minimal mode in Berkeley by the turn of the decade, experimenting, for example, with canvases occupied by a single large X. Morris was a more flamboyant personality, expressing with great versatility his more theatrical inclinations. He was also a vanguard theorist and like Donald Judd drew attention for his writing as well as his innovative work in the plastic and performing arts.

In 1961 De Maria and Morris created what may be considered the first Minimal sculptures. The first to be publicly exhibited were the 4′×4′×8′ natural wood boxes shown by De Maria in July 1961 in tandem with a lecture at George Maciunas's AG Gallery.

During the same year Morris began creating what he was to refer to as "unitary forms," signifying "simple regular and irregular polyhedrons" [February 1966 44] of plywood painted neutrally in what would be known as "Morris gray." Like De Maria, he and then-spouse Simone Forti had met Young in the Bay Area in 1959. Forti and Morris were students of Ann Halprin when Young and Terry Riley were providing the noise-track for her performances. The couple were in New York in 1960, and in that year or early in 1961 Morris contributed to *An Anthology* an essay on "Blank Form" sculpture. By the time the collection was published in 1963 he had withdrawn the contribution but realized the concept.

In 1961 De Maria also created not Minimal forms per se but virtually featureless boxes—again in natural wood rather than painted plywood—often considered paradigms of the conceptual art that came to the fore later in the decade. In the present context the most important of De Maria's was one of a series of *Ball Boxes* called *Ball Drop,* a 76″×24″×6 ½″ box that came with two square slots just below the top and middle and an invitation to drop the ball into the upper slot. Kenneth Baker observes, "You expect to hear the ball rumble through a maze of channels hidden in the box until it reappears in the hole below. This expectation is exploded by the loud crack which sounds as the ball drops directly from the upper hole to the lower one." He acutely analyzes this as an exposure

of our "irrational habit of ascribing complexity and obscurity to what is
out of sight. The coffinlike shape . . . hints that it enshrines a dead vision
of human reality that continues to haunt us" [82].

De Maria's piece occupies an ambiguous position vis-à-vis Minimal
and concept art that is analogous to that held by Young's contemporary
Compositions. Though primarily conceptual pieces, the works (De Maria's
and at least *most* of Young's) are physically realized but very minimally so.
Although another of the *Ball Boxes* of similar external design has the ball
rolling "through the box side to side on a ramp to the bottom window"
[Johnston February 1963 19], the *Ball Drop* described by Baker may
indeed be read as a Minimalist manifesto, commenting not only on our
ascription of complexity to the unknown but on extraneousness in art.
The shortest distance between two points remains a straight line, it
reminds us, in art as well as life. It is not only the unknown nature of
the interior of the box that provokes the expectation of intriguing com-
plexity but the status of the box in the gallery as a transcendental object.
When we put our coins in the Coke machine box, we expect an efficient
and uncomplex slide of the Coke can (then bottle) from the invisible
interior to the slot. When we drop the ball into the fetishized box in the
middle of the art gallery, on the other hand, we expect convoluted
marvels instead of elementary physics. We expect secrets emblematic of
the occult workings of the creative mind. The piece has no secrets,
however and suggests that the marvels have had their day in sculpture—
a message that had been brought home with finality to painting by
Stella two years earlier.

In the same year Morris's cubic-foot *Box with the Sounds of Its Own
Making* contained a tape recorder playing a three-hour tape of the sounds
recorded during the construction of the box, including the artist's leaving
the room. Its shape was anticipated, however, by *Performance Box* from
1960, an oak box which opened to reveal a switch and instructions
on the lid advising, "TO BEGIN TURN ON—CONTINUE DOING WHAT
YOU ARE DOING—OR DON'T—DO SOMETHING ELSE. LATER SWITCH
MAY BE TURNED OFF—AFTER A SECOND, HOUR, DAY, YEAR, POST-
HUMOUSLY." Again, the classification of these works as "Minimal" is
questionable, as they primarily inhabit the Fluxus space of concept art
cleared earlier by Duchamp, more recently by Cage, and still more
recently the "instructional" concept compositions of Young, George Brecht,
and others. Isolated from the box, the whole "text" of *Performance Box*
reads like one of *Compositions 1960* as written by Cage rather than Young,
who would undoubtedly have left the spectator/participant less leeway.
Equally unMinimal and Duchampian is Morris's more notorious *I-Box* of
1962, a plywood box with a centered and hinged door in the form of a
capital I that when opened reveals a photograph of the grinning and
naked artist. The triple-pun of the title (letter, self, eye) cleverly connects
the autobiographical artist and the at least momentarily, if involuntarily,
voyeuristic spectator.

The inherent narrative of these boxes, like De Maria's, ultimately disqualifies them as Minimal art, just as the deadpan mimesis of Warhol's Brillo boxes from 1964—a three-dimensional elaboration of Jasper Johns's flags, maps, targets, etc.—disqualifies them. De Maria's were affiliated with the concept-art project he called *Meaningless Work*, defined in *An Anthology* as "work which does not make you money or accomplish a conventional purpose," like "digging a hole, then covering it." Another example in the same volume is a bare *Surprise Box* into which one can reach but not see. Once surprised by the contents, one may remove and replace them with the next surprise. A third is two boxes into which one would alternately throw the "things" provided: "Back and forth, back and forth. Do this for as long as you like. What do you feel? Yourself? The box? The things? Remember this doesn't mean anything." If nothing else, the last sentence may place in a different perspective the interpretations of *Ball Drop* provided above.

A more minimally kinetic 1961 example, which still exists in Young's loft, features a small platform on a pedestal. On the left of the platform is a spot marked in ink and a marble ball truncated for stability; on the right is a topless box. Above is written: "PLACE BALL IN BOX. WAIT UNTIL YOU ARE SATISFIED. PLACE BALL BACK ON SPOT."

Morris's *Column* has been proposed as the first full-fledged Minimal sculpture, though De Maria's boxes at AG Gallery seem to have priority with their crucial "lack," noted by Barbara Haskell, "of even a literary component" [1984 99], much less of a kinetic or play element. And like the conceptual works mentioned above, *Column* too was "tainted" by vaguely narrative concerns.

It made its debut at a benefit for *An Anthology* at the Living Theater, dated by Berger 1961 [47]. The benefit, however, was the second of two for *An Anthology* in early 1962. On January 8 works of Cage, George Brecht, Ono, Ichiyanagi, Dick Higgins, Henry Flynt, Claus Bremer, Earle Brown, and Joseph Byrd were performed, while De Maria contributed, according to the program, "some objects in the lobby." Morris's performance was featured on February 5, along with others by Dennis Johnson, Ray Johnson, Jackson Mac Low, Richard Maxfield, Simone [Forti] Morris, Nam June Paik, Terry Riley, Diter Rot, James Waring, Emmett Williams, Christian Wolff, and Young.

Column was the embodiment of Morris's initial example of "Blank Form," the first of two contributions to *An Anthology*, subsequently withdrawn: "A column with perfectly smooth, rectangular surfaces, 2 feet by 8 feet, painted gray." The other examples of "Blank Form" were a 2'×8'×8' wall and 1'×2'×6' cabinet similarly painted. (His second contribution to *An Anthology* gave instructions—for militant anarchists, this circle of artists was extraordinarily fond of giving instructions—for losing an object.)

In rehearsal for his Minimal theater piece, the column appeared "priapically" for three and a half minutes, after which it was toppled by

the artist concealed inside it. It then lay on its side for three and a half minutes more before curtain. The timing was very practically determined, according to Morris, by Young's allotting each performer seven minutes. When Morris was injured in final rehearsal, he was replaced as toppler in the eleventh hour by a string tugged to fell the work that perforce debuted without him [Berger 47–48]. The column, now *Column*, appeared vertically (a similar but horizontal *Floor Piece* was shown later) as an independent piece of sculpture at the first group exhibition of Minimal sculpture at the Green Gallery in early 1963—without theatrics, other than those Michael Fried found inherent in "literalism."

This leads to a fundamental question: if we fail to credit Andre's creation of *Elements* in 1960 on the grounds that it remained a concept rather than visible sculpture, when do we credit Morris with the creation of *Column*—in 1960/61 when it existed on paper as an example of "Blank Form," in 1961 when it was presented as a prop rather than a sculpture (or unitary form)? If we accord a then-prop sculptural status, why not accord it to any previous prop of similar simplicity? The obvious answer is that the hypothetically anterior props were not displayed in isolation, removed from their theatrical context. As long as the column remained on the page, it was a concept. As long as it remained within a theatrical context, it was a prop. As soon as Morris displayed it separately, it became sculpture (or three-dimensional art). In September 1992 Morris unhesitatingly stated that, despite his involvement with creating props for his wife's dance performances, *Column* had been conceived from the start as independent sculpture, though not exhibited as such before it was put to purely temporary use as a prop when he was invited to perform at the benefit. The column was born as a "Blank Form" concept, probably in 1960 and no later than spring 1961 (before De Maria's AG Gallery lecture-demonstration but not necessarily before De Maria conceived the bare boxes there exhibited). It was realized in Morris's studio sometime in 1961 and introduced as a prop in February 1962. It was reborn as a public sculpture when Morris conveyed the column, christened *Column*, to the Green Gallery for vertical exhibition. (All of this provides an interesting appendix to the problems of dating Duchamp's readymades. Was *Fountain* created when the urinal was fabricated, when Duchamp got the idea for exhibiting it, or when he in fact exhibited it? For Conceptual art, the second and third alternatives are acceptable.)

As Minimal art, however, *Column* may be legitimately dated 1963 *or* the point in 1961 at which Morris created it in his studio as an independent artwork, but not from the inception of the "Blank Form" concept in 1960/ 61. Despite the frequent and problematic overlapping of Minimal and Conceptual art, the evidence for creation of a work of Minimal as opposed to Conceptual art must include not only its conception but its physical realization—and arguably its presentation as an artwork. Despite the frequent definition of Minimal sculpture as an art indistinguishable from objects, it ultimately retains traditional status as a transcendental object

and remains subject to traditional procedures of validation—which Morris
was to play with later in the decade—whereas Conceptual art is finally a
more radical departure in its dematerialization and concomitant resistance
to authentication.

Morris's numerous unitary forms were exhibited early, in the vanguard
of Minimal sculpture. De Maria gained recognition first for his Conceptual
art, and later for his earthworks and *Lightning Field* of four hundred
twenty-foot steel rods placed in a mile-by-kilometer field in New Mexico.
That work, mentioned earlier here under the rubric "epic Minimalism,"
Baker considers "the closest thing to a masterpiece to come out of Mini-
malism" [125].

By 1960 Tony Smith, a forty-eight-year-old architect, erstwhile student
at Chicago's New Bauhaus, assistant to Frank Lloyd Wright, and drinking
buddy of Pollock and other Abstract Expressionist painters, began experi-
menting with sculpture; sometime in 1961 or 1962 he conceived and in
1962 (had) created another and equally indifferent contender for the post
of first Minimal sculpture, the six-foot cube *Die*. The dark steel is heavier
emotionally as well as materially than either De Maria's natural-wood
or Morris's bland gray plywood. While its forbidding aspect has been
neutralized by three decades, Chave goes so far as to read the title as not
only a noun but an aggressively imperative verb [1990 52].

If the neo-Dadaist banality of *Column* recalls the Rauschenberg whites
and foreshadows Richard Tuttle's rope and wire pieces, the 6'³ *Die* recalls
the impermeability of the 5'² in Reinhardt blacks and foreshadows Richard
Serra's Cor-Ten sculptures. Smith's piece, however, has none of the subtlety
of Reinhardt or the threatening monumentality common to much of
Serra's work (which Chave analyzes quite tellingly). Like Morris's piece, it
eschews expressiveness in its stark monochromaticism, and further neu-
tralizes involvement with its uniform dimensions.

As controversial as the bald presence of the work itself was its size and
manner of creation. In *Artforum*, Fried accused the coldly self-subsisting
work of abstract anthropomorphism; he quoted Morris [October 1966 21]
quoting Smith's replies to queries as to why he did not make the piece
larger or smaller: "I was not making a monument . . . I was not making an
object." Fried suggested that Smith was making "something like a surrogate
person—that is, a kind of statue." The regressive and "incurably theatrical"
[June 1967 19] quality of this covert illusionism was shared, according to
Fried, with much of what he called "literalist" art a year after Morris
had stressed the "literal space" of sculpture in the same magazine [February
1966 43] and three after Hilton Kramer noted "the more literal mode of
utterance making itself felt at the present time" [June 1964 112].

The other objection leveled against the work reiterates the argument
posed by Richard Wollheim as *advocatus diaboli* in the second half of his
"Minimal Art" essay—mainly its violation of the work ethic. This charge
was to be made and answered repeatedly in the 1960s. The case of *Die* was
even more radical: Smith told Samuel Wagstaff, Jr., "I didn't make a

drawing"—this despite his architectural training—"I just picked up the phone and ordered it" [*Tony Smith*]. When this caused a stir, he explained to Grace Glueck what she called his "farming out the work": "It's not as if I couldn't do the stuff myself. . . . After all, I once was a toolmaker's apprentice. But I'm old [he was fifty-four] and I've done too damned much. I never was a physical type, and now it even hurts me to typewrite. If people didn't do these for me, they'd never get done" [November 27, 1966]. Later designers like Judd and LeWitt would simply commission their own works without excuse or apology.

Throughout the first half of the 1960s, Smith kept his sculpture on the grounds of his New Jersey home. He exhibited *Free Ride* at "Primary Structures" but did not have a solo show until later in 1966, when his works were exhibited at the Wadsworth Atheneum in Hartford and the Institute of Contemporary Art in Philadelphia. He claimed not to have conceived them for exhibition at all ("I did them for myself, as a private thing") and professed indifference to the current trend, describing his works to Glueck as "rather more Stone Age than primary structure." There is something of the menhir dwelling in Smith's polyhedrons, an element of unseen presence which is no more explained away by their geometric solidity than are Reinhardt's square blacks and which segregates him to some extent from the secular objectivism of object sculpture, which may reflect his sense of "the inscrutability and mysteriousness of the thing" [*Tony Smith*].

To continue with the issue of dating, the question here is when the sculpture *Die* was created: (a) when Smith had the idea; (b) when he picked up the phone; (c) when his order was filled at the foundry; (d) when it was delivered to his gate; (e) when it was placed for view on the grounds; (f) when he showed it to someone as sculpture; or (g) when it was first exhibited at the Jewish Museum. Coleridge once observed that one is born either a Platonist or Aristotelian; while the first contingent may opt for (a) or (b), the context of arts called "plastic" urges more empirical criteria, and so I would opt for (e) if deprived the luxury of "(h) all of the above."

By the time of (g), Smith had produced a number of larger works that embodied the monumentality he had evaded in *Die*—the tetrahedron *Generation* was thirty feet high—while in group arrangements like the five polyhedrons of *Wandering Rocks* he utilized smaller scale than *Die* and brought the pieces down to the floor as Morris and others had done by then. Fried had reacted to Smith's use of visible supporting two-by-fours below *Die*—vestiges of "a rudimentary *pedestal*"!—as if he had caught Smith with his hand in Grandma Moses's cookie jar. While admitting that "Beyond a certain size the object can overwhelm," Robert Morris justified the increasing predominance of large sculpture not as triumphalism—Chave prosecutorially allies much of it to Nazi architecture—but rather as "one of the necessary conditions of avoiding intimacy" [October 1966 21]. He did not share the view of others that another such means was distancing

the work by projecting it from the wall. Morris had written in the first installment of his *Artforum* "Notes on Sculpture" that "the relief has been accepted as a viable mode. However, it cannot be accepted today as legitimate. The autonomous and literal nature of sculpture demands that it have its own, equally literal space—*not* a surface shared with painting. Furthermore, an object hung on the wall does not confront gravity; it timidly resists it" [February 1966 43]—a comment which may shed further light on Andre's floor pieces.

The principal practitioner of reliefs was Morris's fellow artist/critic Donald Judd. Born three years before Morris in 1928, Judd had written for *Arts* (renamed *Arts Magazine* in 1962) since 1959. Originally a painter, he moved into sculpture around the same time as Morris and Smith. Judd objected strenuously to being classified by Fried (and others) with Morris and Smith and detested the term Minimalism. He wrote an article for the April 1969 *Studio International* in order "to keep *Studio International* from calling me a minimalist." In the course of that failed effort he noted that "Smith's statements and his work are contradictory to my own. Bob Morris' Dada interests are very alien to me and there's a lot in his dogmatic articles that I don't like" [Judd 198]. Nonetheless, Judd included Morris's work along with his own in his resistance to the application of the more general term "sculpture," referring to it as "the new three-dimensional work" and "specific objects" [181]. His definition of the soon-famous latter term is really not all that specific itself, but the adjective seems to suggest simple and identifiable materials [187] and the noun the anti-illusionistic and anti-compositional nature of the forms [188] and their existence as "an object, a single thing" [183]. "The new work obviously resembles sculpture more than it does painting, but it is nearer painting" [183].

Stella himself expressed admiration for both Andre and Judd, perhaps the sculptors whose repetitive forms were most clearly influenced by his work, but seemed acutely critical in stating, "It was to the detriment of sculpture that it picked up the simplest things that were going on in painting. The sculptors just scanned the organization of painting and made sculpture out of it. It was a bad reading of painting; they really didn't get much of what the painting was about. Repetition is a problem, and I don't find it particularly successful in the form of sculptural objects. There are certain strong qualities in the pictorial convention—the way in which perimeter, area, and shape function—that allow a serial pattern to derive benefits from them. Repeated units on a unified painted ground function a lot differently than on separate units standing on the floor or nailed to the wall. Of course the sculptors will say that it's just a failure in the development of our ability to see—that we're not seeing their work right" [Rubin 70].

Judd's initial works in the reductive style were less stark than either Morris's or Smith's, in terms of contour, texture, and especially color, not surprisingly, considering his vocational roots. Judd made cadmium

red light a trademark of sorts, a far cry from the gray and black of *Column* and *Die*, or the baked white enamel that Sol LeWitt would later make his own. Like La Monte Young among the composers, Judd of all the sculptors of the 1960s has remained truest to his original inspiration, as he continues producing variations on his wall reliefs and floor boxes thirty years after he began them. Although it is questionable how much his later work, however impressive, has added to his achievement, Judd was an inspired original who confronted the limited choices left him in an age when traditional painting in the European tradition was, he felt, "dead" and compositional sculpture illegitimized.

In Judd's case the transitional work was the 1961 *Relief*, a black monochrome four by three feet mounted on four-inch-thick wood, with an aluminum baking pan inserted in its center. Just as Smith's *Die* may be read as a three-dimensional version of Reinhardt, so the Stella influence on Judd's work is clear: in the color, the emulation by the inserted pan of Stella's notched and hollowed paintings, the echo of the framing edge in the edges of the pan, and the intermediary state between two- and three-dimensional art inhabited by the piece as a whole. Judd constructed this work alone but later received the bulk of criticism directed at sculptor-designers who commissioned the fabrication of their designs in industrial workshops. Barbara Rose, who early on identified "object-sculpture" and singled out Judd and Morris for praise [February 1965 34], later noted that for the general public, "the evidence of hard work amounts to an aesthetic prejudice in America" [Rose 1970 43]. The counter-argument advanced—that artists as great as Michelangelo and Rodin directed teams of artists executing their designs—did not hush the criticism.

Relief was a step toward the untitled serial reliefs of identical rectangular forms of iron, steel, and glass which remain most inseparably linked to Judd and most immediately identifiable as his work, just as the titles identify Andre. Judd's horizontally projecting as opposed to box reliefs may have been vaguely suggested by one of the wall reliefs Ronald Bladen exhibited in December 1962, which were described by Judd in the February 1963 *Arts Magazine* as "painted panels held away from the wall. One or two large, simple narrow shapes are held away from each panel" [Judd 75]. Some of these were letter and crescent shapes, while at least one, reproduced on the page cited, was a rectangular solid. In any case, whereas Bladen used a color each for the visible panel and individual projection, Judd's bolder conception was to employ identical projections and affix them directly to the wall. At this point, Bladen's work was not nearly as stark as it would become, and probably none of it qualifies as Minimal art, although it does represent a reductive strategy within the Abstract Expressionist mold. Irving Sandler, in fact, reviewed the Bladen show favorably, not for its simplicity but for the "great deal of complexity . . . created by the contrast of flush and overlapping boards and the shifting shadows they cast, as well as by the difference in impasto and wood-grain texture. The design of the metal bolts . . . adds to the intricacy"

[1962]. From 1961 to 1963 Judd's work documents a struggle toward simplicity from the hybridism of vestigial assemblage in *Relief* and other works and of quasi-sculptural wallpieces composed of wood monochromes sandwiched between narrower horizontals of curved metal.

Despite Morris's objection to Judd's reliefs and their violation of literal sculptural space, Judd also followed Morris, Smith, and the force of gravity down to the floor in many of his box sculptures, originally (and sometimes still at present) notched or grooved, then smooth-surfaced in various metals painted or reflecting the environment in stunning clarity. In their relationship to the surroundings, Judd's mirrored boxes are stunningly holistic conceptions, both drawing the environment into themselves and merging with it—provisionally, insofar as the patterns they reflect change as one moves around the sculpture or the installation. He thus advances upon the achievement of Morris and Smith in multiple perspective and the definition of the exhibition space, although the work arguably skirts the issue of illusionism against which Judd had polemicized. On the one hand, there is no illusion but an unremitting reinforcement and verification of immediate reality in the reflections; on the other, the distortion of space entailed is itself intransigently illusionistic.

What these and other artists shared was a radical though by no means unproblematic objectivity. The industrial mode of creativity and the generation of art via mail or telephone instead of agonistic encounter with raw material demythologized the creative process even more thoroughly than the placement of works on floor or wall instead of pedestal desacralized the art object. In the 1930s Walter Benjamin had written, "that which withers in the age of mechanical reproduction is the aura of the work of art," explaining that "the technique of reproduction detaches the reproduced object from the domain of tradition. By making many reproductions it substitutes a plurality of copies for a unique existence" [221]. What was notable in the serial forms of Judd and others was the status of reproduction as the controlling principle of generating the erstwhile "unique" art work itself, not its copies. Overt replication became the essence of the art work even more than in Kelly's monochrome panels of equal dimensions but distinct colors, the closest precedent being the individually executed but—according to the artist himself—interchangeable blacks of Reinhardt and the identical Rauschenberg white panels.

Another figure who appeared in the early stages of what became known as Minimal sculpture was Dan Flavin, in whose work the industrial quality of the sculpture was even more readily apparent than in Judd's work. Born five years after Judd, he moved like him from relatively simple works in the early 1960s to severely reductive works from 1963 onward. (Morris reached that "unitary" level before either, with *Column* or the eight-foot-square plywood *Slab*, but he too began to concentrate on Minimal as opposed to Duchampian art only in 1963). In the case of Flavin, the material was even more radically reductive and innovative than the plywood, metal, or glass of his colleagues.

Flavin worked with lights, originally placed on cabinets, then simply placed individually or in groups. When individual, his fluorescent rods were still arranged specifically in relation to the exhibition space; the environmental nature of his art was of course determined by his medium. It approached epic Minimalism in his installation for the reopening of the Guggenheim Museum in July 1992, for which the whole of what was now known as the Frank Lloyd Wright Building was entrusted to Flavin. Interestingly, the central column of fluorescent light attracted still more criticism as a totem of the male-dominated collection: "a huge phallic symbol of light penetrating the undulating, feminine forms for which the building is known . . . a monument to this bastion of maleness" [*New York Times* July 19, 1992 II:4 (Letters)]. Perhaps finding it less suggestive than romantic, Flavin was married at its base just before the opening.

If his colleagues had removed sculpture from the pedestal and reduced it to thinghood, Flavin may be credited with dematerializing sculpture from substance into space. A work like *The Diagonal of May 25, 1963* (formerly just *Diagonal*), his first piece composed solely of fluorescent lights, in this case an eight-foot green rod placed at a forty-five degree angle, is at once as unitary a form or specific an object as anything designed by Morris or Judd and simultaneously a virtually immaterial presence. Though coloristic relations are the basis of some of Flavin's work, e.g., corner pieces in which the adjoining walls are bathed in light from rods of contrasting colors, others come close to reducing art to spatial definition. Despite his severity of means, there is an expansive, even Romantic, component in Flavin's work in its literally brilliant dissolution of normal perceptual space.

Other three-dimensional artists of particular note were Sol LeWitt and Ronald Bladen, whose best work represents, respectively the Minimalist apotheosis of geometry and monumentality, and John McCracken, a less versatile artist but one whose reduction of the third dimension was an ingenious inversion of possibilities raised by Stella's projecting stretchers.

After his transitional reliefs of the early sixties, Bladen produced at least three classic works of the period in *Three Elements* (1965), *Black Triangle* (1966) and *The X* (1967). *Three Elements*, originally untitled, was a serial replication of roughly nine by four by two feet trapezoidal solids inclined in a row at the same thirty-degree angle. Conveying a sense of massiveness and dynamic movement reined in by the replication, it was shown at Primary Structures. *Black Triangle*, a huge inverted triangular solid resting on its slightly truncated apex, was the only exhibit at Bladen's show at Fischbach in early 1967, seizing the room at roughly ten feet in height and width and thirteen feet across the top. *The X* was a black figure in that letter shape at 22'×26'×14', spanning two floors of the Corcoran Gallery. In the massiveness of these works and the confrontational attitude of the latter two, Bladen clears the way for the post-Minimal sublimity of Richard Serra.

McCracken was most recognized for monochrome planks of varying length so thin as to resemble unhung monochrome panels by Kelly. Despite their unvarying surfaces, McCracken himself, however, described his works paradoxically as "in a sense, kinetic, changing more radically than one might expect"—a description based on their environmental nature. "At times certain sculptures seem to almost disappear and become illusions, so rather than describing these things as objects, it might be better to describe them as complexes of energies" [quoted Lippard October 1966 34]. As Michael Benedikt observed in reviewing the 1966 Whitney Annual, McCracken's planks tamper with the wall as several Bladen works tamper with the plane of the floor [January 1967 56].

LeWitt, a graphic designer who worked for I. M. Pei in the mid-fifties and whose work in turn was dubbed "sculptecture" by Anne Hoene in 1965, is a master of reductive classicism in a varied and sometimes controversial body of work that continues to change. His major achievement in the 1960s was the assorted cubical structures whose skeletal nature was reinforced by their whiteness. His trademark cubes three-dimensionalize the square grid that had been adapted in painting most effectively by Reinhardt (whose five-feet-square format was echoed by LeWitt's five-feet-cubed pieces), Kelly, and Martin, and as such are also related to some of Andre's tile pieces. But whereas Andre aims to demythologize sculptural space by literally abasing it, LeWitt does so by hollowing it, retaining three-dimensional solidity only vestigially.

If LeWitt's cubes recall the grid structures of International Style architecture as well as the earlier painting, he also echoed industrial production in the hollow box-forms he created, multicompartmental and thus less unitary than those of Judd or Morris. In discussing the work of LeWitt and others, Mel Bochner was to echo Tony Smith's "inscrutability and mysteriousness of the thing" in less romantic terms: "their boredom may be the product of being forced to view things not as sacred but as they probably are—autonomous and indifferent" [Summer 1967 43]. There are unsettling elements in LeWitt's vestigial structures—in the permuted "variations" (e.g., *All Variations of Incomplete Open Cubes*) a sense of the most rigorous geometry disassembling, and even in the holistic pieces a sense of dematerialization akin to the experience of both X-rays and architectural plans showing us the fragile framework of lines, always there and thankfully invisible, which underlies the facade of daily existence.

V

Robert Morris, Donald Judd, and Dan Flavin appeared with others
in the first group exhibition of what would two years later be dubbed
Minimal sculpture in New Works II at the Green Gallery. The show
opened January 29, 1963—an appropriate date since it marked the fifty-
eighth birthday of Barnett Newman and the fifteenth anniversary of his
breakthrough with *Onement I* and the real inception of the reductive
movement in American art that encompassed Newman's and Stella's
rejectivist revisions of Abstract Expressionism, Reinhardt's and Kelly's of
Geometrical Abstraction, and Rauschenberg's of Dada. Just as those
painters had offered monochrome fields and patterns in place of the
skeins of action painting, the rhythmic composition of de Stijl and its
American disciples, and the texturally and often textually busy statements
of anti-art, the new sculptors would dismiss assemblage, mobiles, and
absurdist montage.

 Judd presented some large wood and aluminum constructions, some
partially painted his trademark cadmium red light, Flavin cabinets with
lights, Morris *Column* and *Card File*. The exhibition received a noncommit-
tally descriptive review from Jill Johnston, who wrote on art for *Art
News* before becoming the dance critic of the *Village Voice*, and a predictably
negative review by Sidney Tillim in *Arts Magazine*. Johnston noted Judd's
two "relentlessly expansive and symmetrical" wall-reliefs, Flavin's two
illuminated cabinets, and the "monolithic purity" of Morris's *Column* and
pure ordinariness of his *Card File* [March 1963 50]. Tillim focused his bile
on "Donald Judd's picture-thing" (*Relief*) and a distinctly un-Minimal "I-
don't-know-what-to-call-it by George Segal" (*Bed*). While merely men-
tioning the "bare rectangular wooden column by Bob Morris," he
suggested of his colleague at *Arts Magazine*, "Perhaps Judd is too theory-
bound—a tendency that invites violation" [March 1963 61–62]. In *Art*

International Fried singled out Judd's constructions, which "make one want to see more of his work" and found Flavin's cabinets "well-made but, within their idiom, perhaps sentimental" [February 1963 64].

Four days before the exhibit closed on February 16, the first solo show opened at the André Emmerich Gallery, featuring the work of Anne Truitt, an artist now rather obscure but identified by Clement Greenberg as a precursor of "the Minimalists." According to Greenberg, who in his 1967 catalogue essay for American Sculpture of the Sixties at the Los Angeles County Museum of Art dismissed "Minimal Art" as "too much a feat of ideation, and not enough anything else," "The surprise of her boxlike pieces . . . was much like that which Minimal Art aims at . . . [d]espite their. . . rectilinear zones of color" [Battcock 1968 183, 185]. He restated these comments in a *Vogue* piece on Truitt in May 1968: "If any one artist started or anticipated Minimal Art, it was she, in the fence-like and then box-like objects of wood or aluminum she began making, the former in 1961 and the latter in 1962. . . . Had they been monochrome, the 'objects' in Truitt's 1963 show would have qualified as the first examples of orthodox Minimal Art" [284]. Nonetheless, those multi-colored surfaces (as well as often divisible forms) were a salient feature of her work (which led Judd to parody Greenberg's equivocation with "if the queen had balls, she would be king" [Judd 197]).

Judd's choice of metaphors in his characteristically aggressive riposte is less sexist perhaps than defensive, since his own first show had quickly been compared to Truitt by Rose [1964 41]. As critic, his own review of Truitt's show in the April *Arts Magazine* had been dismissive: "The work looks serious wihout being so. The partitioning of the colors on the boxes is merely that, and the arrangement of the boxes is as thoughtless as the tombstones which they resemble" [Judd 85]. Judd noted the debt of Truitt's dark hues to Reinhardt, as did Michael Fried, reviewing her "fine, intelligent work" in *Art International* and finding it deficient, predictably, on dogmatic formalist grounds: "The junctures between the different colored areas often do not coincide with the steps and junctures of the piece itself, and I admit to having found this a bit confusing, as if there were two rationales to look out for instead of just one" [56]. Jill Johnston gave more space to Truitt's show, most of it descriptive of her "impressive" boxes, than to all of New Works II later in the same issue of *Art News*, concluding, "A sense of radiance informs this work" [March 1963 16].

By the time Truitt's show closed, Robert Morris had appeared in a four-man exhibition billed as Boxing Match at Gordon's, contributing *Wheels, Box with the Sound of Its Own Making, Portal,* and other pieces. This time Judd's complaint was "there isn't, after all, much to look at" [Judd 90], a grievance he echoed a year later reviewing the Black, White and Gray exhibition opening at the Wadsworth Atheneum in Hartford in January 1964. He had "nearly the same interest and disinterest in Tony Smith's . . . boxes . . . as . . . in Morris's three pieces." His review in the March *Arts*

Magazine is of historical interest for Judd's application of the adjective Wollheim and Rose would popularize to his annoyance the next year: "Morris' work implies that everything exists in the same way through existing in the most minimal way, but by clearly being art, purposefully built, useless and unidentifiable. It sets a lowest common denominator; it is art, which is supposed to exist most clearly and importantly, but it barely exists" [118].

Morris and Judd had their first solo shows at the Green Gallery in October and December 1963, respectively. Morris exhibited his Duchampian boxes, *Three Rulers* (yardsticks of different lengths), etc. along with the Minimal *Slab*. Tillim found the exhibition "silly, but that is not the point." The point was the art's propositional nature, which was "stimulating and intriguing, but never deeply engaging" [December 1963 61–62]. Jill Johnston supported Morris with a lengthy description of his "plastic realizations of some primary facts of existence," concentrating on the conceptual and Dada-influenced items [October 1963 14].

Fried called Judd's exhibition of floor and wall pieces "an assured, intelligent show . . . one of the best on view in New York this month" [February 1964], while Rose in the same issue of *Art International* called his work "as far in advance of older notions about sculpture as the new abstraction is in advance of Abstract Expressionism. . . . Judd's sculpture lacks any kind of ingratiating appeal. True, it is simple, but it is also ambitious, original, and substantial" [41]. Tillim was no more enthused than earlier, though more respectful in noting "completely monolithic passivity" despite the obvious attempt at differentiation by "cutting, grooving and notching" [February 1964 20–21]. Lucy Lippard found Judd's "boxlike forms in a white room . . . an odd combination of the clinical and the dramatic" and wondered if the environmental whole exceeded the strength of its constituent parts [February 1964 19]. Hilton Kramer noted the roots of the work in recent painting: "an austerity comparable to, and undoubtedly derived from, the kind of painting in which a single element—a line, say, or a spot—interrupts an even, flat surface . . . a synthesis of Newman's imagery and Louise Nevelson's technology . . . a shift away from the analytic and metaphorical style to the more literal mode of utterance making itself felt at the present time" [June 1964 112]. In the *Times* Brian O'Doherty began a capsule review with "Not this time, Green Gallery, not this time" and ended by observing that Judd's "nonart . . . obligingly expires before one's eyes in a form of suicide some may find of interest" [December 21, 1963].

Within a year of the New Works II exhibition, the new sculpture had gained credibility if little enthusiasm in the art press. Nineteen sixty-four began with exhibitions by Robert Mangold at Thibaut and Frank Stella at Castelli, both opening on January 4, and the Black, White and Gray exhibition in Hartford on the 9th, of considerable historical interest in terms of its comprehensive perspective, as it included Newman, Reinhardt, and Stella paintings, along with Smith, Truitt, and Morris sculptures and

a Flavin fluorescent piece. Flavin had his first one-man show in March at Kaymar (which Judd called "one of the most interesting I've seen this year" [Judd 124]) and another at Green in November ("a giant Purist step"—Jill Johnston [January 1965 13]). Robert Morris's next show at the Green Gallery, now featuring the plywood constructions rather than the Fluxus-aligned works, received high praise from Ted Berrigan ("Their beauty is enough to make these pieces disturbing; their silence is both empty and provocative" [February 1965] and from Rose for their posing of fundamental questions about art [February 1965 35–36].

In 1965 the movement proliferated with the first shows of Carl Andre, Sol LeWitt, and John McCracken. Andre debuted at Tibor de Nagy and was dismissed by Jacob Grossberg in *Arts Magazine*: "One can be over-powered by boredom, and the major piece in this show is overpowering. . . . It is all there and so what? . . . very impersonal and of little conse-quence." Lucy Lippard noticed that "in this day of conceptual extremism," Andre's styrofoam logs offered "one of the most extreme events" [September 1965 58]. She found the lacquered monochromes of Sol LeWitt at John Daniels redeemed from characterlessness by the depth of their multiple coats and the visibility of grain, giving them "a personal touch within an impersonal idiom that is valuable when not overplayed" [58], while Jill Johnston found a closer relationship to Morris in LeWitt's "Purist stance , , , with simplistic geometrical sculpture" [May 1965]. On the other coast John McCracken debuted at Nicholas Wilder in Los Angeles, provoking mention of his name (and nothing more) in *Art in America* and a thoughtful appreciation in *Art News* by John Coplans, who found him "not only imposing but exceptionally intelligent . . . one of the most exciting sculptural exhibitions of recent months" [December 1965 61–62]. Coplans again stressed the continuity between the sculpture and the earlier painting, calling McCracken's work "obviously part of a step-by-step development from a painterly two-dimensional to a sculptural three-dimensional concept" [62].

In 1964 Pop, in 1965 Op, in 1966 Minimal art dominated the art news, a harbinger of the transformation of the art exhibition into its current status as a combination fashion show/initial public offering. The rapid shifts of taste were symptomatic of the acceleration of American cultural life in general under the pressure of social and technological change. The Museum of Modern Art's The Responsive Eye had been the keynote exhibition of the year of Op; Primary Structures was the star of 1966.

But before it opened at the Jewish Museum, Judd had keynoted the year of reductive art at Castelli on February 5 with work even more stripped down, regularized, and featureless than he had shown at Green. Apart from Lippard's praise for "guts and assurance," the show got largely negative reviews, with Dore Ashton finding it "depressing" [April 1966 165], Hilton Kramer feeling a "sense of loss" at its depersonalization

[February 19], and Mel Bochner finding the sculpture a three-dimensional form of art criticism and as such finally "parochial" [April 1966]. Most of the reviews devoted to subsequent shows by Baer at Fischbach, Flavin at Kornblee, Morris at Dwan (Los Angeles), Andre at Tibor de Nagy, and LeWitt at Dwan (New York) were superficial, with the exception of Lippard's "Rejective Art" piece.

With the increasing, if largely casual and/or negative, attention devoted to that art over the past three years, Primary Structures was touted as the exhibition of the year even before it opened on April 27. It was "being hailed as This Year's Landmark Show," as Grace Glueck observed in the *Times* with droll upper case [April 24, 1966]. Two other group shows of note reinforced the Minimal trend. In May, Art in Process opened at Finch College, and Lawrence Alloway's Systemic Painting at the Guggenheim on September 21. As the titles indicate, Primary Structures focused on sculpture, Alloway's exhibit on painting, but the dichotomy is, again, misleading. As Kynaston McShine, curator of Primary Structures, said to Glueck by way of preview, "The line is becoming increasingly hard to draw" between the two.

Minimal sculpture, a phenomenon of the 1960s, derived from the evolution of painting in the 1950s from Newman and Reinhardt to Stella, its aesthetic owing more to Stella than to any sculptural precursor. Max Kozloff stated that without Stella and Noland "the sculptors very likely could not have conceived of their work at all" [February 1965 26]. As mentioned earlier, from the black paintings onward, Stella's work itself had flirted with blatant three-dimensionality, from the use of wide stretchers in the blacks, to the cut-outs in the aluminums to the geometrical constructions of the alkyds. Stella's concern with problem-solving and theory was echoed in the three-dimensional arts. McShine described his sculptors as "hip, sophisticated, articulate. Most are university bred. They've read philosophy, have a keen sense of history, and know what they're supposed to be reacting to. Their art doesn't answer questions, it asks them. Mostly, it questions how to go about making sculpture." McShine thus advanced as a virtue of the new work the reflexive quality Bochner had found parochial and others denatured. The "supposed to" in his quote is in retrospect chillingly prophetic of the subsumption of art by trendiness posing as *Zeitgeist*.

This incestuous perspective led to much criticism of the work as self-conscious, cerebral, and detached from reality, rather than praise for it on the same grounds as the culmination of twentieth-century abstraction. In *Arts Magazine* Rolf-Gunter Dienst described the show's "accumulations of monuments . . . exclusion of tactile surfaces as well as of spatial complexity . . . unequivocality, clarity and extreme reduction . . . overly intellectual, partial solutions" and "clinically pure technology." Finding it "contrived arithmetically," he claimed, "Such programmatic super-cooling and conceptual limitation kill invention in art. The designers of industrial products work in the same spirit as many creators of these Primary

Structures. The same beauty adheres to their products except that industrial products have one advantage—they are practical."

Times critic Kramer was notably out of sympathy, enough so to publish several columns on the subject, including two reviews of Primary Structures, on April 28 and May 1. What was more significant than the negativity of his response was the space devoted to it. Apart from O'Doherty's scattered brief notices, the sculpture had been ignored by the paper for three years. In his first piece Kramer noted the debt to Malevich, Mondrian, and Vantongerloo but continued: "Compared to most of the sculptures and constructions that comprise this exhibition, even the severest painting of Mondrian has an almost 19th-century feeling. For here are 42 American and British artists, young and relatively unknown, who care nothing for the personal touch, the subjective inflection, the private vocabulary, the whole panoply of individual expressive devices that have yielded modern painting and sculpture some of their most glorious achievements." His antipathetic aesthetic is clear in his lament for their rejection of "the romance of the artistic process . . . in favor of a geometrical-cum-architectural regularity that gives expressive priority to clarity of conception over the niceties of craft." Concluding an almost entirely negative reaction to the art itself (he does find "gaiety and high spirits" in "the freewheeling use of color"), Kramer acknowledges that "Mr. McShine has performed a service in organizing this first comprehensive glimpse of a style that promises or perhaps one should say threatens to become our period style" and correctly if woefully prophesies that "We are going to see a good many more of these 'Primary Structures' before the nineteen-sixties have come to an end. . . . For the artists . . . are, whatever the esthetic quality of the results, addressing themselves to some fundamental esthetic questions."

In his second piece, for the Sunday edition, he added to Vantongerloo the much more questionable sculptural influences of Gabo, Max Bill, Calder, David Smith, and Nevelson, and to Malevich and Mondrian added "hard-edge and color-field painting . . . of Kenneth Noland, Morris Louis, and others." Paraphrasing Pater, he called the work "a species of abstract painting aspiring to the condition of architecture." He again described the "detachment and impersonality" of artists "suppressing their individual profiles in the interests of the general esthetic standard they share," which "left me feeling . . . that I had not so much encountered works of art as taken a course in them. One is enlightened, but rarely moved."

Kramer saved his best shot for five Sundays later, after Art in Process had opened at Finch College. Entitling his article "An Art of Boredom?", he took critics Barbara Rose and Susan Sontag to task for glorifying the essentially anti-aesthetic emotion/state of boredom, remarking drily, "Now it is true that much of this art is boring, and one is at first relieved to hear that one's own boredom in confronting it is, after all, the correct response. But then one wonders" [June 5, 1966]. Kramer more broadly attacked the a priori critical apparatus that authenticated and in a sense

created this art, prophesying further "critical and theoretical disquisitions without which minimal art, even more than its predecessors, would scarcely be given the kind of attention it now enjoys. . . . its surpassing visual simplicity and utter lack of expressive or symbolic elaboration gives to its theoretical rationale an importance never before equalled in even the most theory-oriented styles of the past." He mocks "the 'law'" that "the more minimal the art, the more maximum [*sic*] the explanation," concluding, "like nature, art abhors a vacuum, and in that vast imaginative vacuum created by the new minimal art the critics and theorists are in the process of building a new intellectual empire."

Kramer repeats this critique, later popularized by Tom Wolfe, in his preview of Systemic Painting, which he finds "produced as commentaries on, and realizations of, critical ideas" [September 18, 1966, II, 33]. He again censures the "extreme cerebral detachment" of the work, noting, "the very use of a 'system' suggests a flight from sensibility, a conscious evasion of 'other experience.'. . . 'Systemic Painting' might, in essence, be incapable of establishing any meaningful connections with experience at large."

A week before Primary Structures opened, Newman's *Stations of the Cross* series was shown at the Guggenheim. After being included in the "10" show at Dwan along with Andre, Baer, Flavin, Judd, LeWitt, Martin, Morris, Smithson, and Steiner, Ad Reinhardt, appropriately, closed out the year with a solo show, also at the Jewish Museum, that ran from November 25 until mid-January. Along with the praise quoted earlier, his work provoked Michael Benedikt to aver "It is as a spiritual worker, if that doesn't sound too creepy, and as one of the first of a unique *kind* of painter, that we ought to respect Reinhardt" [February 1967 64]. What is unsettling in the statement is that after the pseudo-mystical and other verbiage had been cleared away in accordance with Reinhardt's own directives or "Rules," the word "spiritual" had come to require apology as potentially "creepy."

By spring 1968 John Perreault was lamenting the "disheartening, second-string, second-generation avalanche of 'minimalists' (aren't all second generations disappointing?)" [May 16, 1968 14]. One might agree with the assessment but differ on the ordinal number. By this point all sorts of other enterprises were becoming identified in some way at some time or other as Minimal art: mountainside excavations, hurled lead, process art, rooms filled with earth, the *arte povera* of scattered felt, various conceptual enterprises and environmental constructions, etc. The term, which had been revived in etiolated form fifteen years too late, was in turn applied too broadly and too long.

End

Richard Serra, *Stacks*, rolled steel, 1990. Each piece
93"×96"×10". Shown in Sculpture Hall, Yale
University. Photograph courtesy Michael Marsland,
Yale University, Office of Public Affairs.

W

In Alvin Lucier's Minimal process-piece *I am sitting in a room,* the featured performer is not the "I" but the "room." After speaking/stammering his brief statement, Lucier himself performs no more. He remains only in the form of his taped voice, replayed and re-recorded until it loses its distinctive individuality, then fades from recognition as a human voice, and finally disappears, swallowed up by the room, surviving in a ghostly existence within its resonant frequencies. I am eaten by a room.

Eight years before Lucier's composition, confronting the encaustic target and truncated models of human heads of Jasper Johns's *Target with Four Faces,* Leo Steinberg saw "the end of illusion" and "the death of painting" [March 1962 37]. In Johns's sealed-off parody of representation he found "solitude more intense than anything I had seen in pictures of mere desolation . . . an uncanny inversion of values. With mindless inhumanity or indifference, the organic and the inorganic had been leveled. A dismembered face, multiplied, blinded, repeats four times above the impersonal stare of a bull's-eye." The work, he felt, "implied a totally nonhuman point of view . . . as if the subjective consciousness . . . had ceased to exist"[38]. What Steinberg found most dispiriting was that "all of Jasper Johns's pictures conveyed a sense of desolate waiting . . . human absence from a man-made environment" [38].

In the more rigorously Minimal targets Kenneth Noland had painted by the time of Steinberg's article, the faces were gone, along with the blatant evidence of facture. In historical context, Noland and others fulfilled the implications of Johns's early painting by eliminating even the vestiges of the human represented by the truncated heads that managed to elicit a sense of grim elegy or in Steinberg's experience simply "depression." Minimal art achieved this by leaving only the geometry to contemplate.

Lawrence Alloway interpreted Noland's work similarly in relationship to color-field painting, specifically Newman's and Rothko's: "Both these artists were preoccupied with the problem of content and expended great effort to make their expanses of color symbolic. Noland is of the generation that picked up their formal structure but not their concern with, in Newman's case, the sublime, and, in Rothko's case, the tragic. What remained was the objectness of the painting, purged of humanistic reminiscence" [1975 258].

Frank Stella had developed Johns's ambiguously representational object-art in rigorously systemic and nonrepresentational canvases and in consequence had frequently been charged with nihilism and anti-art. Abstraction had been enhanced by the expulsion of representation— either in the traditional mimetic sense or in the confessional mode of earlier agonistic abstraction. Stella observed coolly, "I always get into arguments wtih people who want to retain the old values in painting— the humanistic values that they always find on the canvas. If you pin them down, they always end up asserting that there is something there besides the paint on the canvas" [Battcock *Minimal* 157–58].

What is most remarkable about his statement is its apparent puzzlement over why anyone would still look for more than paint in a painting, would still *expect* to find human values embodied. Within a decade Reinhardt's art-as-art aesthetic had come to be taken as axiomatic by his successors.

The reductive and impersonal American art of the third quarter of the century arose not only as a reaction to Abstract Expressionism and its analogues in other media but as a reflection of post-World War II American society. It is not coincidental that artists working in stripped-down, regularized, often serial forms were living in an environment in which architectural analogues of those forms were proliferating at an unprecedented rate. The American landscape had been transformed by construction booms both in urban commercial and residential towers in the International Style and suburban houses in the pre-fabricated box patterns of the post-War Levittowns. Techniques of mass production initiated on a large scale during the First World War had been exponentially expanded during the next war effort a quarter-century later. The increasing predominance of assembly-line jobs and products and computerized transactions in every area of life contributed to the oft-lamented sense of alienated conformity, de-individualized identity documented as early as David Riesman's *The Lonely Crowd* (1950) and William Whyte's *The Organization Man* (1956).

Without the luxury of our historical perspective, Barbara Rose suggested in 1965 that Pop art was a "reflection" of "the screeching, blaring, spangled carnival of American life," and "ABC" art the "antidote" [69]. With that luxury, one might wonder now whether Minimal art was, in addition to a contemplative antidote to the chaos, a reflection of less obvious but equally pervasive features of the society. On this point,

Anna Chave goes so far as to deny the avant-garde credentials of Minimal art—despite the abuse heaped on it by the mainstream press—on the grounds that it reinforced by reproduction the systems of power of the society rather than critiquing them from an alien perspective ("With closer scrutiny . . . the blank face of Minimalism may come into focus as the face of capital, the face of authority, the face of the father" [1990 51]). Her dystopian reading of Minimalism is most convincing when focusing on what I believe she correctly describes as the often bullying art of Richard Serra. It was also anticipated by John Coplans in the 1960s in his analysis of serial imagery as evocative of "the underlying control systems central to an advanced, 'free-enterprise,' technological society" [1968 18], on which Nicolas Calas commented: "This is alarming for it implies that Serial imagery serves to reenforce the system of control that managerial order wishes to impose on both our actions and the expression of our ideas and emotions. I, on the contrary, believe that to the precision of control, the artist should oppose the disturbing ambiguities of experience" [Calas 221].

It is not hard to see a relationship between the television screen and Martin's horizontal line drawings, the punched-out computer cards of the day and Poons's lozenge rows, the Levittowns and the LeWitt-towns of the artist's serial forms. More speculatively, however, the predominance of the grid in the art of the period may reflect not only theoretical concerns about all-over pattern and the neutralization of depth but also the rigidly rectilinear street plan of the island where most of the artists worked. The triumph of inorganic clarity in its recent architecture was nowhere echoed more clearly than in the wall reliefs of Donald Judd, who, as Lewis Mumford said of Mies van der Rohe, "used the facilities offered by steel and glass to create elegant monuments of nothingness" [Mumford 77].

One of the most problematic considerations in Minimal music is its relationship to expressive theory. Previously I was inclined to emphasize the expressive and affective elements in Minimalism by contrast to the authorized version of avant-garde music in the 1950s and 1960s. Now I am equally struck by their similarities. The highly intellectual and schematic orientation of Serialism was made for the academy, and university music departments embraced it as a means of reconfirming both their elitism and their scientific aspirations or pretensions. The widespread acceptance of Serialism after World War II in one sense parallels that of Abstract Expressionism. Both reverted from the artistic populism represented by the "American Scene" painters and the American-symphonist school, which were perceived as stylistically reactionary and parochial. Both were of sufficient complexity to validate them as objects of serious analysis.

Serialism had the additional appeals of a scientific and anti-Romantic aura in an age of science-worship after a war felt by many to have been

derived from German Romanticism and scored by Wagner. Serialist theory was, furthermore, eminently teachable, offering the promise of standardized pedagogy much as the textual analysis of the New Criticism in literary study answered the need for readily transmissible criteria of literary evaluation that had arisen from burgeoning college enrollment after World War II. Schoenberg developed the twelve-tone system in response to the chaotic potential of the "emancipation of dissonance"; the later absorption of dodecaphony into Integral Serialism and its academic promulgation represents a further, perhaps deadly, domestication of a revolutionary force. By the 1960s, Serialism in its academic incarnation had unashamedly decayed, along with tape-music for the most part, into research science emblematized in Milton Babbitt's 1958 article entitled (by his editors at *High Fidelity*) "Who Cares If You Listen?" This was in one sense the logical culmination of the postromantic view of the artist as superior outcast; it was now couched, however, not in terms of isolation/martyrdom in the cause of inspired self-expression but of the isolation of a paid employee in the university electronics lab.

While of the major figures only Young produced Serial compositions within the Minimalist style, the legacy of music as technological research had a greater effect on him (along with the others) from the mid-sixties than earlier. The Theatre of Eternal Music had been singing over sine-wave generators and oscillators for years by the time Young and Columbia Records fell out over his singing with the Atlantic—and even today Young spends a good part of his time punching up intervals hitherto unheard on a computer-controlled synthesizer. Riley and Reich, of course, were deeply involved in the technology of tape in the mid-sixties, along with the technophilic phase-shifting pulse gate and time-lag accumulator. Ironically, it is Glass, whose music sounds most futuristic, who has had the least interest in technological manipulation of his music, apart from amplification. However, it is also Glass whose musical pulse is most machine-like and who unrepentantly provided the performance marking "mechanically" in 1967.

In terms of aesthetic, Young and to a lesser extent Riley developed after 1959, despite their university training, less in the tradition of academic Serialism than in the Cageian tradition which finally helped provoke McLuhan's definition of art as anything you can get away with. Their work in the 1960s represents an utter reversion from academic composition. In Cage's Zen-influenced conception, the composer shared with the physician the same ultimate goal: abolishing the profession. The doctor would end disease, the composer the need, perceived as borderline pathological, for sounds other than those already existing around us, which, ideally, would become as entertaining as composed music, if not preferable to it, for the enlightened listener. There is a clear line of descent from Cage's desire to let sounds be themselves rather than vehicles of human expression and Young's aim to "get inside" sounds, the rationale for the sustained intervals and *arabic number* as well as the drone works.

Reich and Glass both turned their back on their earlier academic efforts, Reich his graduate school Serialism, Glass his American-symphonist work of the first half of the 1960s. Their compositions in the second half of the decade, however, are often inspired by theoretical concerns. Glass's *Music in Fifths* is a radically revisionist harmonic étude, just as his other compositions are on one level attempts at solving musical problems or illustrating musical techniques (additive process, cyclic structure, contrary and similar motion)—as if, having undergone one musical re-education under Boulanger, he felt impelled to yet another, entailing his rewriting the theory and harmony texts in his own image before moving on to more ambitious works of the next decade.

Reich's systematizing of Riley's anything-goes tape techniques and his development of phasing similarly represent the more clinical approach to music-making that was part of the training he otherwise rejected, and the young composer in vest and tie turning knobs at the Whitney in 1969 would not have looked much out of place at Columbia-Princeton. His *Pendulum Music* is basically a musical demonstration of entropy and as such represents a Minimalist (and penurious) alternative to well-stocked, well-funded university music labs. In the case of Reich as of Glass, it was not until the next decade began that he was able to integrate his "scientific" discoveries with his love for popular and ethnic music in works imbued with an enormous verve absent in—even antithetical to—the rigor of his experiments through *Four Organs* and before Africa. In retrospect, Reich mocks his own "technocratic" coining of phasing, and can afford to because of the musical distance he has travelled since, although as late as 1981 he was foolishly described as "the musical equivalent of a constructor of ingenious mechanical toys" by Michael Oliver in *Gramophone*.

Throughout the 1960s, then, Minimalist music displays an often ambivalent attitude to the music it aimed to overthrow, experimental or academic, as well as to emotional content. Young and Riley did not speak of either expressing or conveying to the audience emotions per se; they shared, rather, an aesthetic of ecstasy, release from self, with Young averring to Kostelanetz, "If people just aren't carried away to heaven, I'm failing" [Kostelanetz 1968 218] and Riley similarly acknowledging failure if his music does not "bring the listener out of himself" [Mertens 91]. Young similarly reduced the emotional element in performance, from the beginning leaving performers of his work little room for expressive effect and in practice reducing them to Johnny/Janey One-Notes. (Even in his 1990 string quartet, *Time Crystals*, he has the virtuosic members of the Kronos Quartet playing single tones—all drawn, incidentally, from the Magic Chord of *The Well-Tuned Piano*.) He justifies this with an aesthetic—perhaps ethic is a better word—of performance closely akin to Reich's and quite antithetical to the jazz-imbued spontaneity of Riley.

Both Young and Reich ask their musical collaborators to find fulfillment not in subjective engrossment but in almost devotional submission to the process at hand and/or to working within the parameters of rules

agreed upon in advance (which resultant patterns will be added in Reich's works, which pitches may be combined in Young's). Young's relentless perfectionism in good part determined his economy of means: what is of primary importance is the perfection of the intervals as expressions of transcendental harmony, and that is best achieved by severe limitation of their number. Reich ended his 1968 essay "Music as a Gradual Process," in which the last word of the title occurs with tape-looped frequency, by noting, "While performing and listening to gradual musical processes one can participate in a particular liberating and impersonal kind of ritual. Focusing in on the musical process makes possible that shift of attention away from *he* and *she* and *you* and *me* outwards towards *it*" [Reich 11].

On later occasions he confirmed this more polemically; for example, in an interview with Michael Nyman in London the next June, when queried about "the mechanical aspect of your (or Terry Riley's) writing," he replied that this was not necessarily a "sickly trip" (elsewhere in the piece Reich mentions his "demisemiquaver" ritards and days as a "post-man," so this is either a British translation of "sick trip" or Reich spoke the language). Rather "it turns out to be psychologically very useful, and even pleasurable. So the attention that kind of mechanical playing asks for is something we could all do with more of, and the 'human expressive activity' which is assumed to be innately human is what we could do with less of right now" [Nyman 1971 230]. As Young had in his interview with Kostelanetz, so Reich in his interview with Donal Henahan justified his procedure in yogic terms: "Certain people look at music that is totally controlled, written out, as a metaphor for right-wing politics. But I'd suggest that the kind of control I try to exercise on myself and other musicians who play this music is more analogous to yoga. Those are two different conceptions of control—the one imposed from without, the other maintained from within" [October 24, 1971 II, 26].

Nyman's exclusion of Glass from his question may seem as surprising as the inclusion of "we blew our heads off" Riley. Glass had already written "mechanically" atop the score of *Strung Out* three years earlier, but he remained unknown in England until the March 1971 tour. Glass's ensemble work undoubtedly represents an antithetical approach to Riley's *In C*. What gives Riley's piece its vitality is precisely the unpredictability of the work, based on the subjectivity of the duration and inflection of individual modules. The exuberance of the ensemble is based on a sense of communality of individuals as opposed to collectivity in the Glass pieces, in which the modules are often played in unison by the whole ensemble as many times as the composer indicates (on the score or by a nod). The effect may be Bachian, as Tom Johnson found, or regimental, provoking the Fascistic charges leveled at Minimalism by unfriendly critics and composers. Elliott Carter once pointed out the use of repetition as a means of brainwashing in both advertising and Hitler's speeches.

Nonetheless, that relentless repetition, when combined with Glass's

proclivity to the minor, often does have an ominous aura with Orwellian overtones—try watching Fritz Lang's silent *Metropolis* with Glass on in the background. More ominous, perhaps, is Young's unblushing desire to control the listener's emotions by controlling his neurological system, a matter on which he has spoken frequently and unreluctantly, e.g., with John Perreault: "There is evidence, he claims, that specific frequencies always travel through specific pathways of the auditory system, and are thus capable of inducing specific psychological states. By exposure to extreme forms of sound durations it is possible to become conscious of the relationship between specific frequencies and the psychological and emotional states they create" [February 22, 1968 29]. While this may be for the listener's own good—I am convinced it is in almost all of Young's work—suspicion of such an overtly Pavlovian psycho-musical strategy is warranted. Tom Johnson went further (*à la* Cage's sit-in at Oldenburg's *Moviehouse*), objecting to the undeniably ritualistic element of Young's obliging his audience to remove their shoes before entering the perform-ance space as an imposition of "religion" [April 28, 1974 II, 13]. But this imposition is minor indeed compared to the subsequent bombardment of the cerebral cortex with drones.

The crucial problem is that "ecstasy" or ascension "to heaven" demands a release of the auditor's control—ecstasy means etymologically a "standing out" from one's normal self Insofar as one is an auditor, it implies, therefore, submission to an external force which is imposing control purportedly in the service of non-control. The agent of "hypnotic" ecstasy or "trance" music ultimately exercises far greater command than, say, the Baroque composer directing all the elements of his compositions to evoke specific *Affekten*. In this sense the program note of Glass and Wilson advising the audience at their marathon *Einstein* that they could leave and return at will was not only humane but politically correct.

Mertens seems most impressed, and as a composer himself most influenced, by Glass of the composers he analyzes but nonetheless seems ambiguous about his aesthetic. In the final section of his book he offers a brief Freudian and Marcusean analysis of repetition in music, first finding it allied to Thanatos against Eros as a form of repetition-compulsion, then finding its presumably entrancing potential not a form of liberation from our brainwashed diurnal consciousness but a means of reaffirming the authoritarianism of the society. I simply do not *hear* the voice of authority in the toe-tapping *In C* or irresistibly buoyant *Music for 18 Musicians*, but I do in some of Glass. Wilfrid Mellers goes further in stating, vis-à-vis Glass's *Akhnaten*, "although one is not against commercial success and popular appeal, one prefers it to be on behalf of life—as it is with Reich—rather than on behalf of death." He finds Glass's music, rather, an emblem of the societal death-wish, "this most fundamental negation" reflected in the replacement of "cheerfully animistic Beatles, Byrds and Animals" [Animals cheerful?] by "the Enemy, the Clash, the Sex Pistols, and even (ultimate irony) the Police" [Mellers 1987 xxi;

original version 1984 328]. He concludes by observing that "humanity today surely needs more, not less, thought—and art and craft and care—if it is to survive or even deserve to survive, the criminal imbecilities of our world. One cannot discount a force as potent as Glass' music; one may, however, find its implications alarming" [xxii].

This is an obviously heartfelt but overly harsh indictment, directed at the composer probably not only for the repetitive style he shares with others but for his instrumentation (the "rock organs" that grated so in *Four Organs* at the end of Reich's pure-Minimalist period continue to provide the foundation of Glass's ensemble), his amplification (more intense in concert than on disc, where one can in any case lower the volume if so inclined) and his predilection for the minor. Admittedly, Glass's music can often have a deadening effect; at its best, however, it has a stark profundity, when Glass, in my opinion, does not "celebrate death" but simply works in an elegiac vein—precisely the case in the opera Mellers discusses, which opens with the funeral of one Pharoah and ends with the murder of his visionary successor.

In fact, while Glass is recognized as the most successful "serious" theater composer of his generation, he may come to be recognized in the future as its most successful elegist. Later examples that come to mind are the scores of *The Thin Blue Line* (treating the murder of a policeman and imprisonment of an innocent man released only after the film itself was released) and *Koyaanisqatsi* (in Hopi "a way of life that calls for another way of living"—Godfrey Reggio's vision of ever-encroaching technological Armageddon).

Quite unlike Mellers, Mertens finds a transcendentalism in Glass's music that escapes me. In *Music with Changing Parts* a "sudden modulation causes a psychological dis-orientation of the listener and contributes also to the feeling of infinity Glass's music radiates" [77]. Near the beginning of the century T.E. Hulme lambasted Romanticism for "dragging in infinite;" near the end of the century, the habit is dying hard. If disorientation equaled infinity, every wino would see God. Elsewhere, with equal facility, Mertens equates ecstasy with unconsciousness and death [124]. There are fundamental differences between these things, including different techniques and effects of repetition, just as there are different types of trances, trips, etc.

In Minimalism that device, often in alliance with insistent tonal or modal harmonic structures, became central as a means of creating a sonic continuum, very much in reversion from the two prevailing forms of fragmentation: the multiplicity of Cageian experimentalism with its nonjudgmental embrace of the evanescent and fortuitous, and the systematic dismembering of both horizontal and vertical directionality in Serial pointillism. As discussed above, even Morton Feldman's music, despite its low volume and sparse textures, is more allied to Cage's aesthetic of the isolated musical incident than to the holistic pattern of Minimalism.

As opposed to prevailing forms of atomism, Minimalist composers working often with equally or more miniscule building-blocks transformed unitary modules into a continuum by various means: interlocking super-imposition of distinct units (*In C*), exfoliation of a unit by extraction of identical units (*Music for The Gift*, Reich's phase pieces), unvaried repetition of successive units linked by additive/subtractive process (Glass), compo-nential deconstruction of a single unit (*Four Organs*), or simply unvaried repetition of a unit throughout the composition. Of the five, the most radical form of repetition is the last, present only in Young's *arabic numeral* (any sonic unit repeated) and, less radically, *Death Chant* (a melodic line repeated). The title of the latter work is of interest in relation to the technique it illustrates, particularly in comparison to the other chanting Young explored more fully in the drone works. Even in those works, there is a repetition of pitches but rarely with a sense of relentless replication, since the repeated material consists of overtones to a drone which absorbs them into its abiding presence; thus the principal effect is of seamless extension rather than modular replication. The closest Young comes to imbuing those overtones with sufficient definition to bring repetition to the fore is in the successive chanting of three pitches in *Map of 49's Dream*. The sequential combination of the three tones creates an independent *pattern* against the drone, thus differentiating itself more clearly and, I believe, less effectively in light of the "eternal" music it represents.

Most of Glass's early work, with its A A A A A . . . /A+B A+B A+B A+B A+B . . . form has far more in common with Young's relatively limited forays into regularized repetition than the varied repetitive struc-tures of Riley and Reich. He further shares with earlier Young and Riley dynamic levels so high they dare one to think. Yet in combination with that repetition and volume, his often furious rock-derived tempos—their velocity matched in Minimalism only in Young's sopranino work and Reich's tape pieces—make his work immediately recognizable and place it worlds away from any of Young's drone works. In terms of musical ambiance, in fact, Glass and Young are the most remote. Young evokes a primordial unity reflected in titles of his like "The Lost Ancestral Lake Region" in *The Well-Tuned Piano*, echoed in the title of his disciple Michael Harrison's album for harmonic piano, *From Ancient Worlds*. Glass, who once described his music as "the motor on a space machine" [Swan 1978], often depicts a futuristic world of successive distractions adapted and disposed of as required with robotic regularity. Both composers are equally remote from musical humanism, Young in the prehuman, Glass in the posthuman direction.

In the late sixties Glass was Richard Serra's studio assistant and collaborator in the installation and film mentioned earlier. Serra, like Judd originally a painter, was the most inventive artist working in post-Minimal process art. The transitional status of his work at that time is

evident in both his early lead-castings/splashings and his balance or prop pieces, with the emphasis on process perhaps more evident in the first and on Minimalism in the second. Nonetheless the prop pieces (lead sheets affixed to the wall by even heavier cylinders, or Cor-Ten squares balanced against one another precariously as in the self-descriptive *House of Cards*) have an inherently more kinetic and menacing aura than the static and indifferent quality of earlier Minimal sculpture.

This remained the case even in some of his later and more monumental work, like the various incarnations of *Circuit*, in which the necessarily ambulatory spectator is dwarfed by four steel plates arranged as an X without the central intersection. The main import of much of his work is how easily one could be physically annihilated (not coincidentally, he entitled one project the *Skullcracker Series*, and workmen have been crushed installing his pieces). Other forms of annihilation are more implicit.

Stella pursued Reinhardt's irrefrangible rejection of external reference in art by dismissing "the old values . . . the humanistic values." Serra in turn echoed Stella more aggressively when interviewed by Liza Bear in 1976—"I don't have any assumption of humanistic values that art needs to serve"—before extending humanistic to the border of humane in what followed: "If you are conceiving a piece for a public place, a place and a space that people walk through, one has to consider the traffic flow, but not necessarily worry about the indigenous community, and get caught up in the politics of the site. There are a lot of ways in which one could complicate the problem for oneself. I'm not going to concern myself with what 'they' consider to be adequate, appropriate solutions" [Serra 73; cf. 63].

When he won approval three years later for a project that became *Tilted Arc* in Federal Plaza, he found himself perforce very much concerned with such issues. This was not the first of his *Arc* projects in which he had blocked the view and escape of residents and employees on his sites. This time if backfired: the work, installed in 1981, was dismantled beginning March 15, 1989 after extensive and controversial public hearings. Serra's confession, or proclamation, of unconcern for "the indigenous community" was matched by their reaction to his creative license. A casual poll of lunch-hour workers at Federal Plaza three years later found no sense of loss over the removal of *Tilted Arc:* reactions ranged from scatology to gratitude to the deity to one gentleman's dry "It wasn't very well received." Most felt that what had been removed was an eyesore and an obstacle, an eyesore due less to any inherent ugliness (which some also found) than to its placement. It functioned as a barrier not only to free movement but to field of vision. The art-object had not only successfully opposed anthropomorphism but finally imposed itself at the humans' expense, at least temporarily.

Next to the Yale Art Gallery is what was formerly the Art School Library, occupied since January 1990 by two massive steel slabs entitled

by Serra *Stacks* in deference to the "indigenous community" during his student years in the sixties. The contents of the previous stacks had been moved to the Randolph Library some years after Serra graduated, after which the room housed inadequately and on a purely temporary basis statuary from Angers Cathedral. Unlike the earlier Serra works, the upper-case *Stacks* do not threaten to collapse on the spectator, enclose him in a vise, or even block his exit. They merely face each other and ignore him.

Many admire the assured and unambiguous manner in which Serra's work defines the space. And one could credit much of his work with bringing Minimalism full circle back to the sublime of Newman with images of the awesome and majestic after it had been progressively diminished almost *ad absurdum* to wires on the wall. Yet Serra's massive and featureless monoliths tower over the spectator like tablets of immutable law, suggesting nothing so much as elemental power. On leaving the room one passes through a makeshift no-man's-land where the Baptist and five saints continue their nomadic trans-Atlantic existence, awaiting a permanent home. It is hard not to smile, but uneasily.

Stella had spoken of his works as objects. Barbara Rose had quoted Alain Robbe-Grillet's 1956 essay "Une voie pour le roman futur" in "ABC Art": "Now the world is neither meaningful nor absurd. It simply is. . . . In place of this universe of 'meanings' (psychological, social, functional), one should try to construct a more solid, more immediate world. So that first of all it will be through their presence that objects and gestures will impose themselves, and so that this presence continues thereafter to dominate, beyond any theory of explication that might attempt to enclose them in any sort of a sentential, sociological, Freudian, metaphysical, or any other system of reference" [66]. A year before Rose's essay and eight years after Robbe-Grillet's, Susan Sontag had published "Against Interpretation," in which she similarly espoused an art freed of encrustations of anthropomorphism and critical allegorizing. "What matters" in Alain Resnais' *Last Year at Marienbad*, she wrote, "is the pure, untranslatable, sensuous immediacy of some of its images, and its rigorous if narrow solutions to certain problems of cinematic form" [19]—concerns already articulated by Stella in his medium. She similarly praised the "liberating anti-symbolic quality" [21] shared by old Hollywood films and *nouvelle vogue* French films and justified her title thus: "By reducing the work of art to its content and then interpreting *that*, one tames the work of art. Interpretation makes art manageable, comfortable" [17].

The heroic antagonist to the tyrant interpretation in her essay, which itself may be read symbolically as an aesthetic allegory, is "Transparence . . . the highest, most liberating value in art—and in criticism—today. Transparence means experiencing the luminousness of the thing in itself, of things being what they are" [22–23]. Two years later Tony Smith spoke of "the inscrutability and mysteriousness of the thing" and Mel Bochner

vindicated the "boredom" attendant upon Minimal art as "the product of being forced to view things not as sacred but as they probably are—autonomous and indifferent."

This univocal approach to art and nature and concomitant acceptance—"embrace" is too intimate—of the irremediable alienation of both from human concerns culminates in Serra's work, in which mankind is finally displaced by matter. With the phenomenological rejection of any vestige of the traditional analogical relationship of man and nature and the formalist rejection of traditional mimetic, expressive, or communicative concepts of art, not only is the book of nature erased but man is further divorced from his *own* creation. Nature, first of all, is viewed—very questionably—not in any organic relationship with humanity but as a conglomerate of alien objects, to interpret which is to violate their independence by colonizing them with meaning.

Secondly, the perceived autonomy and indifference of nature is then ascribed or bequeathed to the productions of erstwhile-human realm of art, which now shuns anthropomorphism in a radical assault on Ruskin's pathetic fallacy. Even within the uniquely human activity of art growing prohibition arises against projecting the humanity of the creator onto the objects of his own creation. Situated in a world of things grown ever more remote, the artist is to replicate it—not its appearance as in representational art, but its mode of being, *être-en-soi*—in additional things of his own design and/or handiwork that preserve equal distance.

This censorship of the imposition of human will decrees initially that, as with Cage and Rauschenberg, one is to let the material of one's medium—sounds, colors, etc.—"be themselves." In a sense Minimalism takes this to the next level in not only granting raw material its independence but in subjecting the artwork to its modality. Young bangs a pot for an hour to "get inside the sound" rather than to organize sounds in traditional musical terms, and Stella insists that paint on the canvas must *remain* "as good as it was in the can," not get worse (or better). The highest aspiration of the visual artwork is to be "a real object," in the form of boxes, walls, or stretches of rope.

Once this is achieved, the art-object simulates an autonomy from the human will, which has in fact created it, as complete as that hypothetically and very debatably attributed to Nature. Thus empowered, it turns not only away from but against humanity in art and music which assert in their volume (spatial and electronic, respectively) the brute primacy of the physical or sonic components of their media, geared to dominate and overwhelm the human will.

The course of Minimal art from the sublime of Newman to the sublime of Serra leads from apocalyptic humanism to the most profound alienation in the history of art. The art that has followed this object-worship or reolatry has thus far been condemned to existence as design commodities no longer remotely capable of being taken seriously in

any but commercial terms, in which they are thus taken all the more seriously.

It is hard to read Bochner's phrase "things not as sacred but as they probably are" without hearing Blake's "For every thing that lives in Holy." It is hard to dwell in the world of Minimal sculpture without—perhaps the sentence is best ended before "without," but I have in mind to add "feeling extraneous." Its acknowledgment of an alien universe it devotedly replicates in art is precisely the opposite of Blake's desire not only to create art but to continuously recreate reality in vision. Once reified and fetishized as much as any Old Master, each Minimalist slab, lead sheet, or plywood wall becomes, like Blake's "serpent temple" Stonehenge, a sacrificial altar of natural religion. To his apocalyptic humanism the concept of a nonanthropomorphic art would not have been debatable theory but the sheerest blasphemy, reduction of our universe to the limit of opacity. The possessive adjective is appropriate, since for Blake art was a paradigm of specifically human existence and the final transformation of reality itself into the culminating vision of *Jerusalem:* "All Human Forms identified even Tree Metal Earth & Stone. all / Human Forms identified. . . . "

This is of course an extreme Romantic version of the artistic quest as a cosmic psychomachia and as such represents all that progressively other-directed Minimalism (follow the path from Newman to Stella to Tuttle, or from acoustic long-tone works to electronic drones and self-generating process pieces) rejects, despite countervailing mystical proclivities in some of the music. An alternative version of quest-romance, more amenable to the Minimalist sensibility, appears in Peter Handke's novel *Absence*.

The title of the novel suggests both the fragmented state of the questers and the goal of the quest as described by the old man who leads the expedition: "I believe in those places without fame or name, best characterized perhaps by the fact that *nothing* is there, while all around there is *something*. . . . The grass there will have trembled as only grass can tremble, the wind will have blown as only wind can blow, a procession of ants through the sand will have been a procession of ants, the raindrops in the dust will have taken on the incomparable form of raindrops in the dust. In that place, on the foundations of emptiness, we shall simply have seen the metamorphosis of things into what they are" [43–44].

The final words echo various comments on Minimal art, but the ascription of ultimate reality is more problematic when the "things" in question are of human handiwork. While Handke's metamorphosis of things of nature into themselves is predicated on "emptiness," the "things" of Minimal art, although free of "humanistic values" and transcendental allusion, are burdened with human and metaphysical absence. Stella's "What you see is what you see" thus provides, finally, a less accurate synopsis of one's experience of Minimal art than the more ambiguous

emblem of Wallace Stevens's Snow Man, who "beholds" both "Nothing
that is not there and the nothing that is" [54].

Minimalism conjured up (no)thingness in monochromes, theoretically
infinite drones and open fifths, slabs and vacant plinths. It delineated a
paradoxically static metamorphosis in radiating but fixed patterns of
pigment, music similarly exfoliating complex overtone or resultant pat-
terns from unvaried material, and endless permutations of the same cube.
Whether any or all of these enterprises succeeded as art is for each one
to judge. Whether the autonomous and indifferent reality they evoke
exists anywhere outside the artwork any more or less than Blake's
humanized universe, or is itself just another authenticating myth, no one,
by definition, knows.

X Acknowledgments

For the generous provision of interviews, books, articles published and unpublished, tapes, scores, reproductions, logs, photos, microfilms, information, commentary, and valuable time I am grateful to Jonathan Bernard, Rob Brenner, John Cage, Holliday T. Day, David Farneth, Ron Firman, Ileana (flor de las) Flores, Robin Frank, Jon Gibson, Don Gillespie, Philip Glass, Laura Graham, Renata Hedjuk, H. Wiley Hitchcock, Judith Keenan, Joseph Kubera, Char Langos, Penny Liebman, Ingram Marshall, Anthony Martin, Robert Morris, Sasha Newman, I Wayan Rai, Steve Reich, Terry Riley, Carlos G. Rivera, Christine Schiller, Gary Schuster, K. Robert Schwarz, Charles Sitler, Morton Subotnick, Veronica Tomask, Rujapon Wipasuramonton, La Monte Young, and Marian Zazeela, along with the staffs of the Leo Castelli Gallery, G. Schirmer Music, WKCR-FM, WNYC-FM, the New York Public Library (Central Research Library and Library for the Performing Arts and its Mid-Manhattan, Donnell, and Lincoln Center branch libraries), the Queens Public Library (Broadway, Central, and Jackson Heights branches), the Library of Congress, the Chiang Mai University Library, the USIS-Chiang Mai Library, the Museum of Modern Art and its library, the Guggenheim Museum, the Jewish Museum, the Whitney Museum, and the Yale Art Gallery. I am indebted to the Fulbright Program agencies (the Council for International Exchange of Scholars and the United States Information Agency) for a Senior Lecturing/Research Fellowship affording me a year to organize material and gain perspective from the gracious confines of Thailand between lectures on this and other subjects.

Y Bibliography

This bibliography lists all works cited in the text in brackets by page number, except for unpaginated and single-page works, and with additional identification when necessary for clarity. "*AC*" indicates my book *American Composers*. Quotations without corresponding references derive from conversations with Terry Riley (1987, 1991, 1992), La Monte Young, and Marian Zazeela (1991, 1992); and John Cage, Jon Gibson, Philip Glass, Robert Morris, Steve Reich (all 1992). Various uncited but valuable works are also listed here by way of recommendation to those interested in exploring the topic further. Equally valuable works dealing with later developments in Minimalism are not included.

Ad Reinhardt. New York: Rizzoli/Museum of Modern Art; Los Angeles: Museum of Contemporary Art, 1991. [With an essay by Yve-Alain Bois.]

Ad Reinhardt: The Black Paintings 1951–1967. New York: Marlborough Gallery, 1970. [With an essay by Barbara Rose.]

Alloway, Lawrence. Introduction to *Systemic Painting*. New York: Guggenheim Museum, 1966.

———. *Topics in American Art Since 1945*. New York: Norton, 1975.

Art Minimal I. Bordeaux: Musée d'Art Contemporain, 1985.

Ashton, Dore. "Art: A Change in Style." *New York Times,* March 12, 1959, 28.

———. "Art: An Emphasis on Size." *New York Times,* October 16, 1959, 61.

———. "Clyfford Still." *New York Times,* November 15, 1959, II, 19.

———. "Art: Drawn From Nature." *New York Times,* December 29, 1959, 23.

———. "The Artist as Dissenter." *Studio International,* April 1966, 164–67.

———. "The Anti-Compositional Attitude in Sculpture: New York Commentary." *Studio International,* July 1966, 44–47.

———. *American Art Since 1945*. New York: Oxford University Press, 1982.

———. *About Rothko*. New York: Oxford University Press, 1983.

———, ed. *Twentieth-Century Artists on Art*. New York: Pantheon, 1985.

Aupin, Michael. *Abstraction.Geometry.Painting: Selected Geometrical Abstract Painting in America Since 1945*. New York: Abrams, 1989.

Axsom, Richard H. *Prints of Ellsworth Kelly: A Catalogue Raisonné 1949–1985*. New York: Hudson Hills, 1987.

Baigell, Matthew. *A Concise History of American Painting and Sculpture*. New York: Harper and Row, 1984.

Baker, Kenneth. *Minimalism: Art of Circumstance.* New York: Abbeville Press, 1988.

Balken, Debra Bricker. *Patricia Johanson: Drawings and Models for Environmental Projects, 1969–1986.* Pittsfield, Mass.: Berkshire Museum, 1987.

Bangs, Lester. *Psychotic Reactions and Carburetor Dung.* Edited by Greil Marcus. New York: Knopf, 1987.

Barron, Stephanie. "Giving Art History the Slip." *Art in America,* March-April 1974, 80–84.

Battcock, Gregory. "Robert Morris." *Arts Magazine,* May 1968, 30–31.

———, ed. *Minimal Art: A Critical Anthology.* New York: Dutton, 1968.

———, ed. *Idea Art: A Critical Anthology.* New York: Dutton, 1973.

———, ed. *The New Art: A Critical Anthology.* Rev. ed. New York: Dutton, 1973.

———, ed. *Breaking the Sound Barrier: A Critical Anthology of the New Music.* New York: Dutton, 1981.

Benedikt, Michael. "New York Letter." *Art International,* December 1966, 64–69.

———. "New York: Notes on the Whitney Annual." *Art International,* January 1967, 56–62.

———. "New York." *Art International,* February 1967, 63–65.

Berger, Maurice. *Labyrinths: Robert Morris, Minimalism, and the 1960s.* New York: Harper and Row, 1989.

Benjamin, Walter. *Illuminations.* Translated by Harry Zohn. New York: Schocken, 1969.

Berkson, William. "In the Museums [Barnett Newman]." *Arts Magazine,* June 1966, 44.

Bernard, Jonathan W. "The Minimalist Aesthetic in the Plastic Arts and in Music." *Perspectives of New Music,* 1993.

Berrigan, Ted. "Reviews and Previews." *Art News,* February 1965, 13.

"The Black Monk." *Newsweek,* March 15, 1965, 90.

Blok, C. "Minimal Art at The Hague." *Art International,* May 1968, 18–24.

Bochner, Mel. "In the Galleries." *Arts Magazine,* April 1966, 57.

———. "Primary Structures." *Arts Magazine,* June 1966, 32–35.

———. "Art in Process—Structures." *Arts Magazine,* September/October 1966, 38–39.

———. "Systemic." *Arts Magazine,* November 1966, 40.

———. "Serial Art/Systems: Solipsism." *Arts Magazine,* Summer 1967, 39–43.

Bois, Yve-Alain, Jack Cowart, and Alfred Pacquement. *Ellsworth Kelly: The Years in France, 1948–1954.* Washington: National Gallery of Art, 1992.

Borden, Lizzie. "The New Dialectic." *Artforum,* March 1974, 44–51.

Bourdon, David. "Our Period Style." *Art and Artists,* June 1966, 54–55.

———. "The Razed Sites of Carl Andre." *Artforum,* October 1966, 14–17.

———. "Master of the Minimal." *Life,* February 3, 1967, 45–51.

Broad, Elaine. "A New X? An Examination of the Aesthetic Foundations of Minimalism." *Music Research Forum* 5 (1990), 51–62.

Cage, John. *4'33".* New York: Henmar, 1960.

———. *Silence.* Middletown: Wesleyan University Press, 1961.

———. *0'00".* New York: Henmar, 1962.

Calas, Nicolas and Elena Calas. *Icons and Images of the Sixties.* New York: Dutton, 1971.

Campbell, Lawrence. "Reviews and previews." *Art News,* January 1964, 18–19.

Canaday, John. "Art: Running the Gamut." *New York Times,* October 21, 1961, 36.

———. "Art: With Pretty Thorough Execution [Newman and Alloway Provide the Rope]." *New York Times,* April 23, 1966, 26.

Caux, Daniel. Liner notes to *Four Organs/Phase Patterns,* Shandar SR 10.005, 1971.

Chave, Anna. *Mark Rothko: Subjects in Abstraction.* New Haven: Yale University Press, 1989.

―――. "Minimalism and the Rhetoric of Power." *Arts Magazine*, January 1990, 44–63.

Coates, Robert M. "Art." *New Yorker*, May 21, 1966, 177–79.

―――. "Art." *New Yorker*, December 10, 1966, 172–76.

Coe, Robert. "Philip Glass Breaks Through." *New York Times Magazine*, October 25, 1981, 68–80, 90.

Colin, Ralph F. "Fakes and Frauds in the Art World." *Art in America*, 1963, No. 2, 86–89.

Colpitt, Frances. *Minimal Art: The Critical Perspective*. Ann Arbor: UMI Research Press, 1990.

Coplans, John. "John McLaughlin, Hard Edge, and American Painting." *Artforum*, January 1964, 28–31.

―――. "Los Angeles." *Art News*, December 1965, 52, 61–62.

―――. *Serial Imagery*. Pasadena: Pasadena Art Museum, 1968.

―――. *Ellsworth Kelly*. New York: Abrams, 1972/73.

Davis, Douglas M. "The Dimensions of the Miniarts." *Art in America*, November-December 1967, 84–91.

Davis, Peter G. "3 Pieces by Glass Probe, the Sonic Possibilities." *New York Times*, January 17, 1970, 22.

de Antonio, Emile and Mitch Tuchman. *Painters Painting*. New York: Abbeville Press, 1984.

de Kooning, Elaine. "Pure Paints a Picture." *Art News*, Summer 1957, 57, 86–87.

Dienst, Rolf-Gunter. "Apropos Primary Structures." *Arts Magazine*, June 1966, 13.

Ederfield, John. *Morris Louis*. New York: Museum of Modern Art, 1986.

Finn, Robin. "Boom! Does Power Tennis Mean Poor Tennis?" *New York Times*, March 8, 1992, VIII, 7.

Flavin, Dan. " '. . . in daylight or cool white.' an autobiographical sketch." *Artforum*, December 1965, 21–24.

Forti, Simone. *Handbook in Motion*. Halifax: Press of Nova Scotia College of Art and Design; New York: New York University Press, 1974.

14 Sculptors: The Industrial Edge. Minneapolis: Walker Art Center, 1969. (With essays by Barbara Rose, Christopher Finch, Martin Friedman.)

Frankenstein, Alfred. "Music Like None Other On Earth." *San Francisco Chronicle*, November 8, 1964, 28.

Frascina, Francis, ed. *Pollock and After: The Critical Debate*. New York: Harper and Row, 1985.

Fried, Michael. "New York Letter." *Art International*, December 1962, 54–58.

―――. "New York Letter." *Art International*, February 1963, 60–64.

―――. "New York Letter." *Art International*, April 1963, 54–56.

―――. "New York Letter." *Art International*, February 1964, 24–25.

―――. "New York Letter." *Art International*, April 1964, 58.

―――. *Three American Painters: Kenneth Noland, Jules Olitski, Frank Stella*. Cambridge: Harvard University, Fogg Art Museum, 1965.

―――. "Shape as Form: Frank Stella's New Paintings." *Artforum*, November 1966, 18–27.

―――. *Jules Olitski: Paintings 1963–1967*. Washington: Corcoran Gallery of Art, 1967.

―――. "Art and Objecthood." *Artforum*, June 1967, 12–23.

―――. *Morris Louis*. New York: Abrams, 1979.

Geldzahler, Henry. "Interview with Ellsworth Kelly." *Art International*, February 1964, 47–48.

————. *New York Painting and Sculpture: 1940–1970*. New York: Dutton/Metropolitan Museum of Art, 1969.

Gibson, Jon. Notes to CD *In Good Company*. New York: Point, 1992.

Ginsberg, Allen. *Collected Poems 1947–1980*. New York: Harper and Row, 1984.

Glass, Philip. *The Music of Philip Glass*. Edited by Robert T. Jones. New York: Harper and Row, 1987.

Glueck, Grace. "Anti-Collector, Anti-Museum." *New York Times*, April 24, 1966, II, 24.

————. "Any Number Can Play [Mr. Pure]." *New York Times*, November 13, 1966, II, 18.

————. "No Place To Hide." *New York Times*, November 27, 1966, II, 19.

————. "Art Notes: Air, Hay and Money." *New York Times*, May 25, 1969, II, 42.

Goodman, Peter. "Sound the Trumpets." *Newsday*, November 14, 1988, II, 15.

Goossen, E. C. *Ellsworth Kelly*. New York: Museum of Modern Art, 1973.

Graham, Dan. "A Minimal Future? Models and Monuments: The Plague of Architecture." *Arts Magazine*, March 1967, 32–35.

————. "Carl Andre." *Arts Magazine*, December 1967/January 1968, 34–35.

Greenberg, Clement. *Art and Culture*. Boston: Beacon, 1961.

————. "Anne Truitt." *Vogue*, May 1968, 212, 284.

Griffiths, Paul. *Modern Music: The Avant Garde Since 1945*. New York: Braziller, 1981.

Handke, Peter. *Absence*. Translated by Ralph Manheim. New York: Farrar, Strauss, and Giroux, 1990.

Harrison Cone, Jane. "Judd at the Whitney," *Artforum*, May 1968, 36–39.

Haskell, Barbara. *Blam! The Explosion of Pop, Minimalism, and Performance 1958–1964*. New York: Norton/Whitney Museum, 1984.

————. *Donald Judd*. New York: Norton/Whitney Museum, 1988.

————. *Agnes Martin*. New York: Abrams/Whitney Museum, 1992.

Henahan, Donal. "Repetition, Electronically Aided, Dominates Music of Steve Reich." *New York Times*, May 28, 1969, 37.

————. "Steve Reich Presents a Program of Pulse Music at Guggenheim." *New York Times*, May 9, 1970, 15.

————. "Reich? Philharmonic? Paradiddling?" *New York Times*, October 24, 1971, II, 13, 26.

————. "The Going-Nowhere Music and Where It Came From." *New York Times*, December 6, 1981, II, 1, 25.

Hess, Thomas B. "The Phony Crisis in American Art." *Art News*, Summer 1963, 24–28.

————. *Barnett Newman*. New York: Museum of Modern Art, 1971.

Hitchcock, H. Wiley. *Music in the United States: A Historical Introduction*. 2nd ed. Englewood Cliffs: Prentice-Hall, 1974.

————, ed., *The New Grove Dictionary of American Music*. New York: Grove's Dictionaries, 1986.

————. "Minimalism in Art and Music: Origins and Aesthetics." 1988 slide lecture.

Hoene, Anne. "In the Galleries." *Arts Magazine*, September-October 1965, 63–64.

Hollander, John. *The Untuning of the Sky: Ideas of Music in English Poetry, 1500–1700*. New York: Norton, 1970.

Hopps, Walter. "An Interview with Jasper Johns." *Artforum*, March 1965, 32–36.

————. *Robert Rauschenberg—The Early 1950s*. Houston: Houston Fine Art Press, 1991.

Horowitz, Leonard. "Art: A Day in the Country." *Village Voice*, May 23, 1963, 10.

Hunt, Ronald. "Yves Klein." *Artforum*, January 1967, 32–37.

John Cage. New York: Henmar, 1962. [Catalog; interview by Roger Reynolds].

Johnson, Tom. "Music." *Village Voice,* December 9, 1971, 46–47.
———. "Music." *Village Voice,* January 13, 1972, 35–36.
———. "Music." *Village Voice,* February 3, 1972, 35.
———. "Music for a Joy-toned Trance." *Village Voice,* April 6, 1972, 42.
———. "Music." *Village Voice,* June 15, 1972, 37.
———. "Variations on a Note." *Village Voice,* August 17, 1972, 32.
———. "Changing the Meaning of 'Static.'" September 7, 1972, 45.
———. "Music." *Village Voice,* October 5, 1972, 41–42.
———. "Music." *Village Voice,* November 23, 1972, 46.
———. "Music." *Village Voice,* March 8, 1973, 37–38.
———. "Music." *Village Voice,* March 15, 1973, 35.
———. "Lyricism is Alive, and, Well…". *Village Voice,* April 12, 1973, 51.
———. "Music." *Village Voice,* May 3, 1973, 46.
———. "A Galleryful of Spinets." *Village Voice,* May 24, 1973, 41.
———. "Music." *Village Voice,* June 7, 1973, 51–52.
———. "Frail Ghost in Strong Voice." *Village Voice,* June 21, 1973, 51.
———. "Music." *Village Voice,* July 5, 1973, 38–39.
———. "A La Monte Young Diary," *Village Voice,* July 26, 1973, 41.
———. "Getting Fogbound in Sound." *Village Voice,* December 20, 1973.
———. "Meditating and On the Run." *Village Voice,* January 31, 1974, 44–45.
———. "Music." *Village Voice,* March 14, 1974, 41.
———. "In Their 'Dream House,' Music Becomes a Means of Meditation." *New York Times,* April 28, 1974, II, 13.
———. "Chugging Away to an Ultimate High." *Village Voice,* June 13, 1974, 55.
———. "Charlemagne Palestine Ascends." April 18, 1977, 74.
———. "From Rags to Bass Drums." *Village Voice,* January 1, 1979, 65.
———. "The Original Minimalists." *Village Voice,* July 27, 1982, 68–69.
Johnston, Jill. "Walter De Maria." *Art News,* February 1963, 19.
———. "New works." *Art News,* March 1963, 16.
———. "Reviews and Previews: New names this month." *Art News,* March 1963, 50.
———. "New names this month." *Art News,* October 1963, 14–15.
———. "Music: La Monte Young." *Village Voice,* November 19, 1964, 14, 20.
———. "Reviews and Previews." *Art News,* January 1965, 13.
———. "Reviews and Previews." *Art News,* May 1965, 18.
Jones, Robert T. "3 Films by Serra And Glass's Music Offered at Whitney." *New York Times,* May 21, 1969, 43.
———. "An Outburst of Minimalism." *High Fidelity/Musical America,* February 1983, 26.
———. "Philip Glass: Musician of the Year." *High Fidelity/Musical America 1985 Directory of the Performing Arts.*
Judd, Donald. *Complete Writings 1959–1975.* New York: New York University Press, 1975.

Kertess, Klaus. *Brice Marden: Paintings and Drawings.* New York: Abrams, 1992.
Kozloff, Max. "The Further Adventures of American Sculpture." *Arts Magazine,* February 1965, 24–31.
———. "Larry Poons." *Artforum,* April 1965, 26–29.
———. "New Paintings by Gene Davis." *Artforum,* April 1967, 53–54.
Kostelanetz, Richard. *The Theatre of Mixed Means.* New York: Dial Press, 1968.
———. *On Innovative Musicians.* New York: Limelight Editions, 1989.
Kramer, Hilton. "The Season Surveyed." *Art in America,* June 1964, 108–14.
———. "Constructed to Donald Judd's Specifications." *New York Times,* February 19, 1966, 23.
———. "Representative of the 1960's." *New York Times,* March 20, 1966, II, 21.
———. "Reshaping the Outermost Limits." *New York Times,* April 28, 1966, 48.

———. "'Primary Structures'—The New Anonymity." *New York Times,* May 1, 1966, II, 23.

———. "An Art of Boredom?" *New York Times,* June 5, 1966, II, 23.

———. "'Systemic Painting': An Art for Critics." *New York Times,* September 18, 1966, II, 33.

———. "Ad Reinhardt's Black Humor." *New York Times,* November 27, 1966, II, 17.

———. "Art: Melting Ice, Hay, Dog Food, Etc." *New York Times,* May 24, 1969, 31.

Krauss, Rosalind. *Passages in Modern Sculpture.* New York: Viking, 1977.

———. *The Originality of the Avant-Garde and Other Modernist Myths.* Cambridge: MIT Press, 1985.

———. "Overcoming the Limits of Matter: On Revising Minimalism." In *American Art of the 1960s,* ed. John Elderfield. New York: Museum of Modern Art, 1991.

La Barbara, Joan. "New Music." *High Fidelity/Musical America,* November 1977, MA 14–15.

Lanes, Jerrold. "New York." *Artforum,* May 1969, 59–60.

Lansford, Alonzo. "Variations on Reinhardt." *Art Digest,* November 1, 1946, 21.

Legg, Alicia, ed. *Sol LeWitt.* New York: Museum of Modern Art, 1978. [With an introduction by Legg and essays by Lucy Lippard, Bernice Rose, and Robert Rosenblum.]

Leider, Philip. "The Thing in Painting Is Color." *New York Times,* August 25, 1968, II, 21–22.

LeWitt, Sol. "Paragraphs on Conceptual Art." *Artforum,* June 1967, 79–83.

Lippard, Lucy. "New York." *Artforum,* February 1964, 18–19.

———. "New York Letter." *Art International,* May 1965, 50–53.

———. "New York Letter." *Art International,* September 1965, 57–61

. *Ad Reinhardt: Paintings.* New York: Jewish Museum, 1966.

———. "New York Letter: Off Color." *Art International,* April 1966, 73–75.

———. "Rejective Art." *Art International,* October 1966, 33–36.

———. "Ronald Bladen's Black Triangle." *Artforum,* March 1967, 26–27.

———. "Sol LeWitt: Non-Visual Structures." *Artforum,* April 1967, 42–46.

———. "Homage to the Square." *Art in America,* July–August 1967, 50–57.

———. "Constellation by Harsh Daylight: The Whitney Annual." *Hudson Review,* Spring 1968, 174–82.

———. *Tony Smith: Recent Sculpture.* New York: Knoedler, 1971.

———. *Grids grids grids grids grids grids grids grids.* Philadelphia: Institute of Contemporary Art, University of Pennsylvania, 1972.

———. *Six Years: The Dematerialization of the Art Object from 1966 to 1972.* New York: Praeger, 1973.

———. *Ad Reinhardt.* New York: Abrams, 1981.

Louchheim, Aline B. "By Extreme Modernists." *New York Times,* January 29, 1950, II, 9.

Lucie-Smith, Edward. *Movements in Art Since 1945.* Rev. ed. London: Thames and Hudson, 1984.

Lyotard, Jean-François. *The Lyotard Reader.* Edited by Andrew Benjamin. Oxford: Basil Blackwell, 1989.

Mackie, Alwynne. *Art/Talk: Theory and Practice in Abstract Expressionism.* New York: Columbia University Press, 1989.

Mandelowitz, Daniel. *A History of American Art.* 2nd ed. New York: Holt, Rinehart and Winston, 1970.

Marcus, Greil. *Lipstick Traces: A Secret History of the Twentieth Century.* Cambridge: Harvard University Press, 1989.

Marden, Brice. *Brice Marden.* New York: Guggenheim Museum, 1975. [With an essay by Linda Shearer.]

———. *Brice Marden: Schilderijen Tekeningen Etsen 1975–80.* Amsterdam: Stedelijk Museum, 1981.

Marshall, Richard. *Immaterial/Objects.* New York: Whitney Museum, 1991.

Martin, Agnes. *Agnes Martin.* Philadelphia: Institute of Contemporary Art, University of Pennsylvania, 1973. [With an essay by Lawrence Alloway.]

The Maximal Implications of the Minimal Line. Annandale-on-Hudson: Bard College, 1985. (With an introduction by Linda Weintraub and essays by Donald Kuspit and Phyllis Tuchman.)

McShine, Kynaston. *Primary Structures.* New York: Jewish Museum, 1966.

Mellers, Wilfrid. "A Minimalist Definition." *Musical Times,* 1984, 328.

———. *Music in a New Found Land: Themes and Developments in the History of American Music.* Rev. ed. New York: Oxford, 1987.

Mellow, James R. "New York Letter." *Art International,* November 1966, 54–59.

Mertens, Wim. *American Minimal Music.* London: Kahn and Averill, 1983.

Meyer, Ursula. *Conceptual Art.* New York: Dutton, 1972.

Michelson, Annette. "10×10: 'concrete reasonableness.'" *Artforum,* January 1967, 30–31.

———. "Agnes Martin: Recent Painting." *Artforum,* January 1967, 46–47.

Minimal Art. The Hague: Cemeentemuseum, 1968. (With an introduction by E. Develing and essay by Lucy Lippard.)

Moore, Carman. "Music: Park Place Electronics." *Village Voice,* June 9, 1966, 17.

———. "Music: Park Place Pianos." *Village Voice,* March 23, 1967, 15.

———. "Fragments." *Village Voice,* January 18, 1968, 25, 28.

———. "Music: Zukofsky." *Village Voice,* May 1, 1969, 28.

Morgan, Robert. *Twentieth-Century Music: A History of Musical Style in Modern Europe and America.* New York: Norton, 1991.

Morris, Robert. "Notes on Sculpture." *Artforum,* February 1966, 42–44.

———. "Notes on Sculpture, Part II." *Artforum,* October 1966, 20–23.

———. "Notes on Sculpture, Part 3." *Artforum,* June 1967, 24–29.

———. "Notes on Sculpture, Part IV: Beyond Objects." *Artforum,* April 1969, 50–54.

Mumford, Lewis. *The Lewis Mumford Reader.* Edited by Donald L. Miller. New York: Pantheon, 1986.

Naifeh, Steven and Gregory White Smith. *Jackson Pollock, An American Saga.* New York: Potter, 1989.

Neilson, John. "La Monte Young." *Creem,* November 1987, 44.

Newman, Barnett. *Selected Writings and Interviews.* Edited by John P. O'Neill. New York: Knopf, 1990.

Newsweek. "Art." May 16, 1966, 104–05.

Nyman, Michael. "Steve Reich: An Interview with Michael Nyman." *Musical Times,* March 1971, 229–31.

———. "Steve Reich, Phil Glass." *Musical Times,* May 1971, 463–64.

———. "S R–mysteries of the phase." *Music and Musicians,* June 1972, 20–21.

———. *Experimental Music: Cage and Beyond.* London: Studio Vista; New York: Schirmer, 1974.

———. "Steve Reich: Interview." *Studio International* 1976, 300–07.

O'Doherty, Brian. "Abstract Confusion." *New York Times,* June 2, 1963, II:11.

———. "Recent Openings." *New York Times,* December 21, 1963, D20.

———. "Frank Stella and a Crisis of Nothingness." *New York Times,* January 19, 1964, II:21.

———. "Art: Avant-Garde Deadpans on the Move." *New York Times,* April 11, 1964, 22.

————. *Object and Idea: An Art Critic's Journal 1961–1967.* New York: Simon and Schuster, 1967.

Oliva, Achille Bonito. "Robert Ryman Interviewed." *Domus,* February 1973, 50.

Oliver, Michael. Review of Deutsche Grammophon release of *Six Pianos* and *Music for Mallet Instruments, Voices, and Organ. Gramophone,* September 1981, 402.

Ono, Yoko. *Grapefruit.* New York: Simon and Schuster, 1970.

Osborne, Harold, ed. *The Oxford Companion to Twentieth-Century Art.* Oxford: Oxford University Press, 1988.

Page, Tim. "Steve Reich's *Music for 18 Musicians* finally gets a good treatment on vinyl." *Columbia Spectator,* November 2, 1978.

————. "Framing the River: A Minimalist Primer." *High Fidelity/Musical America,* November 1981, 64–68, 117.

————. "Steve Reich Approaches 50." *New York Times,* June 1, 1986, II, 23–24.

Palmer, Robert. "La Monte Young: Lost in the Drone Zone." *Rolling Stone,* February 13, 1975, 24–26.

————. "A Father Figure for the Avant-Garde." *Atlantic Monthly,* May 1981, 48–56.

Pelinski, Ramon. "Upon Hearing a Performance of *The Well-Tuned Piano:* An Interview with La Monte Young and Marian Zazeela." *Interval,* Spring 1984, 13–20; Summer 1984, 16–24. [Reprinted from *Parachute* magazine, 19 (1980, 4ff.)]

Perreault, John. "Minimal Art: Clearing the Air." *Village Voice,* January 12, 1967, 11.

————. "A Minimal Future? Union Made: Report on a Phenomenon." *Arts Magazine,* March 1967, 26–31.

————. "Color as Light." *Village Voice,* March 9, 1967, 12.

————. "Stripes and Stripes." *Village Voice,* November 30, 1967, 21.

————. "Blown Cool." *Village Voice,* December 7, 1967, 18.

————. "Simple, Not Simple-Minded." *Village Voice,* January 18, 1968, 16–17.

————. "La Monte Young's Tracery: The Voice of the Tortoise." *Village Voice,* February 22, 1968, 27, 29.

————. "Plastic Ambiguities." *Village Voice,* March 7, 1968, 19–20.

————. "Pulling Out the Rug." *Village Voice,* May 16, 1968, 14–15.

————. "Art [Anti-Illusion]." *Village Voice,* May 29, 1969, 16.

Pierce, James Smith. "Design and Expression in Minimal Art." *Art International,* May 1968, 25–27.

Pincus-Witten, Robert. "'Systemic' Painting." *Artforum,* November 1966, 42–45.

————. *Postminimalism.* New York: Out of London Press, 1977.

Preston, Stuart. "Diverse New Shows." *New York Times,* April 29, 1951, II, 6.

————. "Highly Diverse." *New York Times,* November 22, 1953, II, 15.

————. "Color Keys Four Painters' Work." *New York Times,* February 6, 1955, II, 10.

————. "About Art and Artists: Lesser Known Figures Give One-Man Shows of Promise at Galleries Here." *New York Times,* May 26, 1956, 41.

————. "Highly Diverse One-Man Shows." *New York Times,* November 11, 1956, II, 16.

————. "Real and Surreal in the Week's Exhibitions." *New York Times,* October 25, 1959, II, 23.

————. "Art: 'Sixteen Americans.'" *New York Times,* December 16, 1959, 50.

————. "The Shape of Things to Come?" *New York Times,* December 20, 1959, II, 11.

————. "Art: At Opposite Poles." *New York Times,* October 21, 1961, 11.

Rainer, Yvonne. *Work 1961–73.* New York: New York University Press, 1974.

Randel, Don, ed. *The Harvard Dictionary of Music.* Cambridge: Harvard University Press, 1986.

Ratcliff, Carter. "Mostly Monochrome." *Art in America,* April 1981, 111–131.

Reich, Steve. *Writings About Music.* New York: New York University Press, 1974.

———. Liner notes to *Music for 18 Musicians,* ECM 1-1129, 1978.

Reinhardt, Ad. *Art-as-Art: Selected Writings of Ad Reinhardt.* Edited by Barbara Rose. New York: Viking, 1975.

Reise, Barbara. "Greenberg and the Group." *Studio International.* Part 1: May 1968, 254–57; Part 2: June 1968, 314–15.

———. "Untitled 1969: a footnote on art and minimalstylehood." *Studio International,* April 1969, 166–172.

Restany, Pierre. *Yves Klein.* Translated by John Shepley. New York: Abrams, 1982.

Rich, Alan. "Ringo, Paul, Lenny, George, Elvira, Dave, Wolfgang and John." *New York,* April 8, 1968, 113–14.

———. "Over and Over and Over and..." *New York,* May 25, 1970, 54.

———. "La Monte Young's Minimalist Marathon." *Newsweek,* July 27, 1987, 58.

Richardson, Brenda. *Frank Stella: The Black Paintings.* Baltimore: Baltimore Museum of Art, 1976.

Riley, Terry. Liner notes to *In C,* Columbia Masterworks MS 7178, 1968.

Robert Mangold. La Jolla, California: La Jolla Museum of Contemporary Art, 1974.

Robert Ryman. New York: Dia Art Foundation, 1988.

Robins, Corinne. "Object, Structure or Sculpture: Where Are We?" *Arts Magazine,* September/October 1966, 33–37.

Rockwell, John. "Terry Riley, Organist, Plays Improvisations." *New York Times,* April 7, 1973, 30.

———. "11 Players Perform Terry Riley's 'In C.'" *New York Times,* April 27, 1973, 28.

———. "Music: Reich Meditations." *New York Times,* May 19, 1973, 28.

———. "Philip Glass Works to Broaden Scope Beyond 'In' Crowd." *New York Times,* June 28, 1973, 58.

———. "What's New." *High Fidelity/Musical America,* August 1973, MA 7, 31–32.

———. "La Monte Young Plays at Kitchen." *New York Times,* May 2, 1974, 67.

———. "There's Nothing Quite Like the Sound of Glass." *New York Times,* May 26, 1974, II, 11, 21.

———. "Music: The Avant-Garde." *New York Times,* June 3, 1974, 39.

———. "The Evolution of Steve Reich." *New York Times,* March 14, 1982, II, 23–24.

———. *All-American Music: Composition in the Late Twentieth Century.* New York: Knopf, 1984.

———. "The Death and Life of Minimalism." *New York Times,* December 21, 1986, II, 1, 29.

———. "Music: La Monte Young." *New York Times,* May 21, 1987, C22.

———. "Feldman's Minimalism in Maximal Doses." *New York Times,* January 12, 1992, II, 28.

Rodman, Selden. *Conversations with Artists.* New York: Devin-Adair, 1957.

Roob, Rona. "Ad Reinhardt and the Museum." *Museum of Modern Art Members Quarterly,* Summer 1991, 6–7.

Rose, Barbara. "New York Letter." *Art International,* February 1964, 40–41.

———. "Looking at American Sculpture." *Artforum,* February 1965, 29–36.

———. "ABC Art." *Art in America,* October/November 1965, 57–69.

———. "New York." *Artforum,* November 1967, 57–60.

———. *A New Aesthetic.* Washington: Washington Gallery of Modern Art, 1967.

———. *American Painting: The 20th Century.* Skira, 1970.

———. "A Conversation with Gene Davis." *Artforum,* March 1971, 50–54.

———. *American Art Since 1900.* New York: Praeger, 1967. Rev. ed., New York: Holt, Rinehart and Winston, 1975.

————. Interview with Robert Rauschenberg in *Rauschenberg*. New York: Vintage, 1987.

Rosenberg, Harold. *The Anxious Object*. Chicago: University of Chicago Press, 1964.

————. *The De-definition of Art*. New York: Horizon Press, 1972.

Rosenblum, Robert. "The Abstract Sublime." *Art News*, February 1961, 38–41, 56, 58.

————. "Frank Stella." *Artforum*, March 1965, 20–25.

Rosenblum, Ron. "La Monte Young: Eternal Music in a Dreamhouse Barn." *Village Voice*, February 12, 1970, 5–6, 63–66.

Rowell, Margit. *Ad Reinhardt and Color*. New York: Guggenheim Museum, 1980.

Rubin, William S. "Younger American Painters." *Art International*, January 1960, 23–24.

————. *Frank Stella*. New York: Museum of Modern Art, 1970.

Rudikoff, Sonya. "New York Letter." *Art International*, January 1963, 76–78.

Sandler, Irving. "Reviews and Previews [Ronald Bladen]." *Art News*, December 1962, 15.

————. "The New Cool-Art." *Art in America*, February 1965, 96–101.

————. "Reinhardt: The Purist Blacklash." *Artforum*, December 1966, 40–46.

————. "John D. Graham: The Painter as Esthetician and Connoisseur." *Artforum*, October 1968, 50–53.

————. *The Triumph of American Painting: A History of Abstract Expressionism*. New York; Praeger, 1970.

Schaefer, John. *New Sounds: A Listener's Guide to New Music*. New York: Harper and Row, 1987.

Schonberg, Harold. "Music: The Medium Electric, the Message Hypnotic." *New York Times*, April 15, 1969, 42.

————. "Music: A Concert Fuss." *New York Times*, January 20, 1973, 36.

————. "Plumbing the Shallows of Minimalism." *New York Times*, February 21, 1985, C18.

Schwarz, K. Robert. "Steve Reich: Music as a Gradual Process." *Perspectives of New Music*, 19 (1980–81), 374–92; 20 (1981–82), 226–86.

Serra, Richard. *Richard Serra: Interviews, etc. 1970–1980*. Yonkers: Hudson River Museum, 1980.

Shepard, Richard F. "Going Out Guide." *New York Times*, January 18, 1973, 46.

Sontag, Susan. *Against Interpretation*. New York: Dell, 1969.

Spector, Naomi. "Essential Painting." In *Robert Mangold*. La Jolla: La Jolla Museum of Contemporary Art, 1974.

Steinberg, Leo. "Contemporary Art and the Plight of Its Public." *Harper's*, March 1962, 31–39.

Steinberg, Michael. "BSO 'Spectrum' Aims at New Audience." *Boston Globe*, October 3, 1971, 71.

————. "BSO Keeps a Promise." *Boston Globe*, October 9, 1971, 8.

Strickland, Edward. *American Composers: Dialogues on Contemporary Music*. Bloomington: Indiana University Press, 1991.

Swan, Annalyn. "The Rise of Steve Reich." *Newsweek*, March 29, 1982, 56.

Swed, Mark. "La Monte Young Tunes the Piano His Way." *Los Angeles Herald Examiner*, November 1, 1985, 36–37.

Tatge, Catherine, director. *American Masters: Robert Motherwell*. PBS documentary, 1991.

Tillim, Sidney. "The Month in Review." *Arts Magazine*, March 1963, 59–62.

————. "In the Galleries [Robert Morris]." *Arts Magazine*, December 1963, 61–62.

————. "The New Avant-Garde." *Arts Magazine*, February 1964, 18–21.

————. "Larry Poons: The Dotted Line." *Arts Magazine*, February 1965, 16–23.

Time. "Art: Engineer's Esthetic." June 3, 1966, 64–67.
———. "Art." December 23, 1966, 51.
———. "Music: Recordings: The Twelve Tones of Christmas." December 8, 1967, 52.
Tischler, Barbara. *An American Music: The Search for an American Musical Identity.* New York: Oxford, 1986.
Tomkins, Calvin. "A Keeper of the Treasure." *New Yorker,* June 9, 1975. 44–66.
———. *Off the Wall: Robert Rauschenberg and the Art World of Our Time.* New York: Penguin, 1981.
Tony Smith Two Exhibitions of Sculpture. Hartford: Wadsworth Atheneum; Philadelphia: Institute of Contemporary Art, 1966.
Tuchman, Phyllis. "An Interview with Robert Ryman." *Artforum,* May 1971, 46–53.
Tuchman, Robert, ed. *American Sculpture of the Sixties.* Los Angeles: Los Angeles County Museum of Art, 1967.
Tucker, Marcia. *Richard Tuttle.* New York: Whitney Museum, 1975.

Unitary Forms: Minimal Sculpture by Carl Andre, Don Judd, John McCracken, Tony Smith. San Francisco: San Francisco Museum of Art, 1970. [With an introduction by Suzanne Foley.]
Upright, Diane. *Morris Louis: The Complete Paintings.* New York: Abrams, 1985.
———. *Ellsworth Kelly: Works on Paper.* New York: Abrams, 1987.

Vidic, Ljerka. "La Monte Young and Marian Zazeela." *Ear,* May 1987, 24–26.
Von Meier, Kurt. "Los Angeles: American Sculpture of the Sixties." *Art International,* Summer 1967, 64–68.

Waldman, Diane. *Robert Ryman.* New York: Guggenheim Museum, 1972.
———. *Kenneth Noland: A Retrospective.* New York: Guggenheim Museum, 1977.
Wallace, Dean. "Newcomer to Tape Music." *San Francisco Chronicle,* January 29, 1965, 41.
Walsh, Michael. "Melody Stages a Comeback." *Time,* August 10, 1981, 63.
———. "The Heart is Back in the Game." *Time,* September 20, 1982, 60–62.
Warburton, Dan. "A Working Terminology for Minimal Music." *Intégral* 2 (1988), 135–59.
Wasserman, Emily. "An Interview with Composer Steve Reich." *Artforum,* May 1972, 44–48.
Wechsler, J. "Why Scale?" *Art News,* Summer 1967, 32–35, 67–68.
Williams, Margaret, director. *Steve Reich: A New Musical Language.* London: MJW Productions documentary, 1987.
Wilson, Ann. "Linear Webs." *Art and Artists,* October 1966, 46–49.
WKCR-FM. *La Monte Young Fifty-Sixth Birthday Retrospective,* October 20–22, 1991. (With commentary by the composer and other musicians and critics.)
WNYC-FM. Broadcast of Philip Glass, *Music in Twelve Parts.* (With commentary by the composer.) 1981.
Wolfe, Tom. *The Painted Word.* New York: Farrar, Strauss, and Giroux, 1975.
Wollheim, Richard. "Minimal Art." *Arts Magazine,* January 1965, 26–32.

Yates, Peter. *Twentieth Century Music.* New York: Pantheon, 1967.
Young, La Monte. *30-Year Retrospective* (program notes for May 18, 1987 performances). New York: Dia Art Foundation Performance Space, 1987.
———. *The Well-Tuned Piano 81 x 25 6:17:50–11:18:59 PM NYC.* Booklet with Gramavision Records 18-8701, 1987. (Includes articles by Young, Marian Zazeela, and David Farneth.)

———. Program notes. *The Music and Poetry of Angus MacLise.* New York: Dia Art Foundation, May 16, 1989.

———. Program notes. *The Music of Terry Jennings.* New York: Dia Art Foundation, May 23, 1989.

———. *90 XII 9 c. 9:35-10:52 PM NYC The Melodic Version (1984) of The Second Dream of the High-Tension Line Stepdown Transformer from The Four Dreams of China (1962).* Booklet with Gramavision Records R2 79467, 1991.

———. Liner Notes to Michael Harrison CD *From Ancient Worlds,* New Albion Records NA042, 1992.

———, and Jackson Mac Low, eds. *An Anthology.* New York, 1963.

———, and Marian Zazeela. *Selected Writings.* Munich: Heiner Friedrich, 1969.

Yves Klein. Paris: Centre Georges Pompidou, 1983.

Yves Klein 1928–1962: A Retrospective. Houston/New York: Institute for the Arts, Rice University/The Arts Publisher, 1982.

Zelevansky, Lynn. "Ad Reinhardt and the Younger Artists of the 1960s." In *American Art of the 1960s,* ed. John Elderfield. New York: Museum of Modern Art, 1991.

Z Index